Supreme

RIZZOLI
NEW YORK

New York · Paris · London · Milan

Supreme

First Published in the United States of America in 2010 by
Rizzoli International Publications, Inc.
300 Park Avenue South
New York, NY 10010
www.rizzoliusa.com

Editor for Supreme: West Rubinstein

Art Direction and Design by Studio 191

2020 2021 2022 / 18 17 16

Trade edition:
ISBN-13: 978-0-8478-3311-5

Supreme edition:
ISBN-13: 978-0-8478-3496-9

Library of Congress Catalog Control Number: 2009940780

Printed in China

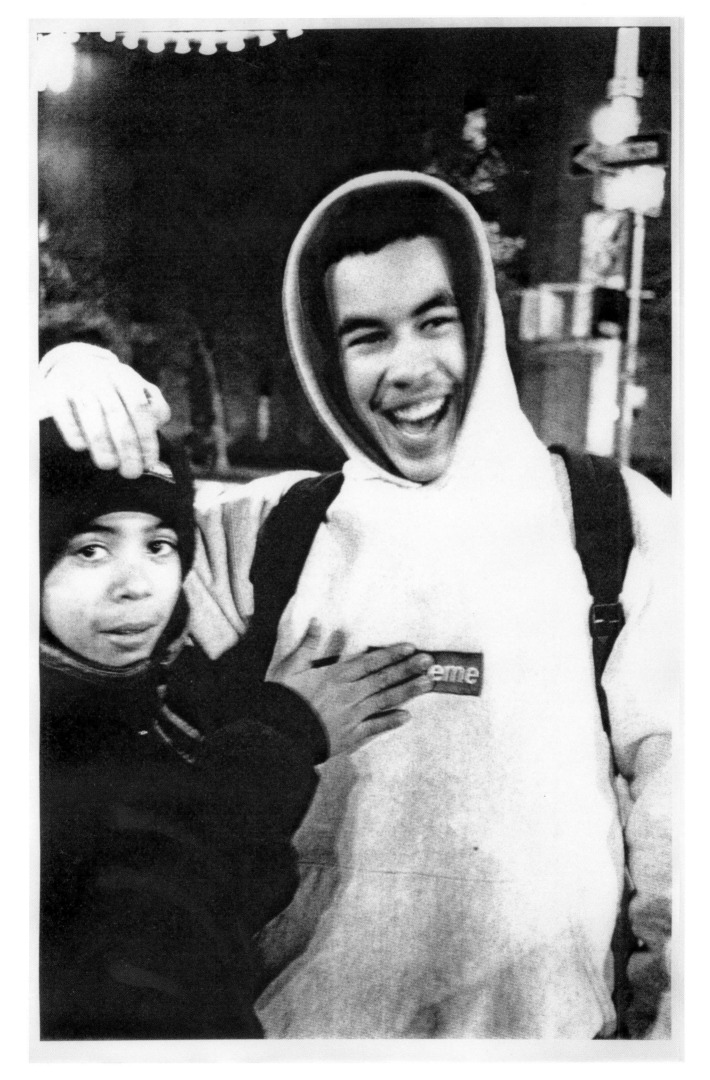

Introduction by Glenn O'Brien

I was a teenager with a skateboard when John Coltrane's *A Love Supreme* came out. My skateboard was plain pine, about a foot and a half long, and it had metal wheels. At first I thought it was for going down big hills, like urban skiing. Fast. I skinned my knees, elbows, trees. I was a beatnik teenager. I loved Coltrane's levitation saxophone and the magic chant—"a love supreme, a love supreme..." It was like an out-of-body experience.

So by the time the Supreme store caught my eye, I had traveled a million miles, far, far from the world of a teenager. But as an eye, I found that logo really appealing. Perfect. Futura Bold Italic. Supreme.

And the word resonated. A great name for a brand. A modernist or post-modernist equivalent of Paramount or Acme or Peerless. It's significant when a brand resonates from the name and logo outward, as if it means what it says, as if it means business. There was something radiant about this label. This was obviously a case of Pop Art. I wanted to check the place out but it was filled with teenagers and that sort of kept me out. Instinctively I didn't want to intrude on a world no longer my own. Although I did notice that they looked kind of like me. Except unwrinkled, and no gray hair. They were mostly dressed cool and classic with stylistic touches signifying independence and cool attitude. I walked on by. But the store was just down the street so I started to keep an eye on it, a third eye on it too.

Brands boast, that's normal. It is the rare brand that means what it says, that delivers, that stands by its word—word being logo. And that logo had its hooks in me. It was the same type that Barbara Kruger used in work like *I Shop Therefore I Am*, but even though it was in that same white and red it didn't

look all that Barbara Kruger to me. Well, it does look a little like *Control*. And it does look like art. Maybe you could say it was Appropriated.

With my eye on Supreme, I noticed that it seemed to be more than a store; it had at least some qualities of a cult. The store would close for installation, just like an art gallery, and then reopen with new merchandise, just like a gallery. But unlike a gallery, Supreme had long lines of customers waiting to get in, and they would even camp out overnight. I eventually learned that there was something analogous to art sales going on here; the cats in the queue were there to get limited-edition merchandise. But I couldn't recall anyone ever camping out for the release of a lithograph.

I also began to notice what was playing on the Nam June Paik-like stack of televisions in the window of the store. You might see some amazing skate footage, or surf footage, or you might see Mohammed Ali fighting. Then one day, there I was in the window. They were playing a DVD of highlights from my old public access show *TV Party*. Suddenly I felt qualified to enter the store. So I did.

And I must say that I never felt like the old guy there, shopping among kids who could be my kids. Supreme is youth fashion, it is street fashion, but there's something—I hate to say—transcendental about it. But when you have the name 'Supreme' you can be transcendental. Coltrane was transcendental. And if you take the name of this brand and attach the word 'Being' to it, you know who I'm talking about.

But to me the big surprise in entering Supreme was that among the merchandise were many things that I would wear—in fact that I would wear out.

They made jeans that I considered perfect. And khakis. And pocketed T-shirts in perfect colors. And these things were all priced fairly and extremely well designed and manufactured. I noticed that the long-sleeved tee that I bought in black, navy, green, brown, and white was assembled with a stretch panel so it would fit perfectly. And the khakis with the reinforced butt were good enough that they would have worked for the U.S. Cavalry before they switched to internal combustion from hay consumption. There was something about the thought, care, and quality that went into the clothes that reminded me of Hermès of Paris. Supreme was obviously intended to be the very best of what it was. And when I made my very first purchases I was delighted with the extra that was thrown into my bag: a couple of bumper stickers that said "Fuck Bush" in that trademark Futura Bold Italic. I think I still have one. The rest I put on parked and empty police cars, very carefully, on my way to Knicks games.

I also noticed that there was something going on here about art. It was pretty obvious in the tee that bore photos that Shawn Mortensen shot of the Zapatistas in Mexico. Masked and armed rebel army girls. Like that Errol Flynn movie, *Cuban Rebel Girls*. There was a Mark Gonzales mural above the shirts, and there were a lot of skateboard decks for sale, which were not exactly what you'd expect, like the Larry Clark decks with images from *Tulsa*. It turned out there were also decks from Rammelzee, Kaws, Peter Saville, and a fake Vuitton deck that was shut down by a lawsuit. Today my kid has a room with an amazing art collection, all on these unbelievably populist-priced decks by Richard Prince, Jeff Koons, Christopher Wool, Damien Hirst. And he rides one too. I just trip over it, but so far I've recovered nicely.

Supreme isn't the first commercial venture to enlist artists to create merchandise, but it is the first to offer the artists' merchandise at a regular price. They could have capitalized on the fact that these are in fact quite limited editions, but they don't broadcast the edition size, or price them any differently from their other boards. It's as if Supreme is redeeming art from its own worst tendencies by making it available to the people who would appreciate it but could never otherwise have it, who would probably appreciate these artists more profoundly than their typical collectors do, who see the work as something loaded with status that can eventually be flipped. These decks are made to be flipped only literally, kick-flipped, heel-flipped…

Andy Warhol said a lot of things about business art, and with some of the most famous artists today employing dozens, even hundreds of people, those ideas of his seem prophetic. I think Warhol realized that in a corporate world it was going to be difficult for the single artist in his studio to compete. And as a Pop Artist he realized that in the future, art was going to be much different from the traditional ideas of it. There was no more nature to imitate. Art was going to be inextricably linked with commerce. But that doesn't mean it has to betray its spirit.

Supreme has great products, but what is really most unique about it is that it seems to be run artistically and philosophically. Supreme exists to make a profit, but also to make things happen. It is a vehicle for artists and designers, and it also makes self-propelled vehicles for kids. Supreme spreads style, but it also spreads thought and information. Culture is its business. It's a brand that practices the arts of living and playing.

And in an era that will be remembered forever for greed, hubris, and excess, this rebel business has been marked by its classical values. Supreme is about value. It gives its customers good value. It makes things to last, not to be consumed and cast aside. Its clothes have great style and flash but they are also designed for utility, economy, and longevity. Supreme mirrors the values that one often associates with the optimism of youth and that one hopes will stick around for once.

Although calling oneself Supreme could be seen as *braggadocio*, it ain't about that. It could be Supreme's supreme virtue that it is modest. Supreme isn't humble, because it's not submissive or apologetic, but it is modest in the root meaning of the word. It is measured. It doesn't promise what it can't deliver. It's unpretentious. It doesn't waste fabric or words or attitude.

Coltrane's *A Love Supreme* ended with a segment in which the artist played a poem he had written, transposing the words into notes. Among the words were: "Elation. Elegance. Exaltation."

Elation—we know what that is: euphoria. Exaltation is to be raised high, in rank, power, or character. Elegance is trickier. It's misunderstood. Elegance isn't about fanciness or showiness; it is about graceful simplicity and effectiveness. Ask a mathematician; elegance is about what works, simply, gracefully, and consistently. If it's Supreme it's simply high-level.

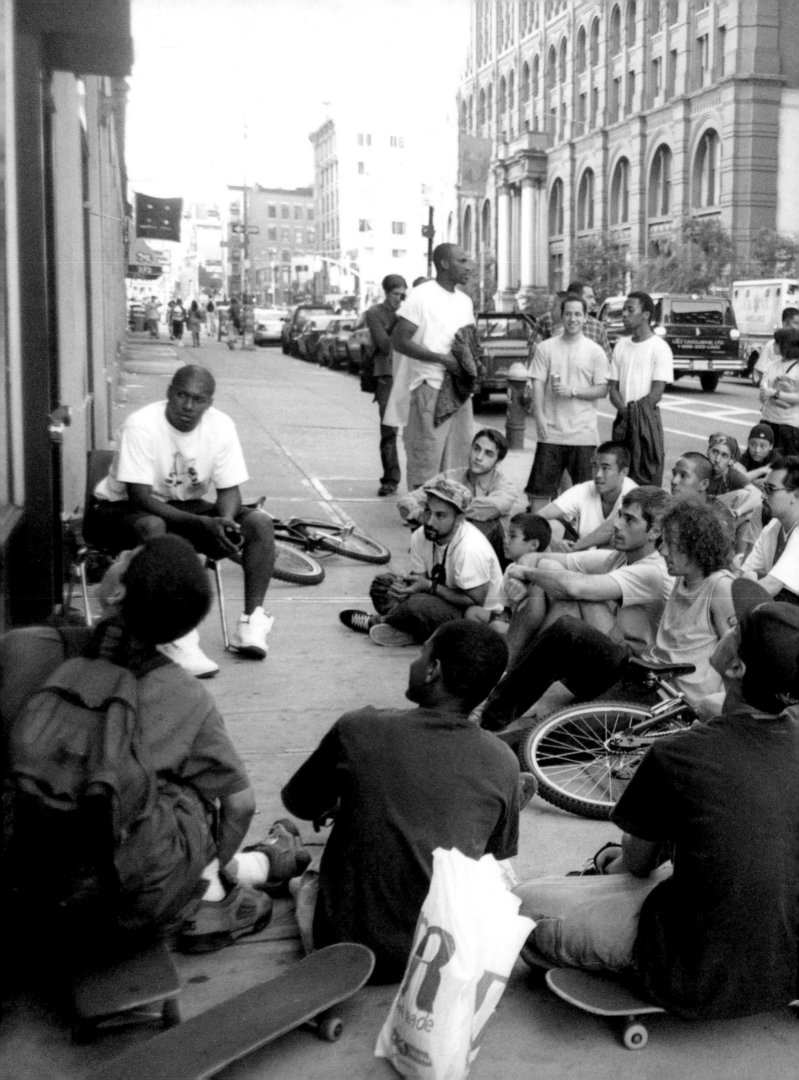

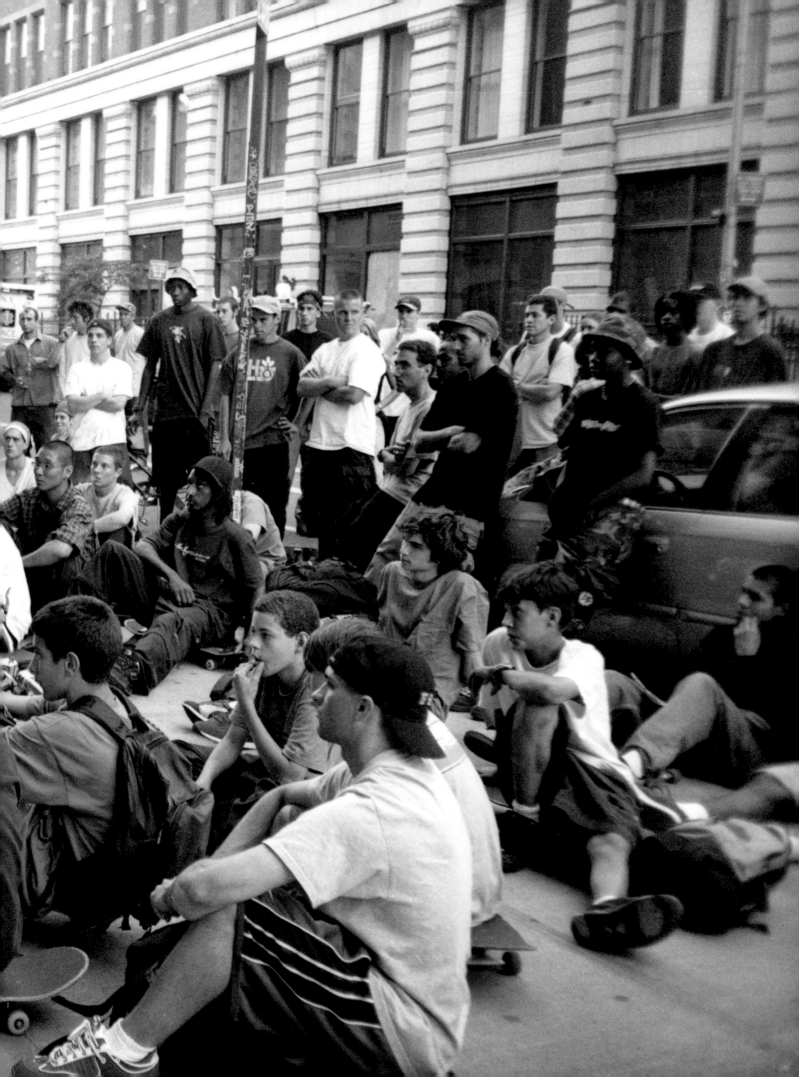

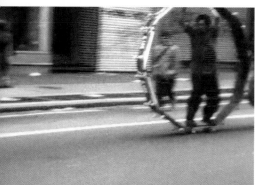
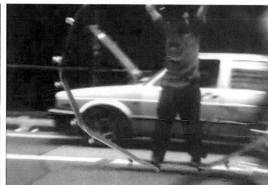

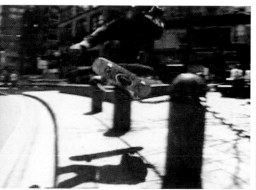
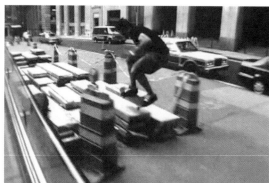
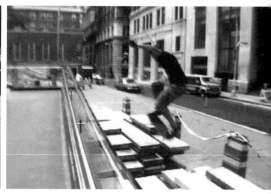

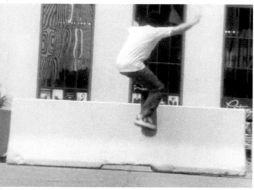

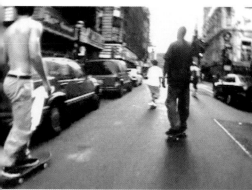
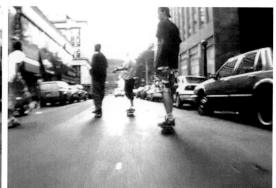
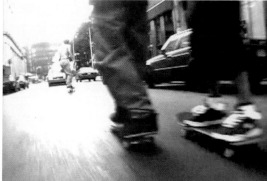

VIDEO STILLS FROM *A LOVE SUPREME*, DIRECTED BY THOMAS CAMPBELL, 1995

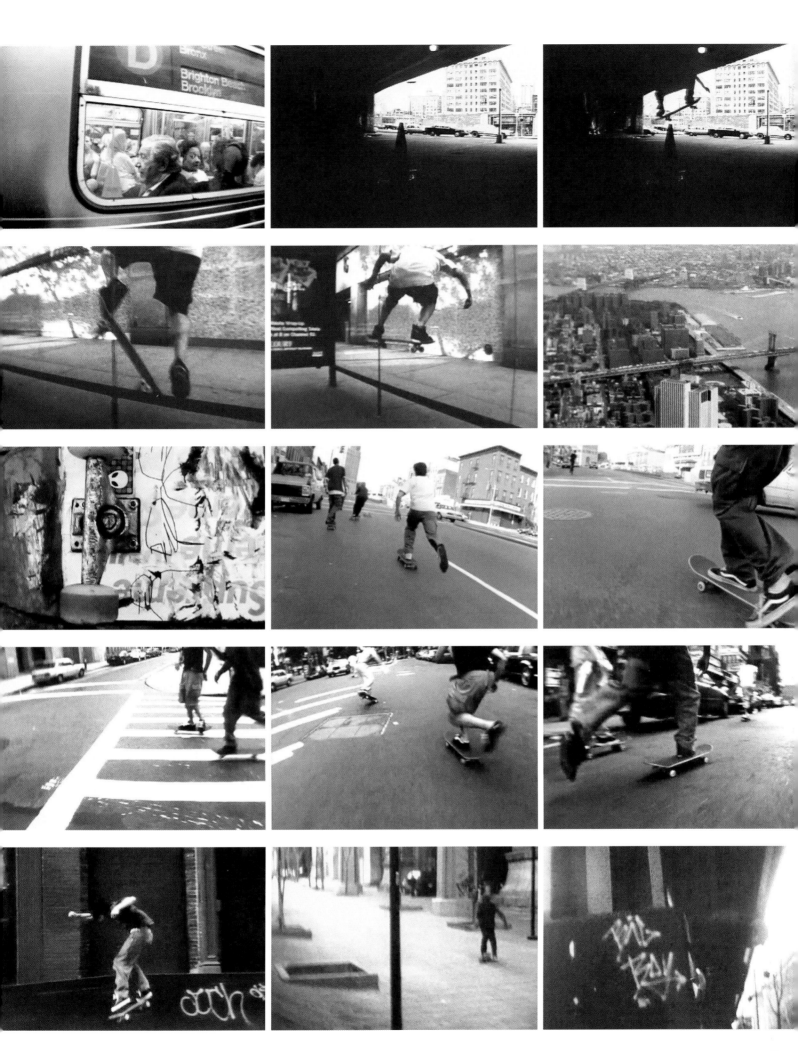

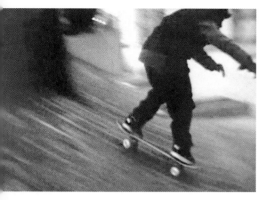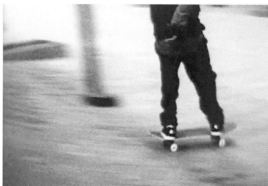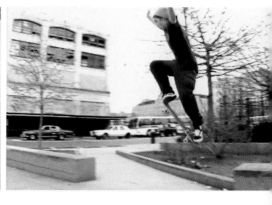

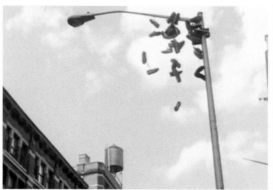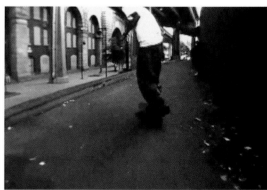
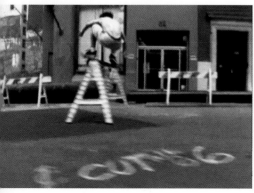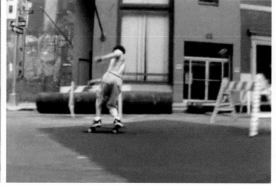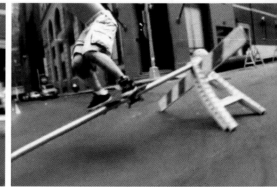

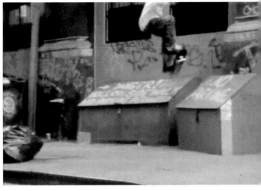
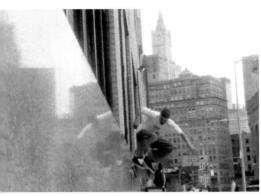

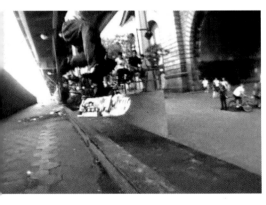
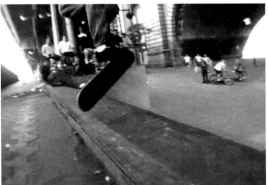
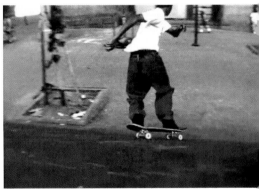
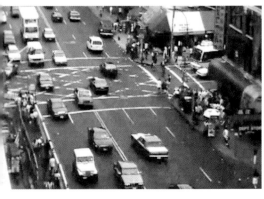
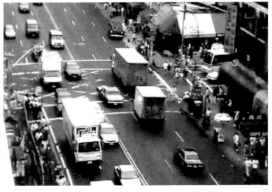

STARRING
PETER BICI
JUSTIN PIERCE
GIOVANNI ESTEVEZ
JONES KEEFFE
RYAN HICKEY

CO-STARRING
SUSKI
LOKI
DANNY SUPA
QUIM CARDONA
KEITH HUFNAGEL
MARK GONZALES
CHAPPY

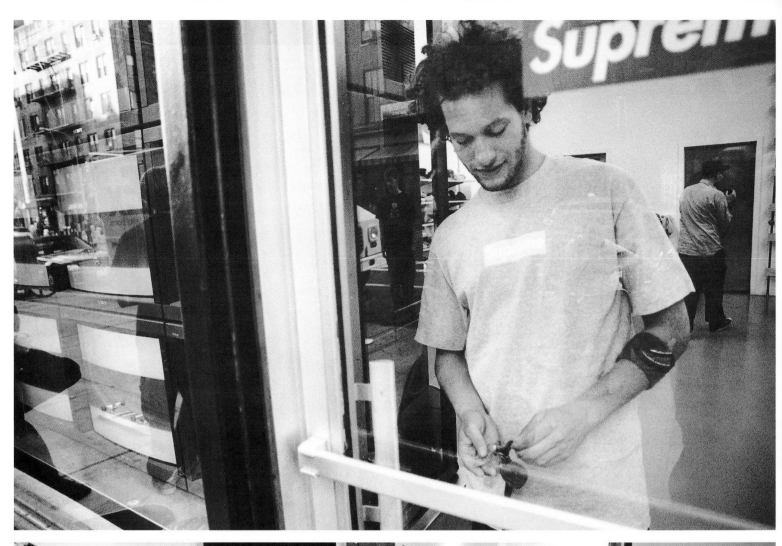
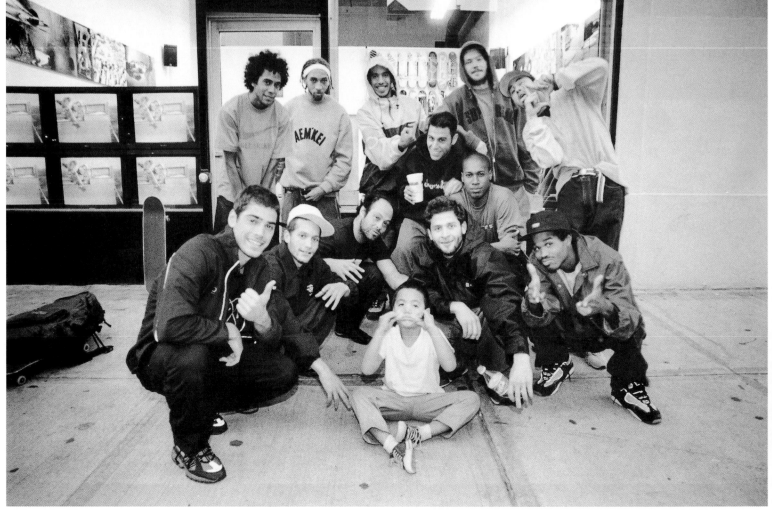

Preface by Aaron Bondaroff

When Supreme opened in '94, New York had a style of skating like no other. It wasn't your ordinary dudefest. Matter of fact, it was no dudes allowed. These skaters were your train-hopping, taxicab-jumping, runaway kids— born and raised in the city.

Kids from every borough and background bombed down hills, crossed bridges and ferries to session the urban paradise. All these travelers and street athletes met each other at the Downtown famous skate spots. Everybody would be checking each other out, snaking each other on lines for skate spots. Some beefed, some fought, but all had a common bond—they were NY skate survivors. The best of the best of these boroughs became friends and joined forces to create an all-star crew of bad boys: the ultimate gang. This gang was called Supreme. Even though the shop was James' baby business at the time, it also housed his army with authentic style, who adopted the brand and helped create its identity. Supreme didn't just cater to the NY street skater, it was and continues to be the last social club standing in Little Italy.

While kids my age were in high school, I was dropped out and graduated from a skate shop. I was lucky at the time because it was kind of a shut-door policy and I was younger than most of them. But I got the green light; I slid in. It wasn't easy in the beginning, even if you worked for the company it didn't mean you were accepted automatically. There used to be a lamppost outside across the street. One thing a member had to do was get a pair of sneakers up there. It meant you were up in the sky and untouchable.

Supreme was so epic and major: race wasn't an issue, money wasn't an issue, we were all one color and that color was character. Some of us worked at the

shop, some of us hung at the shop, and some of us lived at the shop. Stories and tricks and styles passed on from one to another. The lingo was coming from so many different places in the city you couldn't tell where a person was from. We all traded slang and jokes to create a language of our own. I still speak fucked-up from those days.

This social club wasn't so inviting, though, and had a lot of attitude. We made the rules and ran a business that was very successful. People were addicted to the clothes like a drug. We didn't want to work too hard so we developed a sales style that worked in our favor. In the early days it was like, come in, don't touch; you can look with your eyes but not with your hands. It was a crazy way to sell garments but the customer learned the deal: don't fuck with us and we won't fuck with you. The T-shirts were folded so tightly it was like art and if a customer touched the display the staff barked at them, fuck you. All the while the skate team and crew just hanging—pretty heavy for an outsider.

We really created a fucked-up shopping experience, but some people liked the abuse because they would come back for it every day. Long days at the shop, and nights were even longer. Lafayette was our home: we skated in crowds, played soccer in traffic, and whiffle-ball games in Jersey Alley. We never left the block.

This is a piece of history of my life but the legacy still moves forward. In a time of fast-lived fame and not-so-original styles, Supreme still represents the core city dweller. As brands and shops rise and fall, and as the cityscape changes daily, Supreme remains the living, breathing home of authentic New York.

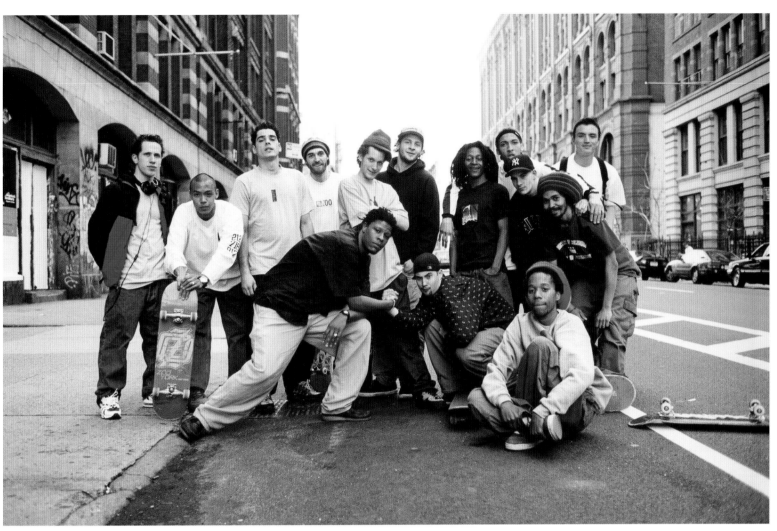

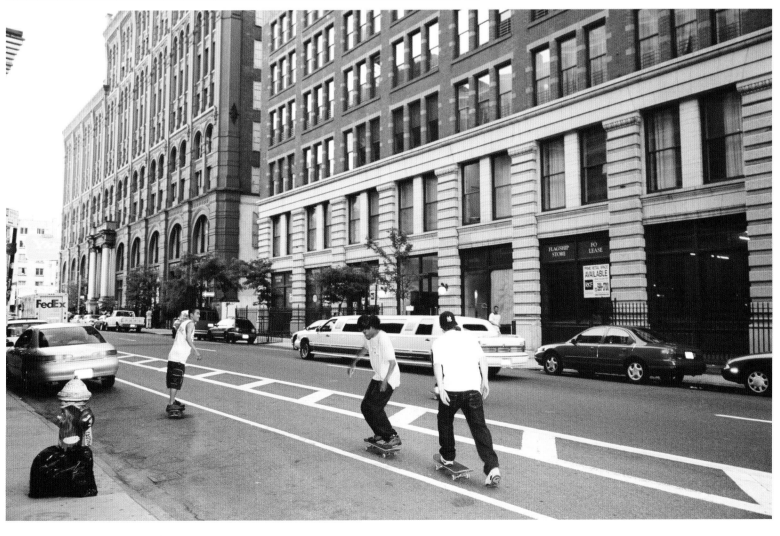

Supreme

SKATESHOP

274 lafayette st. new york tel. 212 966 7799

Supreme

274 lafayette street, new york city

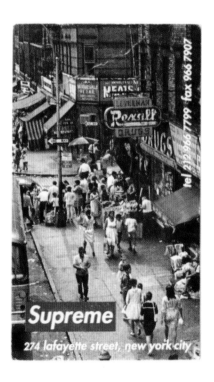

Supreme

274 lafayette street, new york city

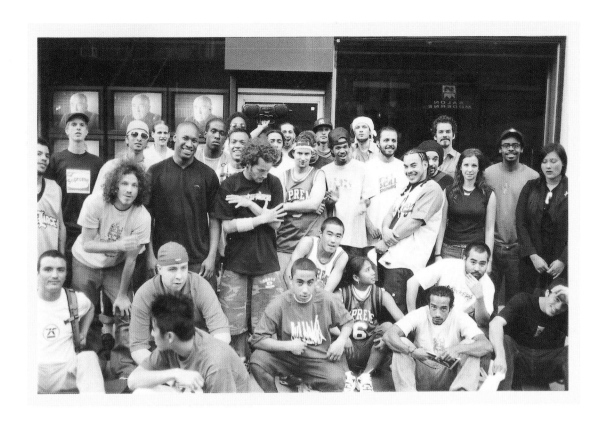

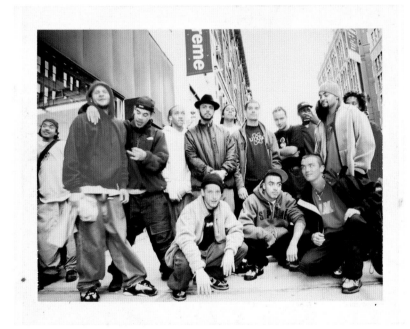

Interview between James Jebbia and KAWS

KAWS: Let's start from the beginning. Originally, before Supreme, you were already involved in retail.

JEBBIA: I came to New York around '83, '84, I had no idea what I was going to do and I had no training in anything and no loot. I always liked clothes, though, so I got a job in a store called Parachute in SoHo. It was a good place to start. The owner, Morgan, was a great boss and gave me responsibilities and taught me how to run a store. I met a lot of great people there who became lifelong friends, some of whom, like my partner Eddie Cruz, I still work with today. After working there for about five years I started to feel stuck and I just wanted to work for myself regardless of what it was. So my girlfriend at the time, Maryann, and myself, started a little flea market together on Wooster Street. During that time we would periodically go back to England and I was always inspired by what was going on there. They had some great small, independent stores like the Duffer of St. George and Bond that carried really cool and unusual things for young people, the kind of stuff you would see in *The Face* and *i-D* magazine. We wanted to do something similar in New York because there was nothing like it at the time. So we found a small space on Spring Street and opened Union in 1989.

KAWS: I remember that Union and Stüssy were the two main staples back then.

JEBBIA: Sure. When we first opened, we carried a lot of English brands because there were a bunch of small ones making cool stuff. Stüssy at the time was a very hard brand to get, but once we did it changed our business. At the time, Stüssy was a phenomenon. Whatever products we got in we would sell out of instantly. It was also my first introduction to Japanese customers. They were very up on Stüssy. We would get tons of these really stylish Japanese and English kids coming in every day to check up on the

new Stüssy stuff. The store was too small, though, and it got to the point that the Stüssy stuff would just dominate the store and take up all the space. We just didn't have enough room. I had met Shawn Stüssy a couple of times and we got along well. So we talked and said, "Let's open up a store."

KAWS: You opened the Stüssy store on Prince Street in 1991?

JEBBIA: Yeah. There came a point, though, when it was becoming a bigger, more available brand. Shawn basically let me know that he wasn't happy and that he was leaving the company. So I started thinking of something else to do because I didn't know how long the Stüssy store would last. And that's when I kind of got the idea for Supreme. I saw the space first, though.

KAWS: Did you know when you were getting the space that Lafayette was a good street for kids who skate, or anything like that?

JEBBIA: I did sense that, yeah. It was an office space when I saw it and the rent was dirt cheap and there wasn't anything else on the block at the time. But I figured it was close to everything, yet so desolate that skaters wouldn't be a problem for our neighbors, because we had none.

KAWS: And why focus on a skate company rather than just a lifestyle brand?

JEBBIA: I was into skateboarding because when I went to the trade shows, like A.S.R. and MAGIC, the only things that would excite me would be the skate stuff. It was just powerful and raw. Also, a lot of the guys who I worked with skated and there didn't seem to be a good skate shop left in the city. I hear people talk about the "golden era" of the classic, cool, fucked-up little skate shop, and how we ushered in their demise. But the fact is that they had all closed in Manhattan by the time we opened. I wanted it to be strictly skate because you really couldn't buy skate products and hard goods in downtown New York at the time. I was really into the decks, the wheels, the tees, sweats, and so on. Basically the graphic stuff that the real hard-core skate companies like World Industries were putting out at the time.

KAWS: That was kind of the roots of all the graphics that would inspire everything else. So it was like going to the source.

JEBBIA: Yeah. I wasn't really up on anything, though. I wasn't knowledge-able about this pro-skater or the history of this or that company. It was new to me and in some ways that was probably good, because had I really been informed and really knowledgeable about the culture—

KAWS: You could have got caught up in the politics of the scene?

JEBBIA: Yes, definitely. For me it was all about the really strong and obscure stuff that the skate companies were making, that was all I was focused on. The space I had rented on Lafayette Street was a clean, rectangular space with high ceilings. It had a decent, classic, old storefront with plenty of glass. I felt that if I could display these striking skateboards in a new, more noticeable way so everybody could see them, and have some monitors facing forward playing dope skate videos so everyday people that walked by could see the level of skill involved in skating, that it would be an exciting and new type of skateboard store that might work. I had no real aspirations though. If it worked, cool, if it didn't, so be it.

KAWS: At that point you weren't even thinking about the big picture with it?

JEBBIA: No. Before it opened I worked really hard to get the store together. But the key thing for me was meeting and hiring a young New York skater named Gio Estevez. I didn't know anything about the New York skate world but he did. It needed to be an authentic skate shop that hardcore skaters would appreciate, but just as importantly a shop that people who didn't skate would appreciate and be intrigued by. And that's pretty much how it went down. So I set it up OK.

KAWS: I guess you did, because what you just said is pretty much the same message you're putting across now. You're not catering to a new audience, it's fundamentally the same. You're making a place for kids to buy a skate product and you're making product that could appeal to a larger audience.

JEBBIA: Yeah. The thing that really legitimized the store, I think, was the people who worked there, not me. Everyone who worked there skated and was part of I guess the local downtown New York skate crew, which I wasn't really aware of. I remember the first day the store opened, there was this whole new bunch of kids there who I never knew, like Justin Pierce, Jeff Pang, Ryan Hickey, Pete Bici, and Harold Hunter. The store was swarmed with all of these skaters because of the crew who were working there, like Gio. I'd been used to Stüssy and Union, where the people who were in the shop were actually in the shop to buy something. But at Supreme they just hung out. I didn't understand it. And I made a conscious decision right then to be behind the scenes. I liked that it was real, it is what it is, and I just wanted it to

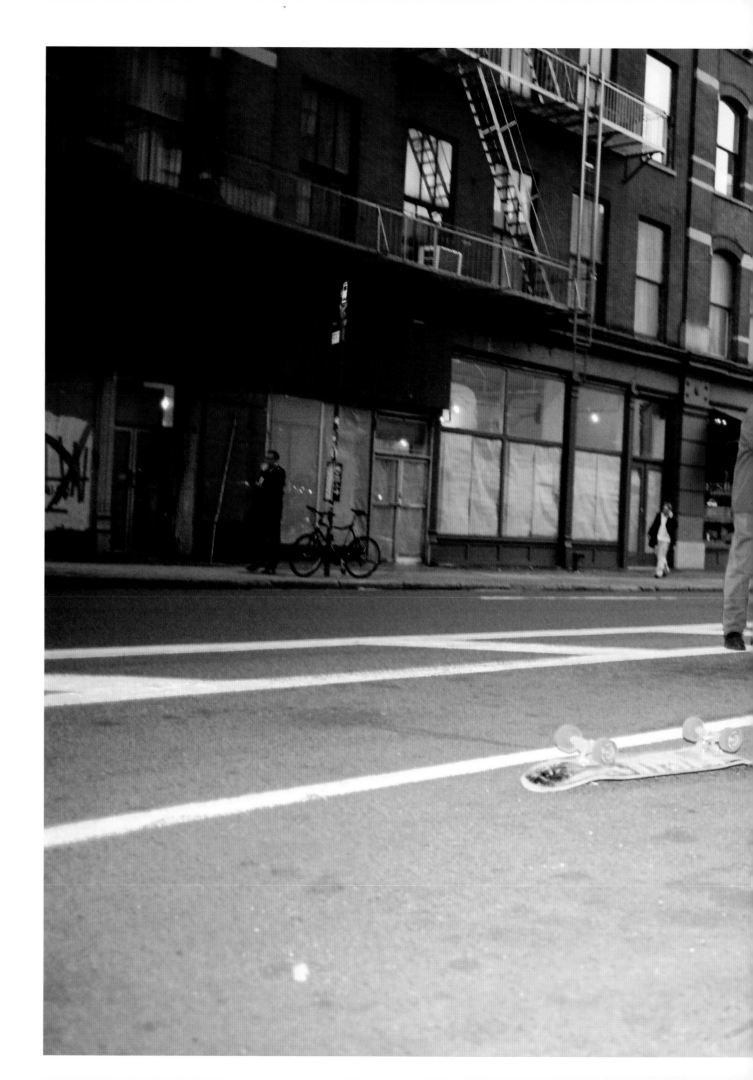

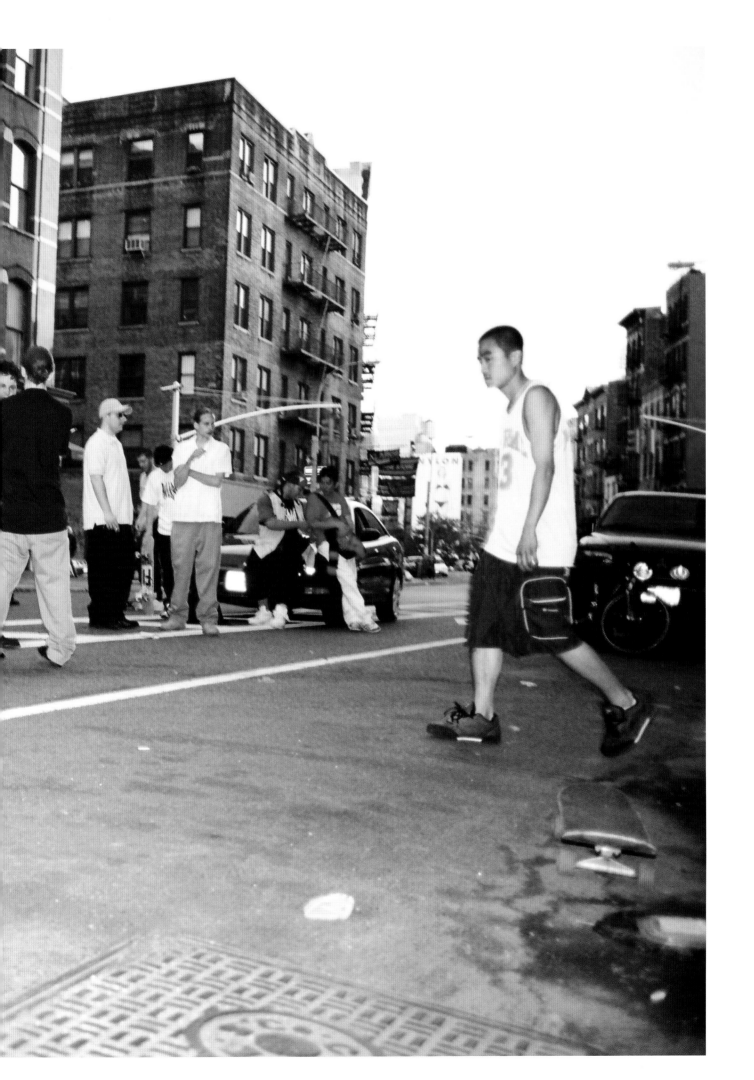

be a true skate shop. So I thought, let these guys handle this, I'm going to handle my business, which is going to be more about making sure we've got good stuff to sell.

KAWS: So you left it up to Gio and those guys to attract the talent? I mean, when you look back at it now, they definitely added a vibe to Supreme.

JEBBIA: Oh, without a doubt. I knew that they were just a crazy crew. There were, I don't know, fifty or sixty skaters who'd just hang out there. And right at that time, too, Larry Clark was filming *Kids,* right around the time we opened. For me, again, it wasn't part of my world, but I knew it felt very rebellious. It felt right and I liked it.

KAWS: And after the flea market and the other stores, this was a brand, this was the first thing with an identity. I feel like Supreme came out as a shop with an identity.

JEBBIA: Well, I was thinking of Supreme as just a skateboard shop, not as a brand. When we opened we made three T-shirts, one with an image of De Niro from *Taxi Driver,* one with an image from the 1970s of a skater with a cool afro, and one with our box logo. The logo came about after my friend showed me mock-ups of the first two T-shirts and they looked pretty flat with just a plain black-and-white photo image, they needed something else. I gave him a Barbara Kruger book I had and asked him to place 'Supreme' over the images in a similar style. And when he came back with the new and improved mock-ups, the actual 'Supreme' graphic that he had done just looked really bold and simple, kind of like the store itself. So we put that on a tee along with the other two graphics, and the first day we opened I was really surprised because those three T-shirts were pretty much the only things that sold that day. We only made about sixty of each but it felt great, I'd never experienced that kind of thing before. Tons of people coming in and sensing that it was something new and fresh. It was cool.

KAWS: Didn't kids put Supreme logo stickers over Calvin Klein ads? I remember you got in trouble for that. Stickers were almost the most common sort of communication tool for skaters.

JEBBIA: Yeah. That was right around the time that we opened. At that time, you know, there's no Internet, there's no money for advertising, there's no magazines to advertise in, and that was a great way of getting your name across.

But when we did them, I've got to say, we tried to do them right. We tried to target minimal ads, then we'd put a logo on there straight and it just looked like our ad. There was definitely a conscious effort to overtake people's advertisements with those stickers and just be noticed in a subtle way. But it was more about getting people to come check out the shop, not that we were trying to establish this important brand.

KAWS: And what kind of product was in the shop at the time?

JEBBIA: Well, for a while we didn't really do any business. We would sell a few skateboards and wheels and some T-shirts and stickers, but no clothing. It was just a good spot to hang out and meet up with friends and there would be a good buzz. Most of the skaters who came in would be dressed well. They had great style. They'd be wearing Polo, Champion hoodies, Carhartt, and other classic stuff. But they didn't wear many skate brands' actual clothing, because most of it came from the West Coast and it didn't suit their style, and most of it wasn't very good. So we slowly started making a few things of our own. When we did we tried to make them as good as possible. When we did a sweatshirt, we embroidered our logo really well and we used a high-quality, heavyweight sweatshirt—it would retail for around $68 while other skate sweatshirts would only be around $48. People noticed and appreciated the difference in the quality and fit of ours, though, and seemed to like them. We followed on from there, basically trying to make better stuff for New York skaters. Our stuff was a little bit more money but it was better product and people could see that. Slowly but surely we started making more of our own clothing and accessories, but it was more out of necessity because we needed more things in our store to sell so that we could pay the rent.

KAWS: Did you always know from the beginning that you were going to do short runs of your products?

JEBBIA: No, not really. The main reason behind the short runs is that we don't want to get stuck with stuff that nobody wants. Aside from the most obvious items, in most cases we don't know how something will sell, so I tend to take a cautious approach, rather than be overly optimistic.

KAWS: I thought that might have had something to do with your working with other people—rather than a massive corporation that's going to make thousands of copies of something, the artists and the brands you work with

know that you're only going to make a quantity that makes sense for you.

JEBBIA: With certain items that is the case—for instance, when we do a deck with an artist together we will come to an agreement to make a certain number—but with most things we pretty much make what we feel is the right amount. We don't want to make large quantities of items and saturate them, but we also want to be a viable business, so we don't do miniscule quantities either. The most important thing for us is having great products in the store that we hope people will like, that they buy, that sell out, and we keep it moving.

KAWS: Was that the segue to Japan, the products that you started making? What do you think it was that sparked the interest in the Japanese market?

JEBBIA: I think so, once we started making a few of our own things. Mind you, it wasn't a whole line or anything—maybe four T-shirts, two sweatshirts, and a hat each season. We would have buyers from Japan come in and want to buy all of it, but we wouldn't let them. The Japanese travel a lot and appreciate when they see something new and authentic, and I think they loved the fact that it came from New York and that the whole vibe of the store was raw, intimidating, and real.

KAWS: Do you think that connection with Japan had an influence on the products you were making?

JEBBIA: Without a doubt. I had no plans of doing anything in Japan but I was fortunate enough to meet up with my partner, Ken Omura. He was young, honest, really hardworking, and knew what he was doing. He wanted to open a Supreme store in Tokyo and that intrigued me, it seemed like a good idea. Up until that point I had simply looked at Supreme as a skateboard store and not really as a brand itself.

KAWS: So it was Ken trying to open a second Supreme store in Japan that made you conceive of Supreme as a larger company?

JEBBIA: I had to, because he actually opened three stores in really quick succession and he didn't have anything to sell, so we had to start making more Supreme products to fill the stores. I remember going to Tokyo in 1996 and really loving it, from the people to the culture, and it felt like there were just incredible stores and brands that were starting to pop up. So having the Supreme stores in Japan, and knowing the level of competition from the brands I considered our peers, like A Bathing Ape, Neighborhood, and Hectic,

really forced us to stay focused and step up our game every season—or be out of business. Without such fierce competition from those great brands I don't know if we would've been forced to make as good a product as we have.

KAWS: How about L.A.? Supreme is such a New York brand, was it easy to translate to the West Coast?

JEBBIA: The thing for us was not to go to L.A. and be like, "Hey, we're from N.Y.C. and we're the shit!" We embraced L.A., but we still wanted it to have a similar aesthetic to the store in New York, and that's why we opened on Fairfax, because there were no other stores there and the rent was cheap just like when we opened on Lafayette. We wanted to do something that was raw, unique, and visually dynamic, and that's why we built the bowl. It wasn't going to be the typical L.A. skate shop. Also, the whole crew who run the store are all hardcore L.A. skaters and proud of it. We're obviously a New York-based company but I view us as a worldwide brand. I'm very glad we opened there, it's been good for us.

KAWS: You've always worked with top people. What made you think about bringing in artists or established figures in different fields? You brought in Mark Gonzales, who is very key in the skate community, and everybody would get that, but then you just did a project with Lou Reed.

JEBBIA: We try and do everything at a high level and don't put limits on what a skate company should or shouldn't do. So we always try to shoot for the top and see if we can make it happen.

KAWS: Was it with boards first that you started working with outside people or was it the calendars, with photographers?

JEBBIA: It was probably the decks. We have found that if the project is really good and feels like a good fit, your approach is sincere and you're not trying to screw anyone over, people are quite open to doing things, no matter how large or established they are. It's no different from you—I know you do many things that are very lucrative, but every now and then there's a cool project that comes along where there's no loot involved but you'll do it anyway because you think it's a good project. That's pretty much how it works with us in certain situations.

KAWS: Well, over time people kind of get an idea of the feel of the brand, so there's a level of comfort at the entry point.

JEBBIA: Exactly. I think if you keep up that body of work then it can only enhance the brand, but if you waver, and try to sneak in some sell-out shit, then—

KAWS: You can't go back.

JEBBIA: Yeah, that's exactly how it is. So at the time, while you're doing the project, you're not thinking, "I'm going to do this so I can go work with other top people." It doesn't really work like that. At that moment you're just trying to do something that is special, and that people will respond to and have a high regard for.

KAWS: I think in recent years established artists are more receptive to the value of doing projects like that, too.

JEBBIA: I also think a big part of it is because the object we're starting with is a skateboard. If we went and said, "Hey, we're doing a basketball or a mouse pad," they would probably say, "Get the fuck out of here!" But a skateboard is a very natural and real medium for art and also a very appealing object for a lot of artists.

KAWS: I mean, it's a flat panel. It's not really a far stretch from a canvas.

JEBBIA: Yeah. And a lot of artists still keep their eyes on the streets, on youth culture, and on what goes on. Most of the time when we are working with an artist they are not that familiar with skateboards, so we send them some samples. They usually really love them and are excited to work on them.

KAWS: But when you work with an artist like Jeff Koons, you have to know that that opens doors to a lot of other artists.

JEBBIA: Sure, doing this artist series properly really came about after working with him. Seeing an artist of his caliber agreeing to do them and then working hard to make them really dope, and seeing that the process of working with him was really smooth, I thought maybe we could continue to do more on this level. And with the help of my friend, Neville Wakefield, we did decks with Richard Prince, Murakami, Christopher Wool…

KAWS: What's the process when you're selecting? I know that you don't pick the guys who are in the limelight at the moment. You'll do something with Jeff but then you'll do something with Rammellzee, who means something to a totally different market. You're cross-pollinating.

JEBBIA: Sure. Most important is whose work will translate best onto a

deck and mean something to our crowd and is not predictable. Working with someone like Rammellzee or Sean Cliver is just as important and relevant to us as working with Damien Hirst or Larry Clark. I'm proud of the decks that we've done and I think in the end we are going to have a great collection that is very unique to us and will probably not happen again. I look back on things like *The Face* magazine or other things I grew up with, and when they're long gone I feel very glad that I got to see and live in that era. So I hope we have something where people say, "Shit, remember that cool piece or that cool deck I got at Supreme all those years ago?" and it takes you back. It's like that with the first big photo print tee that we did with Raekwon. That particular style of T-shirt was big in Harlem and the Bronx at the time, but not in skate or streetwear. I saw that Kenneth Cappello had done this great photo shoot with him and I thought, "Damn, if I could get Raekwon to be in a similar pose with his boy, his gun, and Elmo and shit, it would work really well." Kenneth contacted Raekwon and he was like, "Yeah, I'll do it, for this amount." It was a decent amount of loot but not obnoxious. So we went around his place, paid him, Kenneth did the shoot and it came out really good. And the response to the posters and the tees was awesome—like the decks, I felt it was something new in our market and wasn't crazy difficult to pull off, so we continued with it.

KAWS: It was definitely new to the streetwear market. You were mixing these different worlds that already coexisted, but you were bringing them together and putting it in print. I think it shocked people.

JEBBIA: I think it might shock people because the choices are usually unpredictable and powerful. People think, "Supreme is just this small skate shop on Lafayette Street, how the hell did they come to work with a huge, worldwide icon like Kermit the Frog?" They usually don't know the hard work, the patience, and the loot that went into making it happen, and nor should they. It should appear effortless. I feel this way about a lot of the things we do, from the decks to the clothing we make, to the crew that I work with, to the stores that we build. I feel that we've stepped up and taken risks that will have a long-term benefit for our brand.

KAWS: I always noticed that, like when you first did that calendar. Other bigger companies or businesses would never do a calendar like that because

it doesn't equal dollars, but they don't understand the value added to the company in doing these creative projects.

JEBBIA: Sure. Someone like Terry Richardson or Larry Clark can cost upwards of fifty grand a day. If we come to them with a cool project they might give us a much better deal if it can be shot during a quiet week for them. It will still be a major stretch for a company of our size, but for what we get out of it—aside from great images, we get something that will be viewed by a whole different crowd on a universal level and will stand the test of time.

KAWS: How does Disney agree to Kermit the Frog?

JEBBIA: In my eyes they were cool and smart enough to agree to do the project with us because it's good for Kermit, and a whole bunch of people who were not checking for him suddenly were. We are very selective, and with Tyson, Kermit, or Lou Reed, these projects have usually created a pretty good buzz for us and for them, so it's mutually beneficial.

KAWS: Does one play off the next?

JEBBIA: We did the Raekwon project first, then the Dipset, and then we worked with Mike Tyson. It was a big jump going from local New York rappers to a worldwide icon like Tyson. We worked hard on it for months and he agreed to it. I wasn't sure if we'd do it again. I didn't want to do something predictable, and how can you top Mike Tyson?

KAWS: How did you come to work with larger iconic brands such as Hanes or Budweiser?

JEBBIA: I look at the things that we have done with certain brands as being part of pop culture. It's not the norm for these huge, classic companies to be working with a small skate company, making unique products for them and working in small-scale quantities. I see these products becoming more appealing in years to come, just like you might go to a vintage store and find an old pair of Vans from the 1970s with a Rolling Rock beer print on them. The products are unique and noticeably from a certain time, and that's what I hope happens with some of the things that we have made. But if it's working with more traditional brands, like Nike, The North Face, or A.P.C., who are leaders in their particular fields, then it's strictly about us trying to make exciting products with them. We like doing these collaborations but we don't count on them—they're basically the cherry on top.

KAWS: So right now the company's fifteen years old and you're doing this book with Rizzoli. What do you think the book's going to put across? How are you going about what you select?

JEBBIA: It's funny, because earlier today I was looking at images of all of our old tees, caps, sneakers, and decks through the years, and things look pretty decent to me, even the things that I didn't like much at the time. People will sometimes ask me to pick out a "key item" from the season and I never feel like we have a "key item." However, if you look at things collectively from a jacket down through a deck, the line has been pretty consistent over the years, even when the things we were doing were not what was hot at the time. I've seen that staying true to what you do best has played a major role in our longevity. I would like people to see that we're a small, independent skate company that has done our own thing, in our own way, over many years, and hopefully will continue to do so.

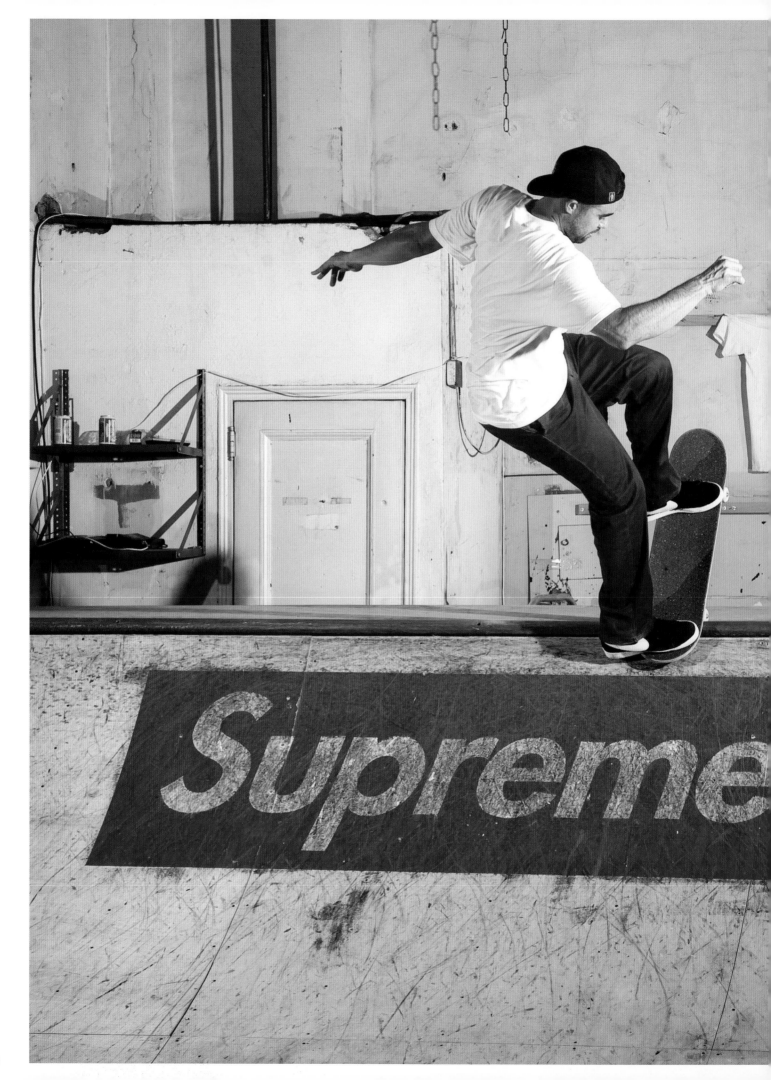

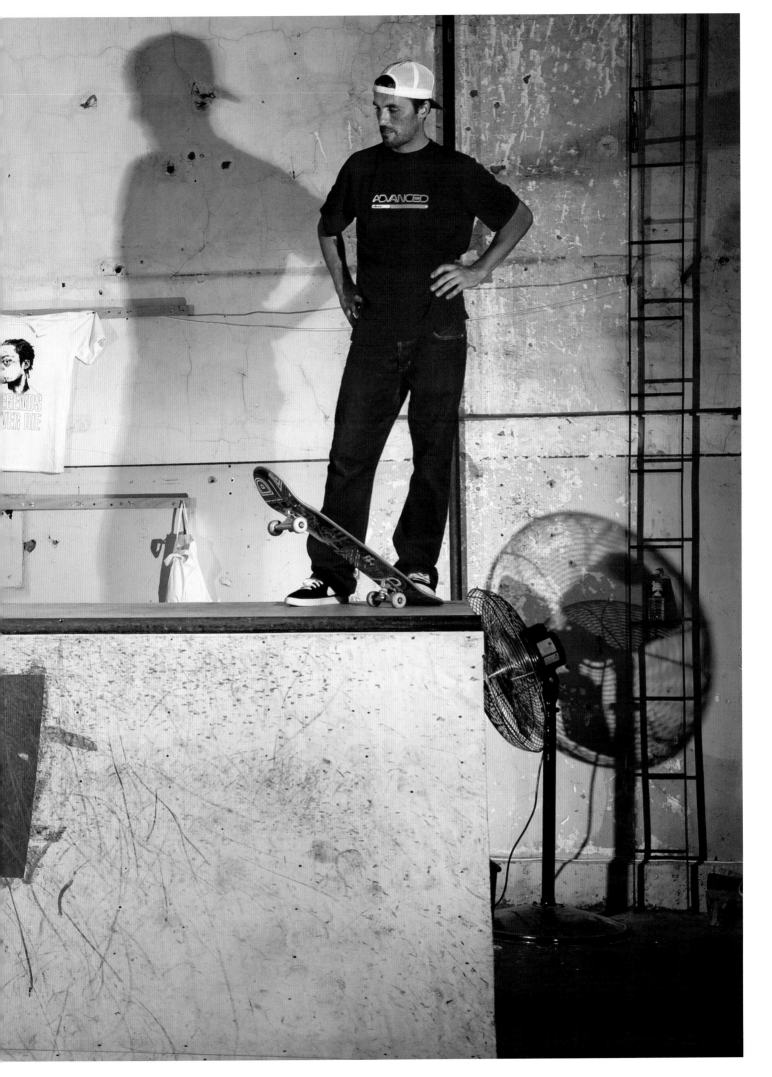

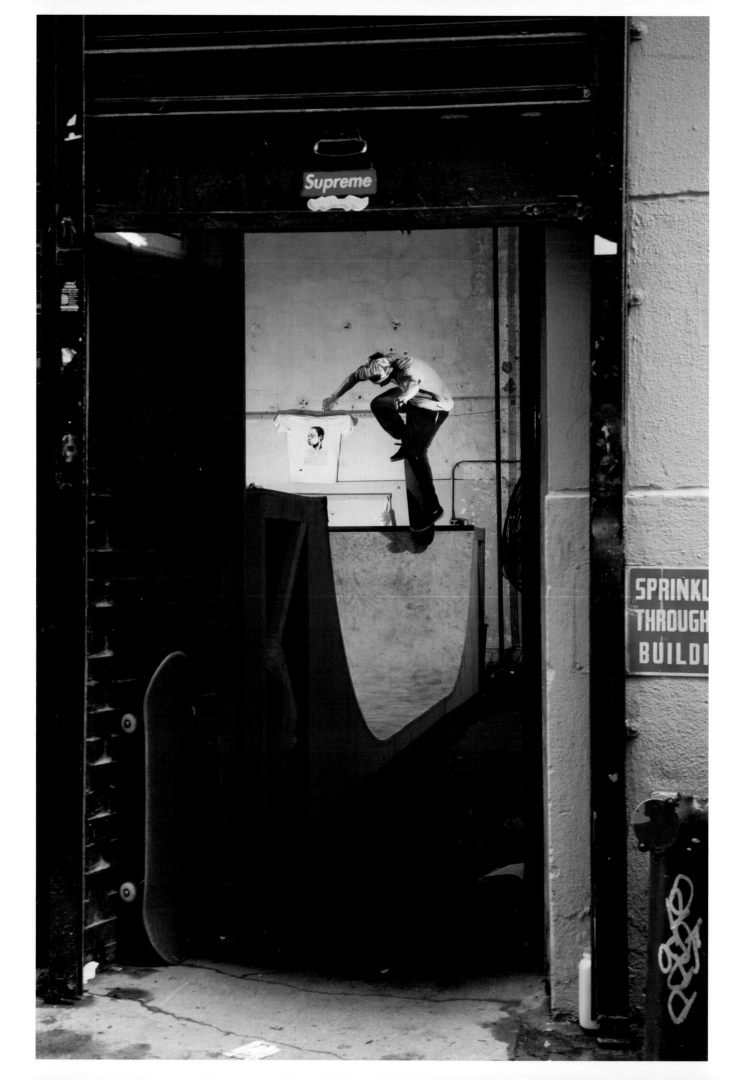

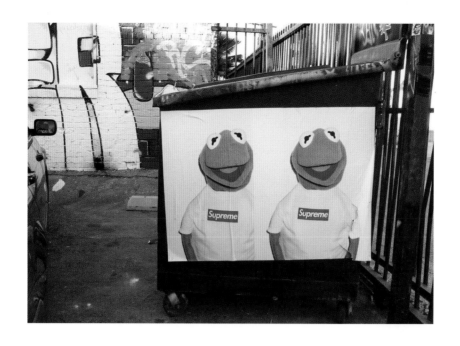

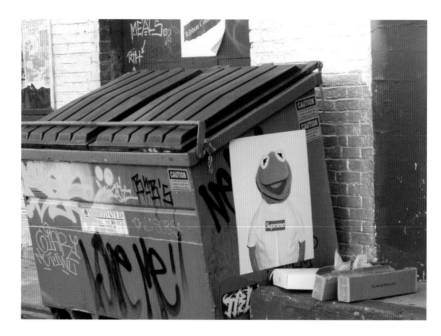

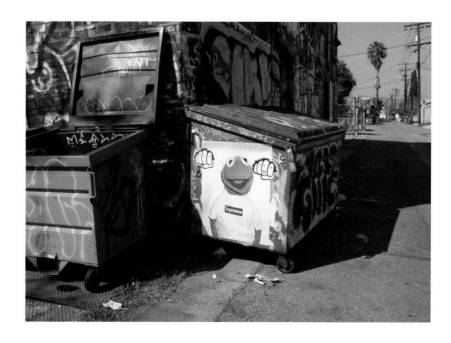

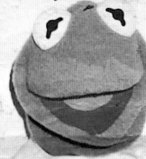
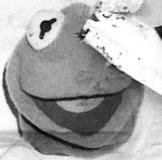

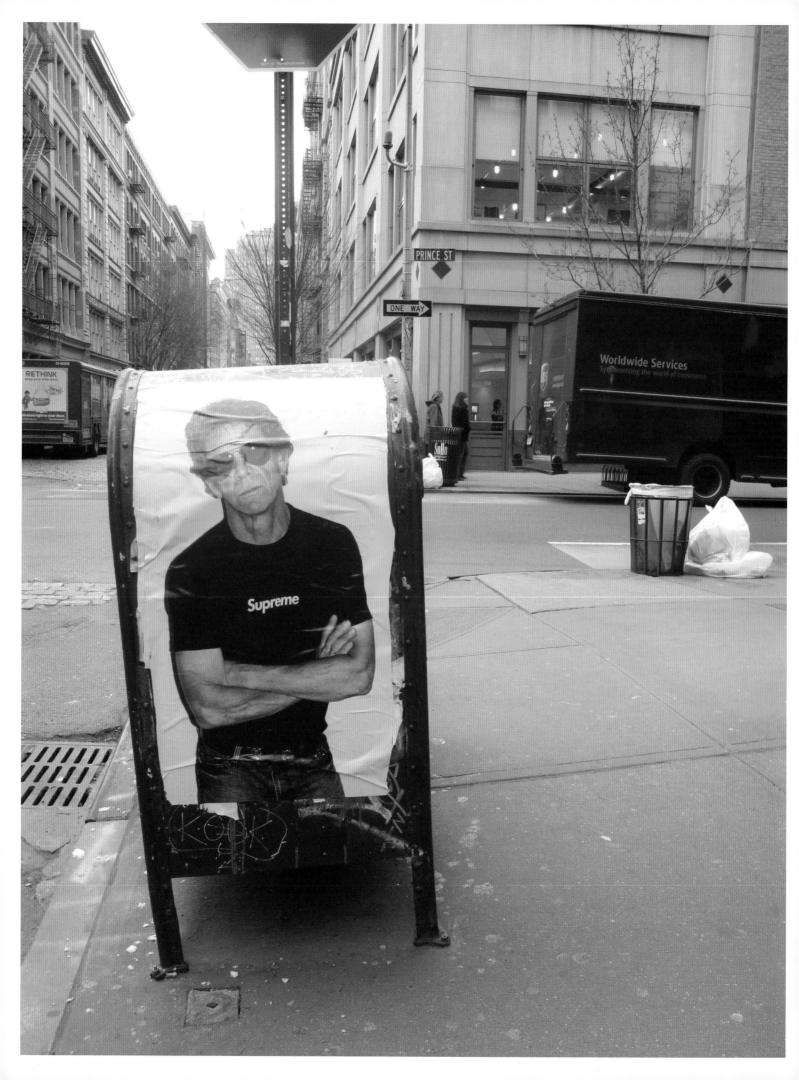

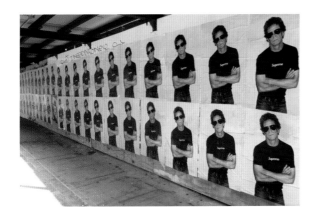

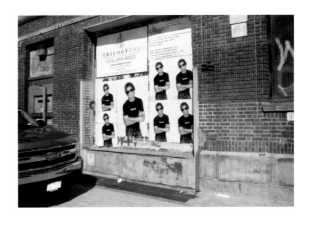

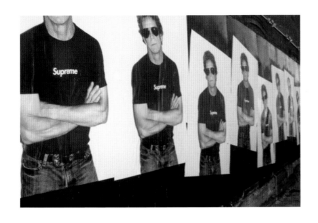

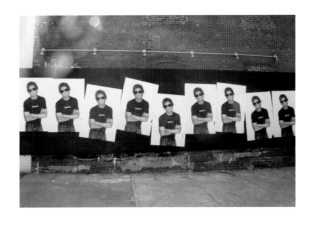

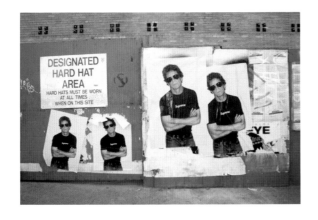

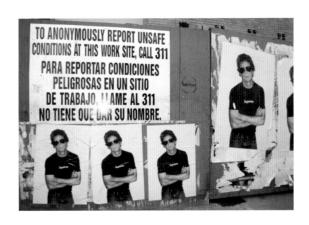

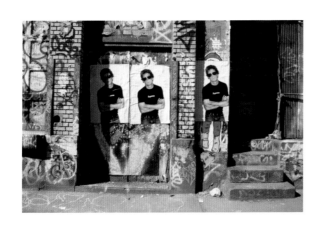

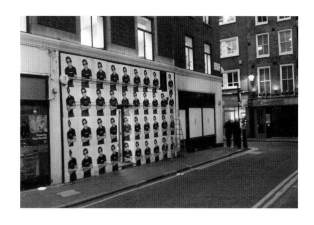

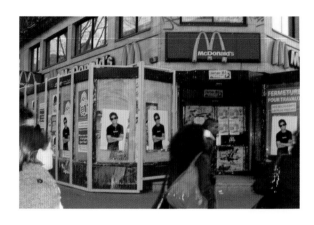

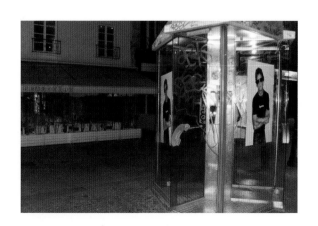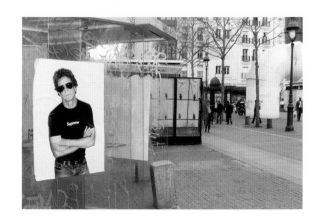

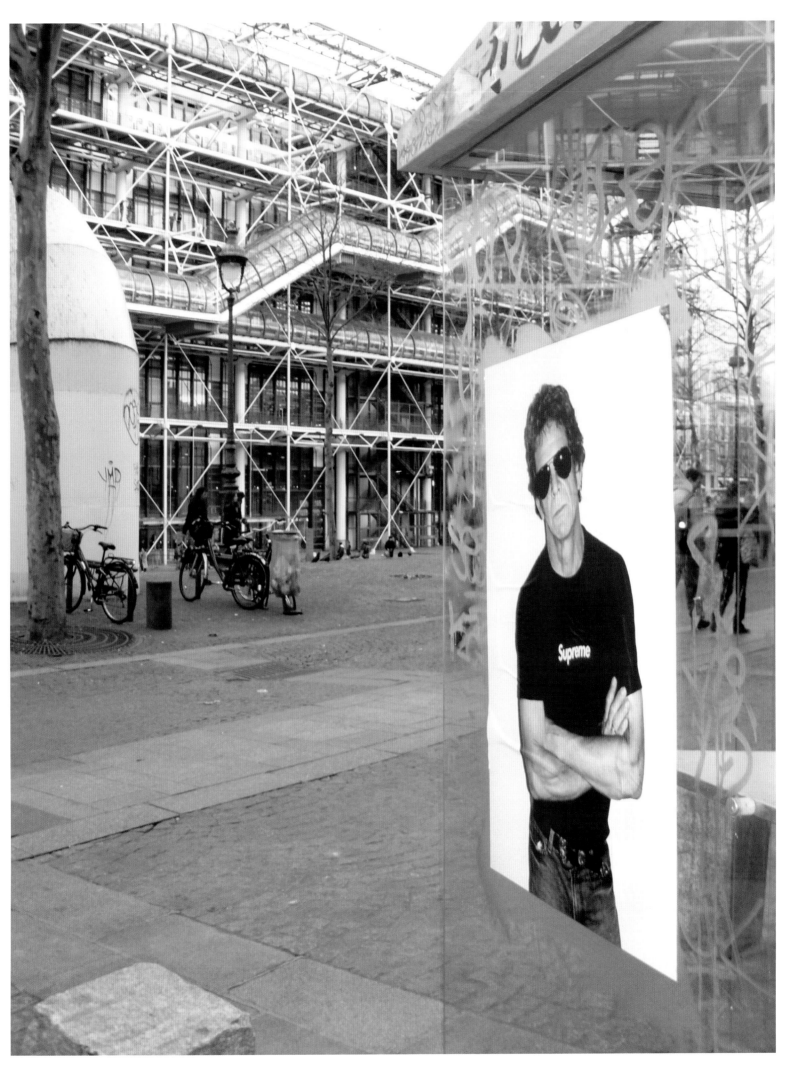

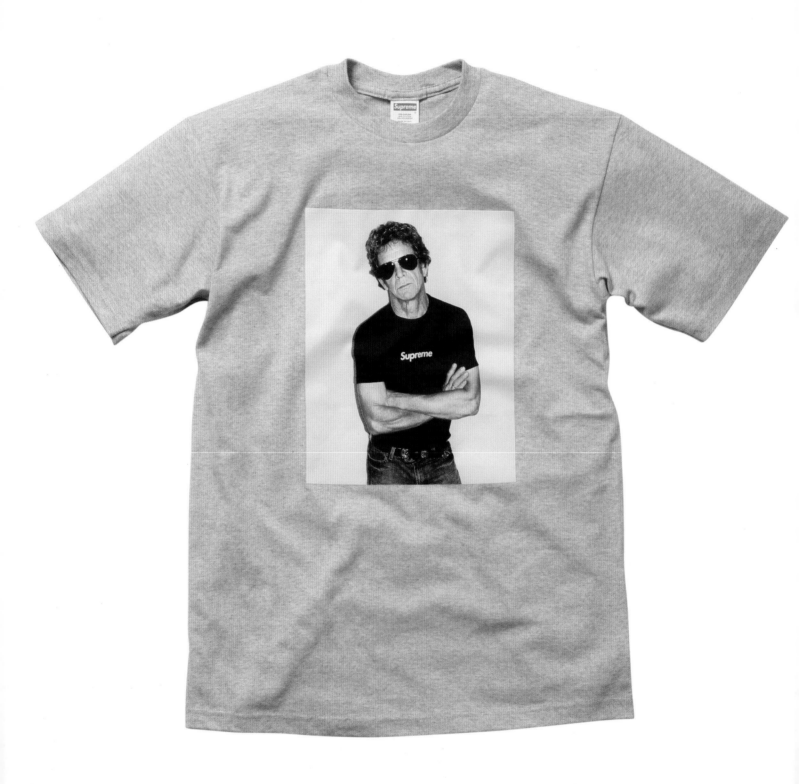

LOU REED 2009

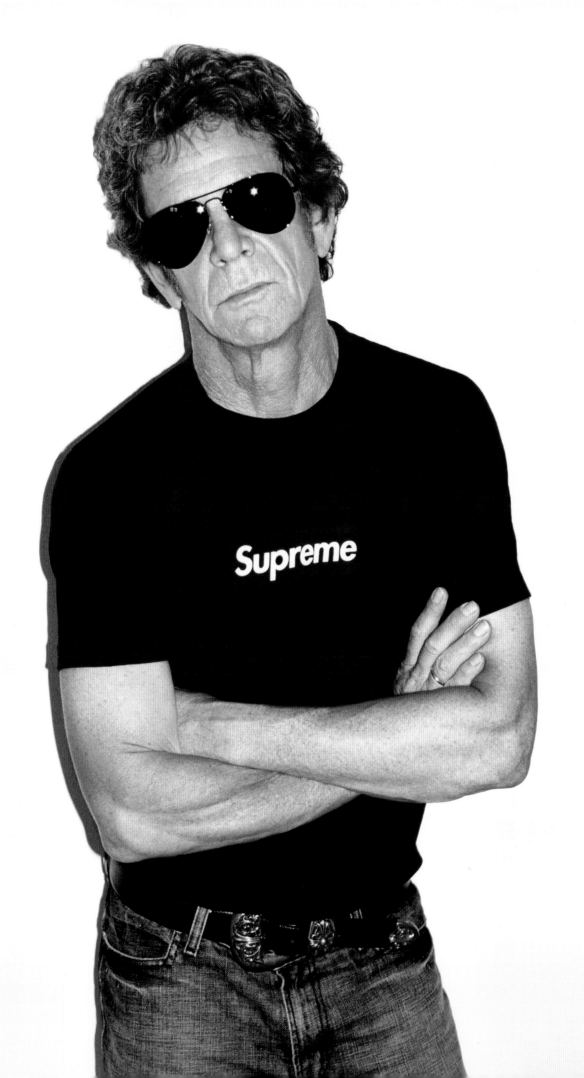

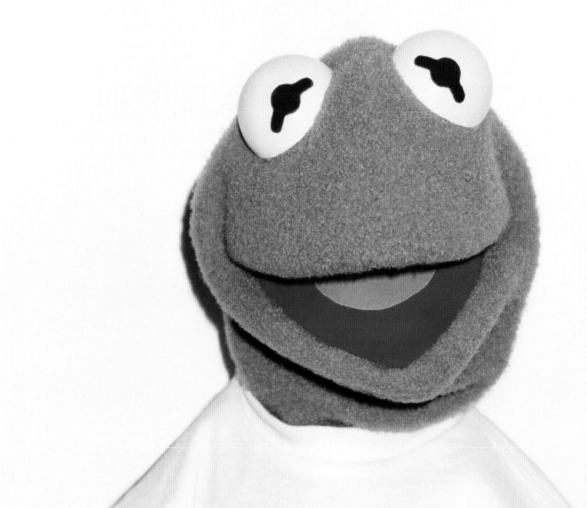

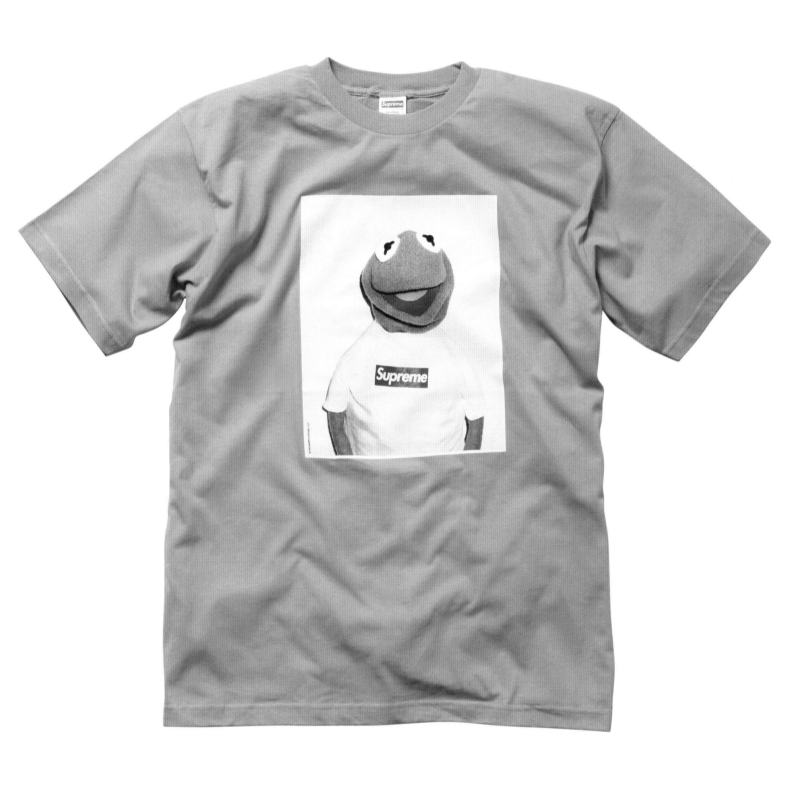

KERMIT 2008

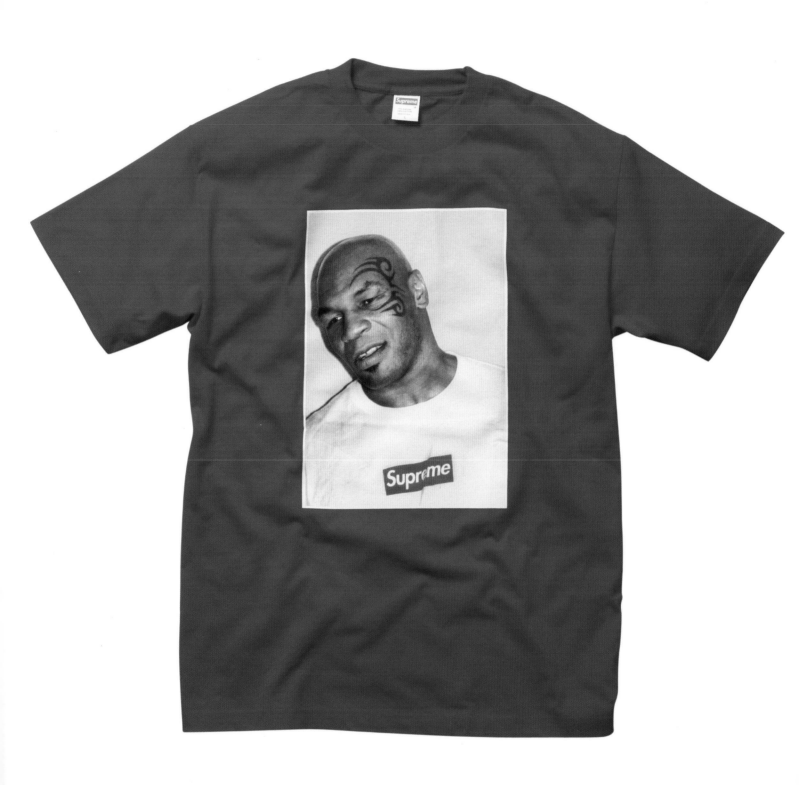

MIKE TYSON 2007

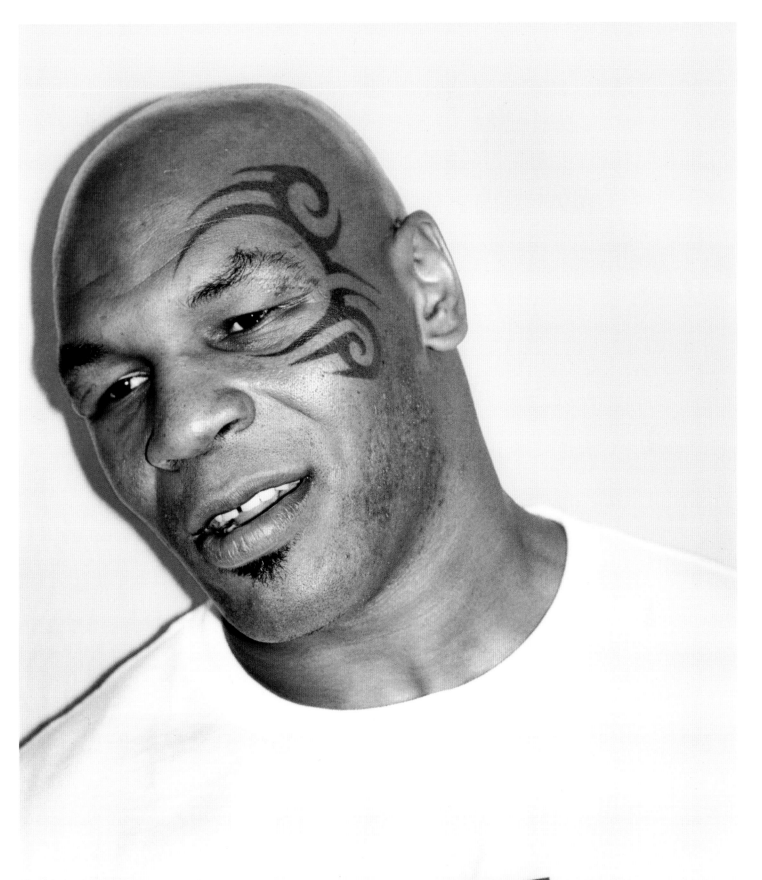

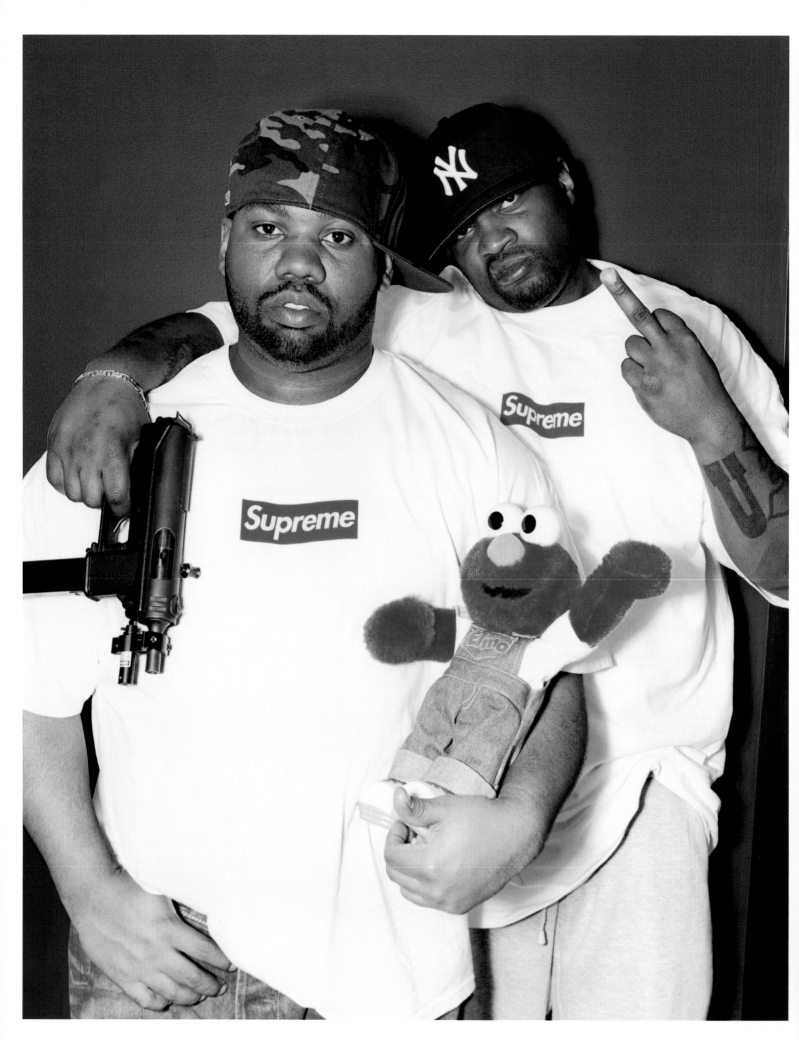

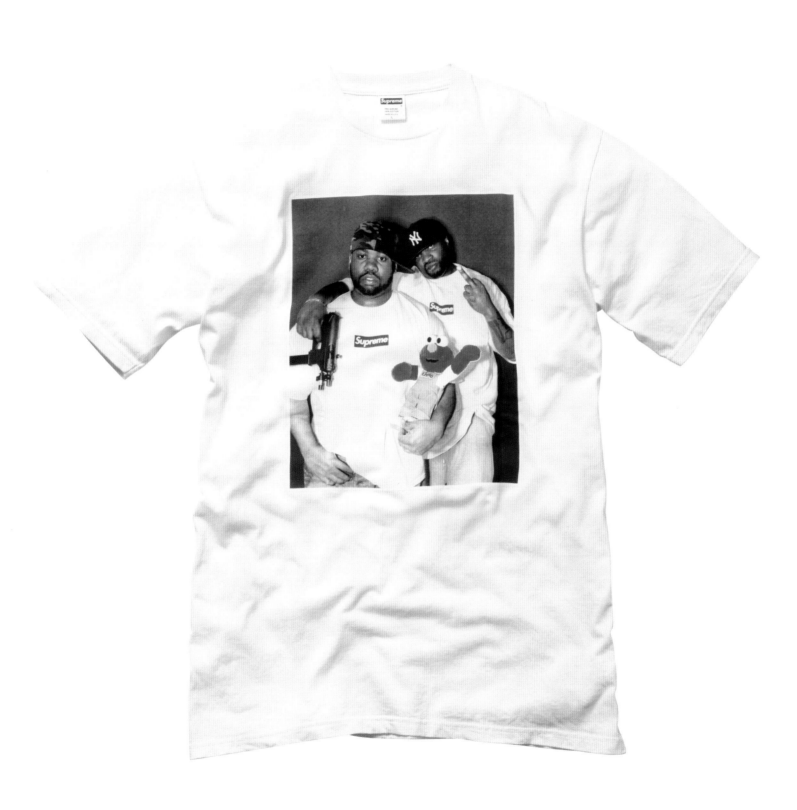

RAEKWON 2005

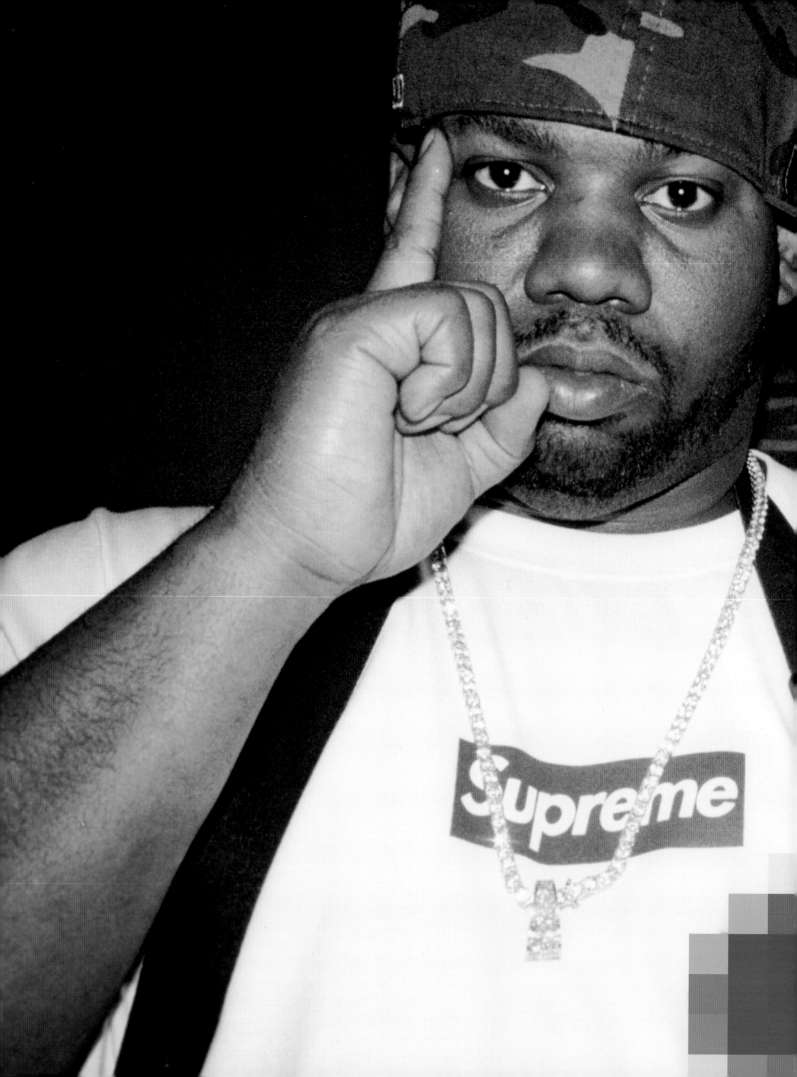

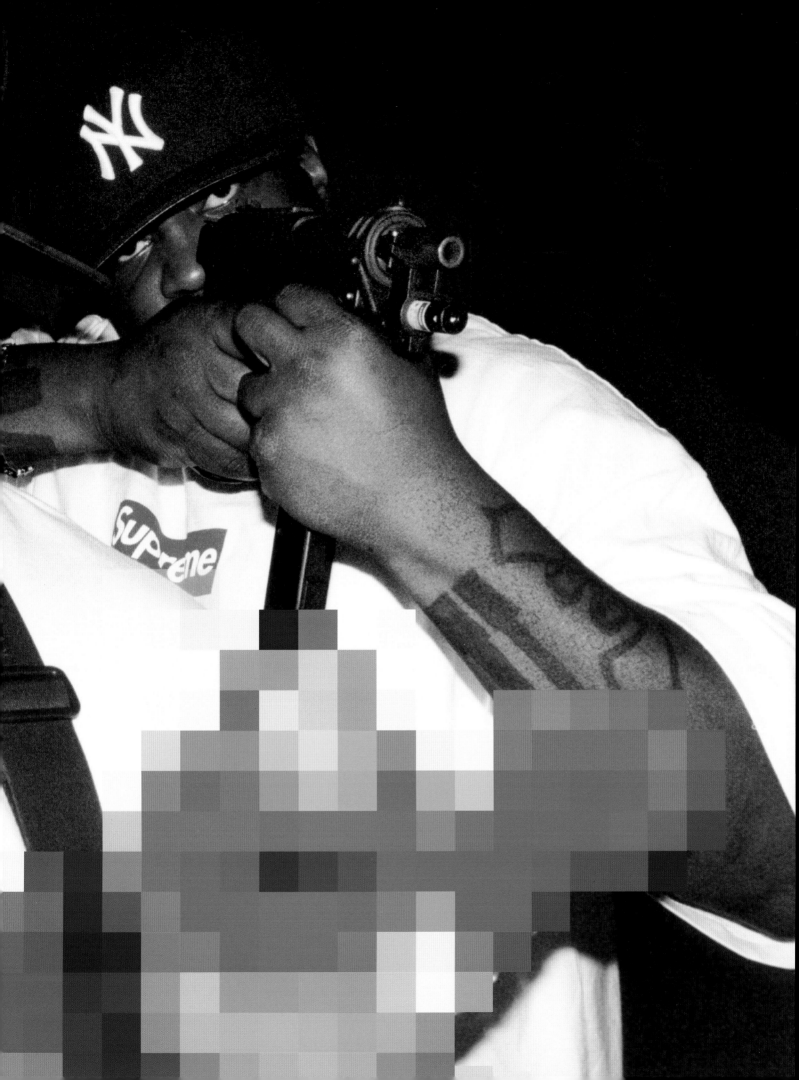

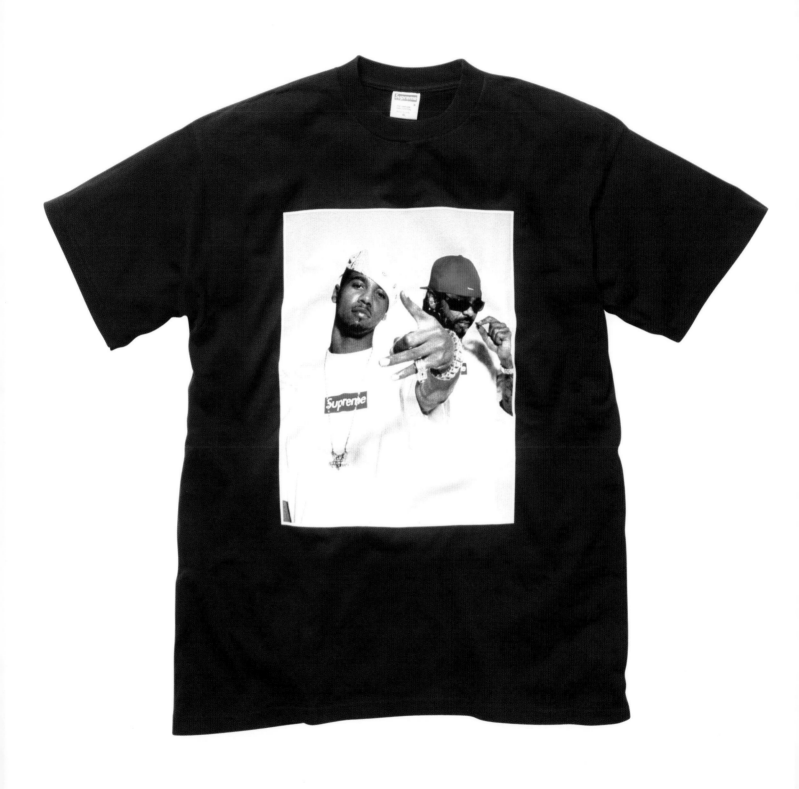

DIPSET 2006

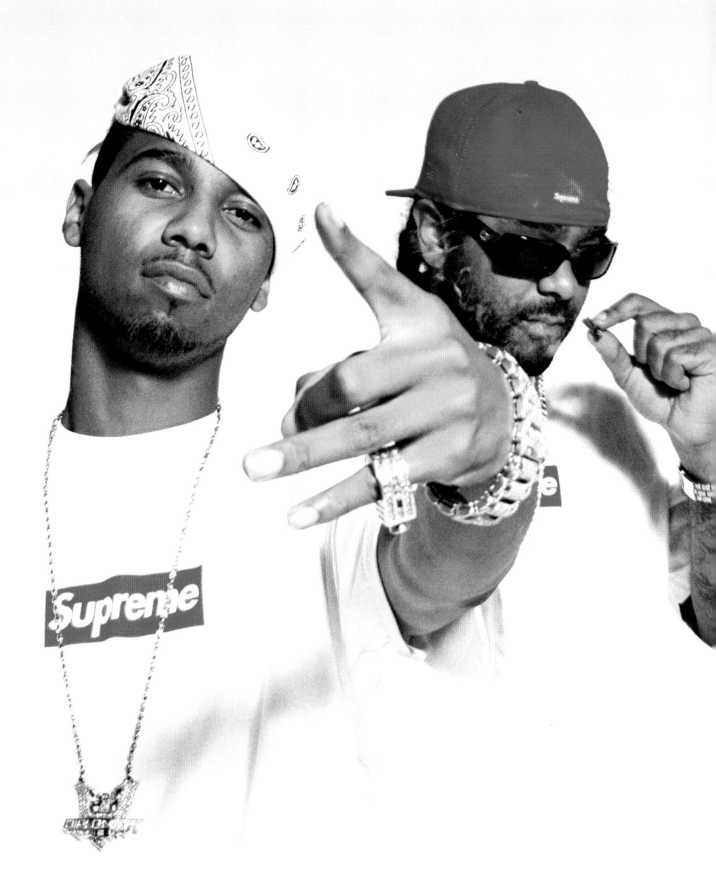

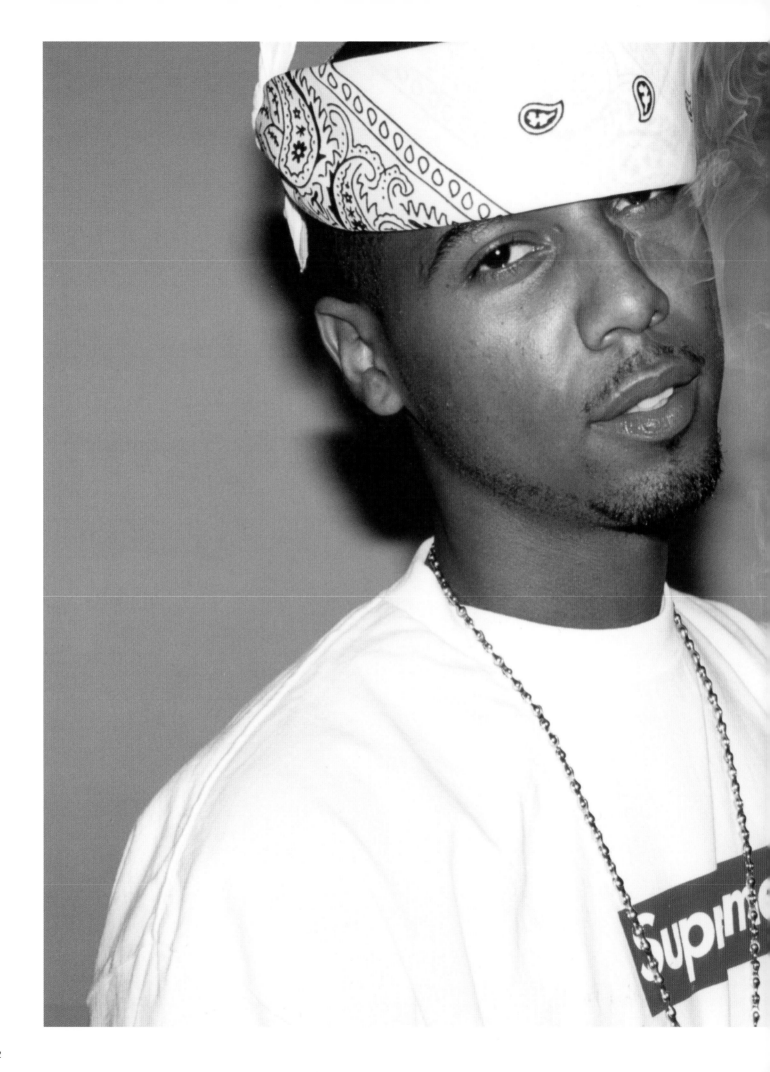

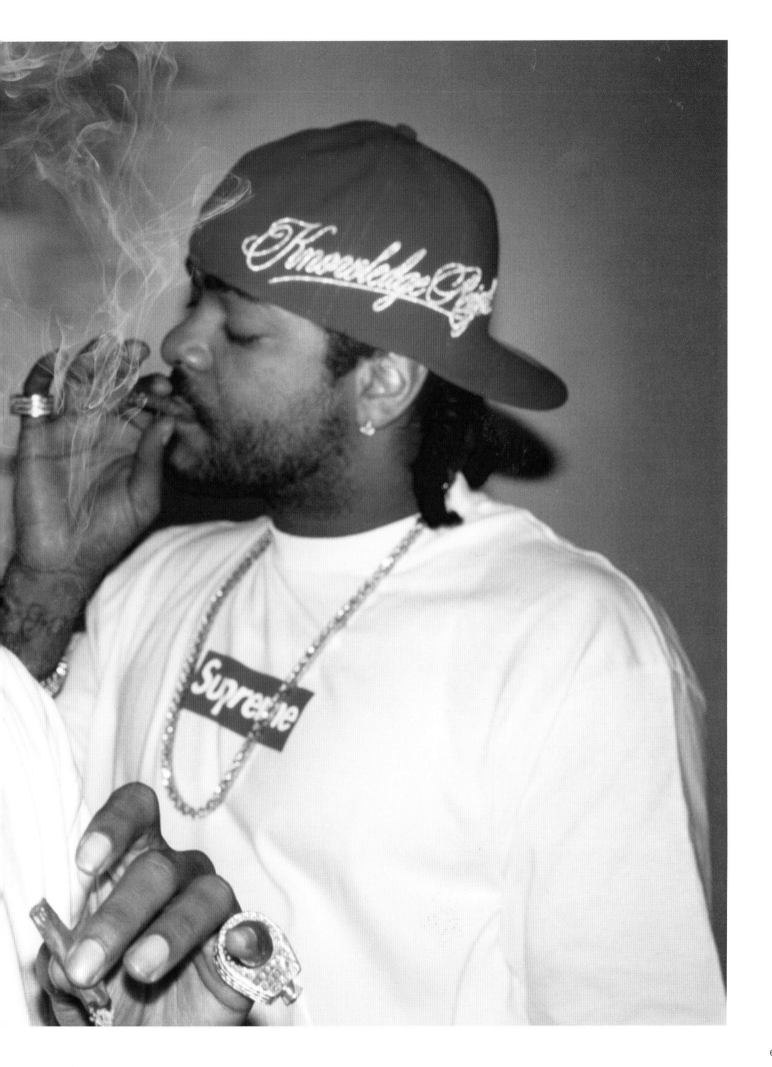

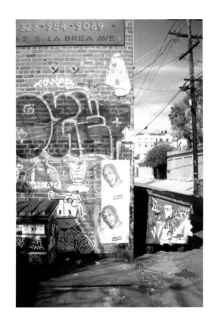

190 Street
Subway Station A

Elevators to 184 St
& Overlook Terrace

Elevator to 184 St & Overlook Terrace

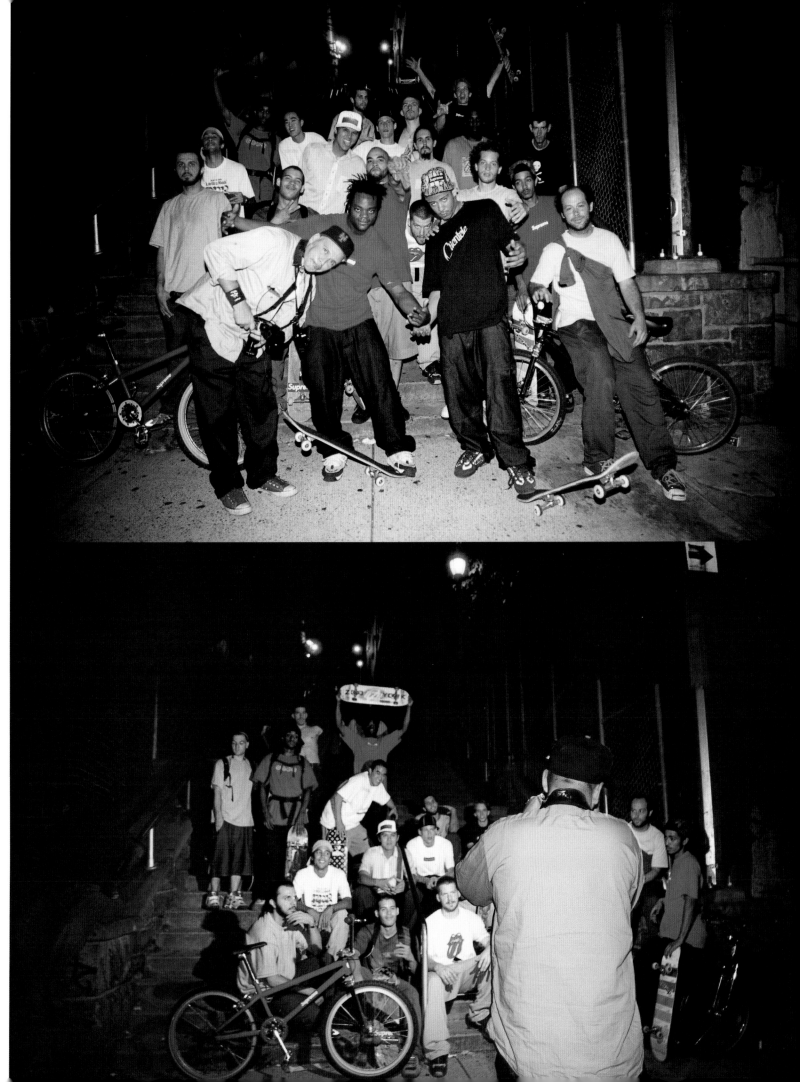

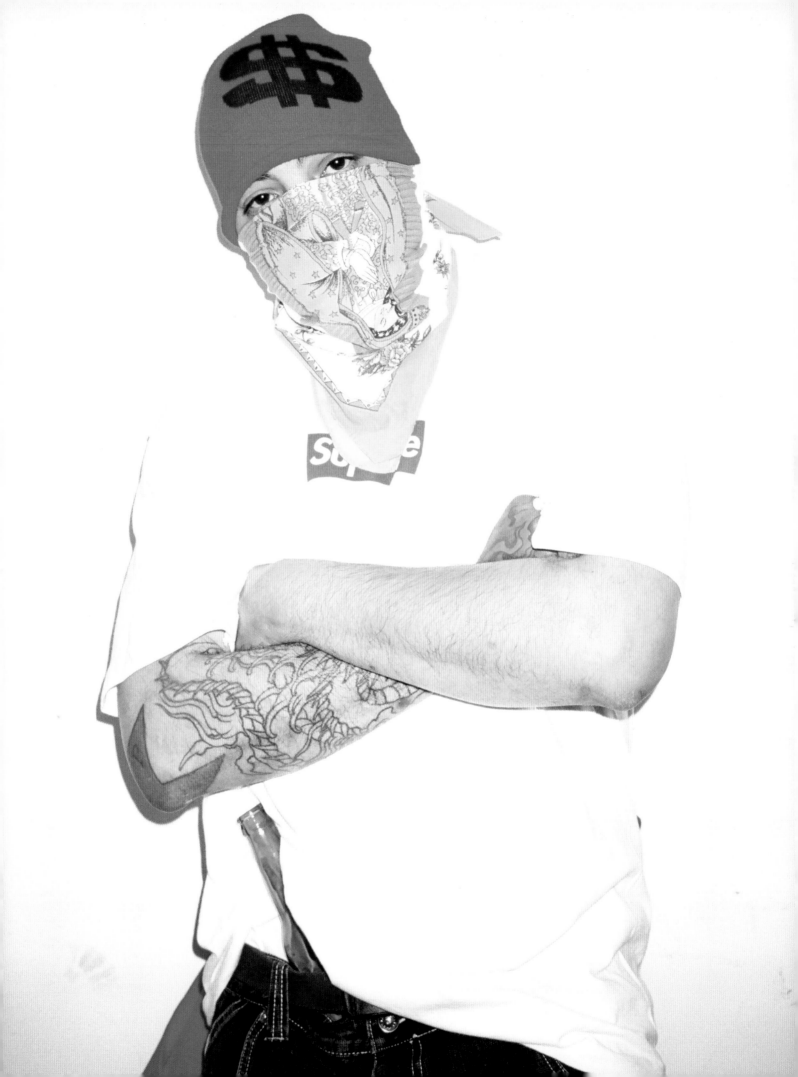

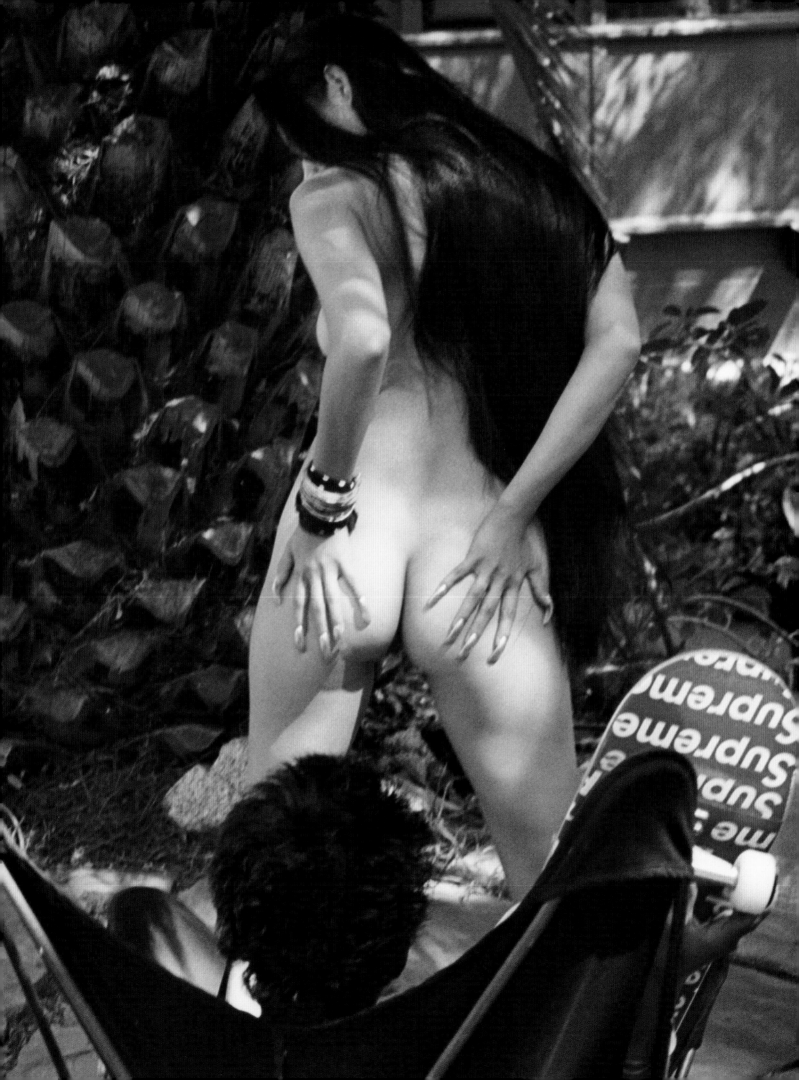

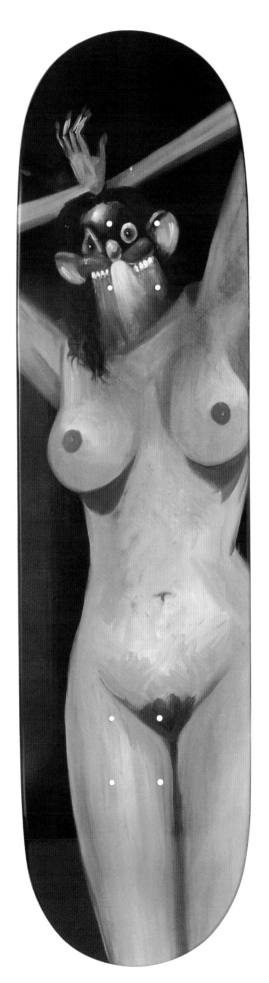
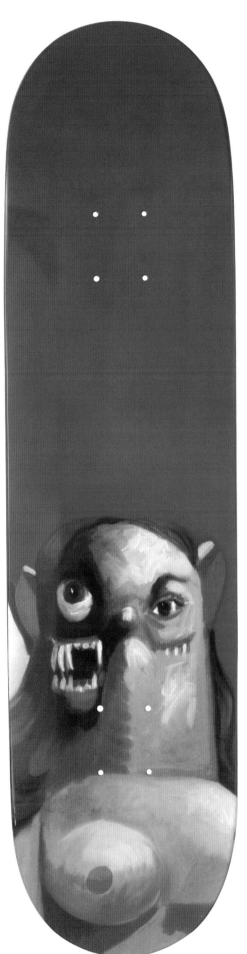
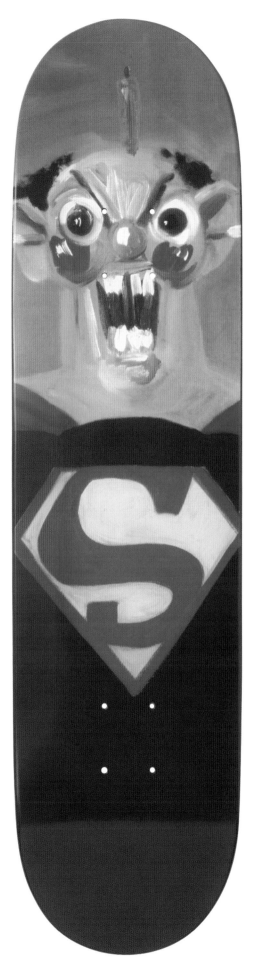

GEORGE CONDO 2010

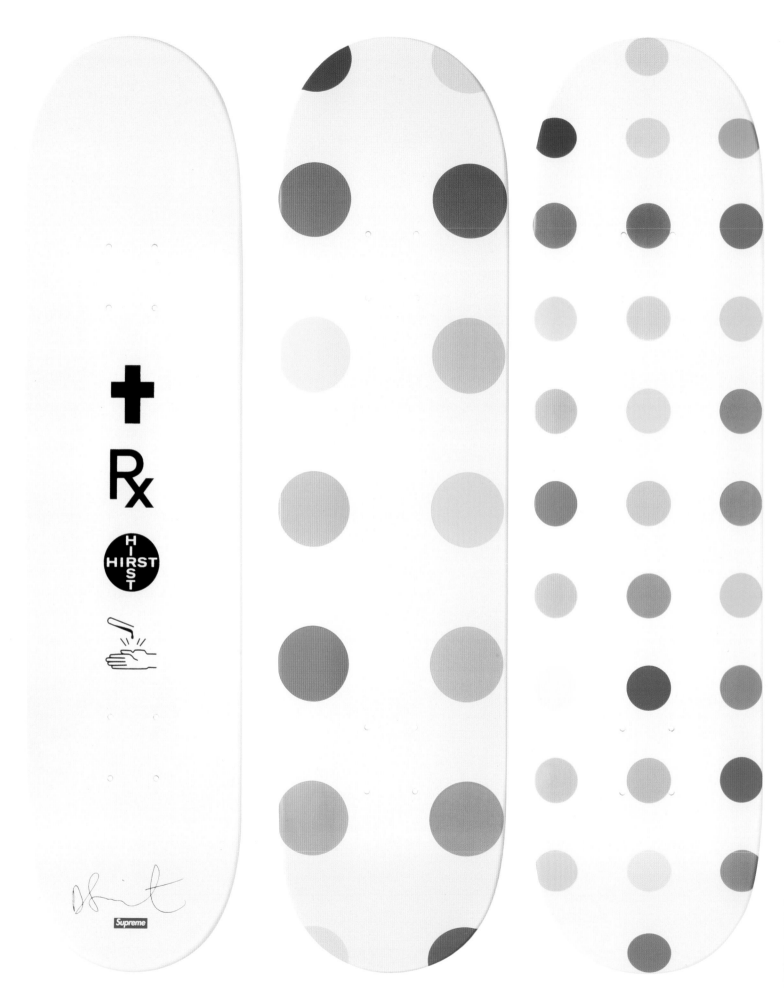

DAMIEN HIRST 2009

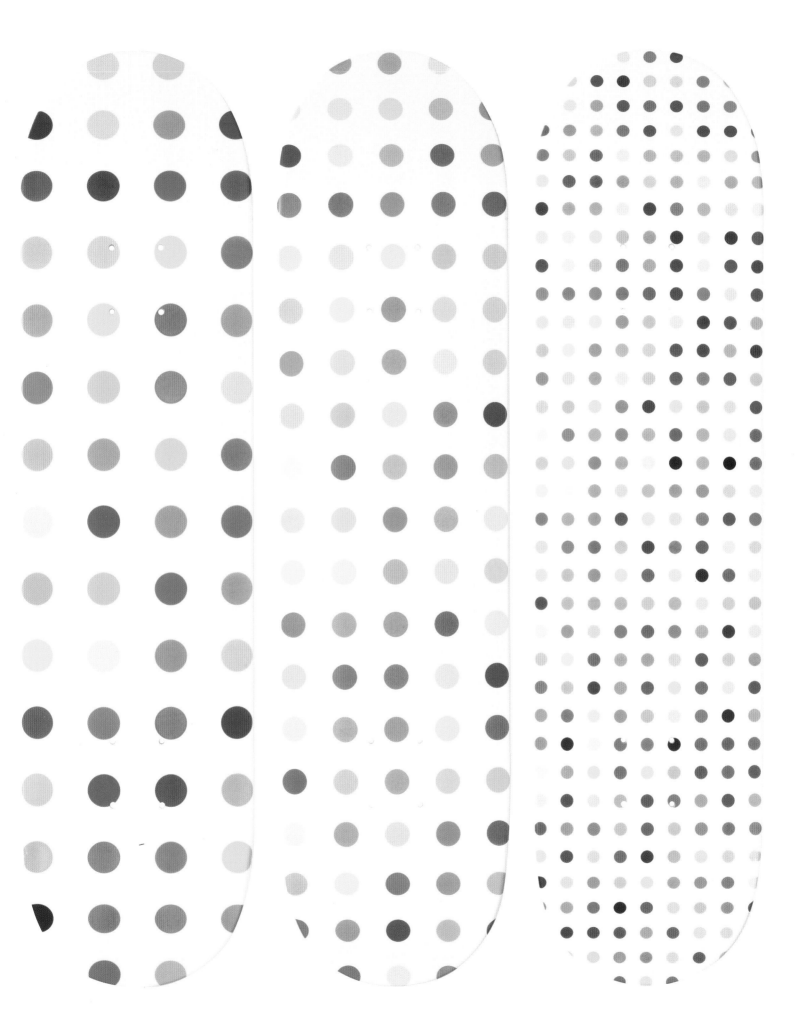

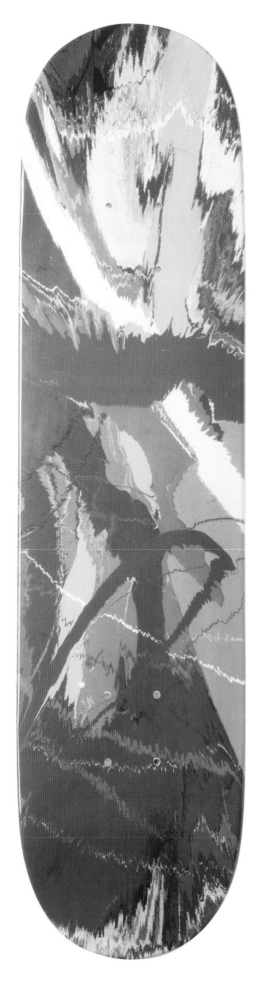
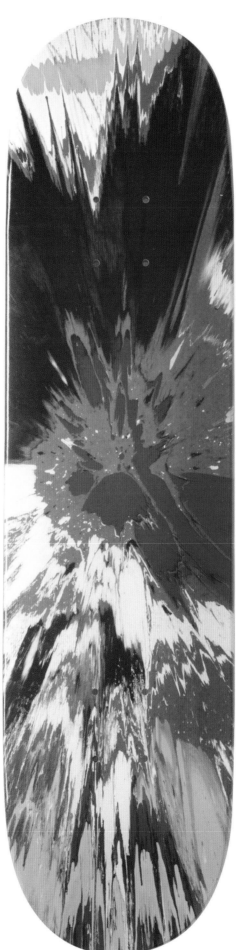
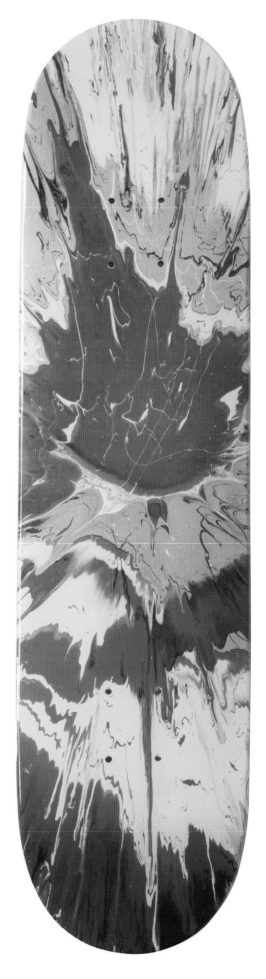

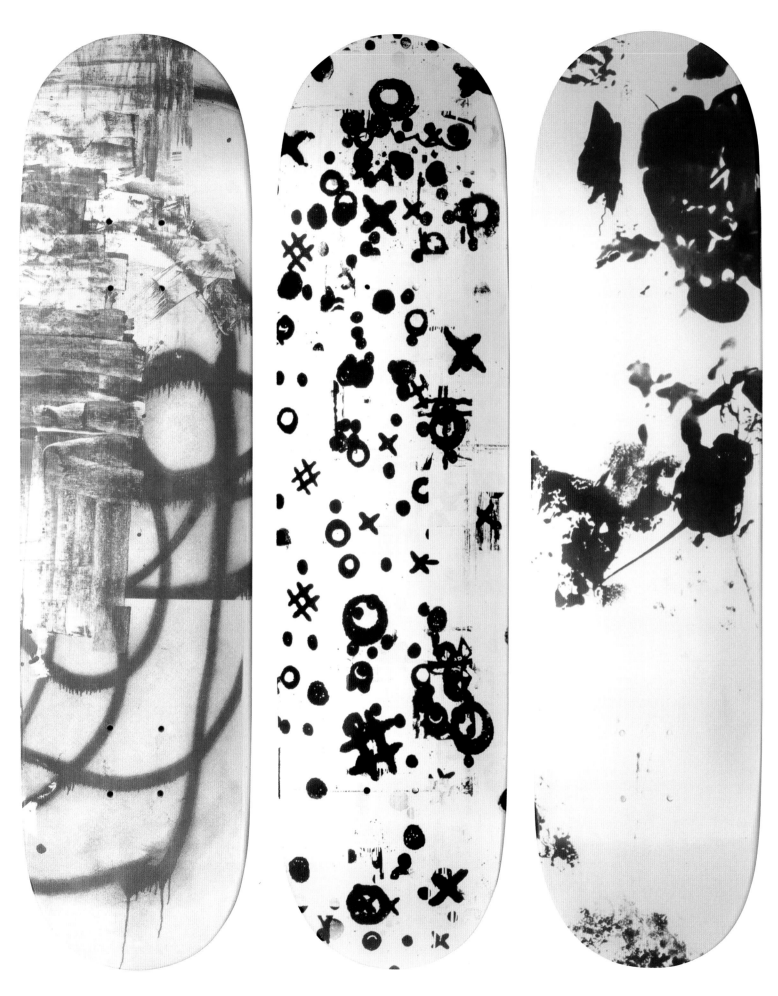

CHRISTOPHER WOOL 2008

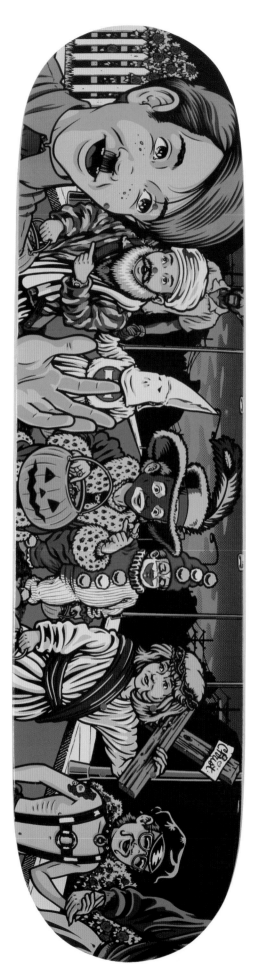
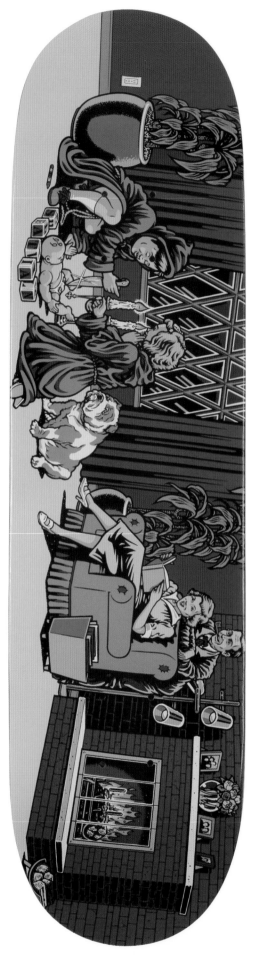

SEAN CLIVER 2008

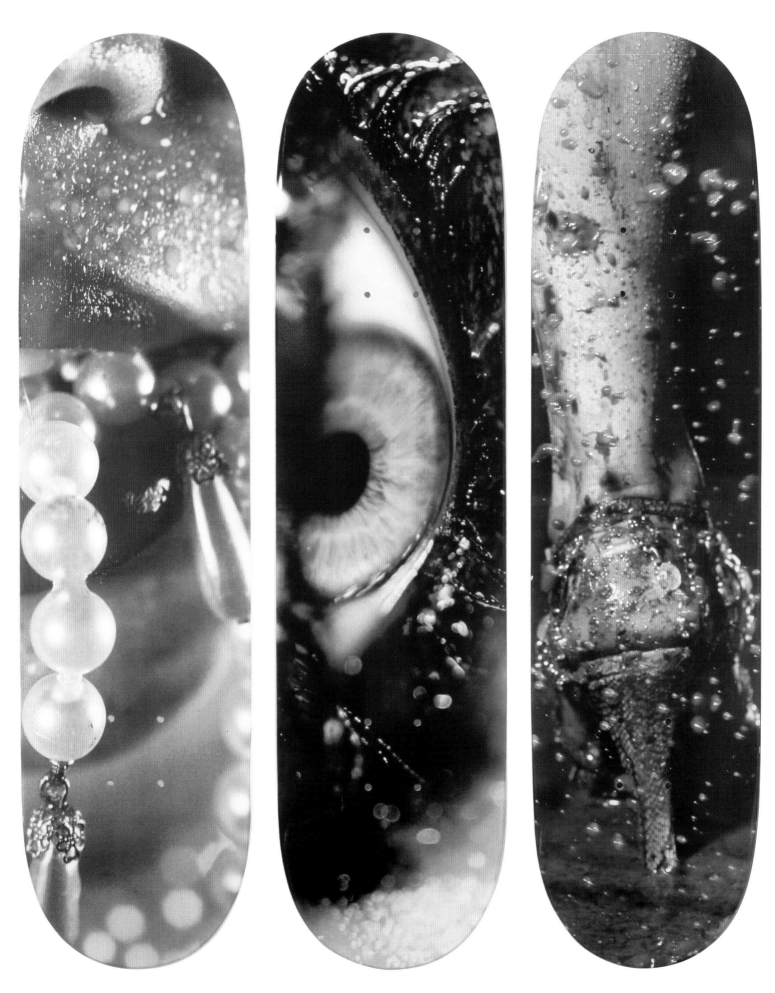

MARILYN MINTER 2008

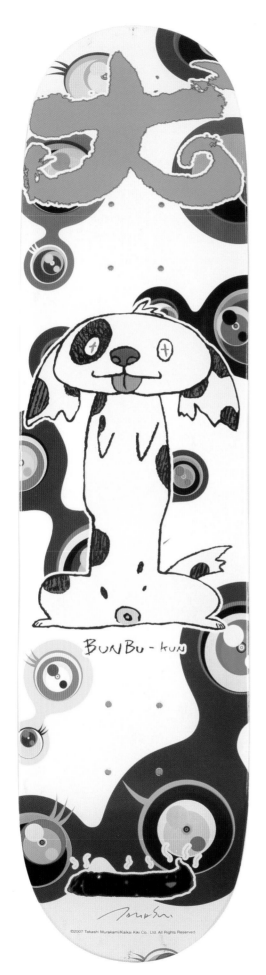
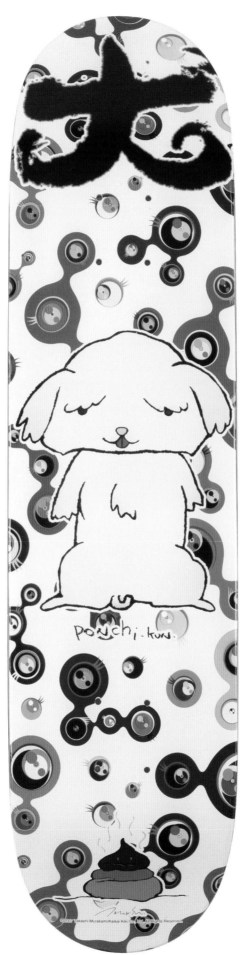
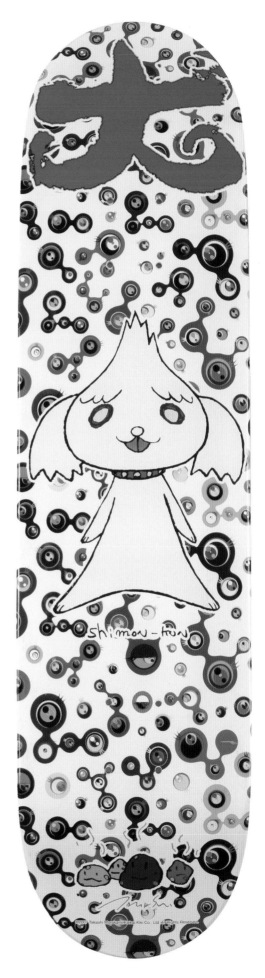

TAKASHI MURAKAMI 2007

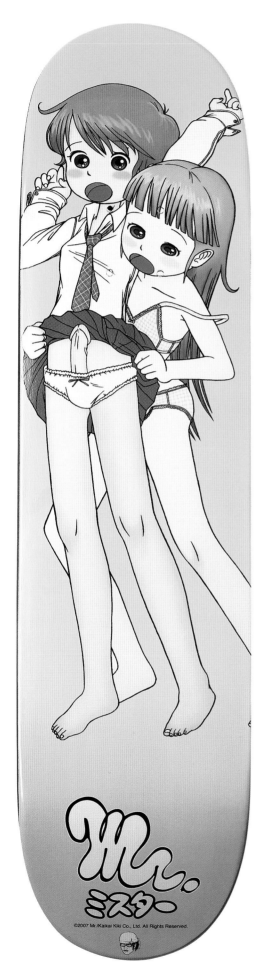

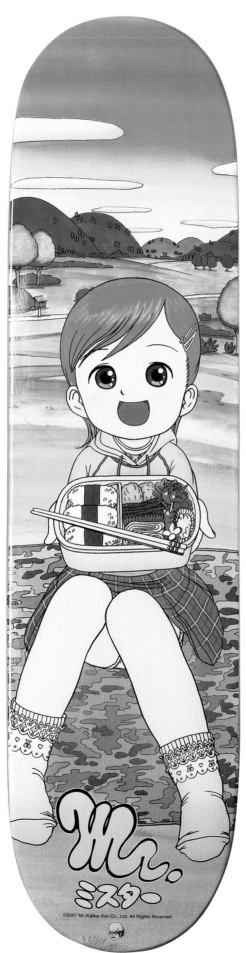

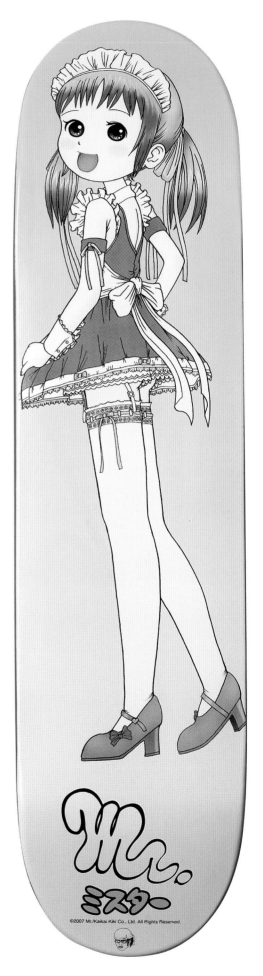

MR. 2007

79

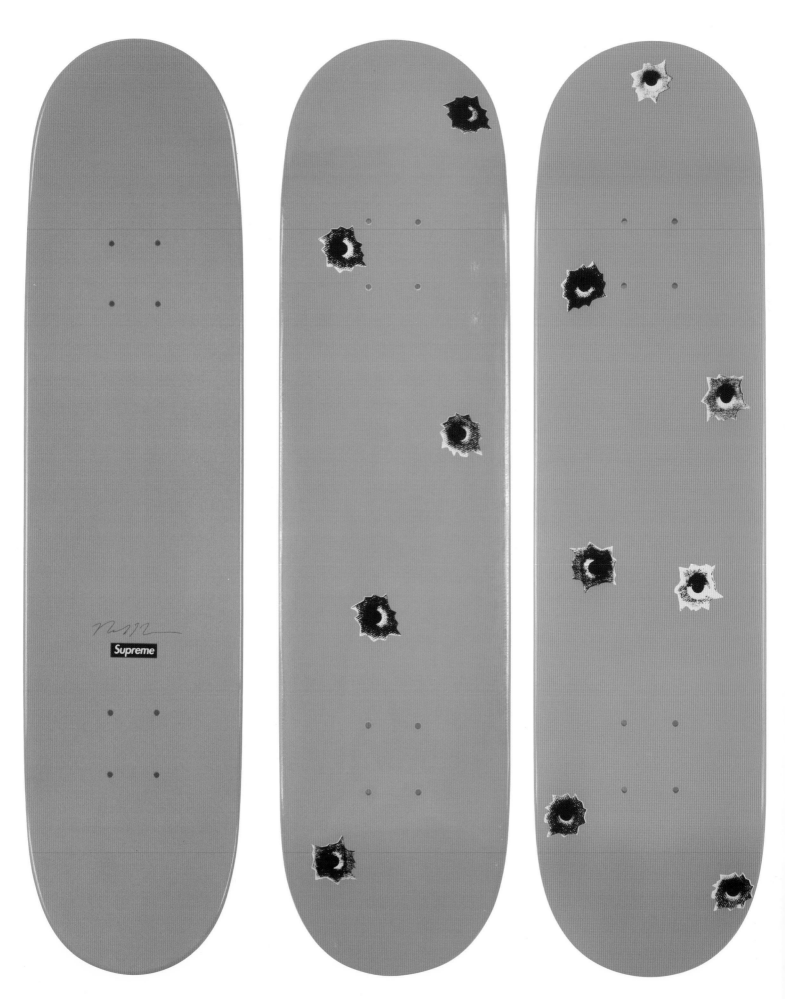

NATE LOWMAN 2007

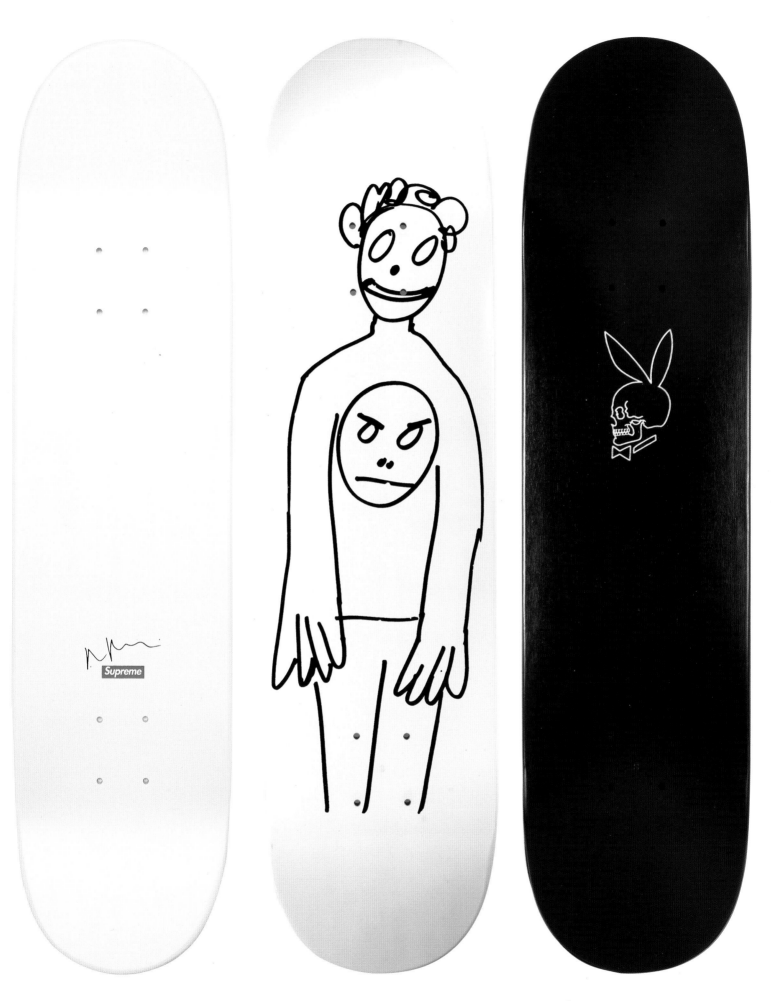

RICHARD PRINCE 2007

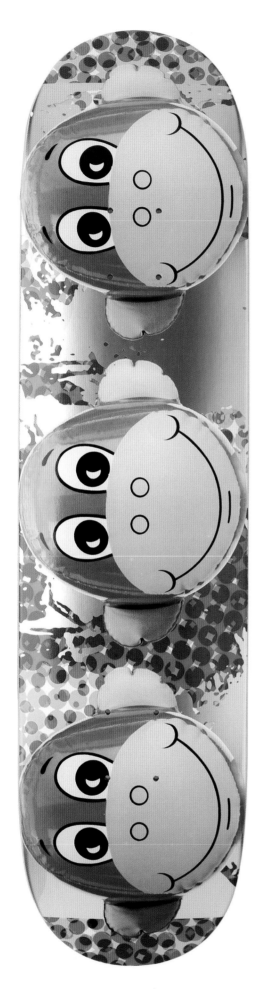
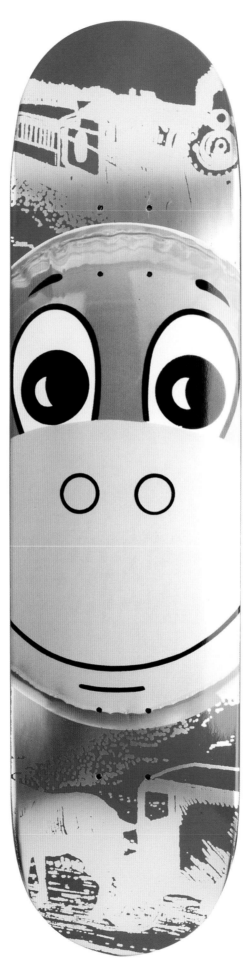
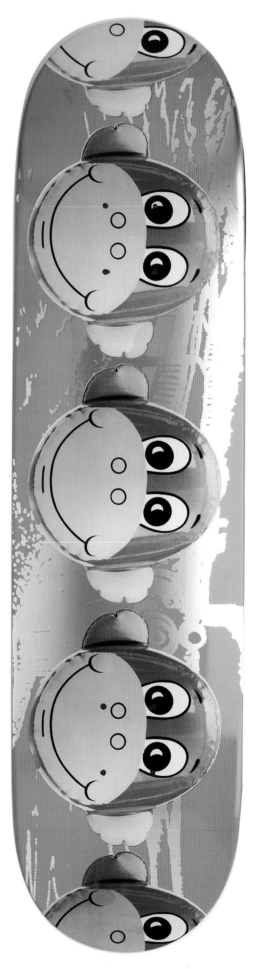

JEFF KOONS 2006

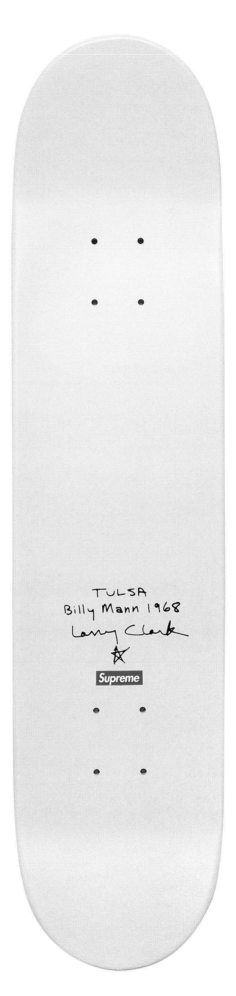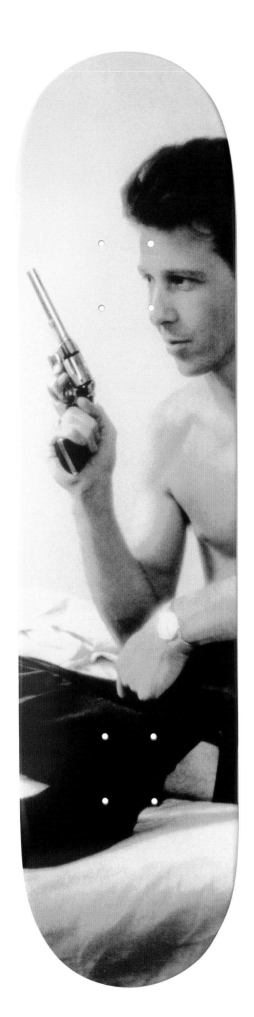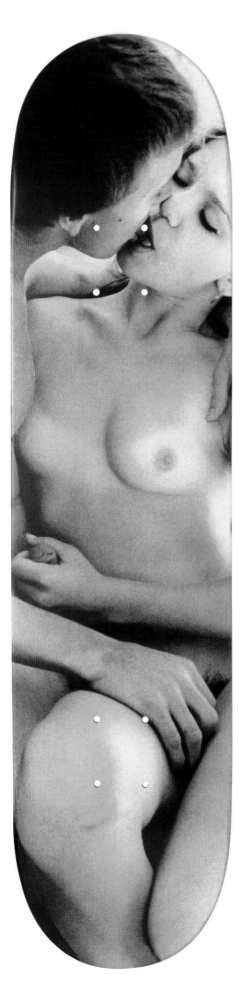

TULSA
Billy Mann 1968
Larry Clark
☆
Supreme

LARRY CLARK 2005

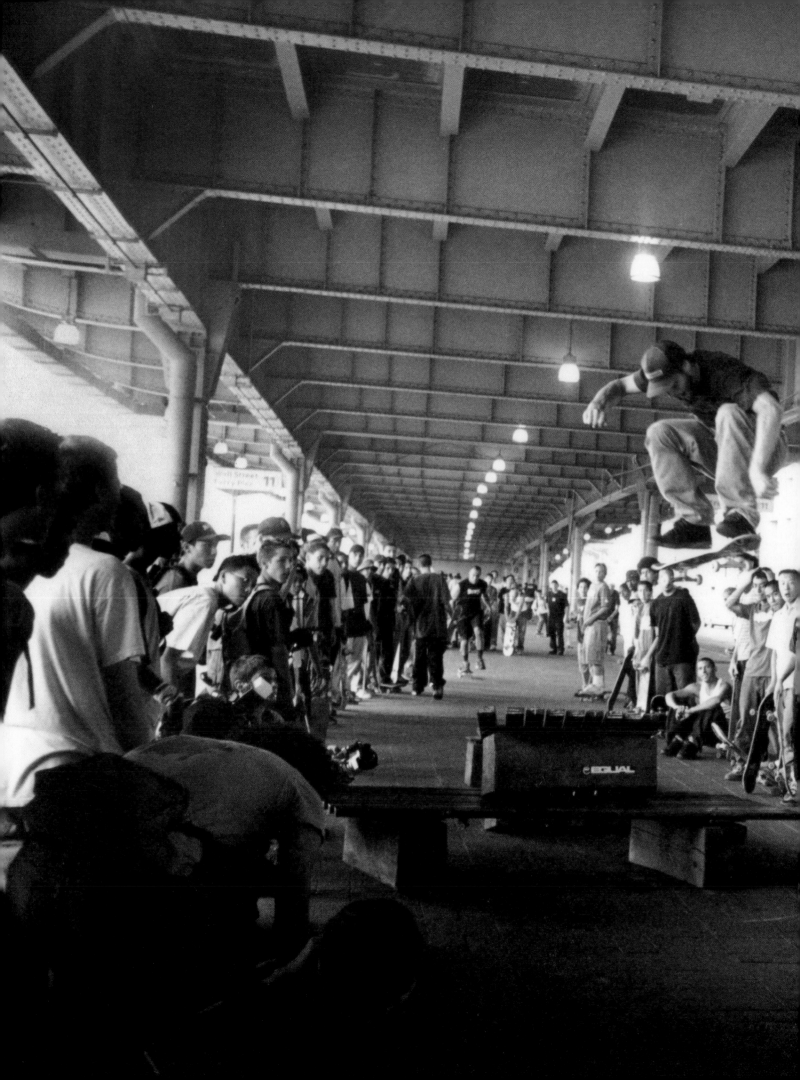

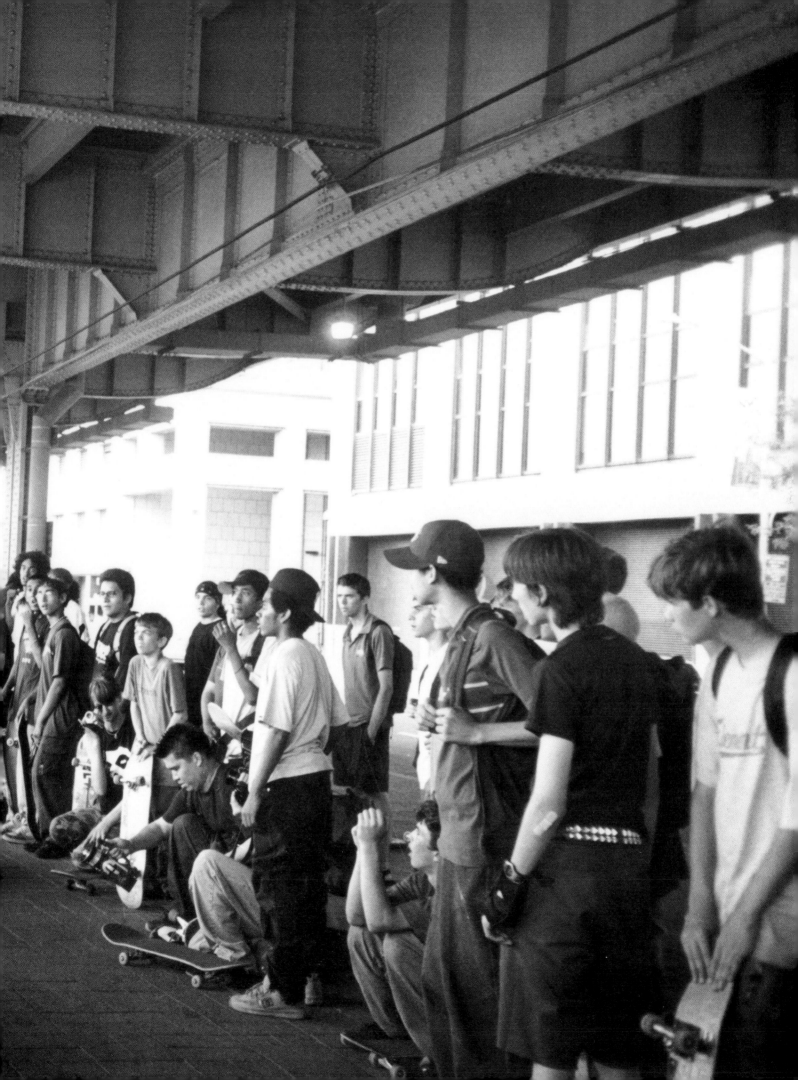

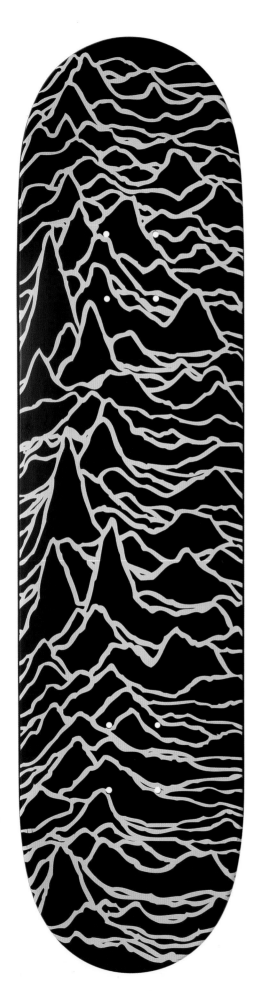
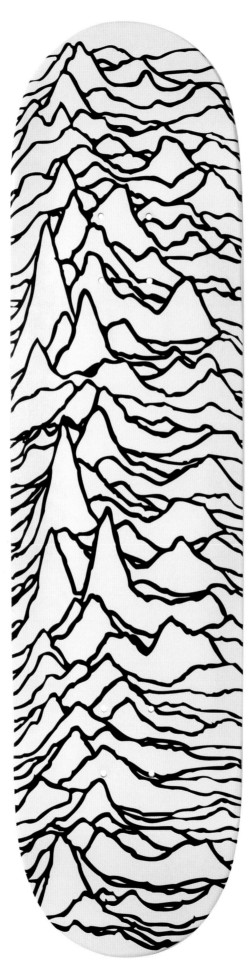

PETER SAVILLE 2005

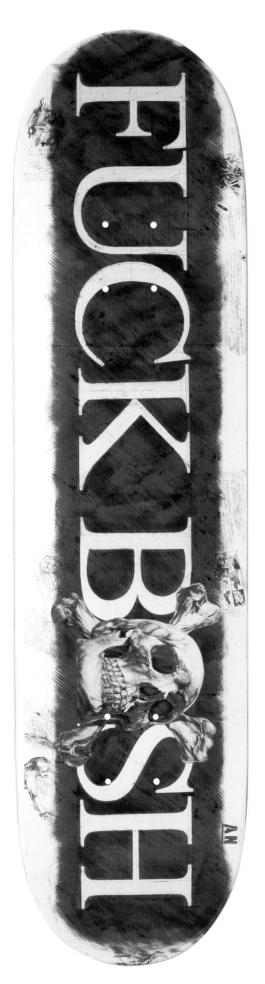
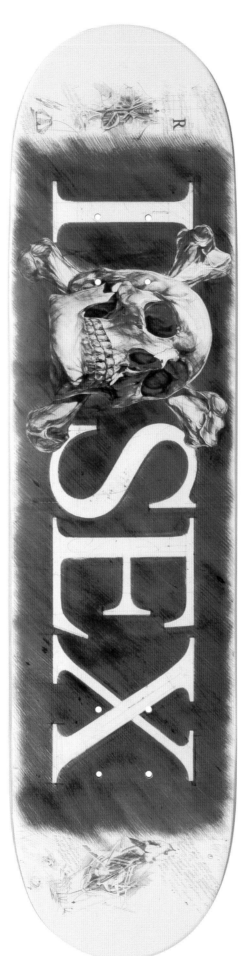
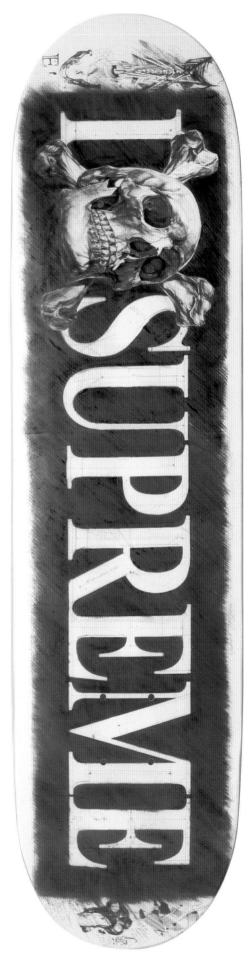

ANDREI MOLODKIN 2004

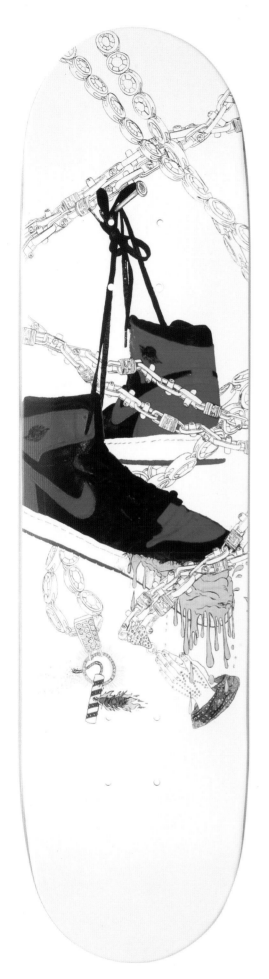
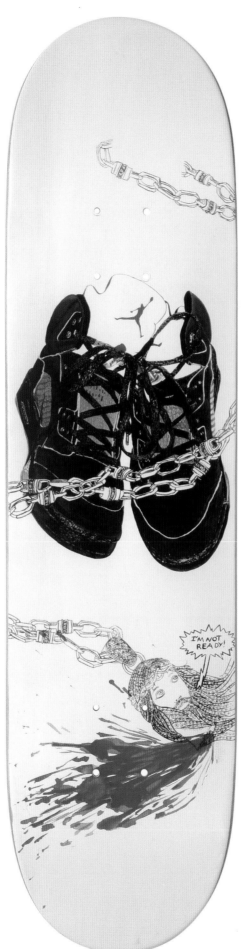
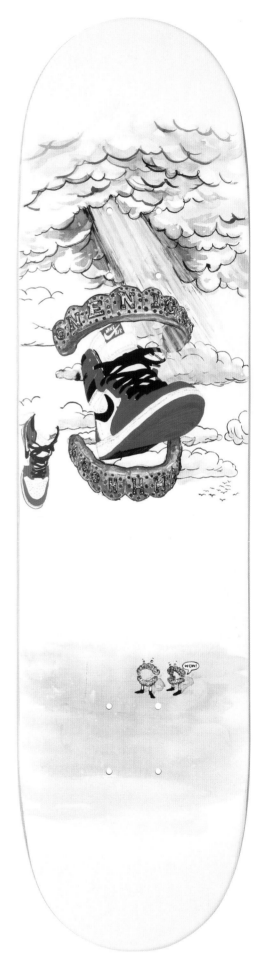

DAN COLEN 2003

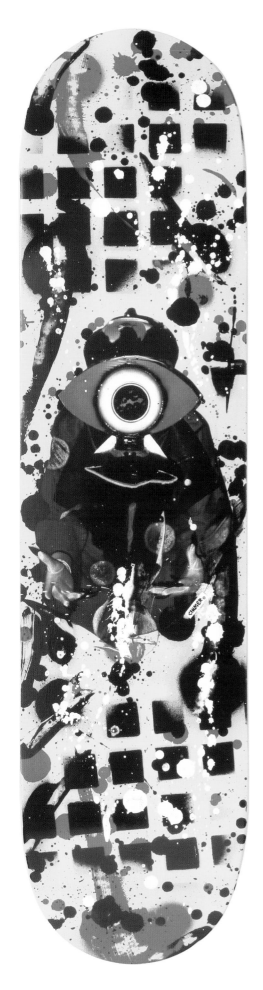
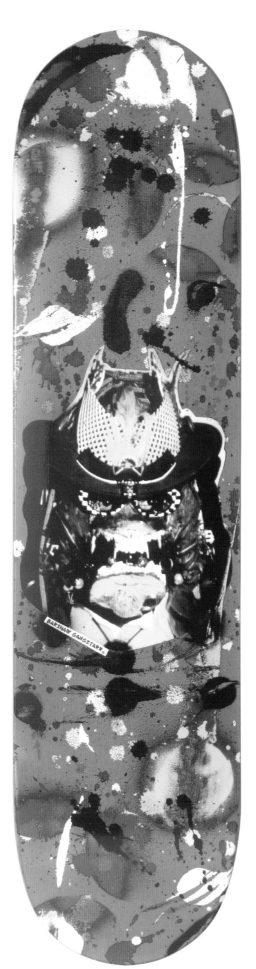
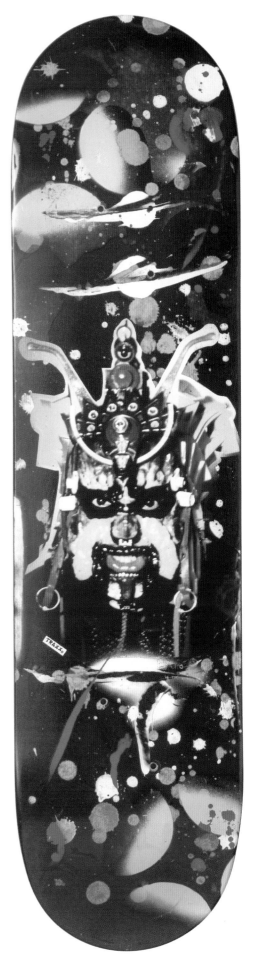

RAMMELLZEE 2002

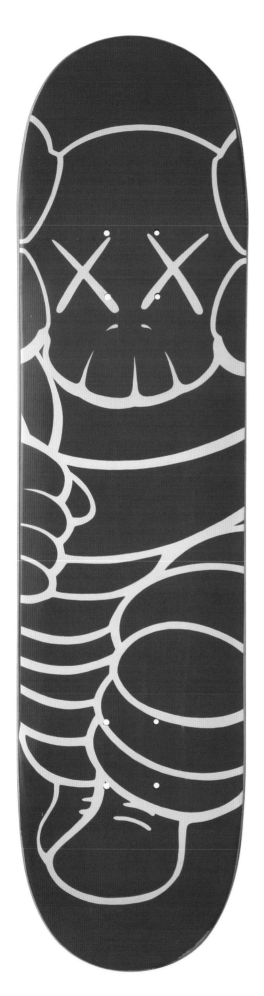

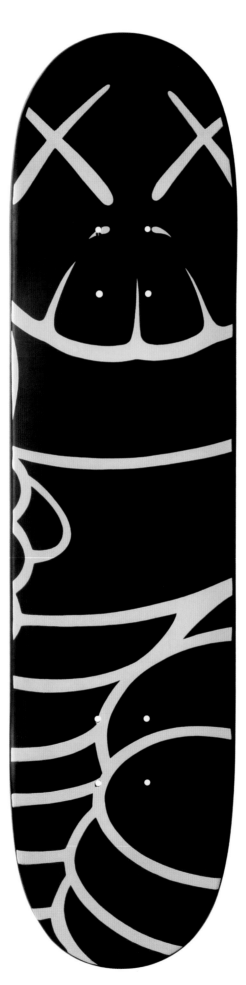

KAWS 2001

RYAN McGINNESS 2000

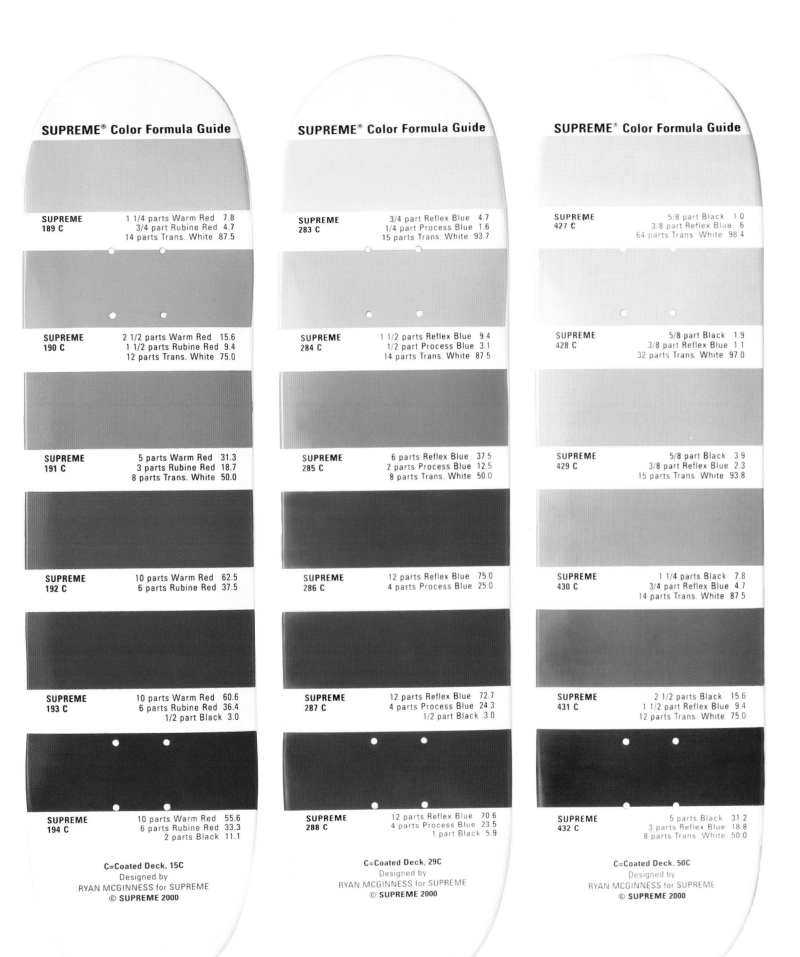

SUPREME® Color Formula Guide

SUPREME 189 C	1 1/4 parts Warm Red 7.8
	3/4 part Rubine Red 4.7
	14 parts Trans. White 87.5

SUPREME 190 C	2 1/2 parts Warm Red 15.6
	1 1/2 parts Rubine Red 9.4
	12 parts Trans. White 75.0

SUPREME 191 C	5 parts Warm Red 31.3
	3 parts Rubine Red 18.7
	8 parts Trans. White 50.0

| SUPREME 192 C | 10 parts Warm Red 62.5 |
| | 6 parts Rubine Red 37.5 |

SUPREME 193 C	10 parts Warm Red 60.6
	6 parts Rubine Red 36.4
	1/2 part Black 3.0

SUPREME 194 C	10 parts Warm Red 55.6
	6 parts Rubine Red 33.3
	2 parts Black 11.1

C=Coated Deck, 15C
Designed by
RYAN MCGINNESS for SUPREME
© SUPREME 2000

SUPREME® Color Formula Guide

SUPREME 283 C	3/4 part Reflex Blue 4.7
	1/4 part Process Blue 1.6
	15 parts Trans. White 93.7

SUPREME 284 C	1 1/2 parts Reflex Blue 9.4
	1/2 part Process Blue 3.1
	14 parts Trans. White 87.5

SUPREME 285 C	6 parts Reflex Blue 37.5
	2 parts Process Blue 12.5
	8 parts Trans. White 50.0

| SUPREME 286 C | 12 parts Reflex Blue 75.0 |
| | 4 parts Process Blue 25.0 |

SUPREME 287 C	12 parts Reflex Blue 72.7
	4 parts Process Blue 24.3
	1/2 part Black 3.0

SUPREME 288 C	12 parts Reflex Blue 70.6
	4 parts Process Blue 23.5
	1 part Black 5.9

C=Coated Deck, 29C
Designed by
RYAN MCGINNESS for SUPREME
© SUPREME 2000

SUPREME® Color Formula Guide

SUPREME 427 C	5/8 part Black 1.0
	3/8 part Reflex Blue 6
	64 parts Trans. White 98.4

SUPREME 428 C	5/8 part Black 1.9
	3/8 part Reflex Blue 1.1
	32 parts Trans. White 97.0

SUPREME 429 C	5/8 part Black 3.9
	3/8 part Reflex Blue 2.3
	15 parts Trans. White 93.8

SUPREME 430 C	1 1/4 parts Black 7.8
	3/4 part Reflex Blue 4.7
	14 parts Trans. White 87.5

SUPREME 431 C	2 1/2 parts Black 15.6
	1 1/2 part Reflex Blue 9.4
	12 parts Trans. White 75.0

SUPREME 432 C	5 parts Black 31.2
	3 parts Reflex Blue 18.8
	8 parts Trans. White 50.0

C=Coated Deck, 50C
Designed by
RYAN MCGINNESS for SUPREME
© SUPREME 2000

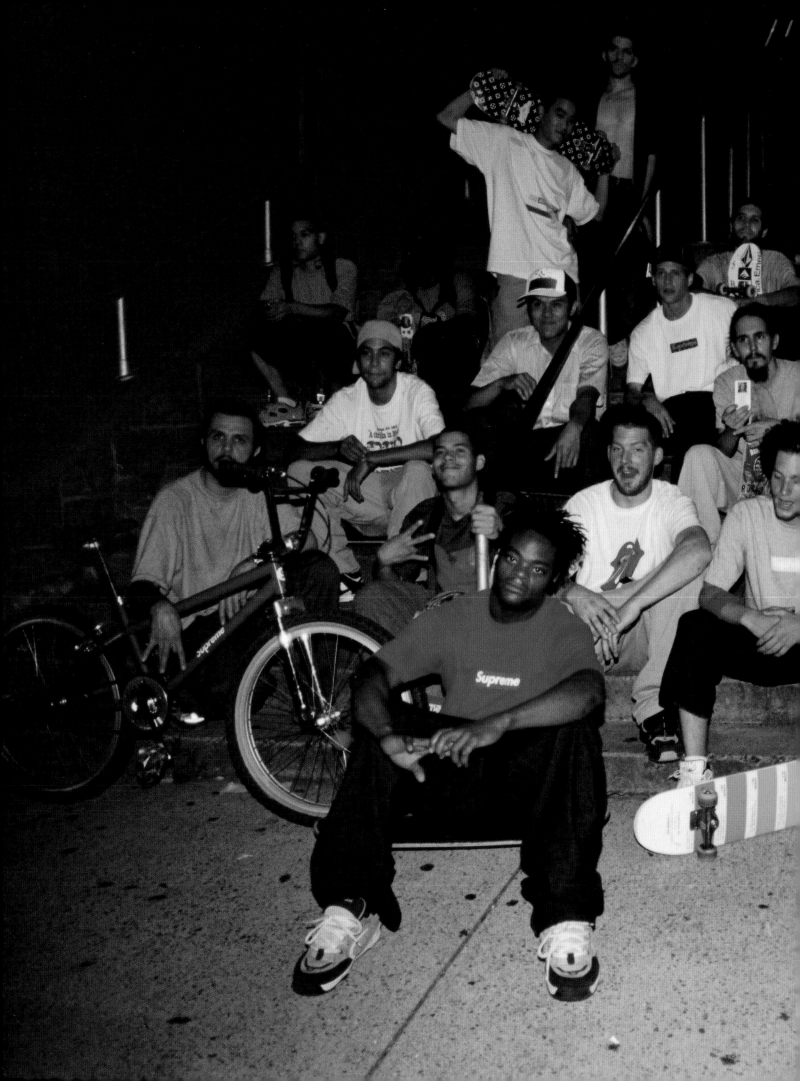

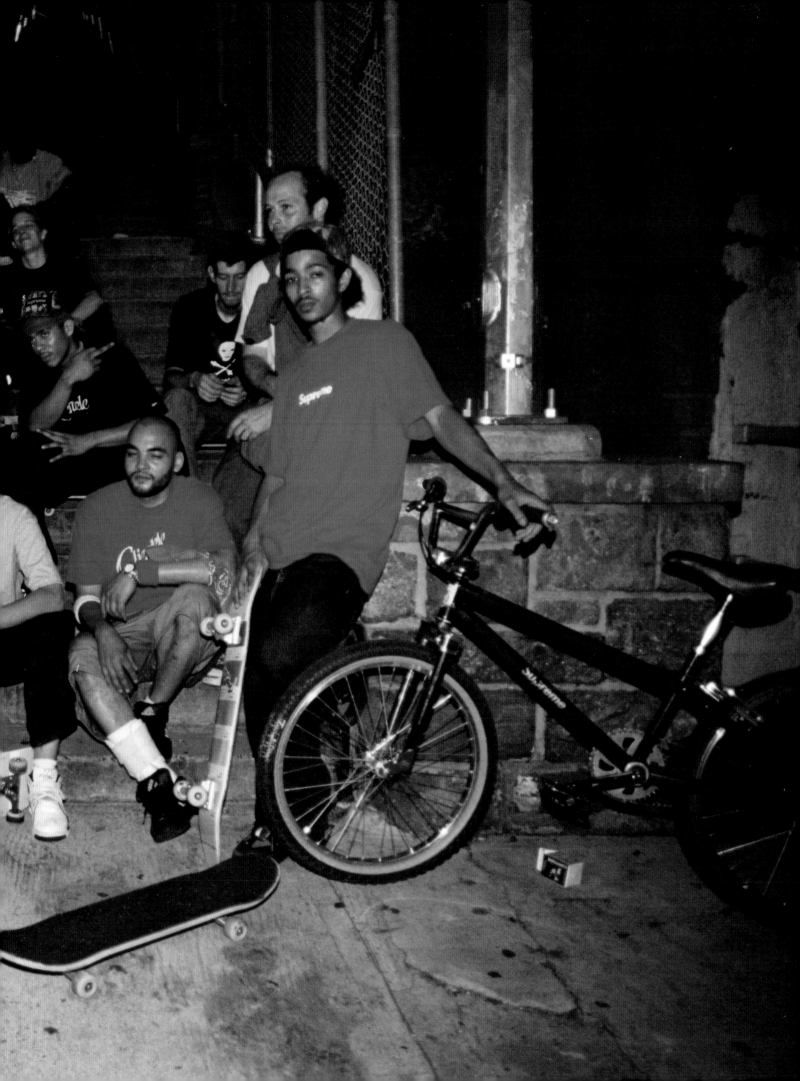

RK
LESH = LT. BROWN = LT. GREEN = LT. PURPLE * COLORS FOR REFERENCE ONLY, PLEASE USE
 SUPPLIED PANTONE COLOR CHIPS/NUMBERS
GHT
FLESH = LT. BLUE = DK. GREEN = DK. PURPLE

ARK
BROWN = DK. BLUE = RED = DK. GREY (80%)

vellow/gold = LT. ORANGE = DK. = LT. GREY (40%)
 ORANGE

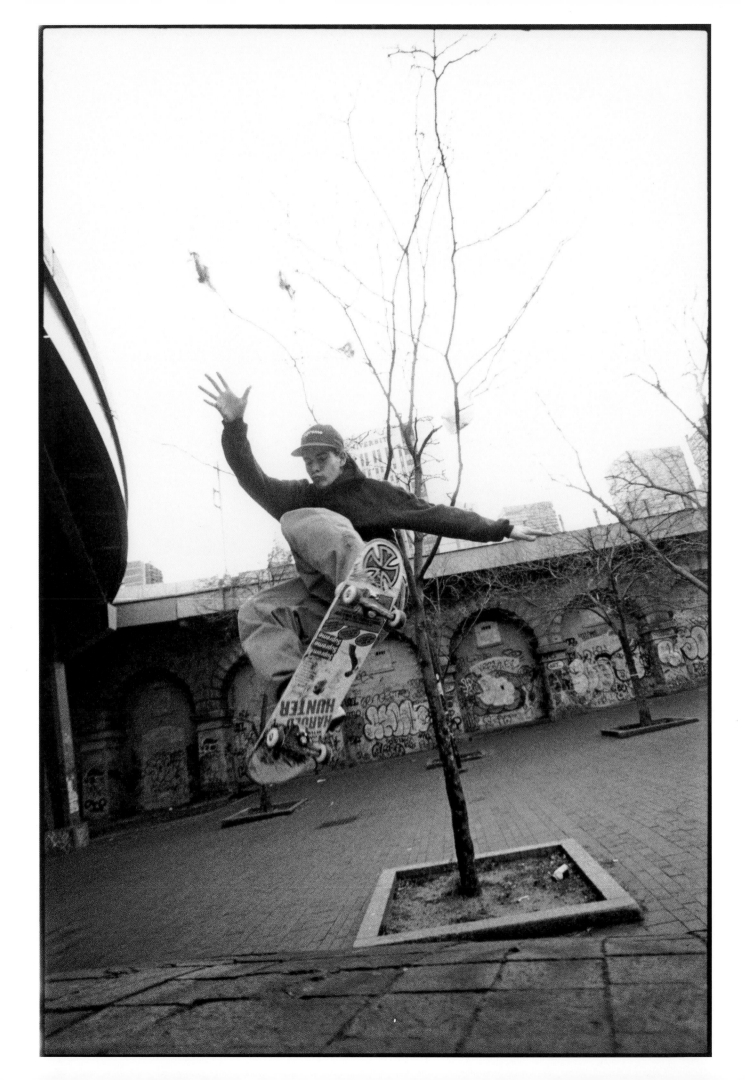

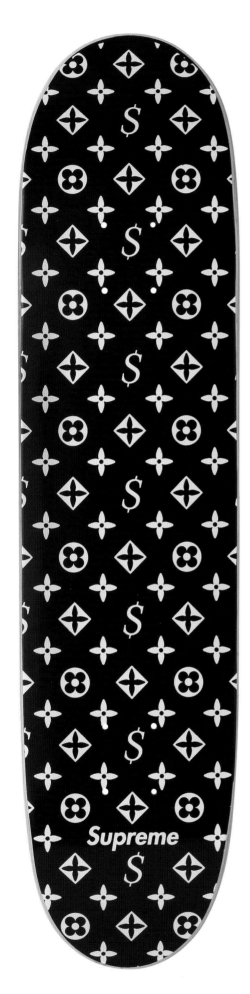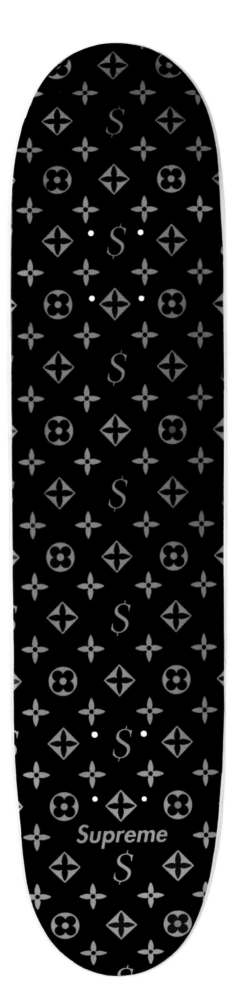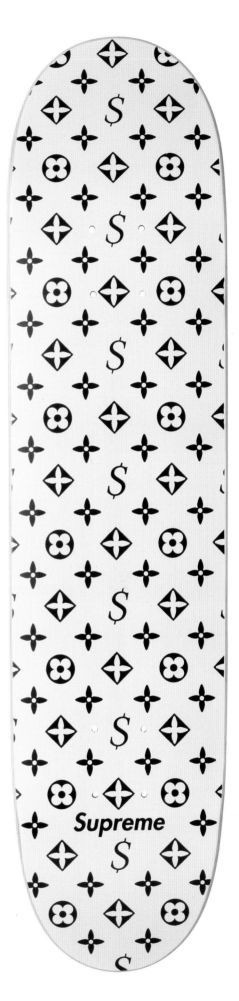

RECALLED MONOGRAM DECKS 2000

SUPREME

FUCK YOU PAY ME

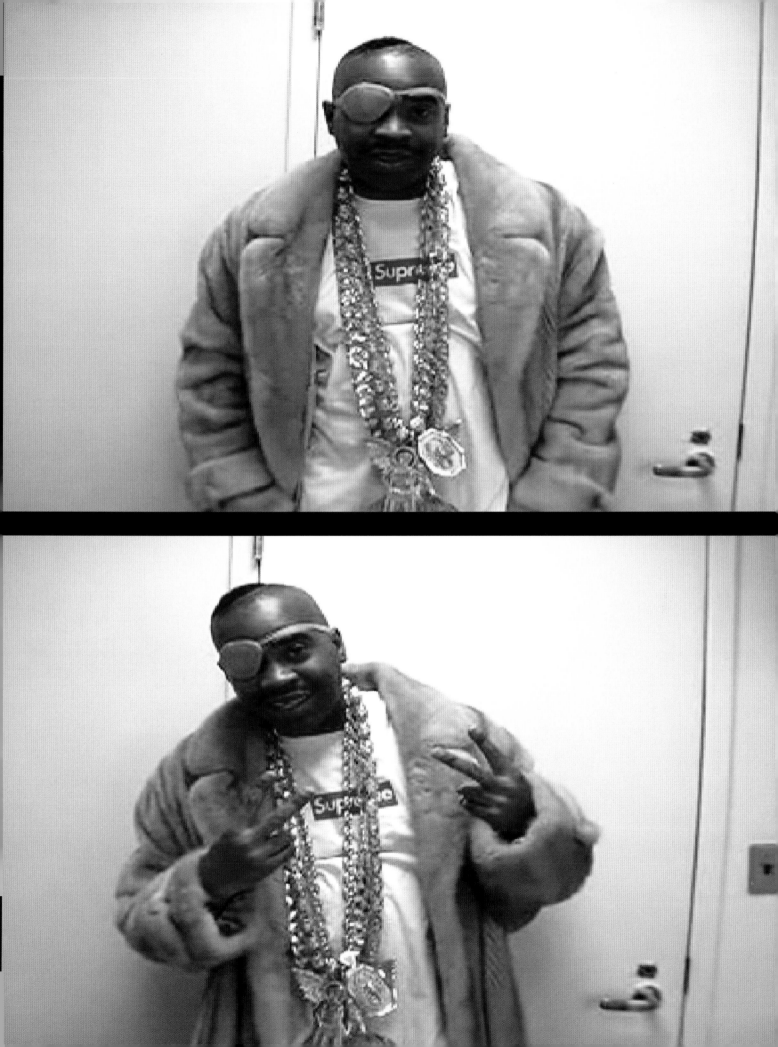

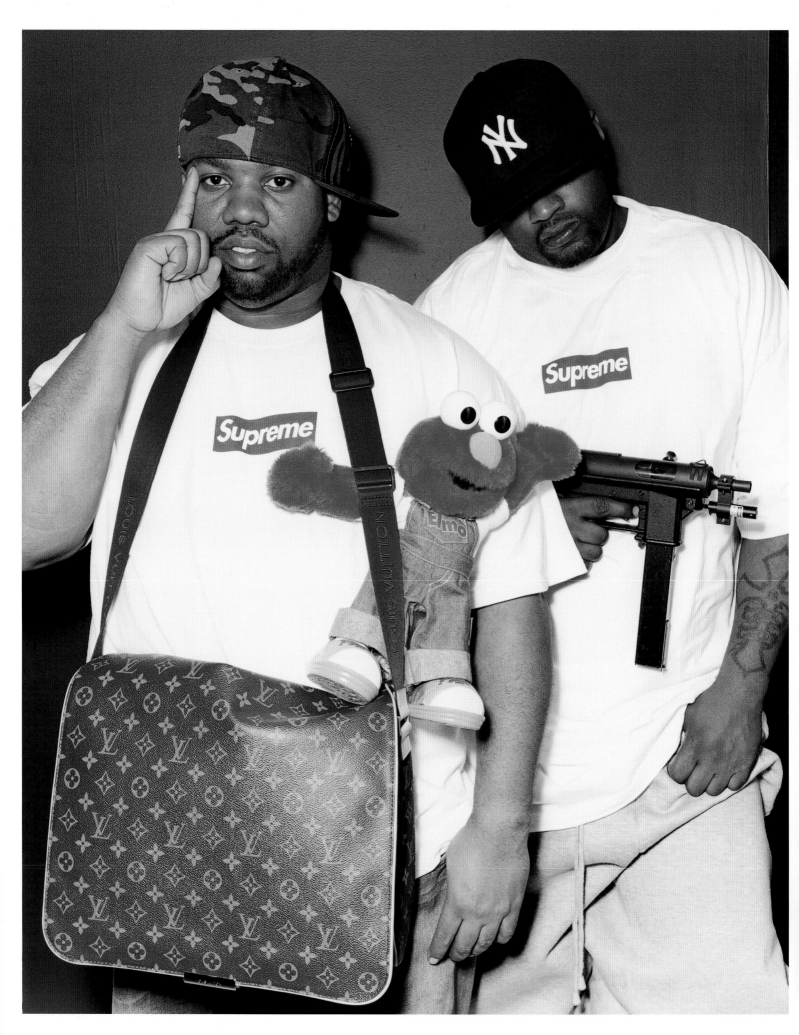

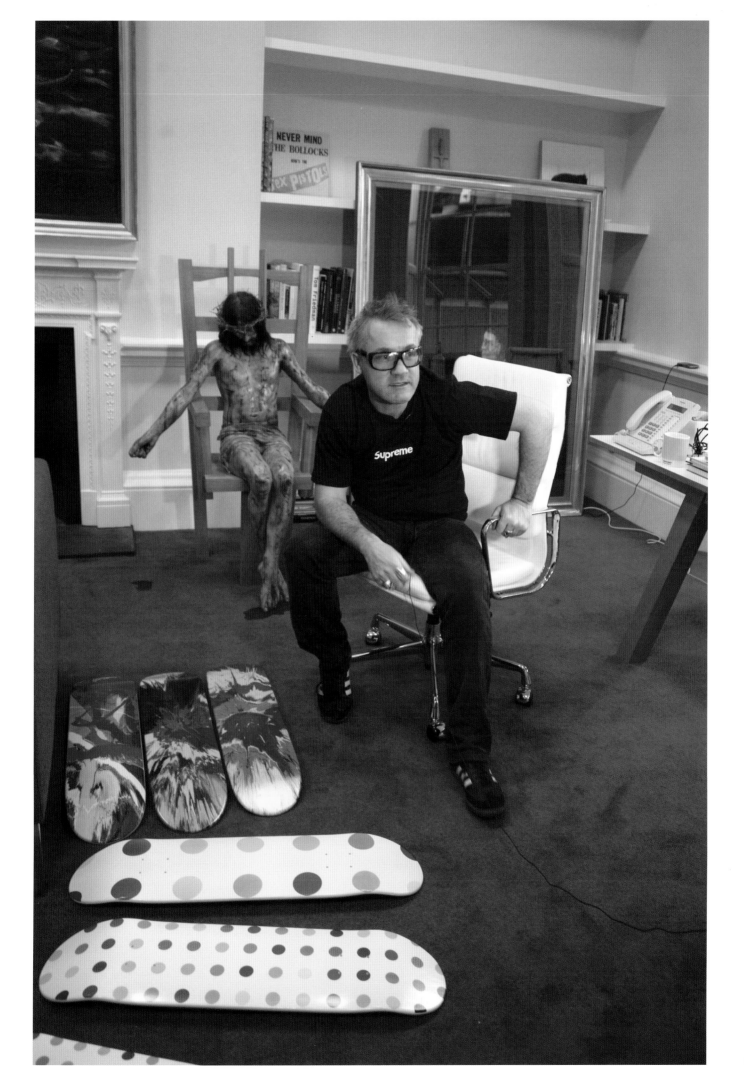

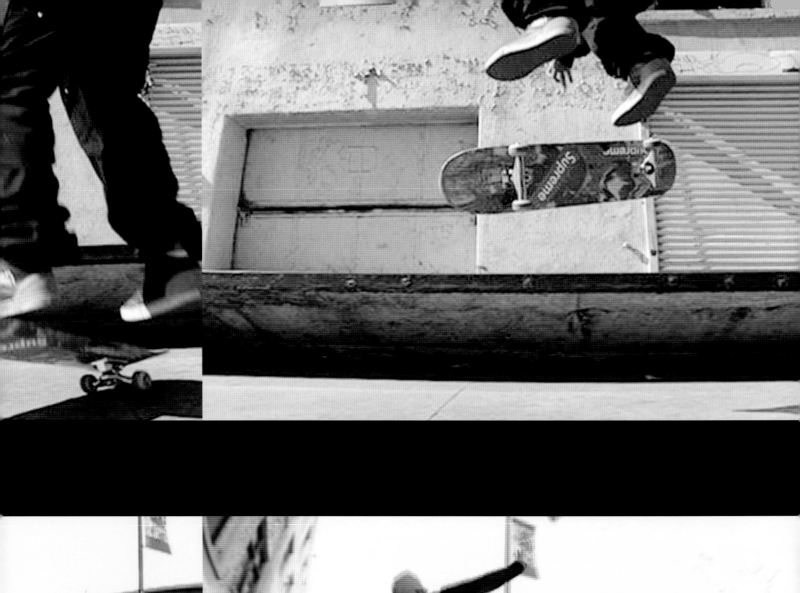
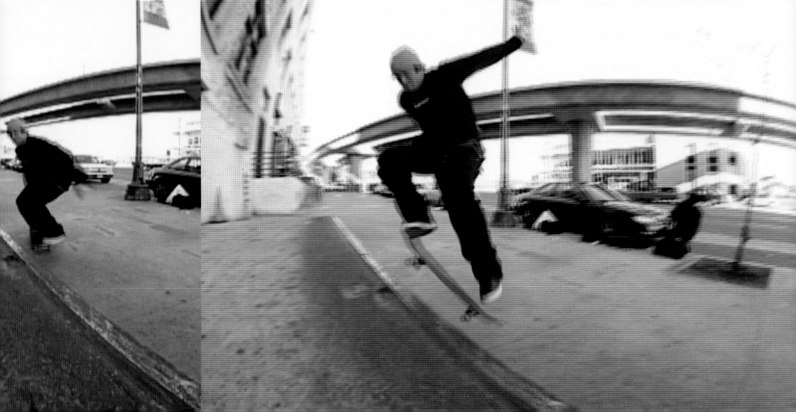

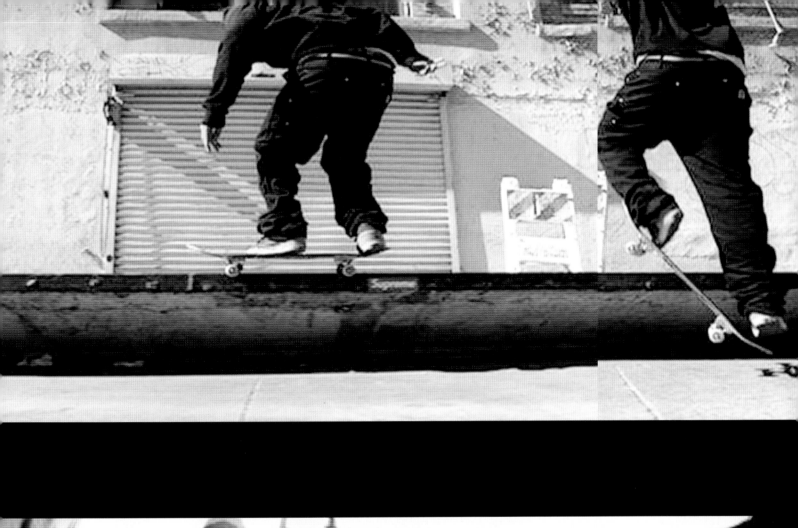
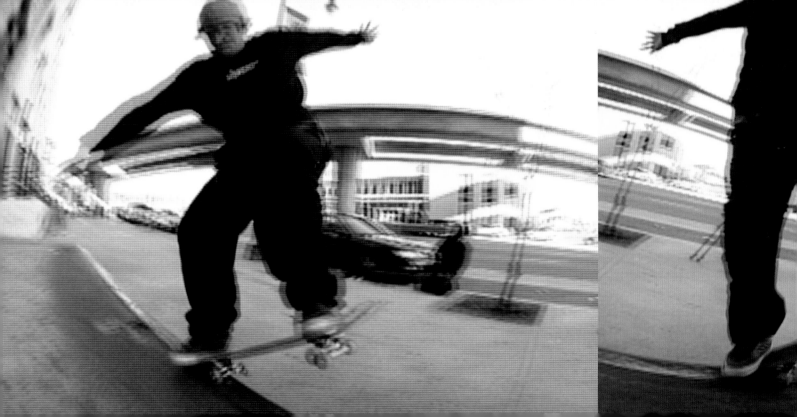

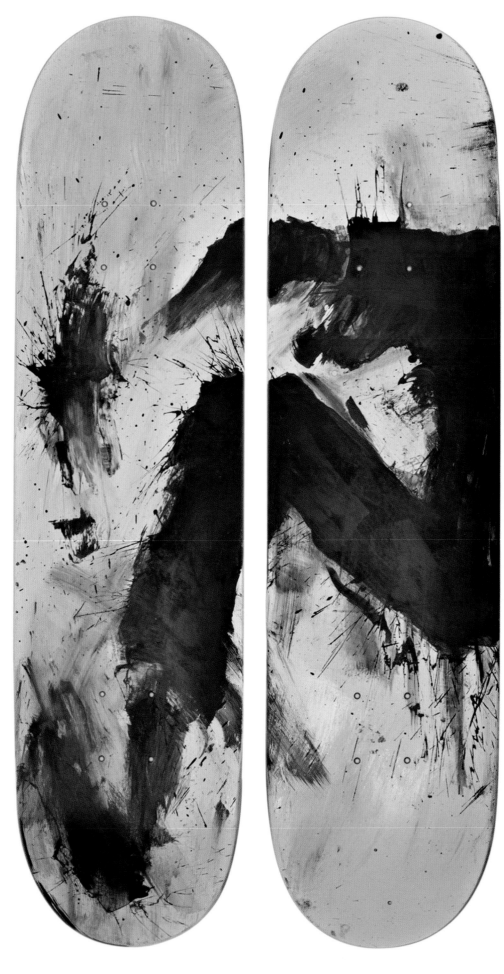

RICHARD HAMBLETON 2005

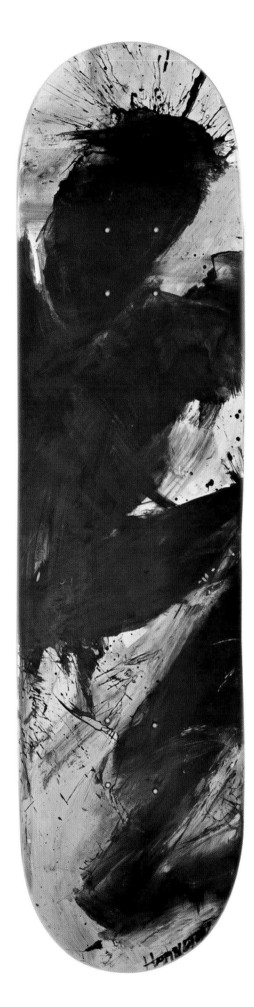
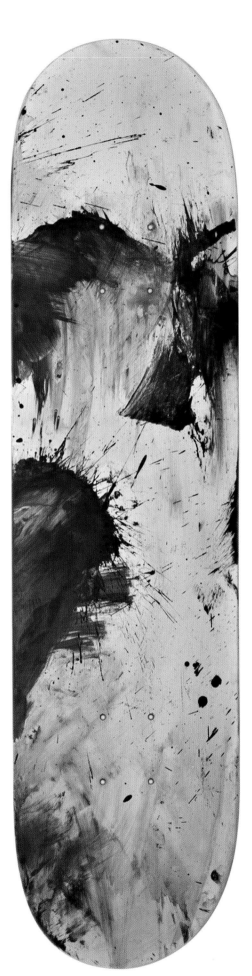

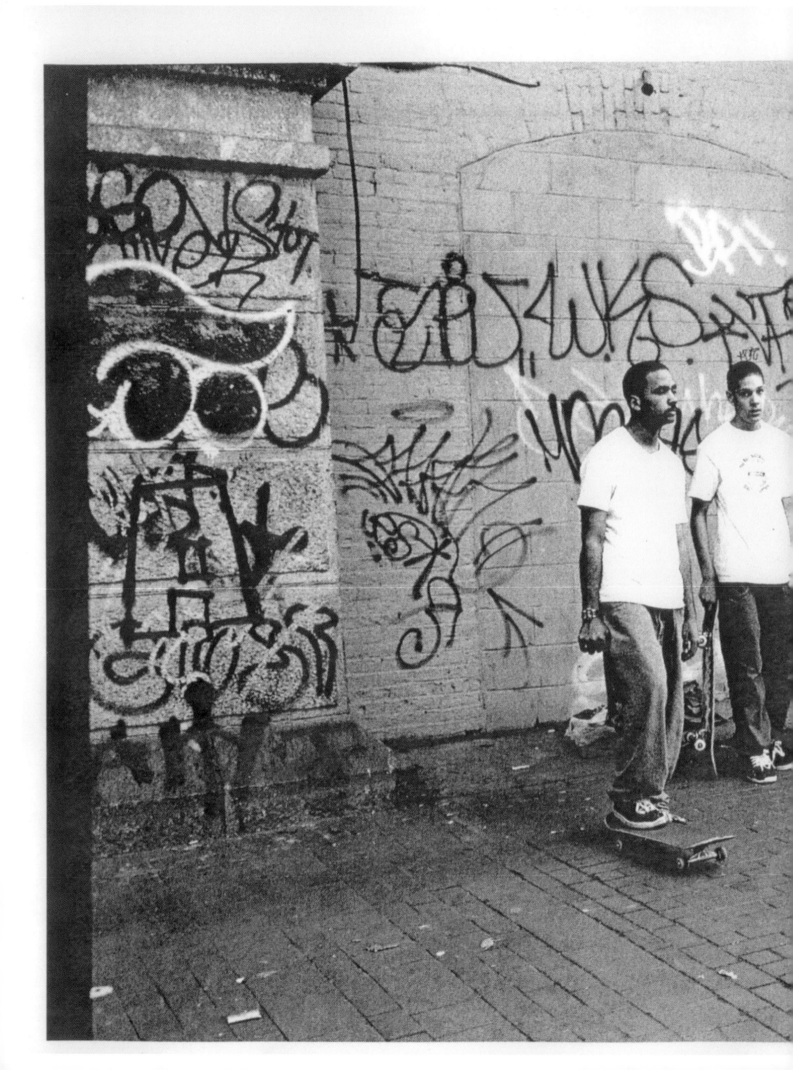

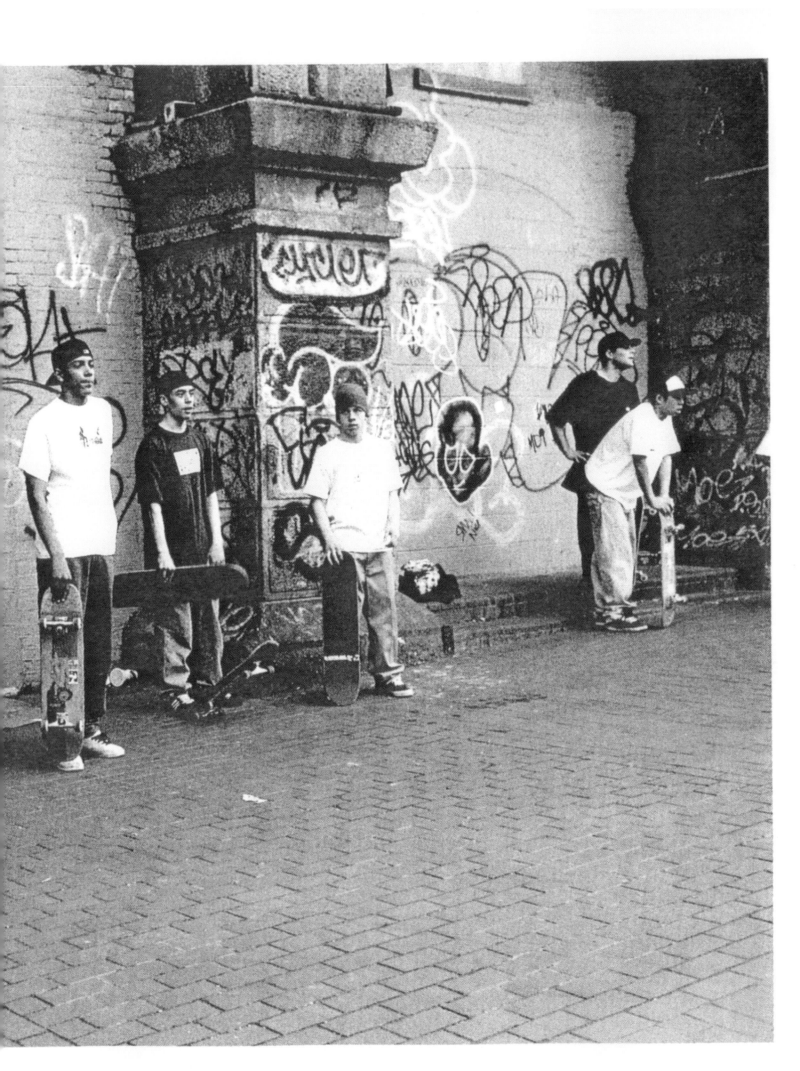

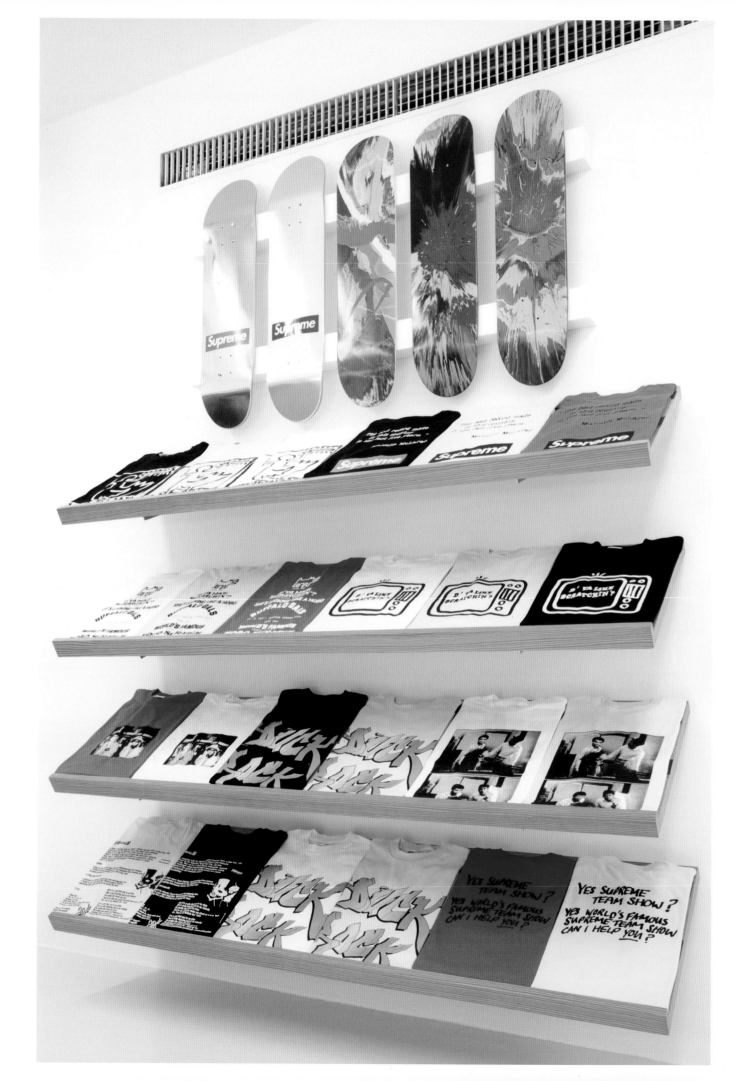

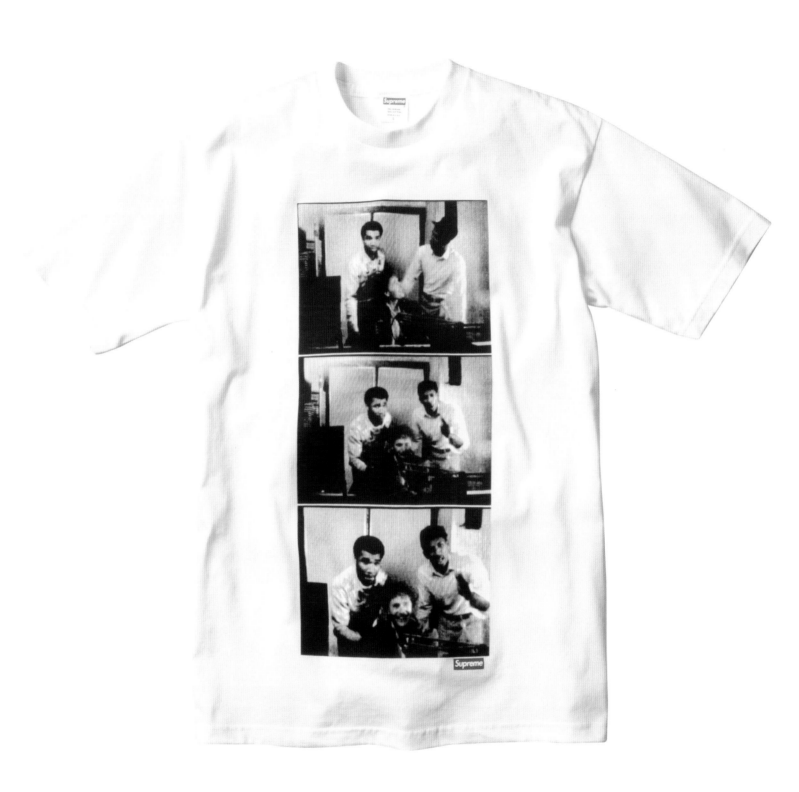

MALCOLM McLAREN 2009

WHAT WOULD BECOME LATER KNOWN AS THE TECHNIQUE OF SCRATCHING —
I WANTED TO PUT THAT ON RECORD, I WANTED TO MAKE THAT THE MAIN
GROOVE OR TEXTURE OR SOUND OF THE RECORD AND UM... I HUNTED
AROUND AND I HAPPENED WALKING DOWN MIDTOWN MANHATTAN AND 42ND
STREET AND SEE TWO GUYS WHO WERE HUSTLING ACTUALLY PLAYING 3 CARD
MONTE FRONTING THESE TOURISTS AND THEY WERE DOING IT BUT AT
THE SAME TIME THEY HAD THIS LIT'LE BEATBOX NEARBY... THIS
HIP-HOP MUSIC I SUDDENLY LOCATED AND ASSUMED IT WAS THEIRS SO
I STRUCK UP A CONVERSATION WITH THEM AND I SAID "WHAT ARE YOU
DOING PLAYING 3 CARD MONTE?" AND HE SAID "WELL WE'RE TRYING
TO GET MONEY TOGETHER BECAUSE IF WE GET MAYBE $400 DOLLARS
WE CAN GO DOWN TO THIS RADIO STATION, A SMALL PRIVATE RADIO
STATION SOMEWHERE IN UPTOWN MANHATTAN, AND IF THEY PUT THIS
MONEY DOWN THEY COULD TAKE A HALF AN HOUR OF AIR TIME." THIS
WAS ONE OF THESE TYPICAL NEW YORK RADIO STATIONS, WHICH WAS
LIKE, AH, AN ETHNIC RADIO STATION, WHERE THERE WOULD BE ONE
HOUR OF ALBANIAN POETRY, AH, ONE HOUR OF MUSLIM TEACHINGS,
ONE HOUR OF, AH, HUNGARIAN LITERATURE FOR ALL THE DISPARATE
ETHNIC ELEMENTS OF NEW YORK AND THEY CALLED THEMSELVES THE
WORLD'S FAMOUS SUPREME TEAM SHOW...

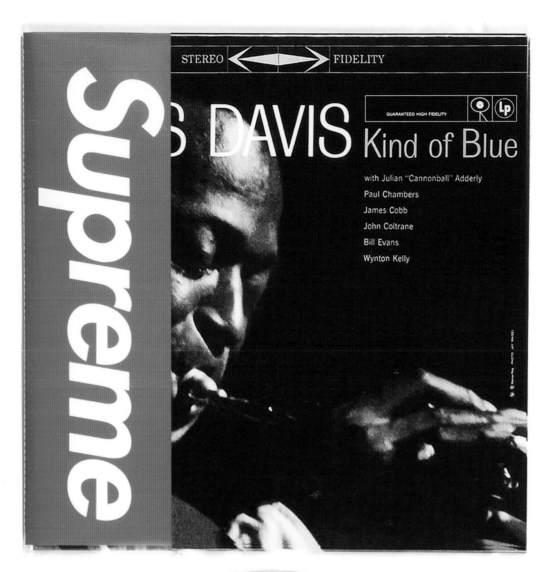

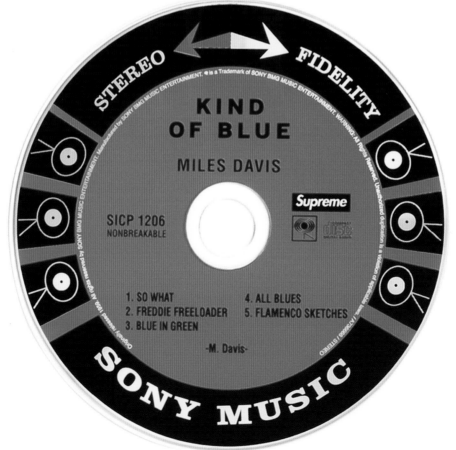

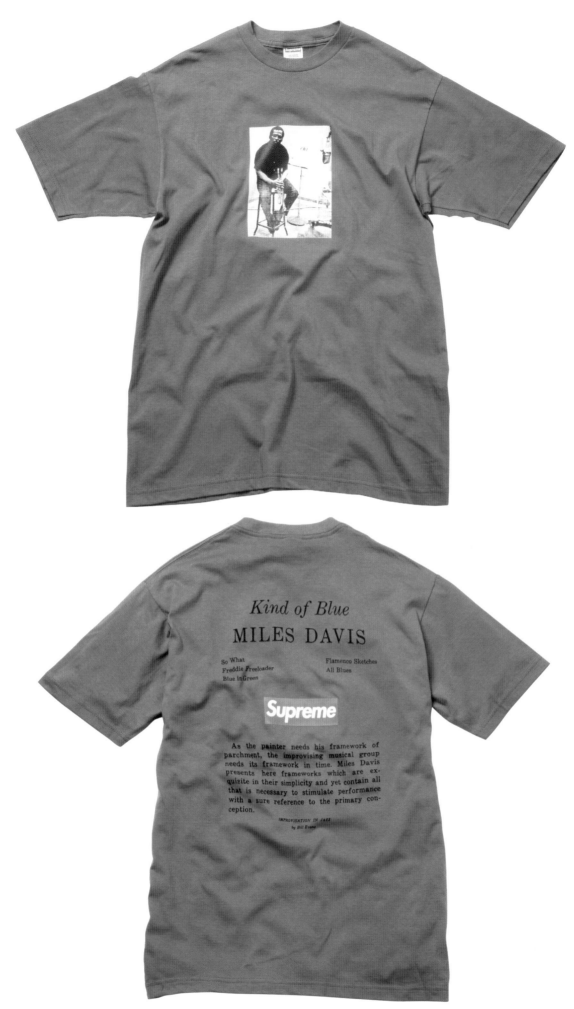

MILES DAVIS 2008

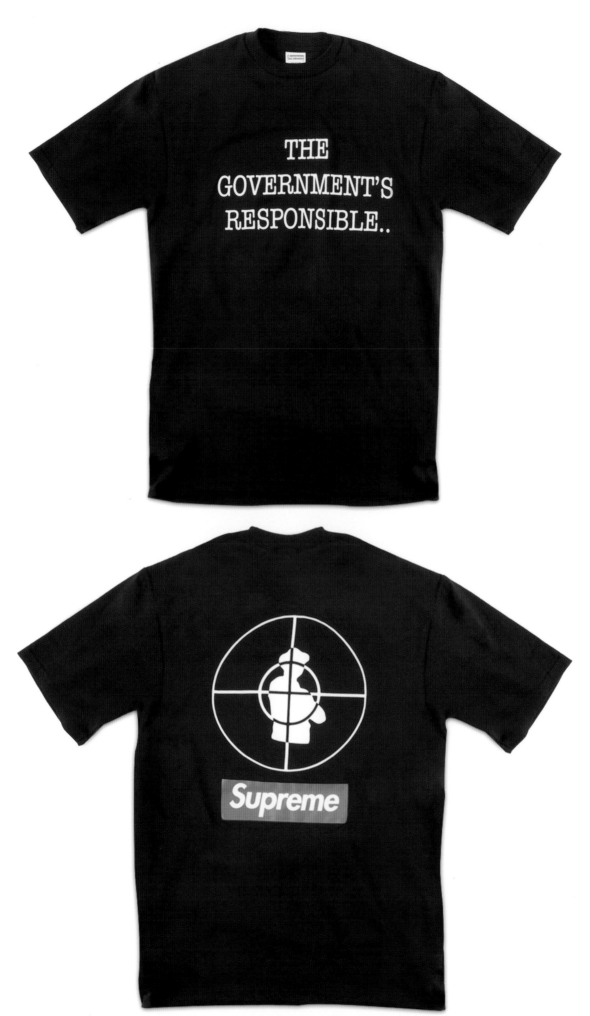

PUBLIC ENEMY 2006

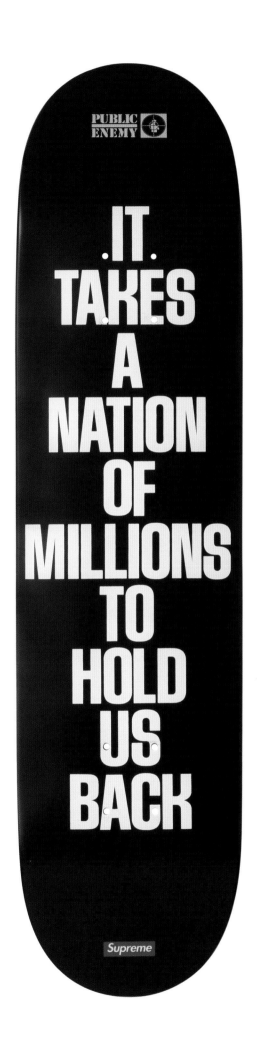

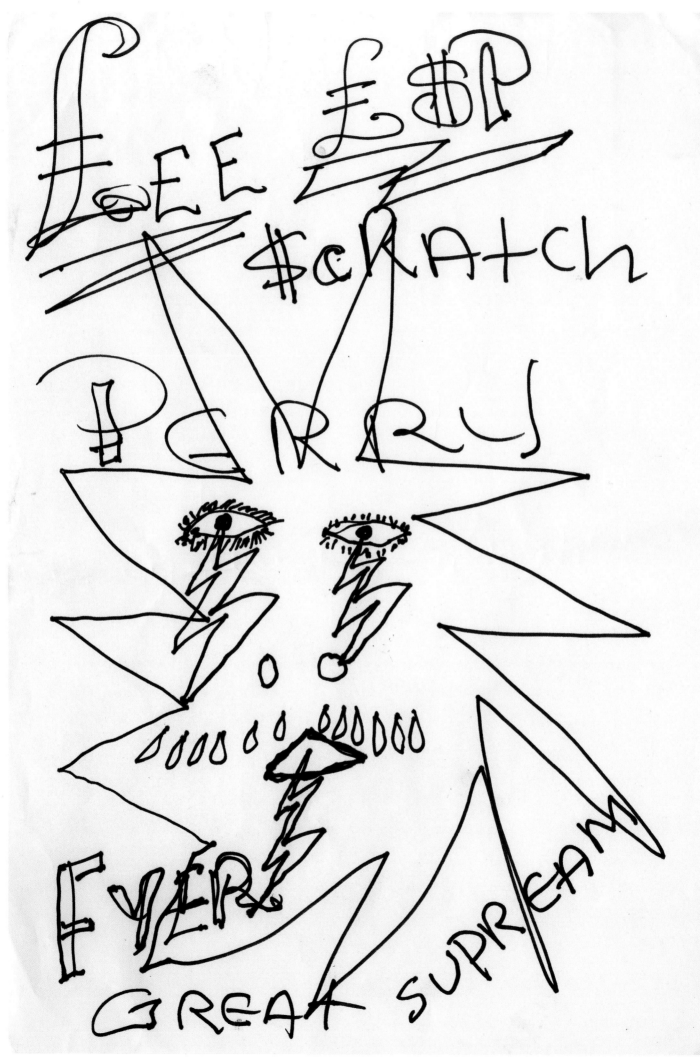

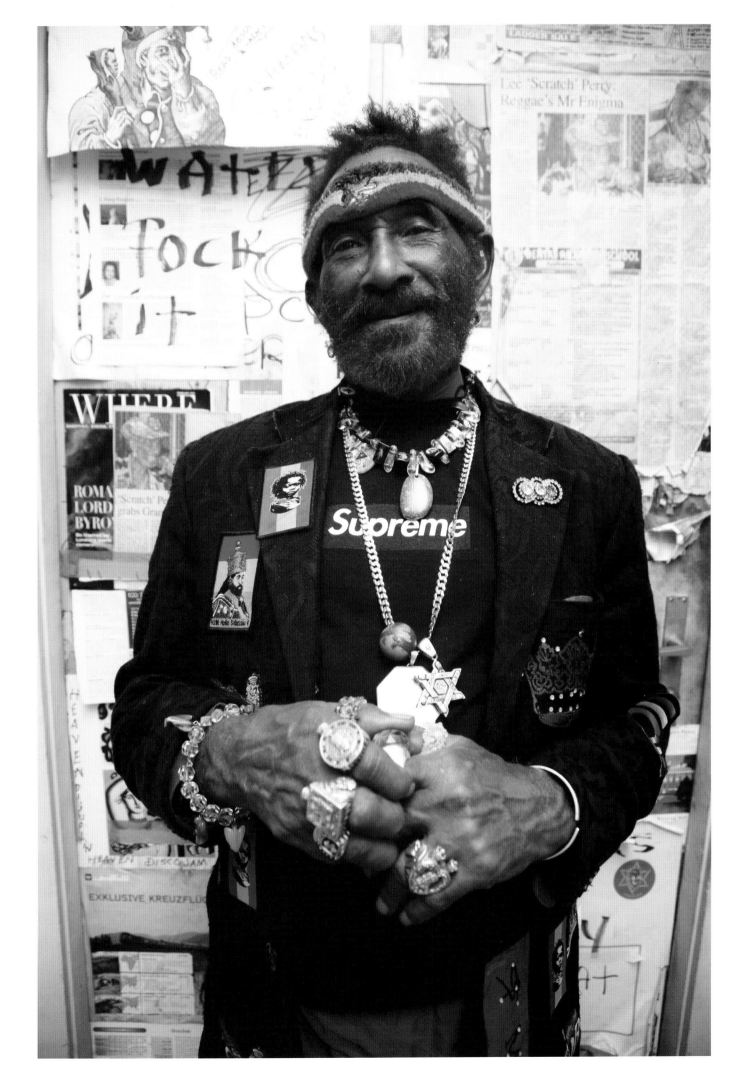

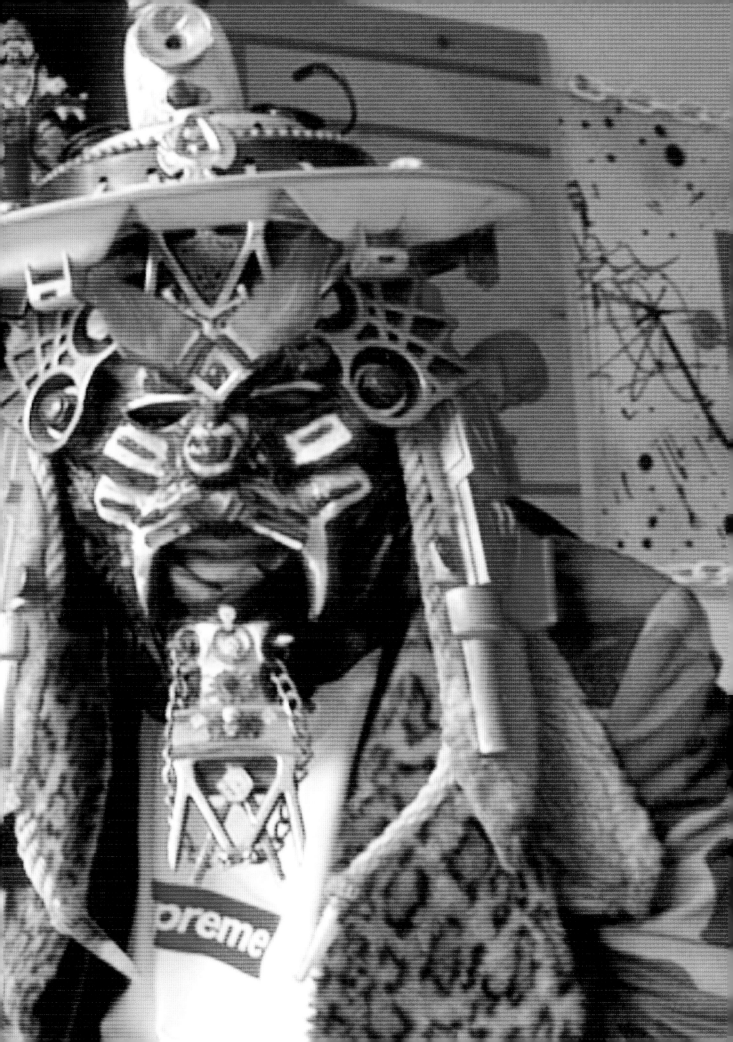

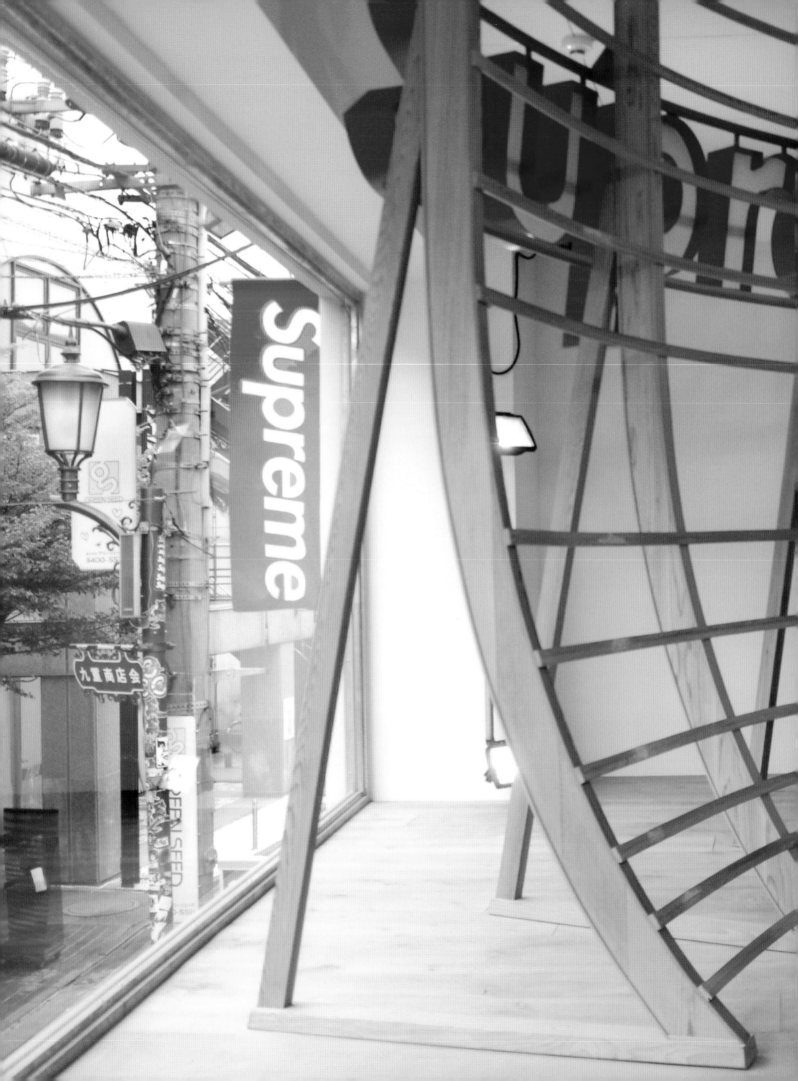

そうとうの大盤振る舞いだと思います。

2000 | 10 44
リラックス
MONTHLY
OCTOBER 2000 定価 680yen ⌂

2000年10月1日発行 (毎月1回1日発行) 第5巻第9号
平成12年3月17日　第三種郵便物認可

relax

特集
SUPREME
イームズ

付録
SUPREME のステッカー
イームズのポスター

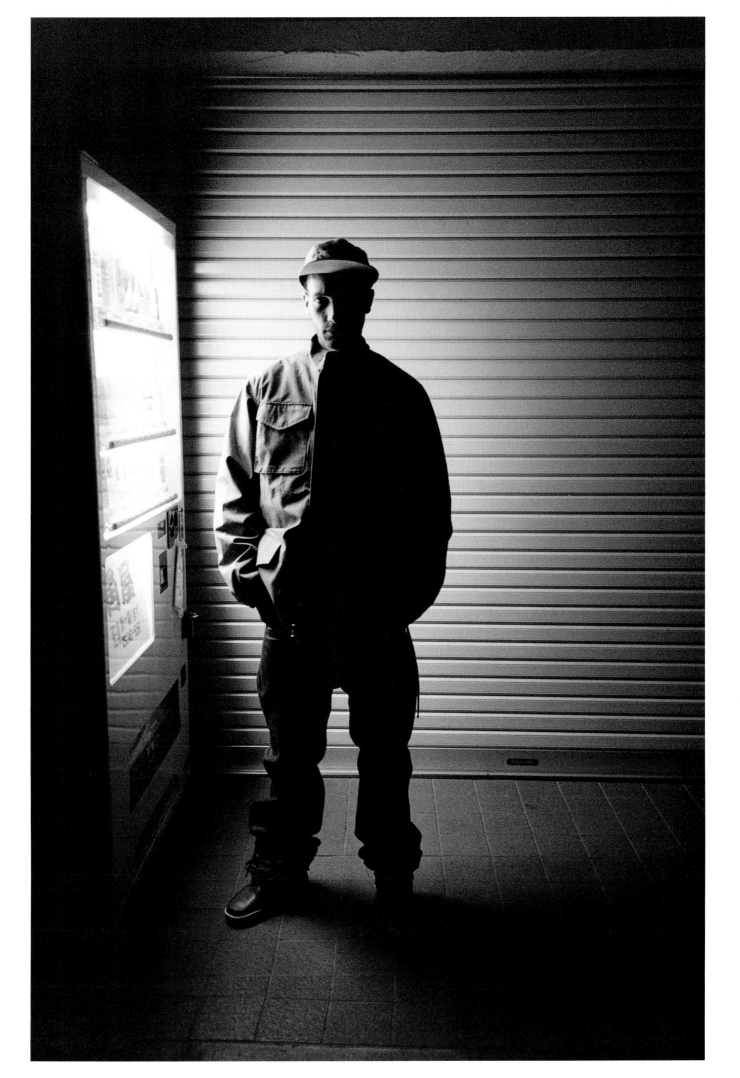

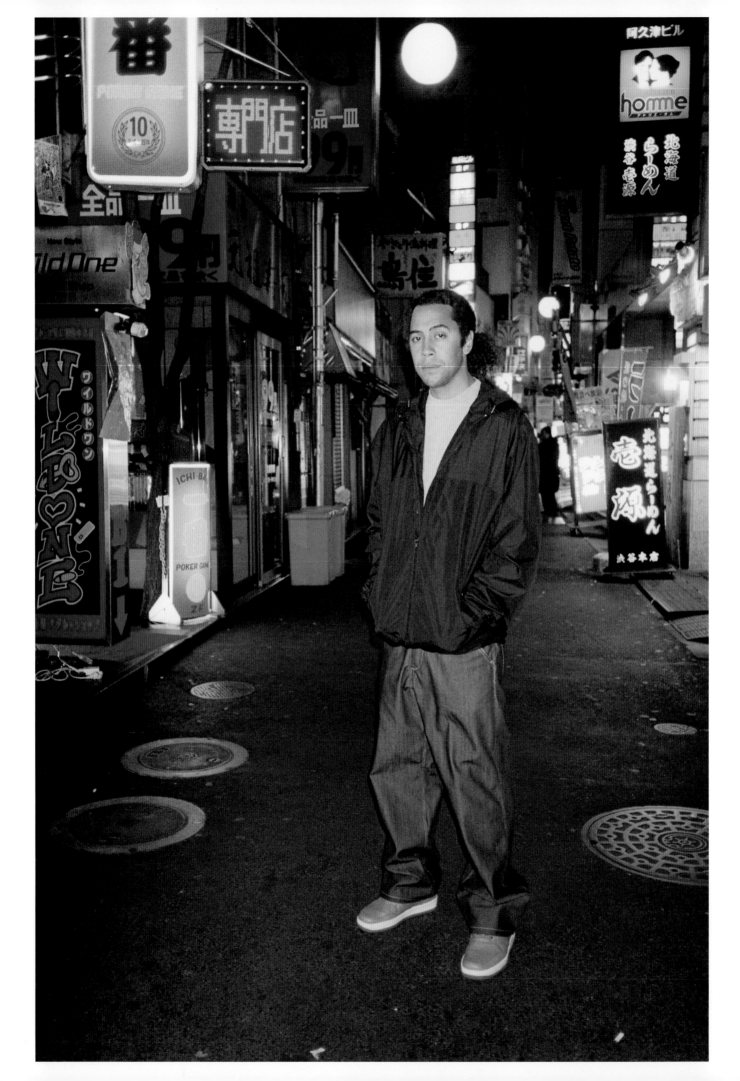

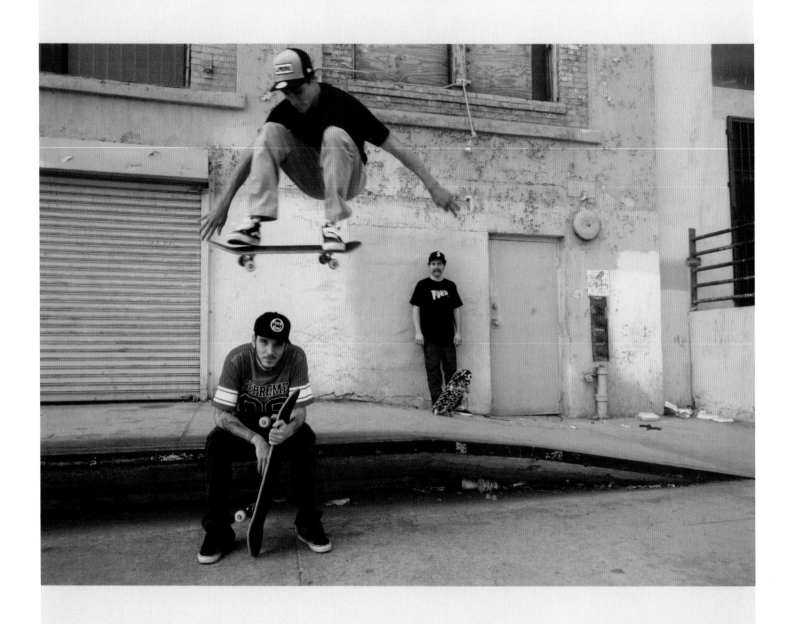

右ページ、Oxford Side Logo New Era
¥8400、Youth Crew Tee ¥6300、その他
モデル私物
左ページ、右 S New Era ¥7350、Fuck
Tee ¥6300、5 Pocket Jean [Raw]
¥24150、その他モデル私物
中 Surfstyle Patch New Era ¥6825、
Pineapple Top ¥10500、Chino Pant
¥23100、その他モデル私物
左 Fuck-Em 5-Panel ¥6825、Football
Top ¥13650、Faded Black Pant
¥19950、その他モデル私物

Tシャツ[Joe Cool Box Logo Tee]¥6300、ビーニー[Twisted Yarn Beanie]¥5250、サングラス[Oakley Supreme Sunglasses]¥26250（すべてSupreme DAIKANYAMA）

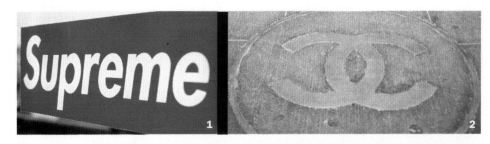

Supreme

the rules of attraction

Although the Chanel and Supreme boutiques are worlds apart, they do have one thing in common—a cultlike following. **Mary Tannen** comparison shops

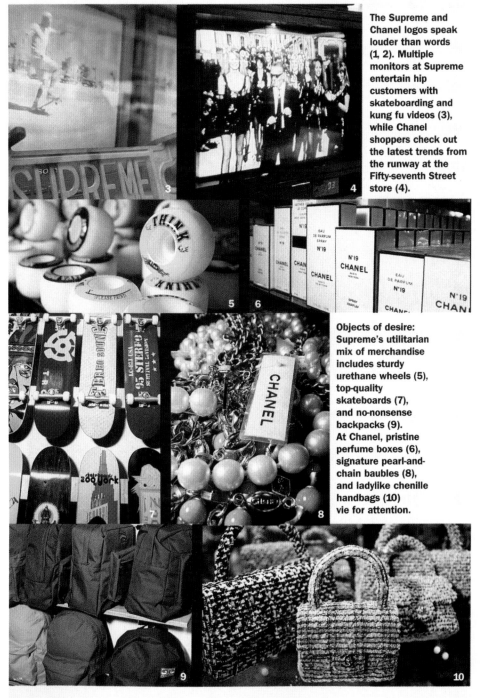

The Supreme and Chanel logos speak louder than words (1, 2). Multiple monitors at Supreme entertain hip customers with skateboarding and kung fu videos (3), while Chanel shoppers check out the latest trends from the runway at the Fifty-seventh Street store (4).

Objects of desire: Supreme's utilitarian mix of merchandise includes sturdy urethane wheels (5), top-quality skateboards (7), and no-nonsense backpacks (9). At Chanel, pristine perfume boxes (6), signature pearl-and-chain baubles (8), and ladylike chenille handbags (10) vie for attention.

This is a tale of two boutiques. One is on East Fifty-seventh Street, within teetering distance in heels from Tiffany, Barneys New York, and the Sherry-Netherland. If you're coming from as far away as Sotheby's or the Carlyle, your driver can drop you off into the white-gloved hands of the waiting doorman. The other is on Lafayette Street between Prince and Houston, convenient by skateboard to SoHo. If you're coming from far away, tuck your board under your arm and take the N or the R train. Two boutiques: Chanel and Supreme. Two locations: uptown and downtown. A few miles and worlds apart, yet at the core of what they are and what they mean to their devotees, they are deeply, fundamentally the same.

It's three o'clock on a crisp, sunny Tuesday, and the doorman at Chanel is busy greeting customers. Upon entering, you notice gleaming mirrors and vitrines, bowls of fresh white lilies, and a hint of Chanel No 5. Just inside is the makeup counter, where a slender 30ish blond with perfect hair and nails is letting the saleswoman show her which shadows, placed where, will give her the Chanel eye. She is in the black Chanel coatdress and the black shoes with thigh-high tights attached. The quilted black Chanel bag dangles by its gold chain from her shoulder. "This is my second day without Seconals. I'm going through withdrawal," she says. The saleslady is supportive.

A woman in a chador rests on the brown suede sofa (modeled after Coco's own). A group of giggly Japanese teens listens as another saleswoman totes up their purchases in Japanese: $690 for the wallet, $330 for the leather jewel case, and $1,415 for the adorable little pink wool backpack.

Upstairs, a saleslady named Tanya hurries to greet a client whose husband bought boots here two weeks ago. They're the wrong size; she had told him to ask for Tanya, but he must have forgotten; the receipt is missing. That boot is perfectly fine, Tanya says, but she personally would prefer the four-inch heel that laces high on the instep. "It's such a sexy shoe." The client agrees. "This boot is like—your mother could wear it," says Tanya.

Three burly Russian women have landed in the shoe nook. One takes wide-legged possession of the black leather sofa. She entered wearing the Chanel slip-on sneakers, unmistakable with the double *C* logo on the broad white rubber toe—a mere $265 a pair, but she is acting as if she owns the place.

A saleswoman comes out with a huge Chanel shopping bag, apologizing to a pair of middle-aged Japanese women for the delay, but the shoppers haven't been impatient in the least. The suede sofa is perfectly comfortable, and there is the video to watch, of models flashing COCO and CHANEL on every avail- ▶202

able surface, from bags to jacket backs. The saleslady hands over the purchase, but the women don't budge. One takes out the large rectangular box and lays it on her lap. She opens it, pulls aside the tissue paper, and, as if handling an infant, lifts out the white rubber boot. Her friend strokes it timidly. The boot is turned slowly in the light, then replaced, reluctantly, in the box.

A younger woman, tawny hair flying and skirt barely covering the essentials, strides up and lights on the high-heeled Mary Janes. She tries them, buys them, and she's off, never glancing at the clothes.

You have identified the three main categories of Chanel shoppers. There is the foreign tourist—Japanese, South American, Middle Eastern, Eastern European, Russian—who comes for accessories, shoes, ties, bags, all clearly marked with the double C's, COCO, or CHANEL, certified totems from the bastion of Western wealth and chic. Then there is the "preferred client." She has her favorite sales associate, who might tactfully set aside something she feels is exactly right. The client receives flowers on her birthday, a card on Valentine's Day. She's invited to the trunk show, where she can order in advance. Last, there's the fashion bird of prey, relentlessly circling the boutiques of the world, seeking out the hot, the new, the must-have this season. She demands to be shown the navy blue jacket with

Anything emblazoned with a logo (5, 6) is a best-seller. Supreme stocks skateboard sneakers in muted hues (7), while Chanel's cap-toe deck shoes attract attention with bright colors (8). Typical shoppers check out the goods wearing characteristic looks from Supreme (9) and Chanel (10).

white trim, she shrugs it on over her Matsuda shirt and Levi's jeans, and she's out of there.

You have also identified the Chanel look: the suit of bouclé wool, the high-high heels, the quilted bag. For $5,000 or so you can acquire the look. Wear it for lunch at '21,' to address the faculty of Columbia Law School, or to a meeting of the board of trustees of the Whitney Museum, and know that you will be taken seriously.

It's a midwinter thaw, Saturday; dusk is closing fast. You thread your way through a roiling knot of mostly male adolescents. Like pigeons coming to roost, they are riding skateboards into Supreme from such nearby 'spots' as the under-region of the Brooklyn Bridge. "Whus-up?" "Whus-up, man?" They touch palms. Some sit outside on their boards, sweaty

Elements of style: Sturdy baseball hats (1) and roomy workman jackets (3) are key components of thrasher fashion from Supreme. Hats made from signature bouclé (2) and shapely pastel jackets (4) are high-fashion classics from Chanel.

and dazed, staring at skateboard videos running simultaneously on six Sonys in the window and listening to the rap music reverberating from the open door. Others, ignoring cars and trucks whizzing perilously close in the gathering darkness, are jumping a wooden tabletop left in the street.

Just inside, Hamilton, elegant in dreads, a heavy gray sweatshirt, and spotless khakis, is putting grip tape on his board: "Damn tape comes off in cold weather." Sancho nods and goes to the counter, where Bianca hands him a wrench so he can tighten his trucks. (Trucks hold the wheels to the board.) Bianca, the pallor of her face set off by red lips and narrow black brows, her Tintin haircut punctuated by a two-inch dragon tattoo at the nape of her neck, is the only female in the store at the moment. Although Supreme sells women's clothes, not many women take up skateboarding as a sport. Chris from Staten Island, who is coaxing a faint beard to grow under his lip, regrets this state of affairs. "I want to be hanging out and have a girl say, 'Can I see your board?' and wham! She does a 180 heel flip over some junk in the road."

There are also two male sales associates in baseball caps, sweatshirts, and jeans. One has many silver hoops through an earlobe. You might mistake the staff for customers if they weren't hyperaware of what is going on in the store and meticulous about refolding the T-shirts after they have been mussed.

In fact, this is the first similarity you notice between Chanel and Supreme: the reverence among customers and staff for the goods. Even though the biggest-ticket item in Supreme (aside from the skateboards) is the $66 Ben Davis lined-cotton-duck construction worker's jacket and the biggest-ticket item at Chanel (aside from the jewelry) is the $6,410 sequin-and-satin evening pants outfit, $20 for the cotton T-shirt with logo bites a bigger hole in the disposable income of the average Supreme shopper than $700 for the silk T-shirt does in that of the Chanel client. And the regular Supreme customer, although his language is rough to the point of being unprintable, is as picky over details of dress as the most exacting Chanel customer, as precise about ▶206

view

how he looks as he is about how he places his feet and distributes his weight when skating. "You won't find anything cheesy here like you do at other skate stores," says Chris.

Because Supreme's selling floor is smaller than Chanel's (600 square feet vs. 3,500 square feet), the selection of stock is pared down even more rigorously. The palette is muted: olive, mustard, navy, brown, gray. The sweatshirts (heavy, fourteen-ounce, 100 percent cotton) come in two styles: with or without hoods. There are two types of hats: baseball and knitted stocking caps, "beanies," as they are called. Only the best skateboards, from seven or eight different companies, are displayed on the rear-wall racks. Everything is sturdy, comfortable, and functional—function in this case being skating.

As at Chanel, name is very important at Supreme. All the apparel is emblazoned with the logo of either a skateboard manufacturer or Supreme. Employees as well as customers are encouraged to place red-and-white eight-inch-long SUPREME stickers on posters around town as Supreme's seal of approval. One especially favored spot was over Kate Moss's bikini in Calvin Klein ads. Apparently, Calvin Klein lawyers didn't get the concept, that the sticker was a *compliment,* and threatened consequences, so that particular location is now off-limits.

You notice narrow wraparound sunglasses here, much like the ones you saw at Chanel. But while the glasses are hot at Chanel, at Supreme they are on their way out. It may surprise you to note that styles change at Supreme, which has an air of being outside fashion, antifashion, but the clothes are always tuned in to the taste of the young and the hip.

Generally the vector of fashion influence points from downtown *toward* uptown, from the young-and-street to the mature-and-moneyed. Besides the snowboarder's wrap sunglasses, the rubber-rimmed sneaker has also migrated uptown to Chanel. Chanel's heavy molded-rubber boot echoes Supreme's affinity for practical workman's gear. You would probably see the construction-worker jacket translated into Chanel before you would see Chanel knocked off for Supreme (a sweatshirt cardigan with SUPREME on the buttons?). There *was* a black skateboard deck by Real with familiar-looking giant interlocking *C*'s that became a hit at Supreme, but the *C*'s stood for Coco Santiago, a professional skateboard rider, not Coco Chanel.

As at Chanel, there are the tourists (mainly British and Japanese) who come for a prize item—usually the Supreme T-shirt—to prove that they have been to and seen Supreme. There

are also the fashion predators, borrowing just one piece for the look (three schoolgirls with magenta, green, and orange hair carrying off camouflage baby tees). But even more than at Chanel, at Supreme you are likely to see customers outfitted in the complete look—sometimes dozens at a time.

The Supreme ensemble is the baseball hat worn backward or the beanie, the fingertip-length construction-worker jacket, tailored to stand slightly away from the body, protecting and concealing. Usually it is open to reveal the Supreme sweatshirt or a flannel shirt. The rumpled jeans, neither flared nor pegged, are worn low, and a few sizes too large. Then there are the flat VANS sneakers. Whereas at Chanel the outfit is finished by the high-heeled, platform-soled shoe, the look here, which otherwise seems cut-off, with the jeans nearly obscuring the feet, is completed by the skateboard. With backpack, but not including board, the whole package will run you anywhere from $200 to $300, which is a hefty investment, but you can wear it with confidence, knowing that everything you buy at Supreme is cool and won't bind or constrict when you are skating. As with the Chanel suit, you are certain of always looking correct.

Both Chanel and Supreme provide a modern suit of armor beneath which you can mask and protect the vulnerable, quirky self. You can sally forth onto the urban jousting field, unburdened by worries about how you look, free to concentrate on such high-risk but thrilling exploits as spiraling into a heady new social circle or slipping a shifty through a hole in an abandoned building. ● VOGUE'S VIEW ▶208

SIMILARITIES	
CLUBBY HANGING-OUT AREA	
CHANEL: the makeup counter	
SUPREME: the street	
ENTERTAINMENT	
CHANEL: videos of the latest Paris collections	
SUPREME: skater or kung fu videos; loud music	
SEATING FOR CUSTOMERS	
CHANEL: six leather or suede sofas	
SUPREME: two Formica chairs or the floor	
DRESSING ROOMS	
CHANEL: two large with three-way mirrors and padded suede walls; two medium-size; and one "cabine"	
SUPREME: one cubicle with sliding door, no mirror	
MIRRORS	
CHANEL: innumerable	
SUPREME: one full-length, one head-size	
CERTAIN LOOK TO SALES HELP	
CHANEL: special uniforms, two for each season	
SUPREME: jeans, piercing, tattoos, youth	
CERTAIN LOOK TO REGULAR CUSTOMERS	
CHANEL: female, slim, blond, 33 years old	
SUPREME: male, shaved, earrings, 15 to 20 years old	
SPECIAL COURTESIES FOR REGULAR CUSTOMERS	
CHANEL: flowers, cards, trunk shows, brunches	
SUPREME: Supreme stickers, postcard mailings, free use of skateboard repair tools	

DIFFERENCES
Only CHANEL has cold drinks served in crystal glasses
Only SUPREME has a skateboard team

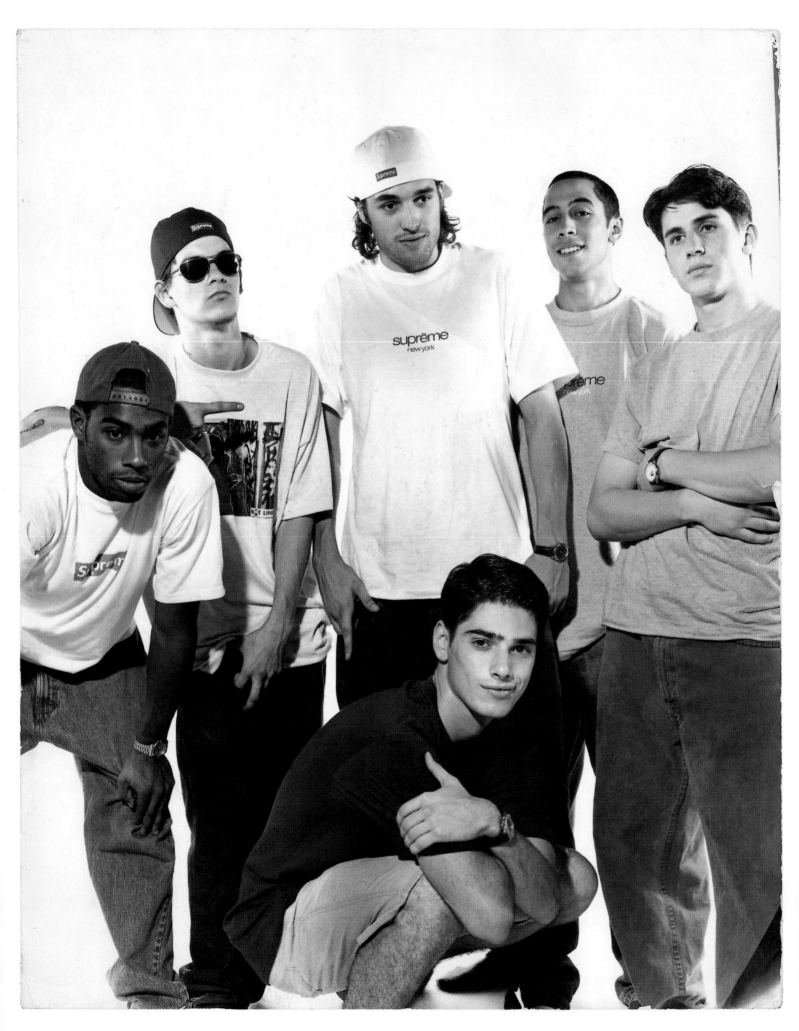

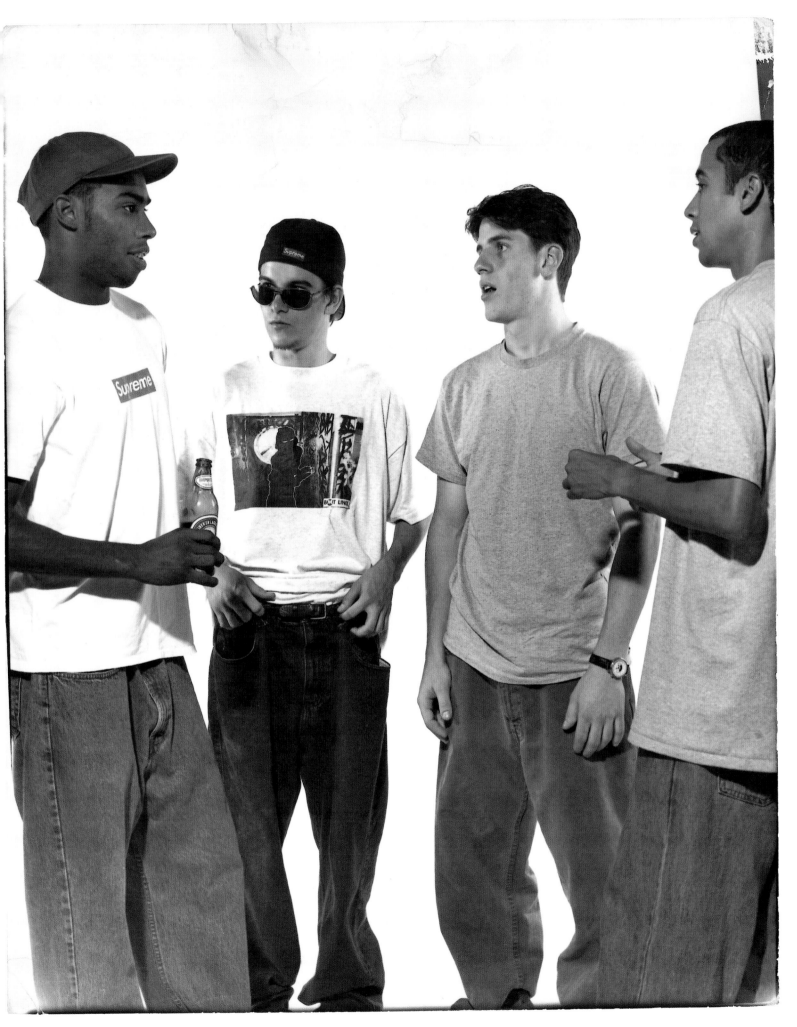

TO "SUPREME TEAM", GIO ESTEVEZ, POOKY JONES, RYAN, PETE, JUSTIN HERNANDEZ, ZOO YORK, W/ ELY & RODNEY, SUPA, ROB G., HAROLD, F. NATIELLO, PANG, STASH, XAV, IVAN PEREZ, LOCKY, BELL, JOEY ALVAREZ, HAMILTON, SANDY, CARTER, CARDONAS, FUTURA 2000, REVOLT, RICKY POWELL, SLEALION, SHADI, ELSKA SANDOR & EVERYONE ELSE WHOS DOWN W/ ROOKIE, RYAN AT FAT BEATS, JEREMY HENDERSON, HUFNAGEL, MARK, HARM, T-MOSS, ARI, JAMAL, PULEO, FAT SAMMY, BOBBITO, STRETCH, MAYA, MAY, PONTE, ANDY KESSLER "O.G." LEE Q., PEACE, I'M OUT!

"ONE LOVE..."

"ROCK HARD, NIGGA WHAT, WHAT?!!"

1995 *1996*

1997 十門丰 *1998*

"LOCK-IT-UP. PAPA!!!"

"HERE WE GO."

HARRY "O.G." JUMONJI "N.Y.C."

* "100% SKATEBOARDER SINCE 1978..." *

"P.M.A."

"WHERE'S MY FAVORITE PIT BULL??"

("STAYING STRONG AT ALL TIMES BEHIND THESE WALLS)" TO MA NIGGA "GIO" BE SAFE, & STAY SUCKER FREE!" ① ★ ★ ★ ③ "718 & 212" "A TRUE REPRESENTATIVE F/ WAY BACK..." EAST COAST PRIDE NIGGA!" "MAD LOVE, & RESPECT, ALWAYS." H.J.

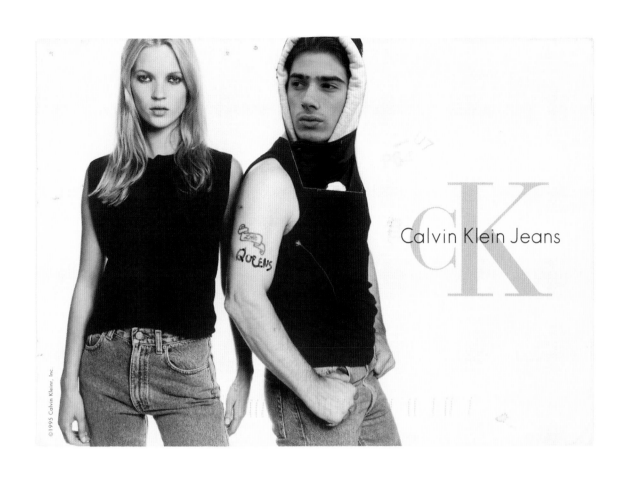

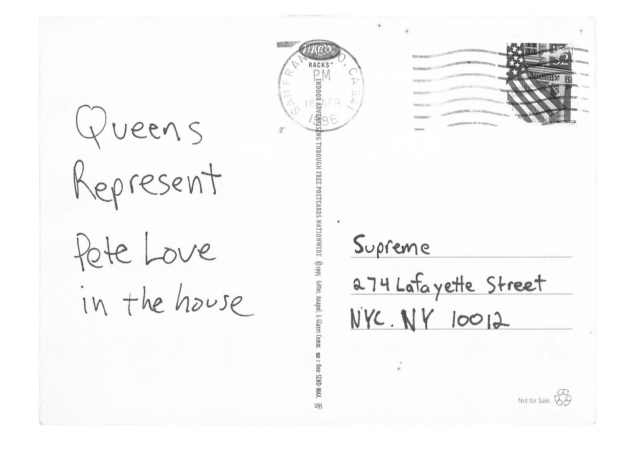

Queens
Represent

Pete Love
in the house

Supreme
274 Lafayette Street
NYC. NY 10012

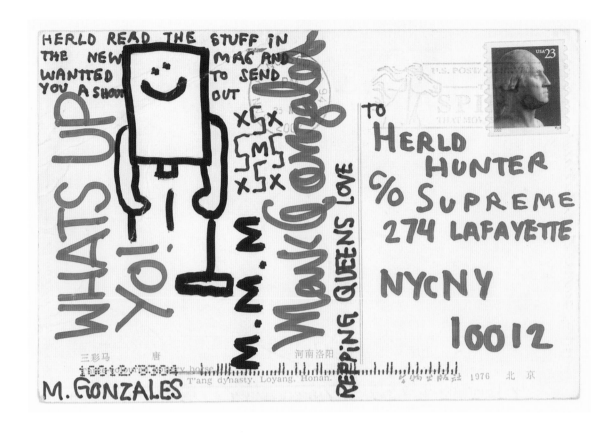

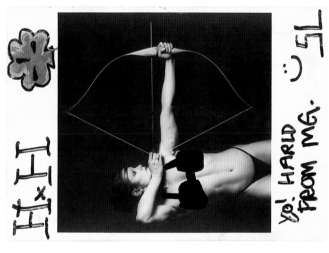

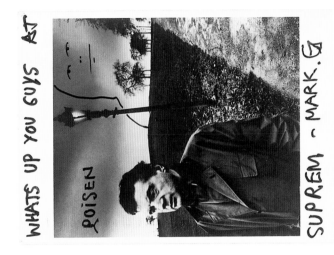

～ The First Annual ～

SPIN Campus Awards

You'd expect the best to be out West, but Supreme has gotten so popular, it's practically global. The hip Manhattan shop has become a favorite among skaters, both local and visiting, because, in addition to stocking cool brands, it carries original board and clothing designs that are exclusive to the store. Though it deals strictly in skateboard gear, the models that pass through from nearby agencies make Supreme something of a scene.

Best Skate Shop

Supreme

New York University
New York City, New York

Lia Michel

Editor In Chief, Lia Michel

Phoebe Reilly

Writer, Phoebe Reilly

Jeanann Pannasch

Managing Editor, Jeanann Pannasch

Douglas Brod

Executive Editor, Doug Brod

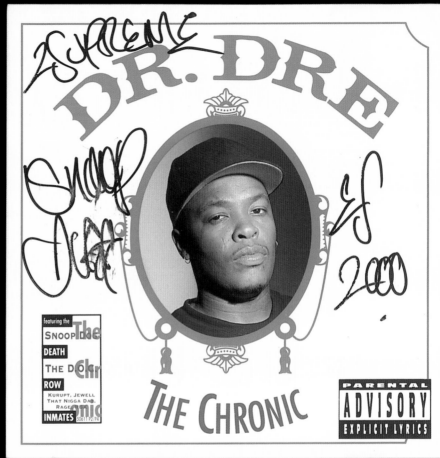

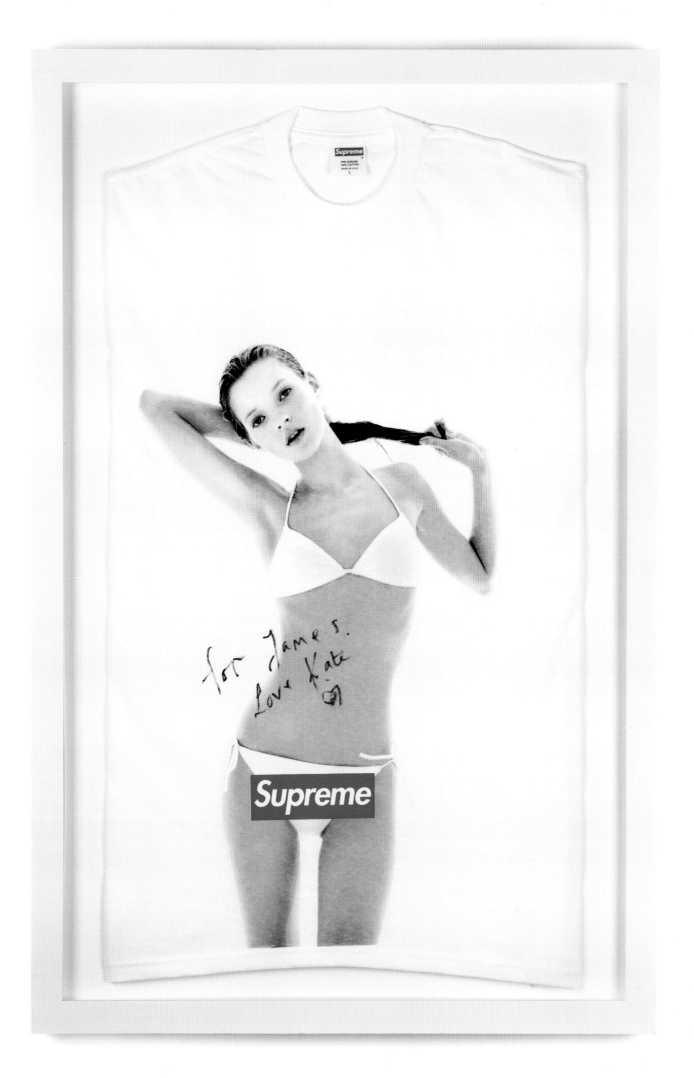

new york 212 966 7799 tokyo 03 5456 0085 osaka 06 6533 0705 fukuoka 092 732 5002

Supreme

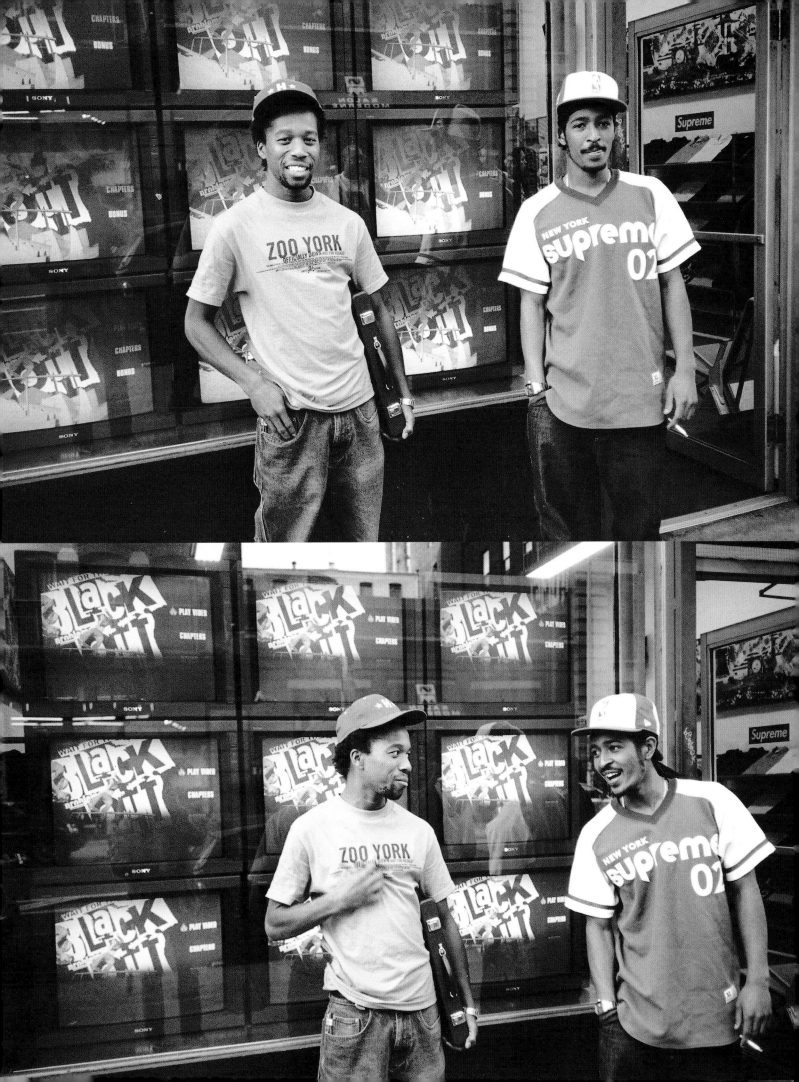

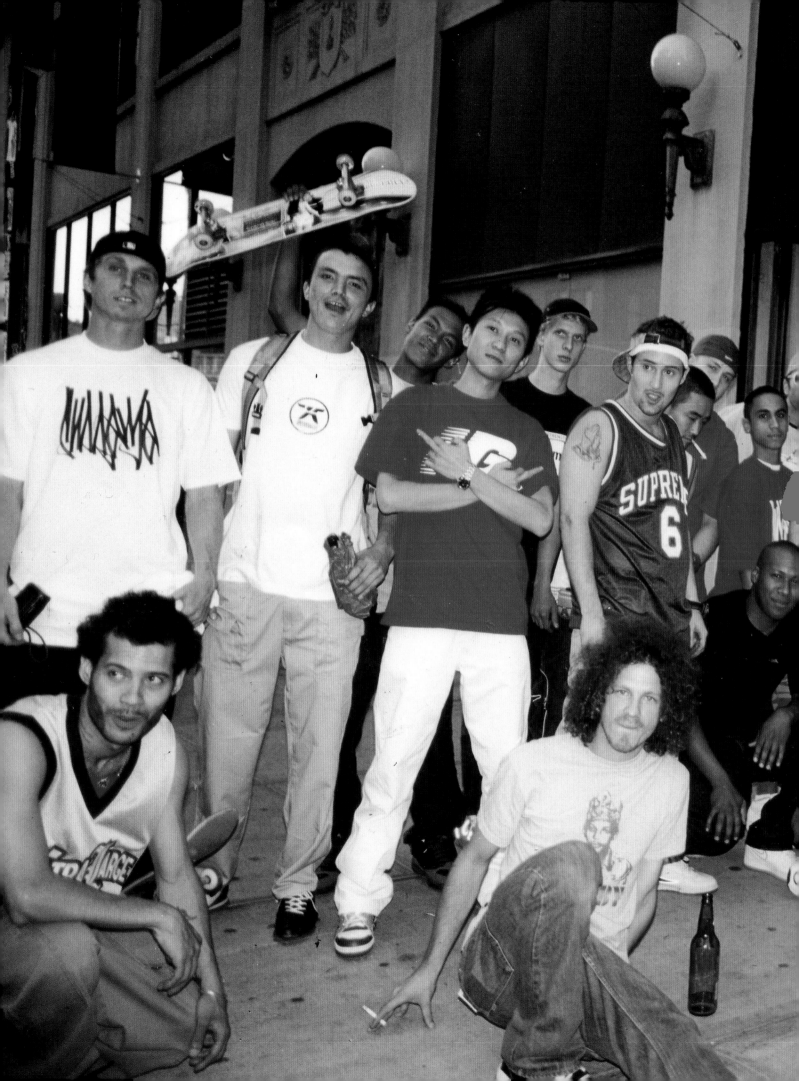

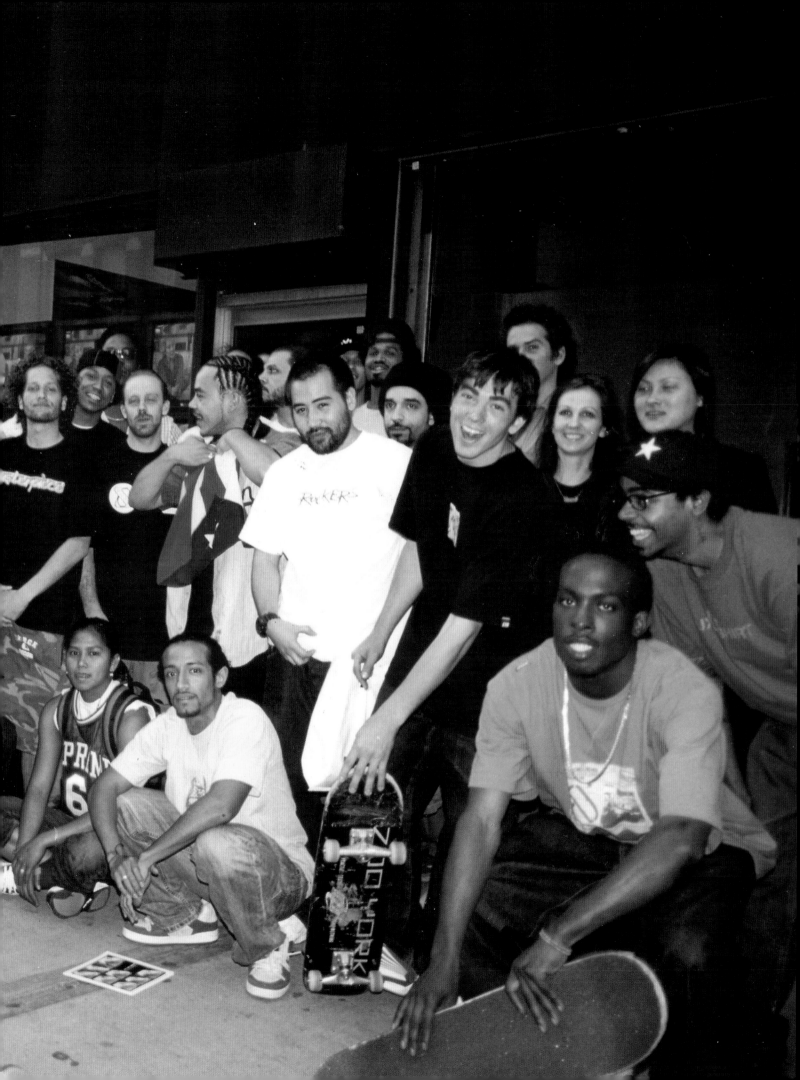

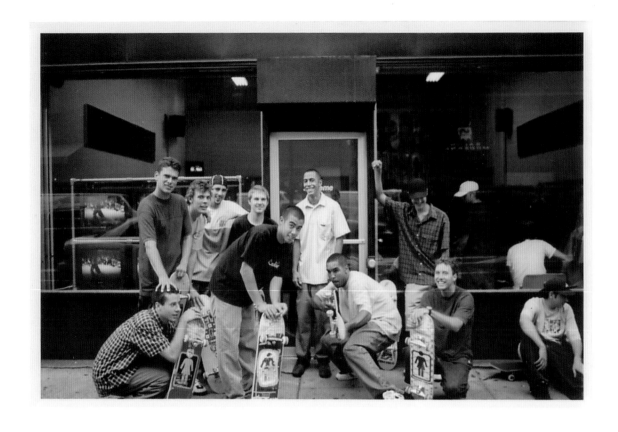

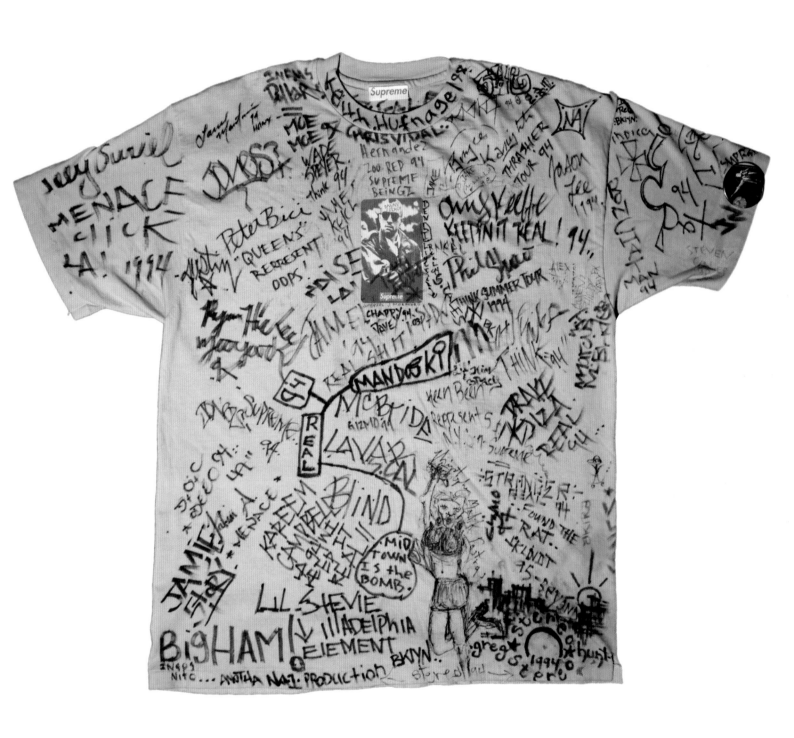

FIRST SUPREME T-SHIRT, SIGNED BETWEEN 1994 - 1999

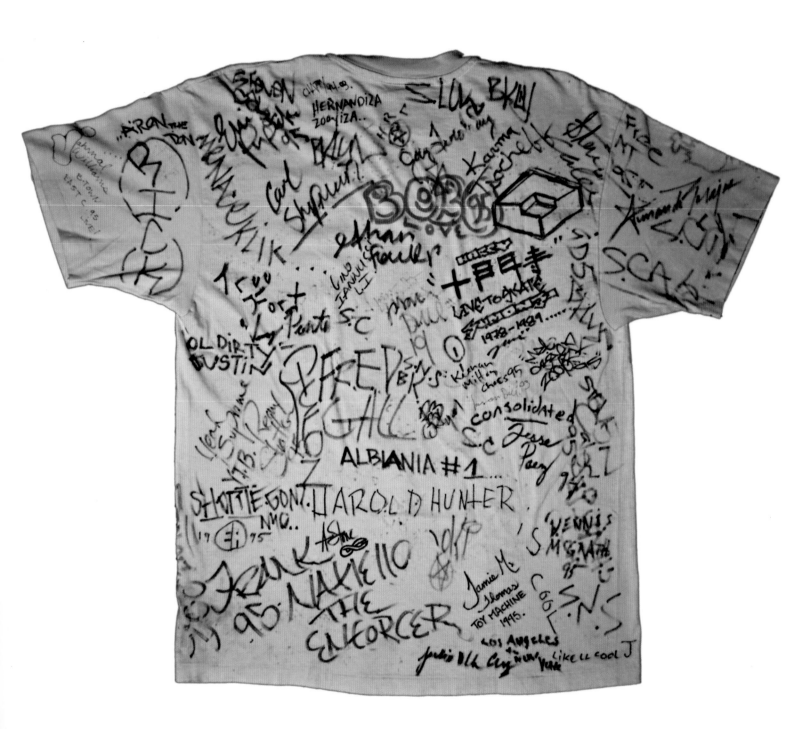

154

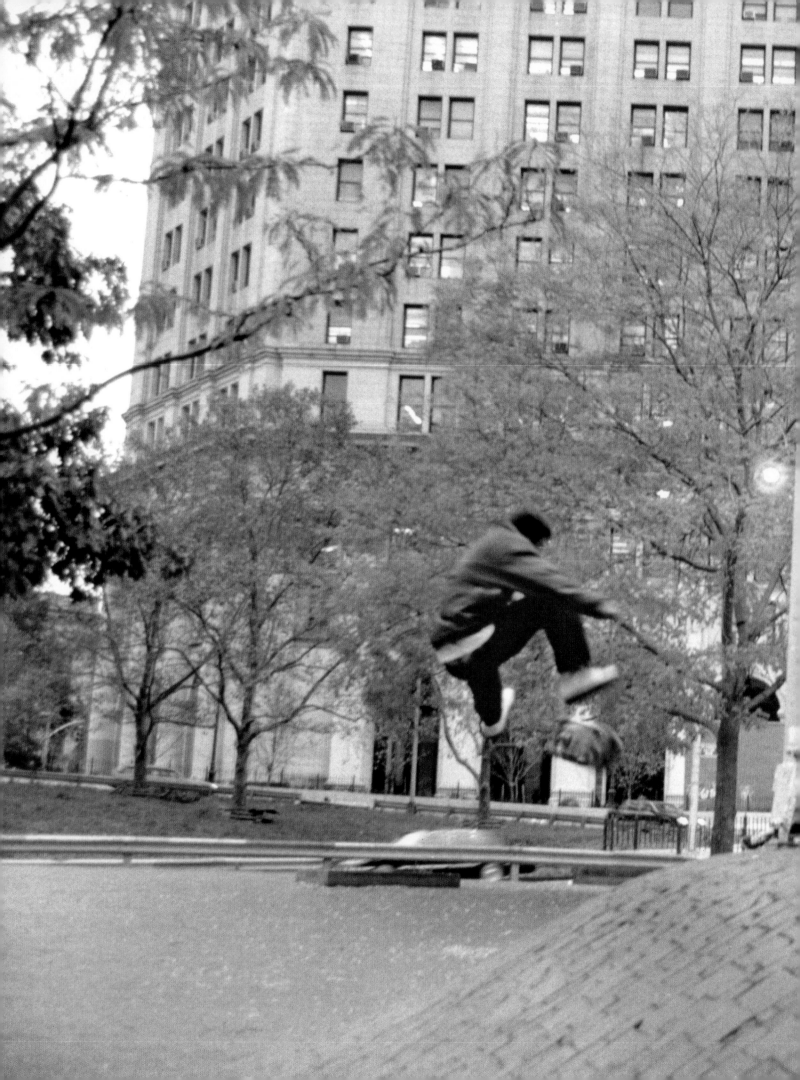

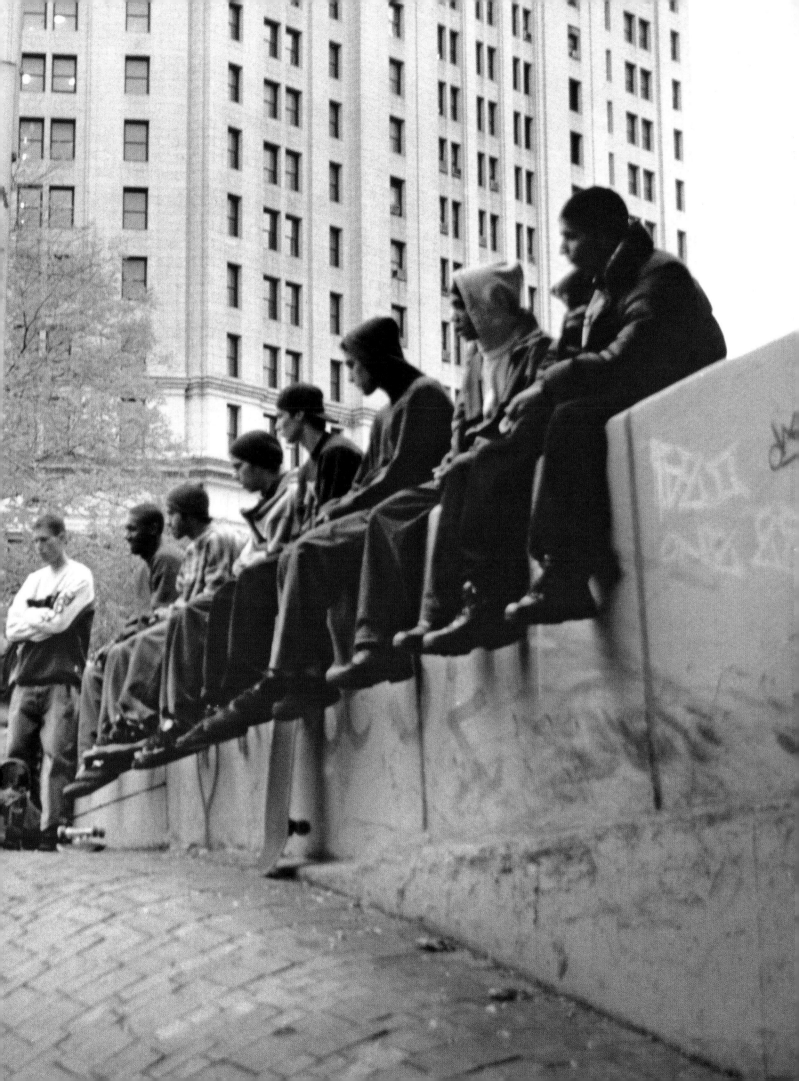

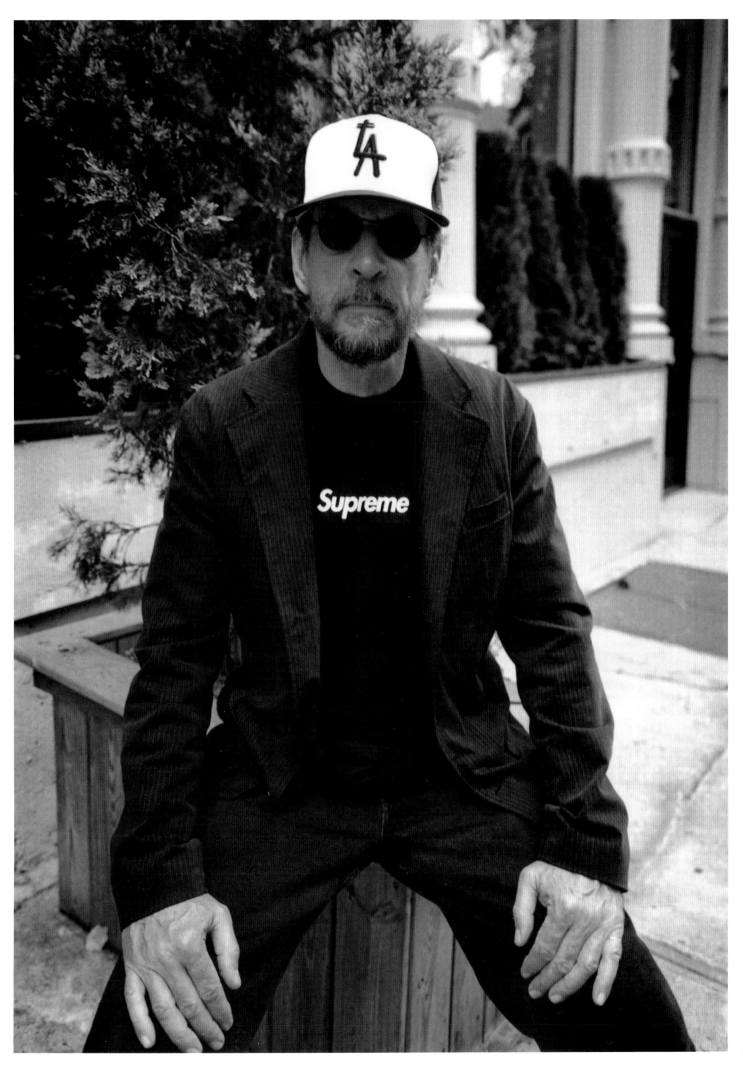

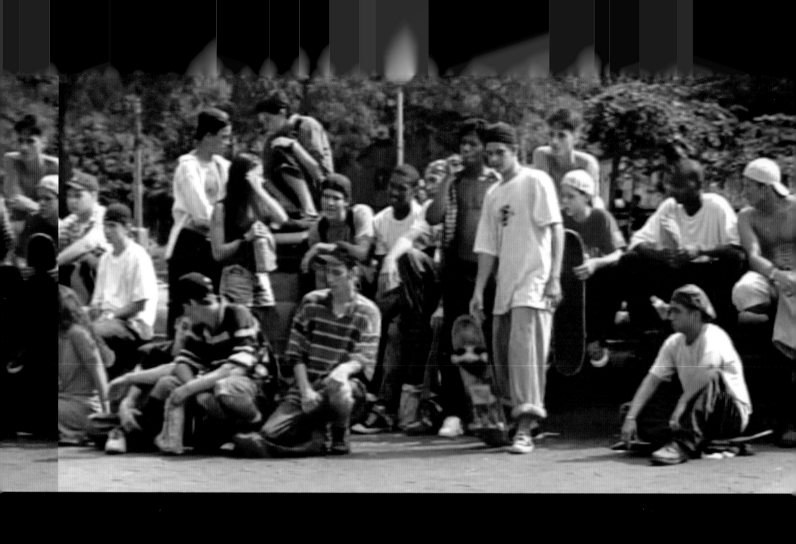
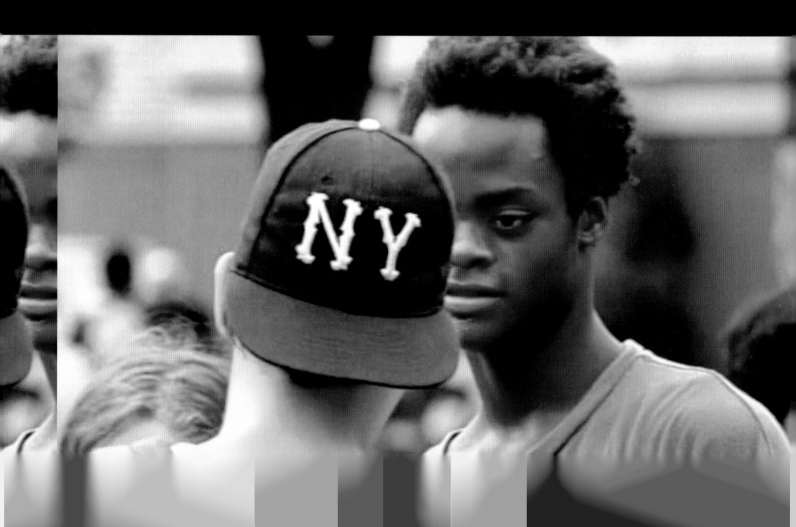

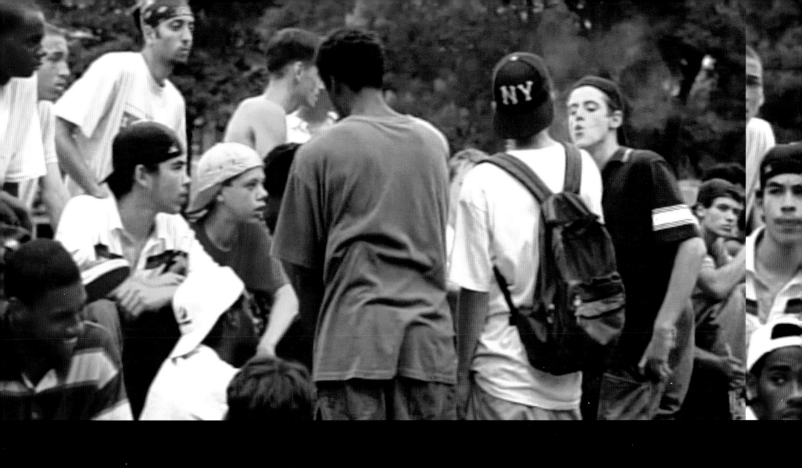

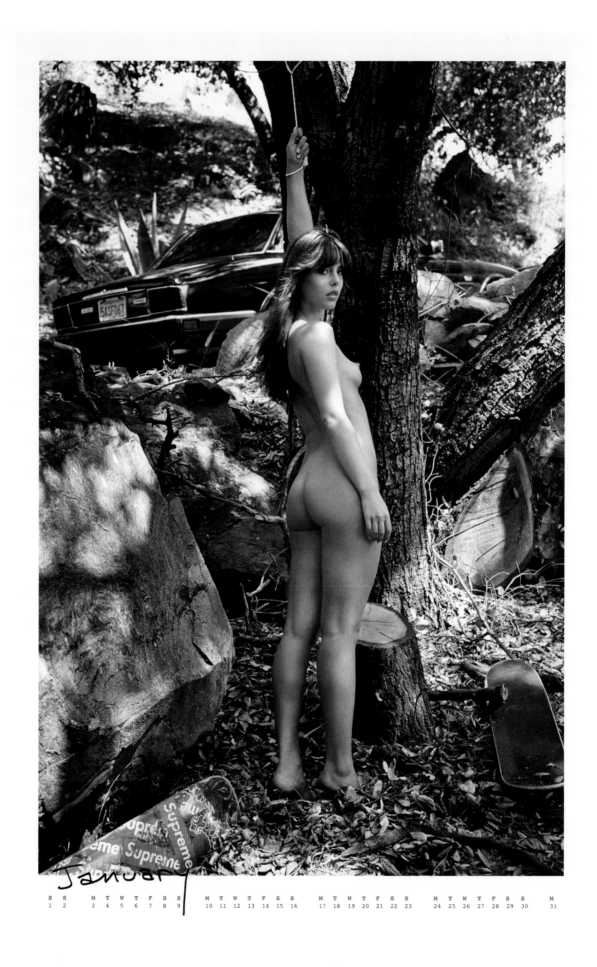

January

| S | S | M | T | W | T | F | S | S | M | T | W | T | F | S | S | M | T | W | T | F | S | S | M | T | W | T | F | S | S | M |
| 1 | 2 | | 3 | 4 | 5 | 6 | 7 | 8 | 9 | | 10 | 11 | 12 | 13 | 14 | 15 | 16 | | 17 | 18 | 19 | 20 | 21 | 22 | 23 | | 24 | 25 | 26 | 27 | 28 | 29 | 30 | | 31 |

SUPREME CALENDAR 2005

164

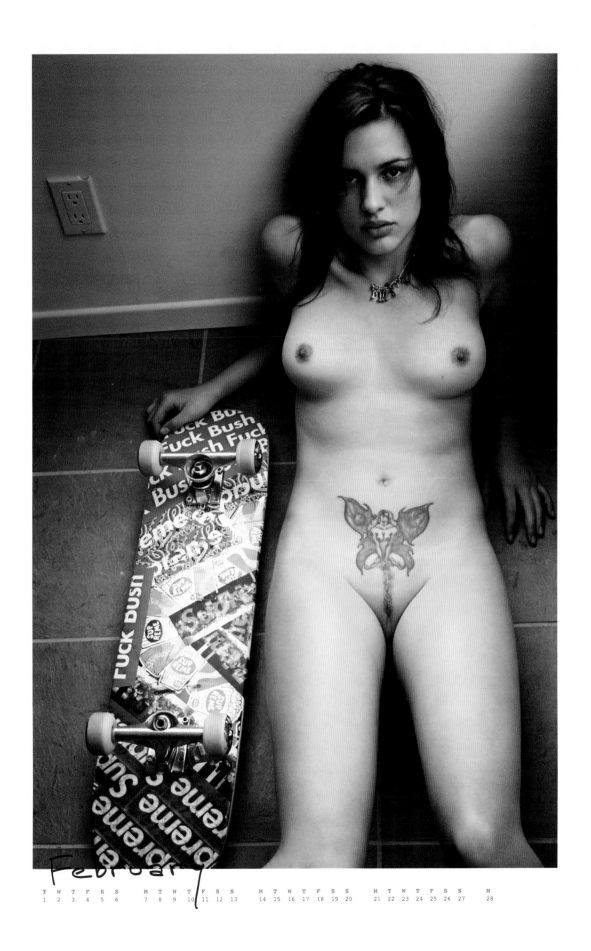

February

| T | W | T | F | S | S | | M | T | W | T | F | S | S | | M | T | W | T | F | S | S | | M | T | W | T | F | S | S | | M |
| 1 | 2 | 3 | 4 | 5 | 6 | | 7 | 8 | 9 | 10 | 11 | 12 | 13 | | 14 | 15 | 16 | 17 | 18 | 19 | 20 | | 21 | 22 | 23 | 24 | 25 | 26 | 27 | | 28 |

165

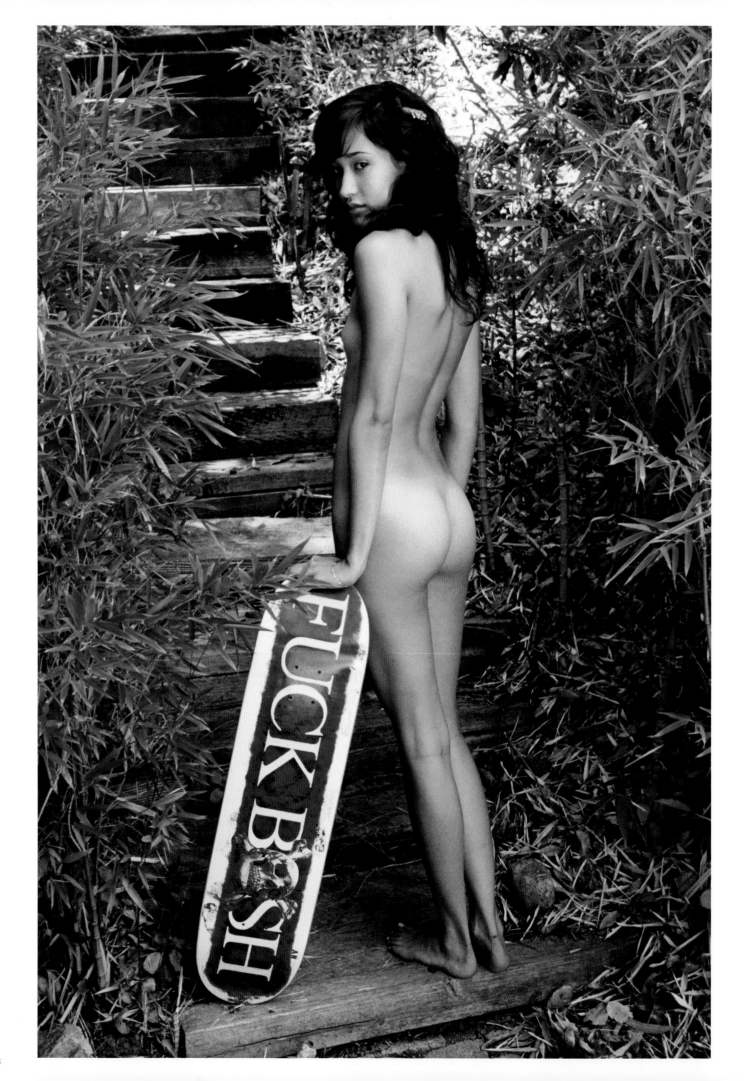

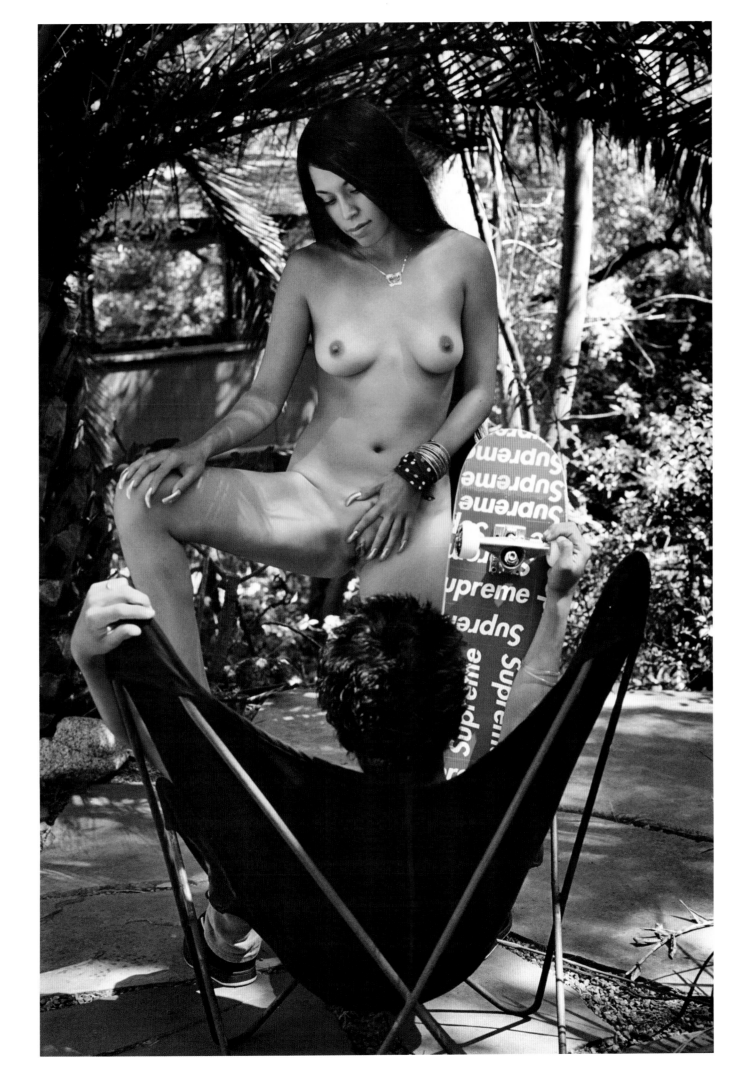

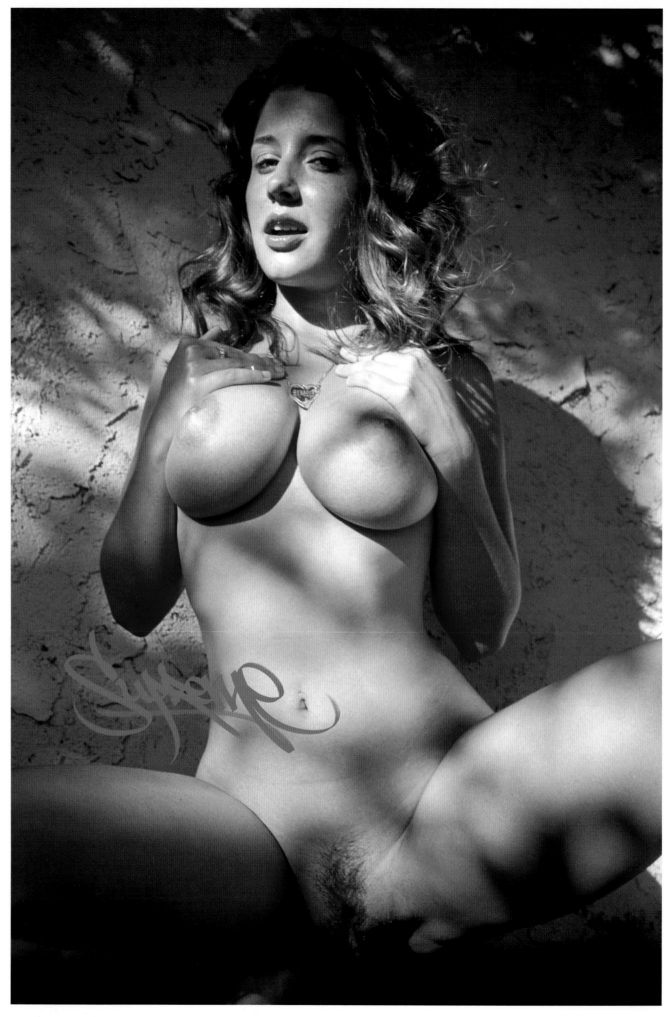

SUPREME CALENDAR 2003

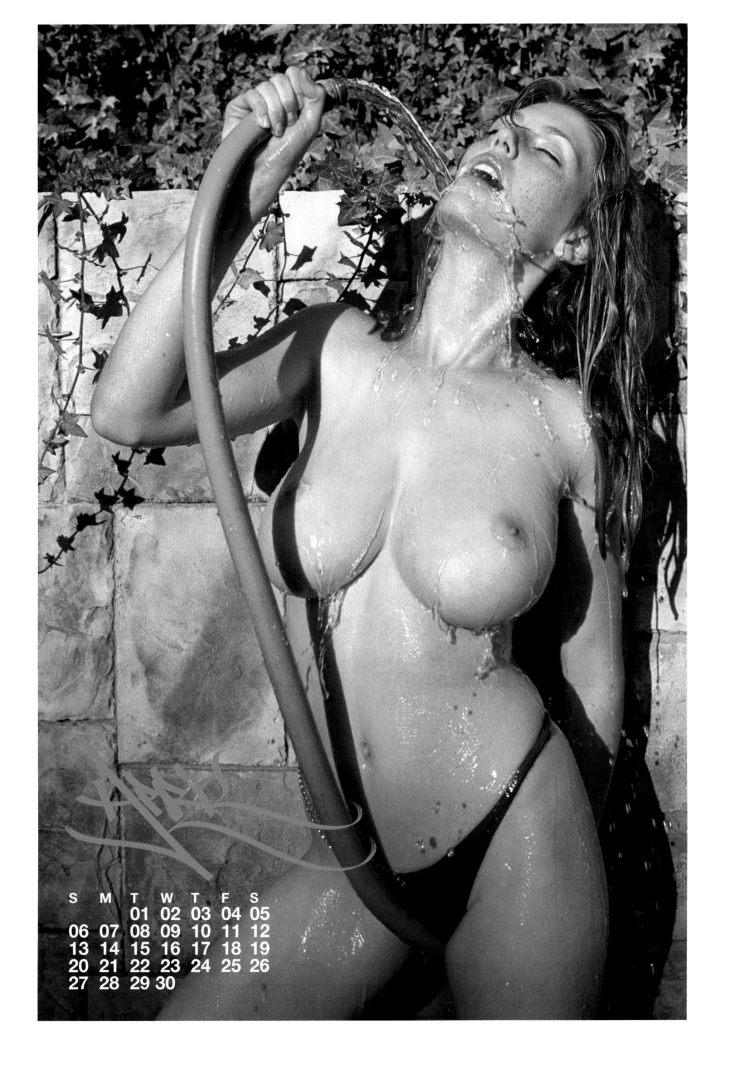

S	M	T	W	T	F	S
		01	02	03	04	05
06	07	08	09	10	11	12
13	14	15	16	17	18	19
20	21	22	23	24	25	26
27	28	29	30			

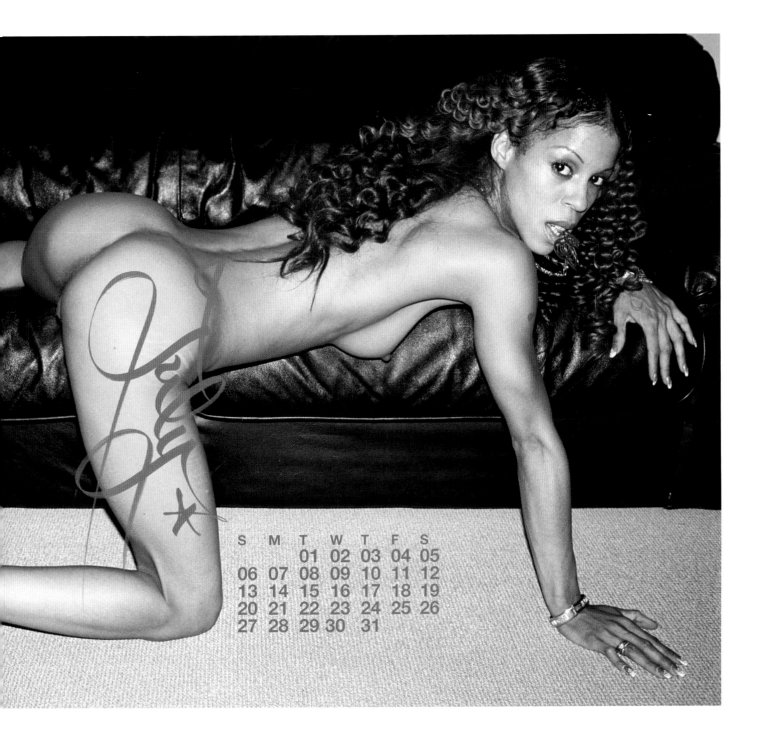

	S	M	T	W	T	F	S
			01	02	03	04	05
	06	07	08	09	10	11	12
	13	14	15	16	17	18	19
	20	21	22	23	24	25	26
	27	28	29	30	31		

171

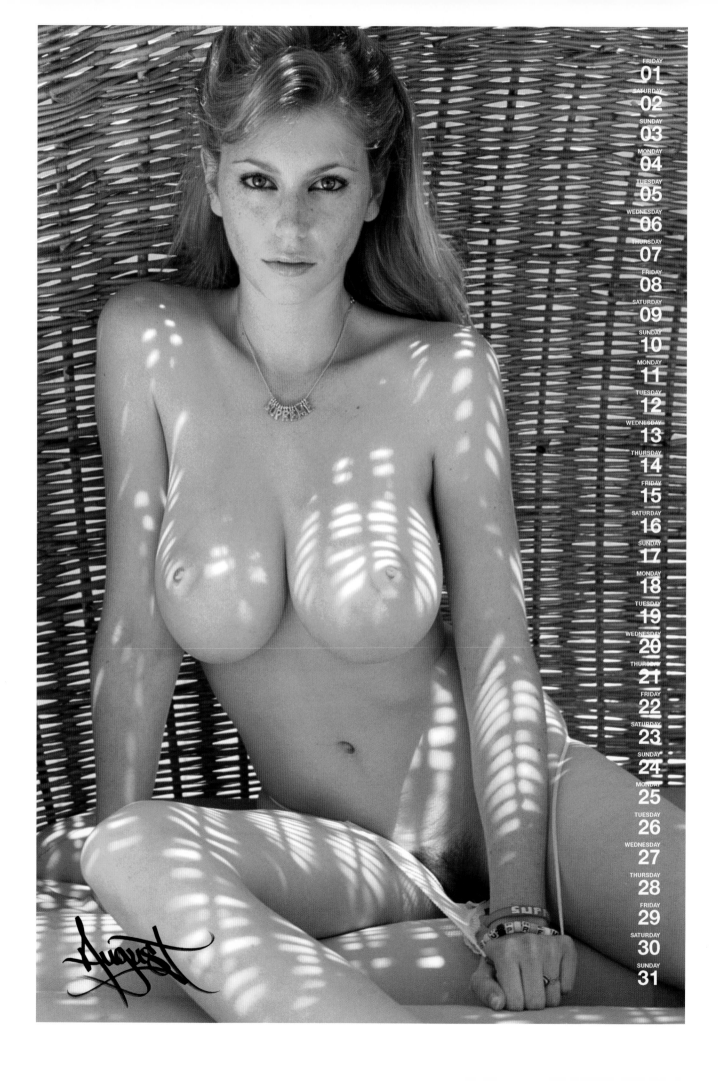

FRIDAY
01
SATURDAY
02
SUNDAY
03
MONDAY
04
TUESDAY
05
WEDNESDAY
06
THURSDAY
07
FRIDAY
08
SATURDAY
09
SUNDAY
10
MONDAY
11
TUESDAY
12
WEDNESDAY
13
THURSDAY
14
FRIDAY
15
SATURDAY
16
SUNDAY
17
MONDAY
18
TUESDAY
19
WEDNESDAY
20
THURSDAY
21
FRIDAY
22
SATURDAY
23
SUNDAY
24
MONDAY
25
TUESDAY
26
WEDNESDAY
27
THURSDAY
28
FRIDAY
29
SATURDAY
30
SUNDAY
31

172

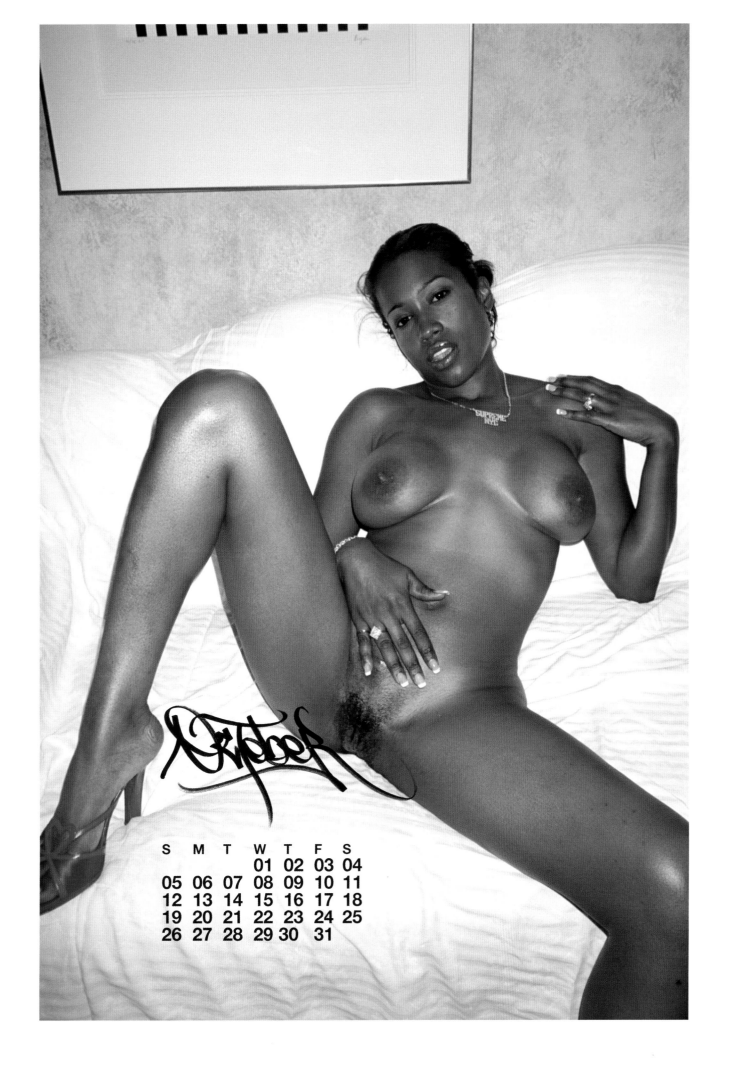

October

S	M	T	W	T	F	S
			01	02	03	04
05	06	07	08	09	10	11
12	13	14	15	16	17	18
19	20	21	22	23	24	25
26	27	28	29	30	31	

March

TH	F	S	S	M	T	W	TH	F	S	S	M	T	W	TH	F	S	S	M	T	W	TH	F	S	S	M	T	W	TH	F	S
1	2	3	4	5	6	7	8	9	10	11	12	13	14	15	16	17	18	19	20	21	22	23	24	25	26	27	28	29	30	31

September

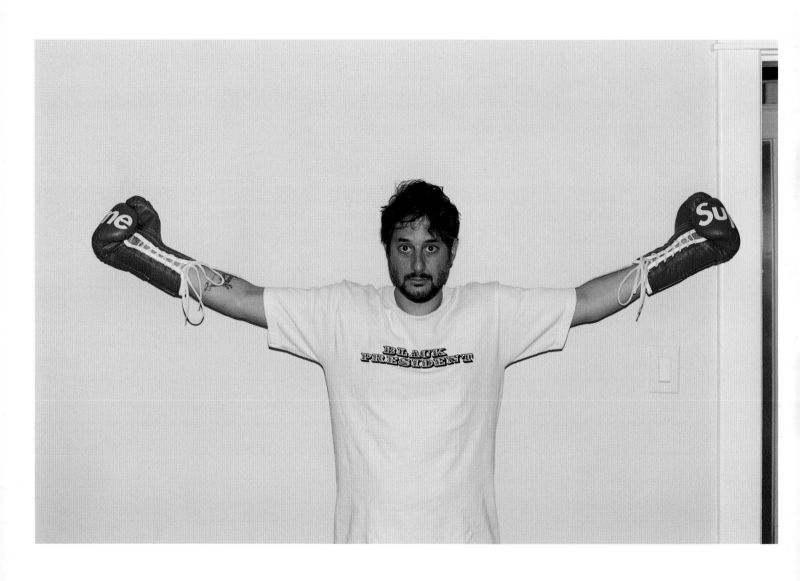

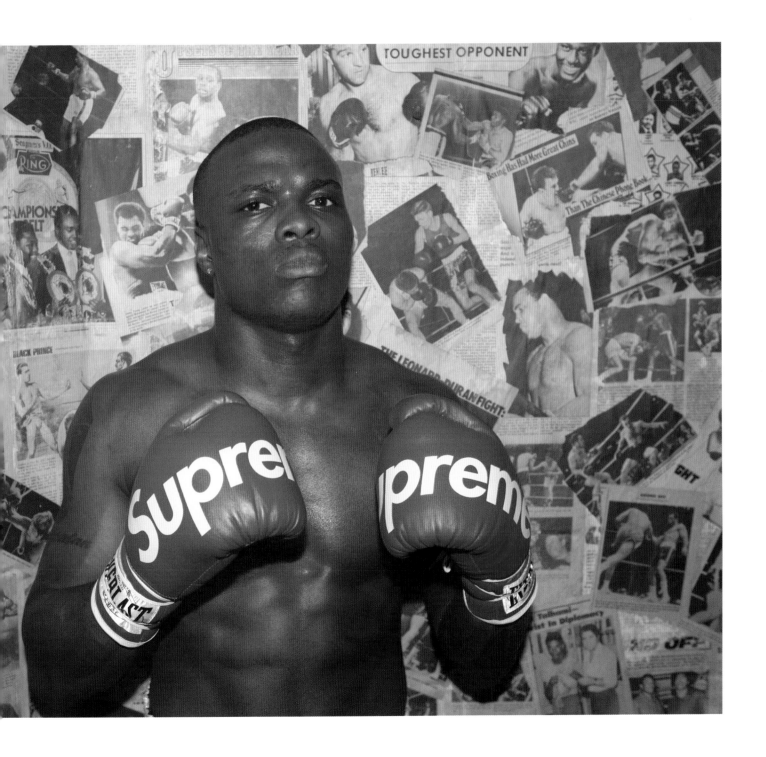

179

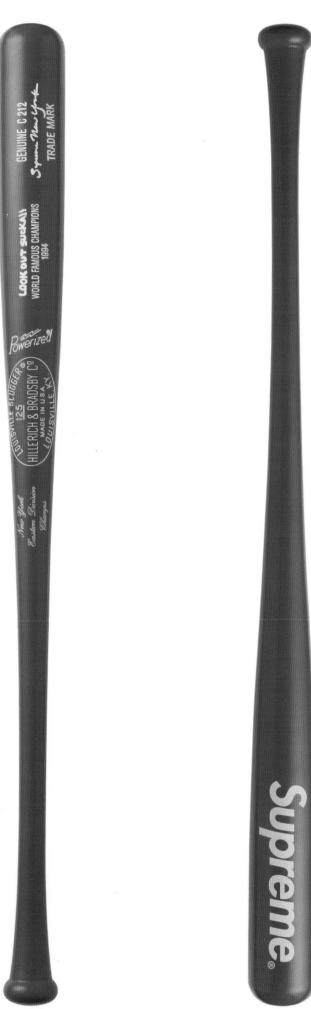

LOUISVILLE SLUGGER 2006

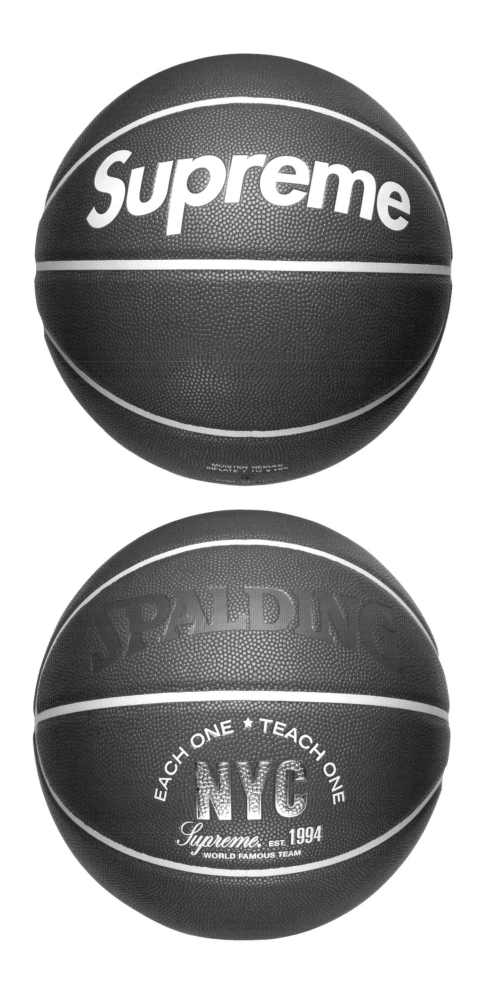

SPALDING 2007

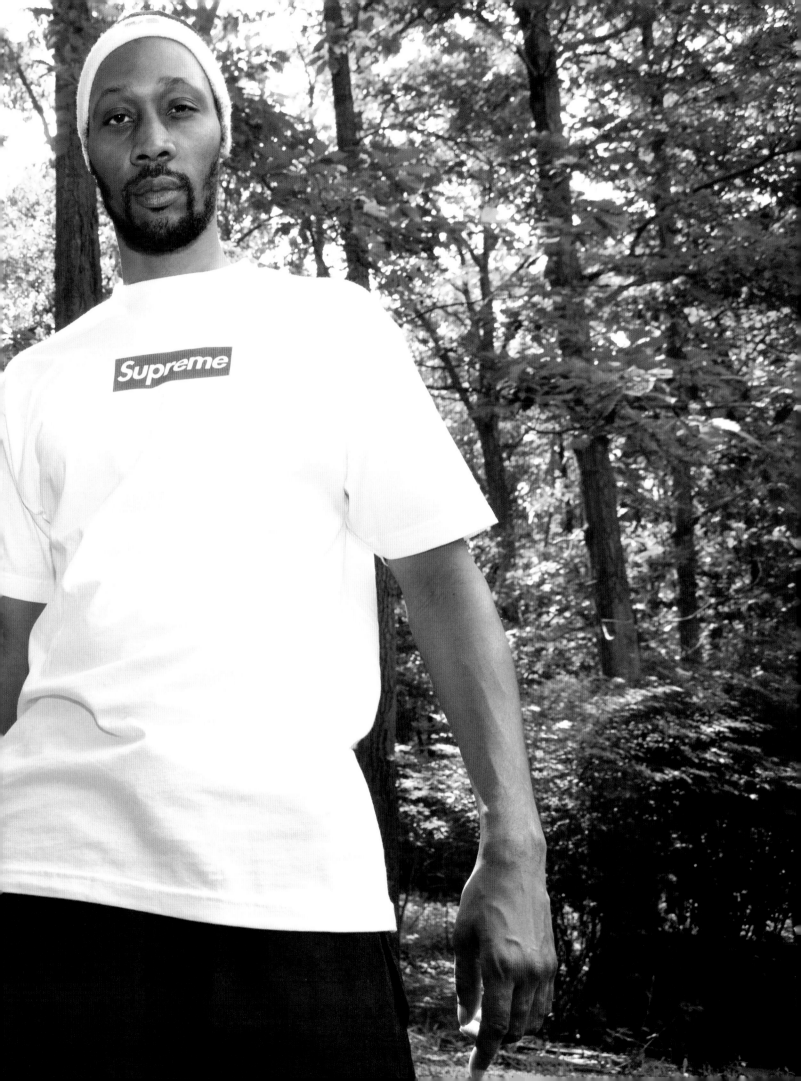

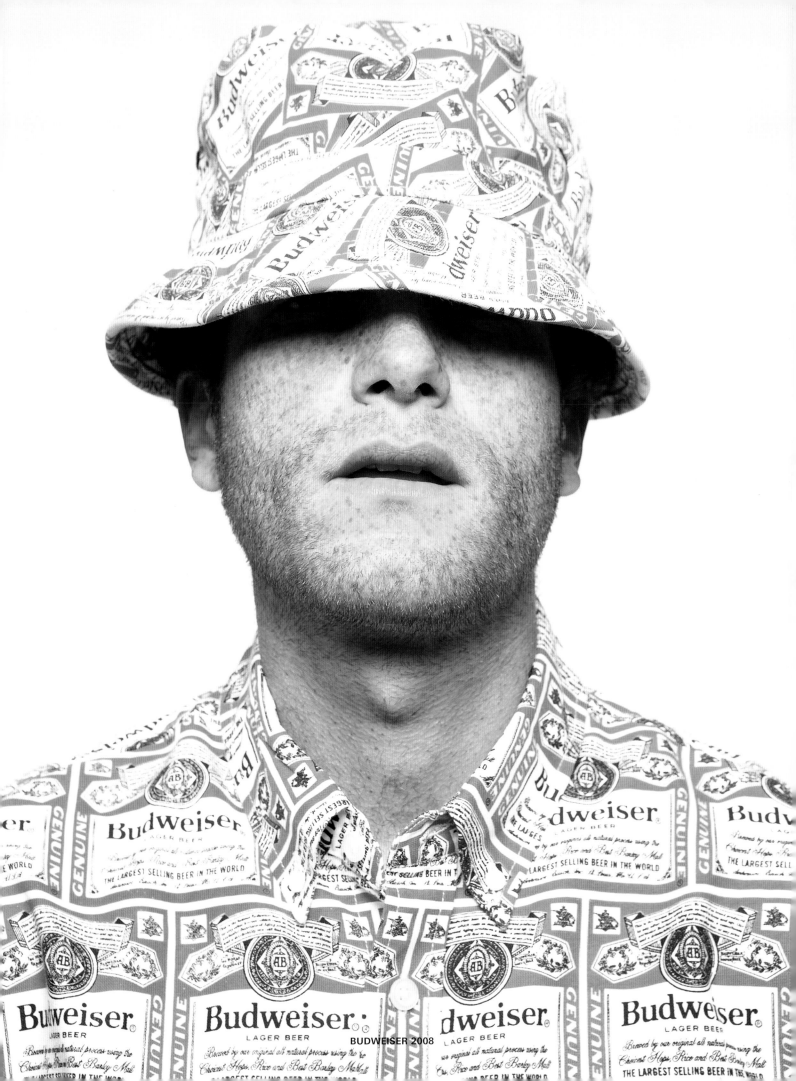

BUDWEISER 2008

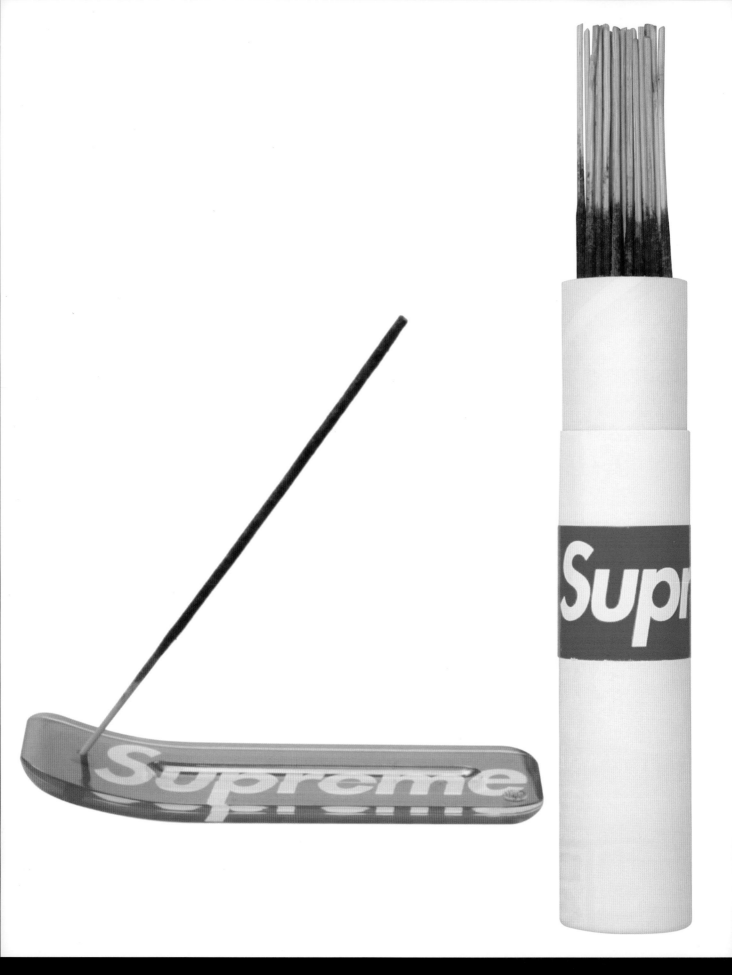

INCENSE 2009

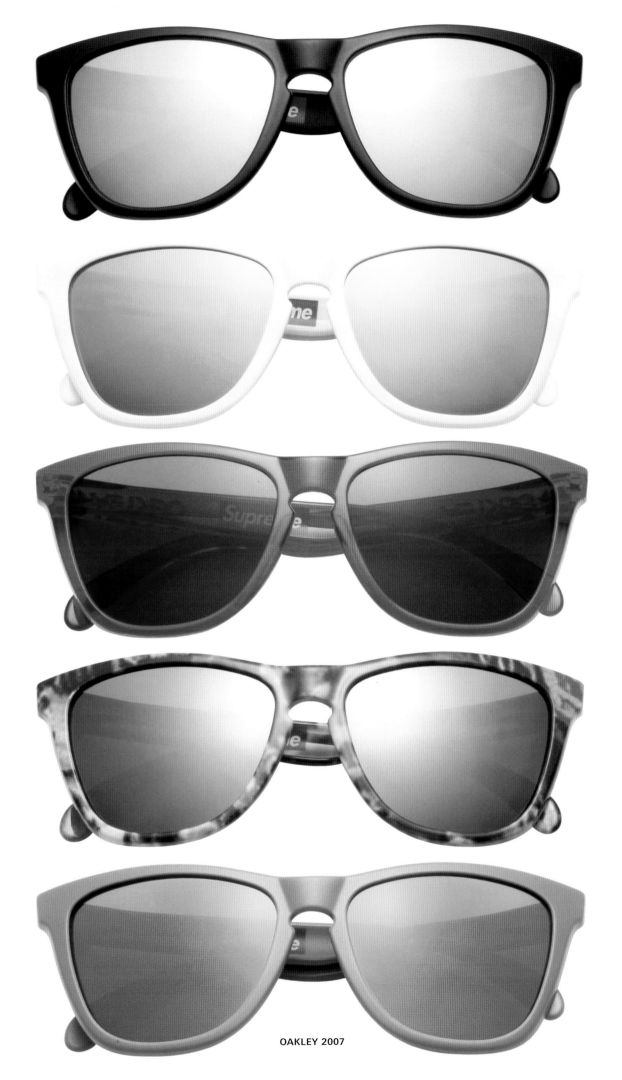

OAKLEY 2007

187

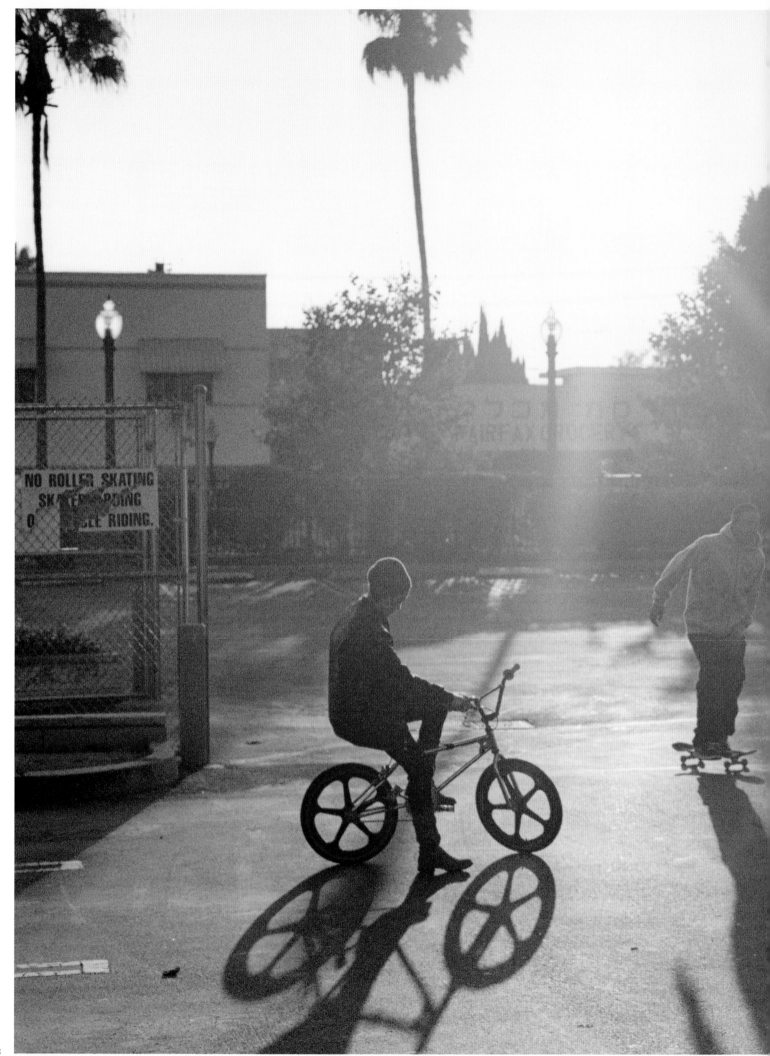

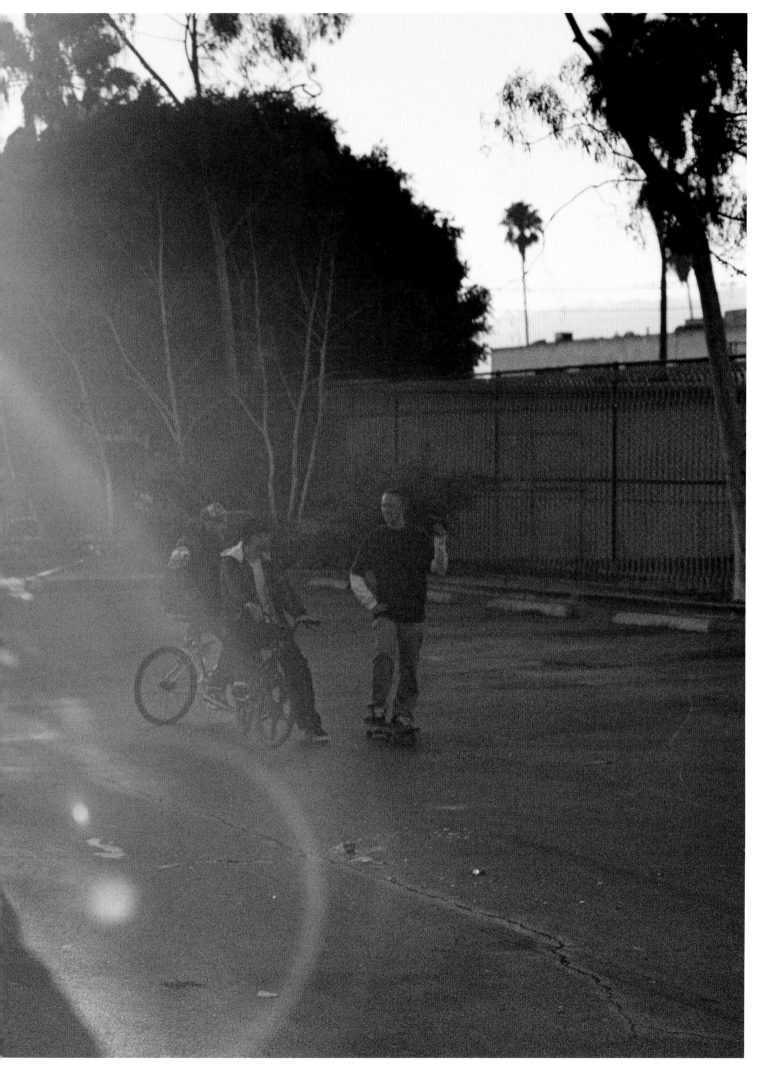

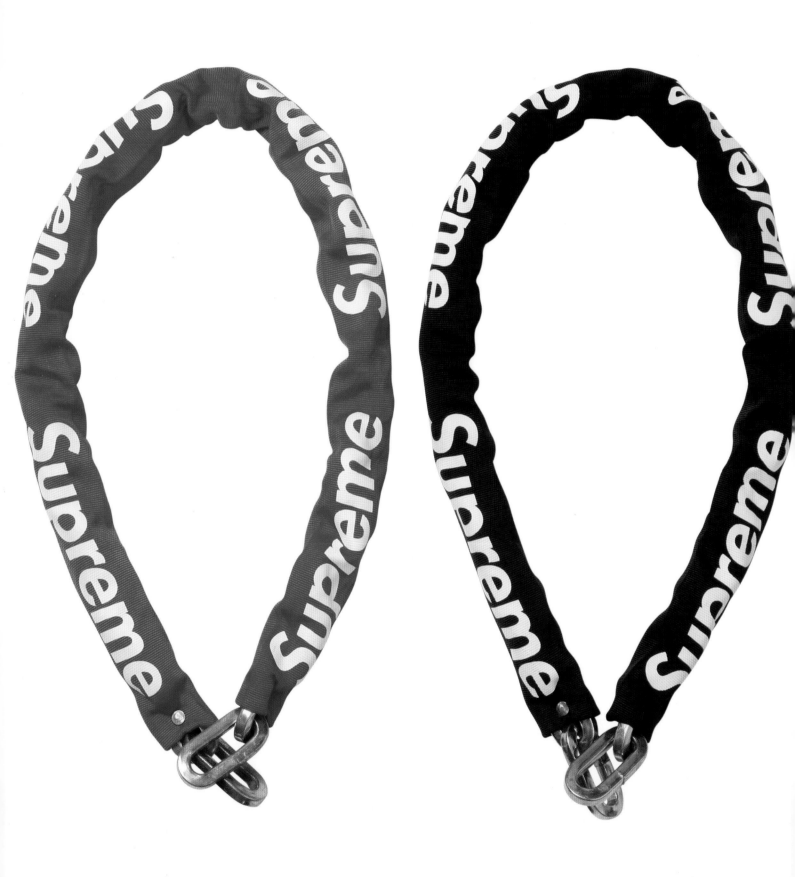

BIKE CHAIN 2007

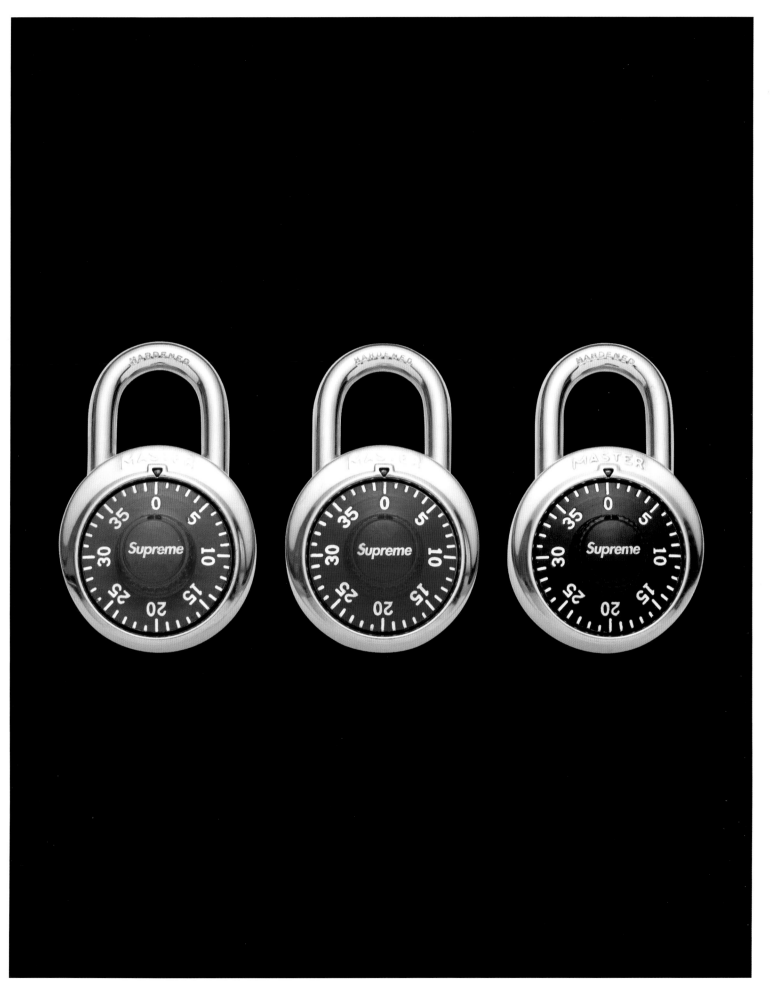

MASTERLOCK 2008

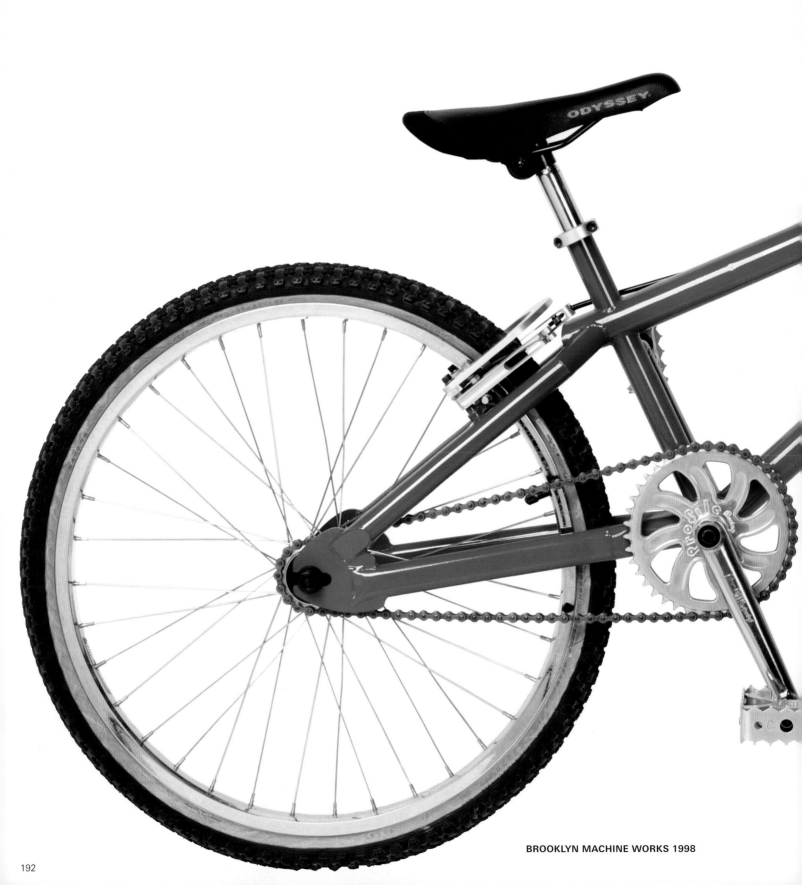

BROOKLYN MACHINE WORKS 1998

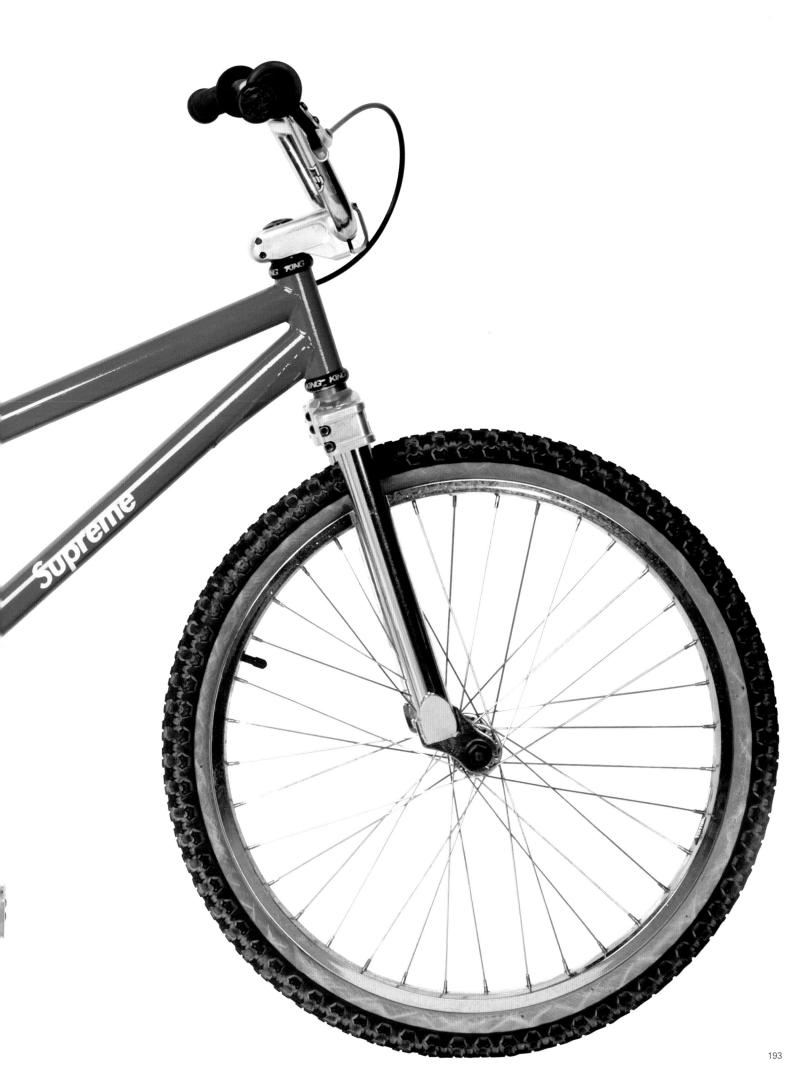

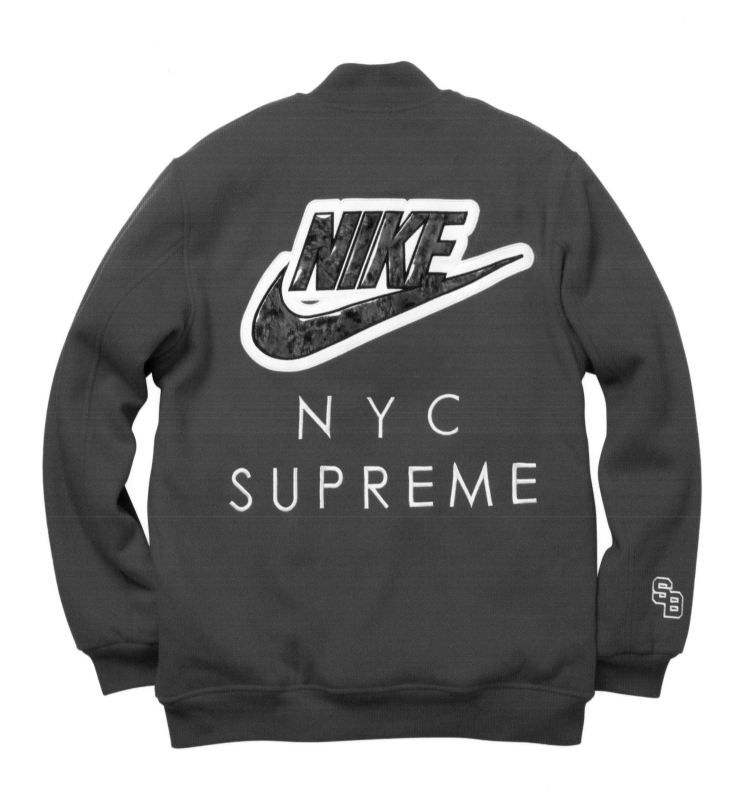

NIKE 2007

BOX CUTTER 2006

RUG 2009

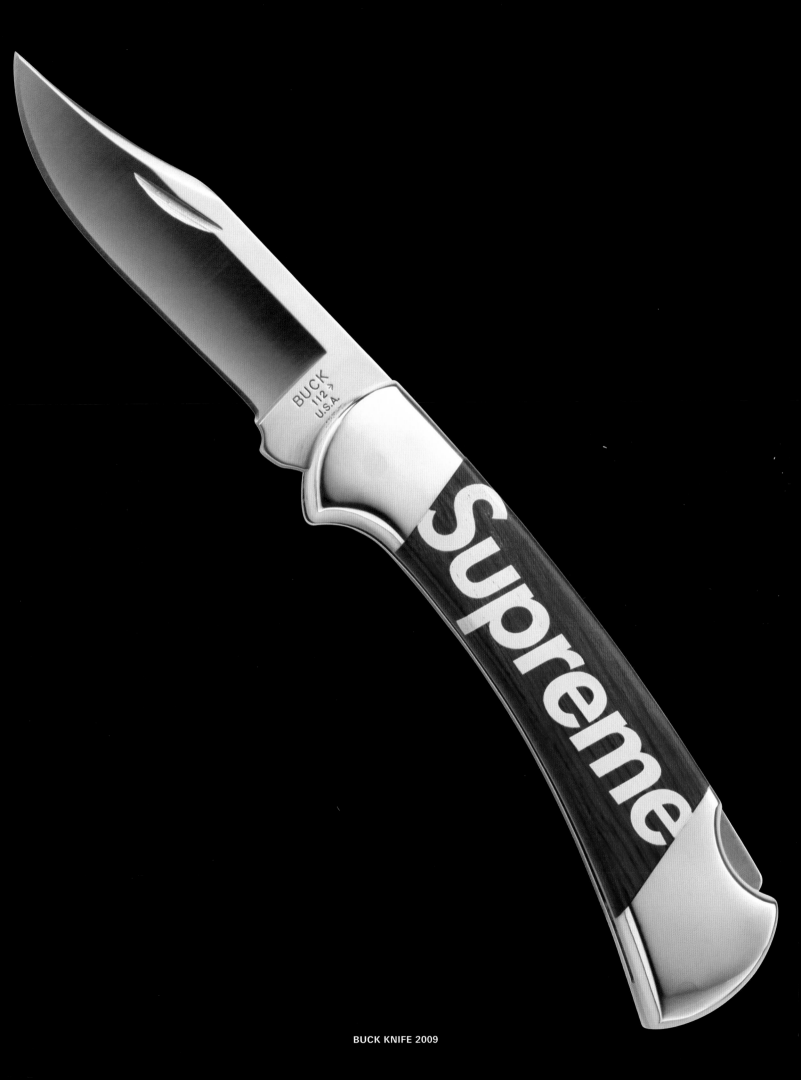

BUCK KNIFE 2009

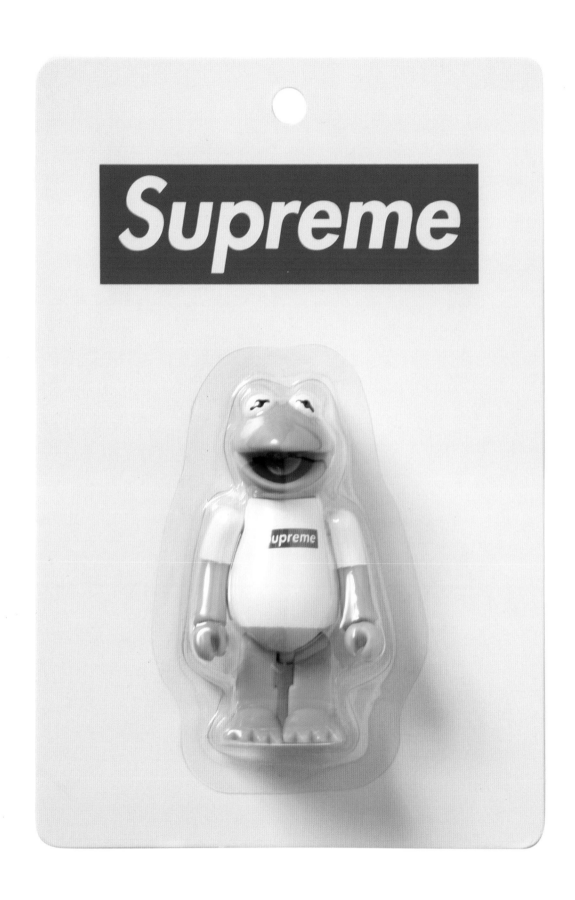

MEDICOM 2008

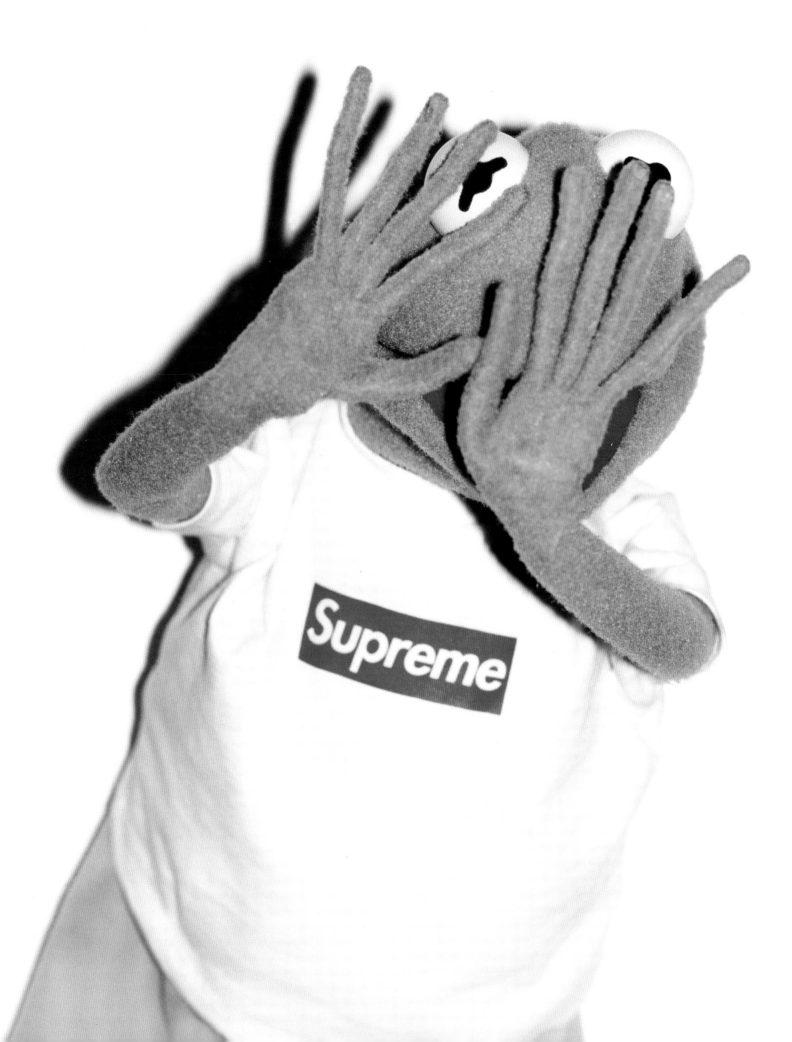

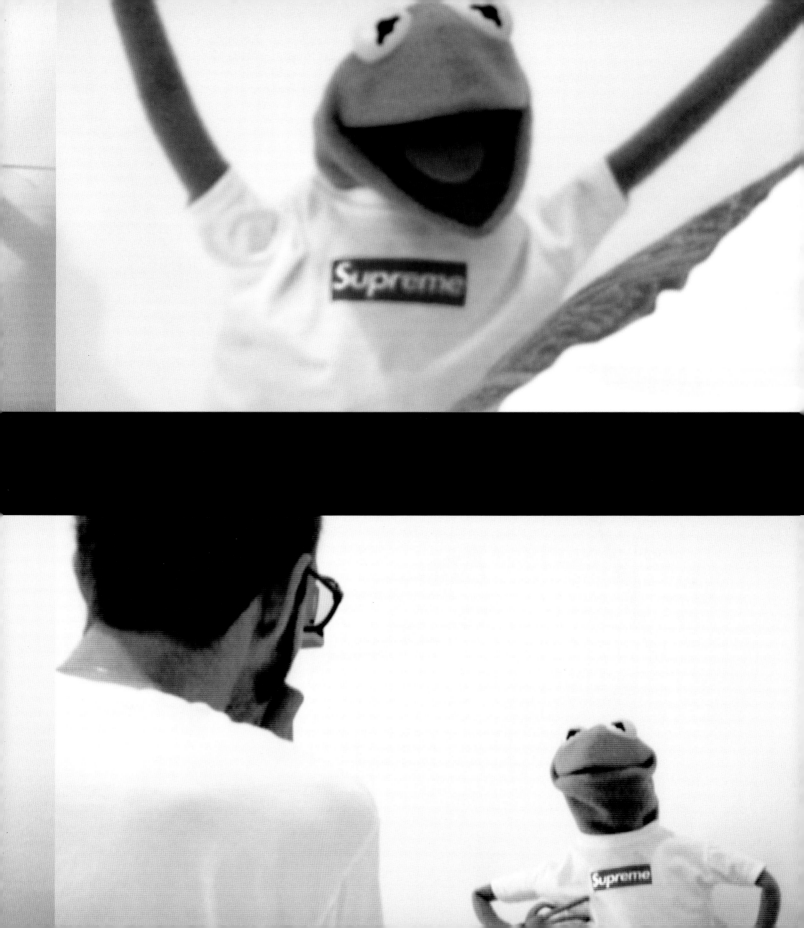

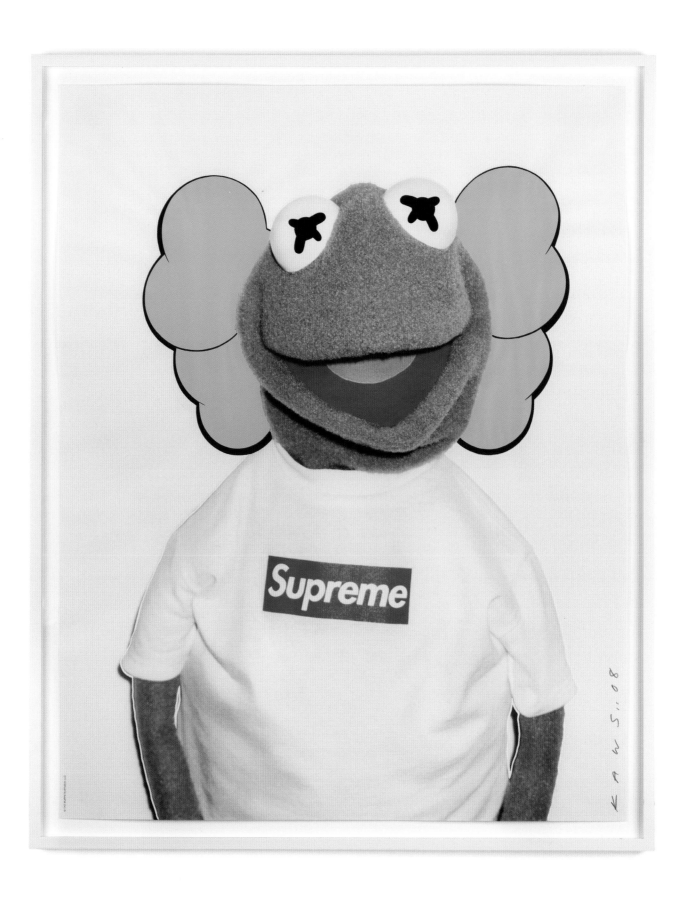

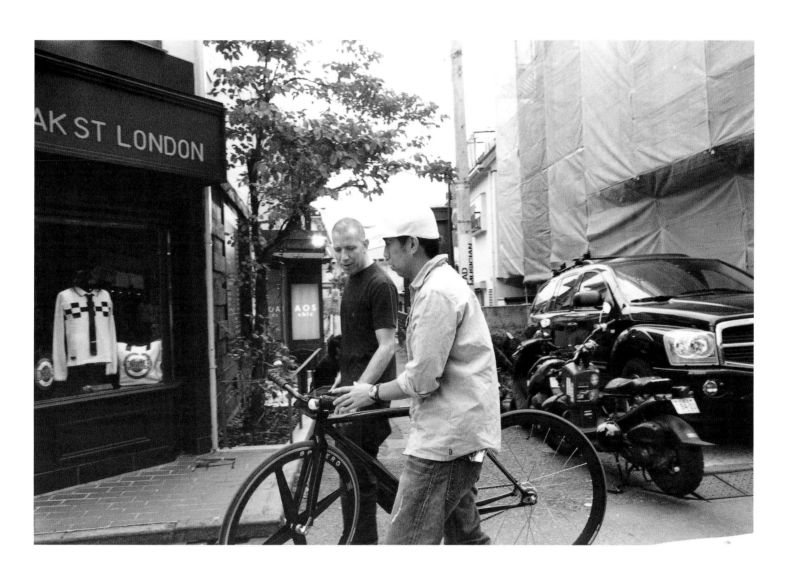

Supreme Book

特別付録 オリジナル・ステッカーシート／クール・トランス12月号別冊

2005 A/W Collection Complete Catalogue, N.Y. & L.A. Style Shooting, Larry Clark, Kim Gordon, Shawn Stussy, Spike Jonze, Supreme Crew's Favorite N.Y. Downtown Guide Map, and more...

e-MOOK smart特別編集

特別付録
1.フリースマフラー
2.特製ステッカー

Supreme

2006 AUTUMN & WINTER COLLECTION

2006秋冬 新作カタログ

スペシャル・フォトシュート
by TERRY RICHARDSON
1. NY+LA Supreme A/W Style
2. 袋とじ「PIN-UP GIRLS」

Supreme 最新トピックス
全国ショップ一覧
Artistインタビュー／
JEFF KOONS, ARI MARCOPOULOS
Supreme×TERRY RICHARDSON
限定Tシャツ 誌上通版

Supreme

BOOK VOL 3.

Special Photo Shooting
VINCENT GALLO×
TERRY RICHARDSON
ヴィンセント・ギャロ×テリー・リチャードソン in N.Y.

Tokyo Creators
トウキョウ・クリエイターズ／篠塚洋介, SKATETHING,
コーネリアス, TET (WTAPS), 成宮寛貴, 江川芳文 (HECTIC),
辺見 馨 (TENDERLOIN), 西浦 豊 (TENDERLOIN)

The Latest Catalogue
2007秋冬新作カタログ

Artist Feature
アーティスト・フィーチャー／村上 隆＆Mr.

Short interview
ショート・インタビュー／北村信彦 (ヒステリックグラマー),
トミー・ゲレロ, ハーモニー・コリン etc.

Special Interview
スペシャル・インタビュー／バッド・ブレインズ

特別付録1「ナイロン製シューズバック」
特別付録2「オリジナルステッカーシート」

WANI MOOK 105

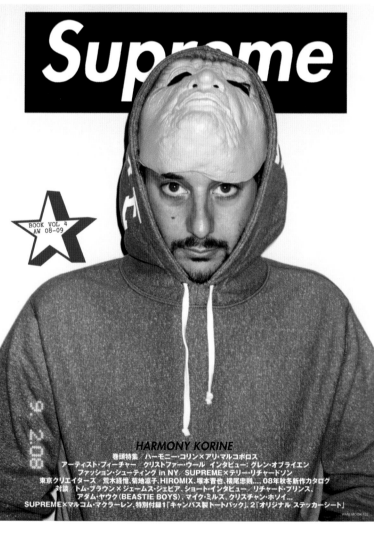

Supreme

BOOK VOL 4
AW 08-09

HARMONY KORINE

巻頭特集 ハーモニー・コリン×アリ マルコポロス
アーティスト・フィーチャー クリストファー・ウール インタビュー：グレン・オブライエン
ファッション・シューティング in NY「SUPREME×テリー・リチャードソン」
東京クリエイターズ 荒木経惟, 菊地凛子, HIROMIX, 塚本晋也, 横尾忠則...08年秋冬新作カタログ
対談 トム・ブラウン×ジェームス・ジェビア, ショート・インタビュー リチャード・プリンス,
アダム・ヤウク (BEASTIE BOYS), マイク・ミルズ, クリスチャン・ホソイ...
SUPREME×マルコム・マクラーレン, 特別付録1「キャンバス製トートバック」, 2「オリジナル ステッカーシート」

WANI MOOK 132

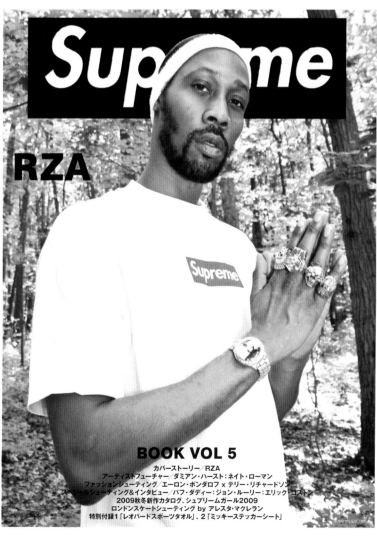

Supreme

RZA

BOOK VOL 5

カバーストーリー／RZA
アーティストフューチャー／ダミアン・ハースト：ネイト・ローマン
ファッションシューティング／エーロン・ボンダロフ × テリー・リチャードソン
スペシャルシューティング＆インタビュー パフ・ダディー：ジョン・ルーリー：エリック・コストン
2009秋冬新作カタログ、シュプリームガール2009
ロンドンスケートシューティング by アレスタ・マクレラン
特別付録1「レオパードスポーツタオル」、2「ミッキーステッカーシート」

WANI MOOK

右：Total Cash Money New Era キャップ¥9450
Hooded Corduroy Baseball Jacket パーカ¥45150
Supreme Jean (Vintage) ジーンズ¥16800
Supreme Box Logo Crewneck スウェット¥18900
左：Double L Cap キャップ¥6300
Mohair Sweater ジップアップセーター ¥28350
以上Supreme（すべてSupreme）ほかモデル私物
※左の人物は鏡に映ったカット

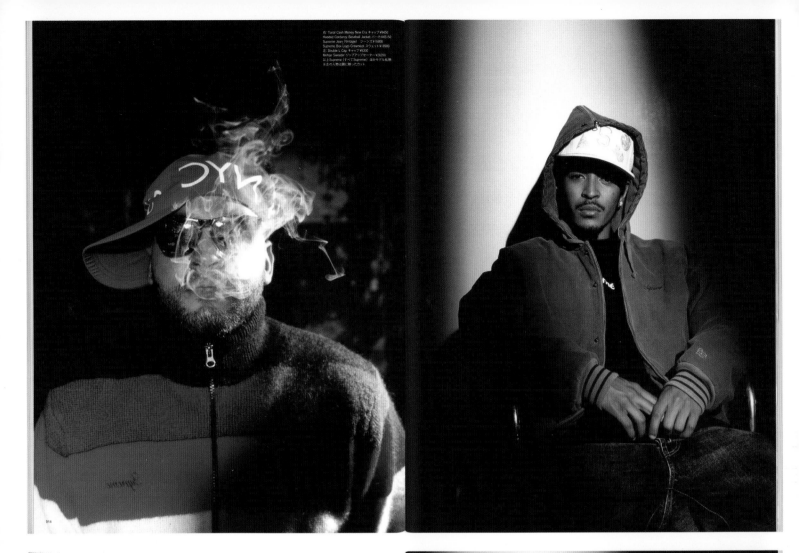

右：Stadium Cap. キャップ¥6300
Stadium Track Jacket トラックジャケット¥34650
Supreme Jean (Vintage) ジーンズ¥16800
左：Illuminati Embroidered Thermal Jacket
ジップアップ刺しゅうブルゾン¥61950
Undisputed T-Shirt Tシャツ¥6300
以上Supreme（すべてSupreme）ほかモデル私物

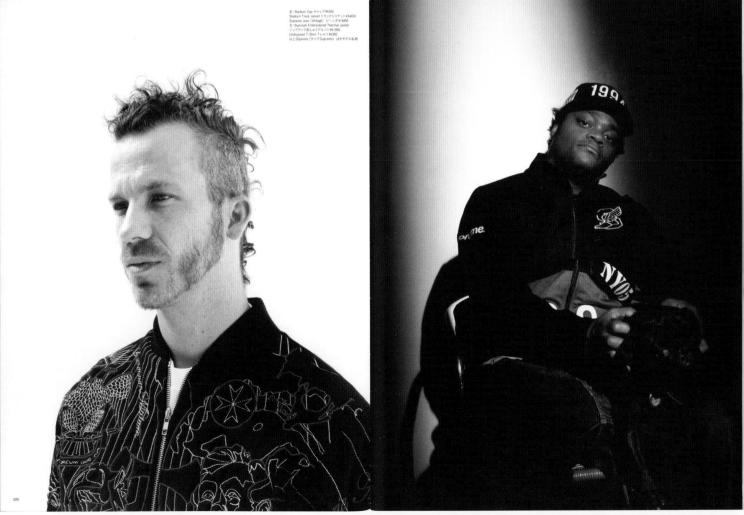

Israeli security on high alert to bar terror, guard VIPs

BY MICHELE GREEN
SPECIAL TO THE NEWS

JERUSALEM — Thousands of Israeli soldiers and police will be deployed in Jerusalem and around the West Bank today as Palestinians bury Yasser Arafat at his Ramallah headquarters.

The show of force by the Israeli Army and police force, dubbed Operation New Reality, aims to ensure that Arafat's funeral does not spill over into mass rioting or clashes between Palestinians and Israeli security forces.

One of the biggest concerns for the Israeli authorities is that tens of thousands of Palestinians might march from Ramallah to adjacent Jerusalem with Arafat's body in an attempt to bury it at the al-Aqsa mosque compound, a disputed holy site in Jerusalem that Palestinians see as a symbol of their struggle.

"We went on high alert this morning once we heard that he had died," police spokesman Gil Kleiman said yesterday. "Our aim is to prevent terrorist at-

WHAT'S NEXT

Palestinian leadership turns to Abbas.
PAGES 50-51

tacks and civil disorder as well as to allow the funeral to go according to plan, so a lot of traffic police will also be out there to ensure that VIPs enter Ramallah without any problems."

Paramilitary police will be armed with riot control gear and

given strict instructions to avoid bloodshed if stone-throwing clashes do erupt at military checkpoints around Ramallah or elsewhere in the West Bank and Gaza Strip, security officials said.

In addition to security headaches over Arafat's funeral, police also have to contend with prayers at the al-Aqsa mosque compound on the last Friday of the Muslim holy month of Ramadan.

About 180,000 worshipers are expected to attend the prayers.

Police fear a riot could occur similar to one that took place on Sept. 29, 2000, the first day of the Palestinian intifadeh.

"We hope that everything will go smoothly, but we are prepared for any eventuality," a senior security official said.

Israeli security forces also have intelligence information that militants might use the flood of Palestinians entering Ramallah for the funeral as a way of smuggling suicide bombers and explosives into the West Bank city.

Brokers busted in $2.5M share fraud

By JOHN LEHMANN

A bunch of big-talking Manhattan brokers bilked unsuspecting investors out of $2.5 million by pressuring them over the telephone to buy shares involving a supposedly promising software company, the feds charged yesterday.

FBI detectives put the cuffs on five of the alleged fraudsters yesterday, hauling them into Manhattan federal court on a 51-count indictment that charged them with securities crimes, including conspiracy and securities, wire and mail fraud.

The men arrested — Igor Kotlyar, Alex Berg, John Donadio, Padraig McGlynn and Gianfranco Carbonara — are accused of tricking 31 investors into buying stock in Thomas Fletcher Securities by using documents plagiarized from materials describing software of another firm, E*Trade.

One investor in Georgia bought $500,000 worth of

the bogus $10 shares after being telephoned by a person pretending to work for Goldman Sachs who said he'd be willing to buy the shares for $25 each, Manhattan U.S. Attorney Jim Comey said.

Investors were told that an initial public offering of Thomas Fletcher — which operated out of offices at 39 Broadway — was imminent, even though the company had no such plans, the indictment said.

Kotlyar also allegedly duped several of the investors in California-based company Transnational Financial Network into transferring half a million shares to him — which he converted to his own use.

After Thomas Fletcher closed shop last November, McGlynn and Carbonara allegedly hatched a scheme to steal funds remaining in clients' accounts by secretly transferring the money to E*Trade accounts and obtaining ATM cards to withdraw the cash.

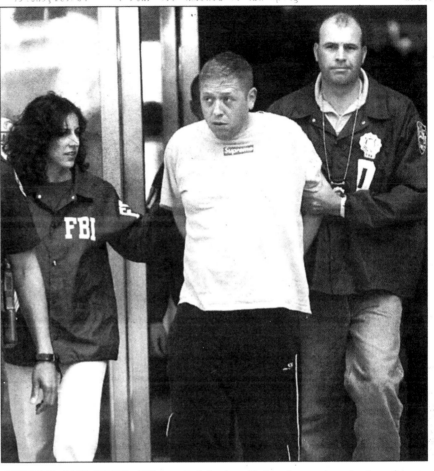

STOCKS AND CONS: FBI agents take Igor Kotlyar to court yesterday after arresting him on charges that he participated in scheme to defraud stock investors.

N.Y. Post: Don Halasy

CHINATOWN RAID COLLARS 25

BY MICHELE McPHEE
NEWS POLICE BUREAU CHIEF

MORE THAN TWO dozen alleged gangsters with ties to Chinese organized crime were busted in predawn sweeps in Manhattan and Queens early yesterday, sources told the Daily News.

Some were busted at illegal gambling operations along Mott St. in Chinatown, and others were rousted from their sleep in Flushing apartments, several law enforcement sources said.

The raids, code-named "C-Town Flush," led to 25 arrests, and 40 suspects were still being hunted last night, sources said.

The suspects are facing federal racketeering charges for a myriad of gang-related crimes, including murder, immigrant smuggling, gambling, prostitu-

"It's a very big case," said a law enforcement official who was among the NYPD detectives, FBI agents and Immigration and Customs Enforcement officials who participated in yesterday's sweep.

"Essentially, it's a group of Fukienese who formed their own 'no-name' gang," the source said. "They were strongarming each other, threatening each other's casinos. There were really no innocent victims. They were preying on each other."

morning in Manhattan Federal Court. NYPD officials had no comment on the case yesterday.

The busts come a year after The News reported that the NYPD formed an Asian-crime task force to deal with an influx of gang and criminal activity in the Chinese community.

Last November, Police Commissioner Raymond Kelly ordered elite detectives from the intelligence division to investigate a rise in home invasions, a deadly feud between rival bus companies and robberies.

organized Chinese street gangs, primarily teenage thugs who formed packs that beat up one another.

Members of one gang, "A-E" for American Eagles or Asian Empire, were among those arrested yesterday, sources said.

Some of the suspects also were gangsters from older Chinese gangs such as the Ghost Shadows and Flying Dragons who were recently released from prison after serving long sentences stemming from major busts in the late 1980s, the sourc-

Scratch haul for postman

BRIAN HAYES of Maywood, N.J., has been following Scratch n' Match since day one. The postal worker never expected to win, let alone win $1,000.

"What happened was I wrote the day's numbers on a piece of paper and was carrying it around for a week. I finally scratched the numbers off and thought, 'This can't be right. I must've written down the wrong numbers,'" said our newest winner. "Then I thought about it and figured that if I was ever going to win it would be on this day. Nov. 11 is my grandmother's birthday."

Melita Ford of Flatbush, Brooklyn, won $100. "I was at home with my youngest daughter, Kia, when it happened. I couldn't believe it. I've been playing for the longest," said Ford. "Christmas is coming, so I'm getting a present for my grandson, he's a year old."

So be sure to pick up The News every day — and check your numbers today on page 84.

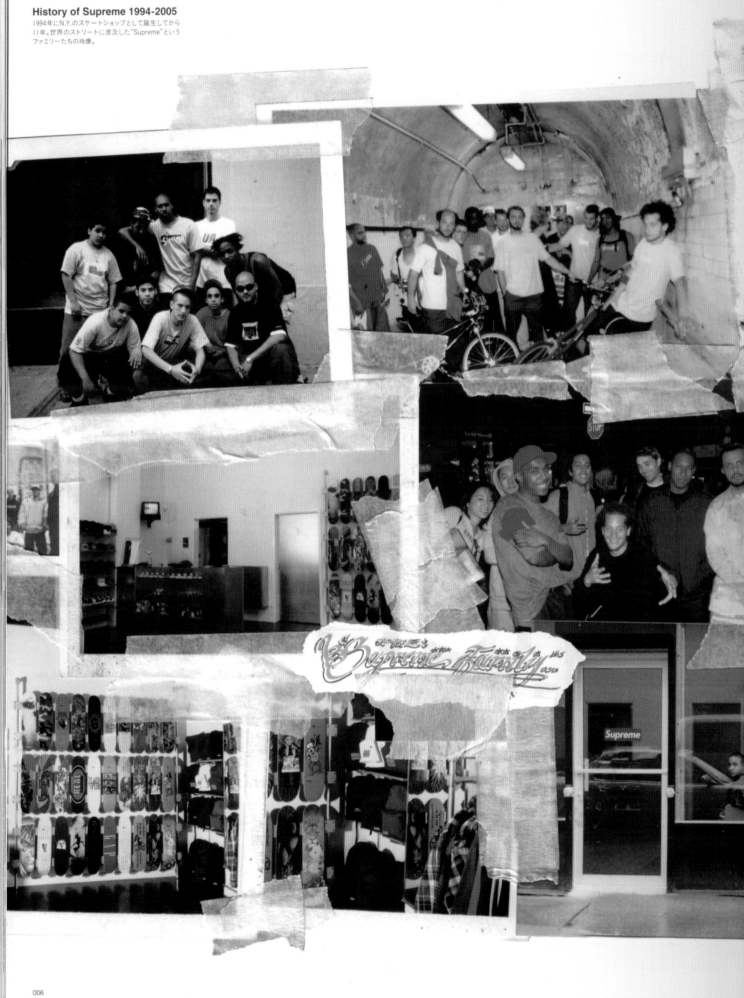

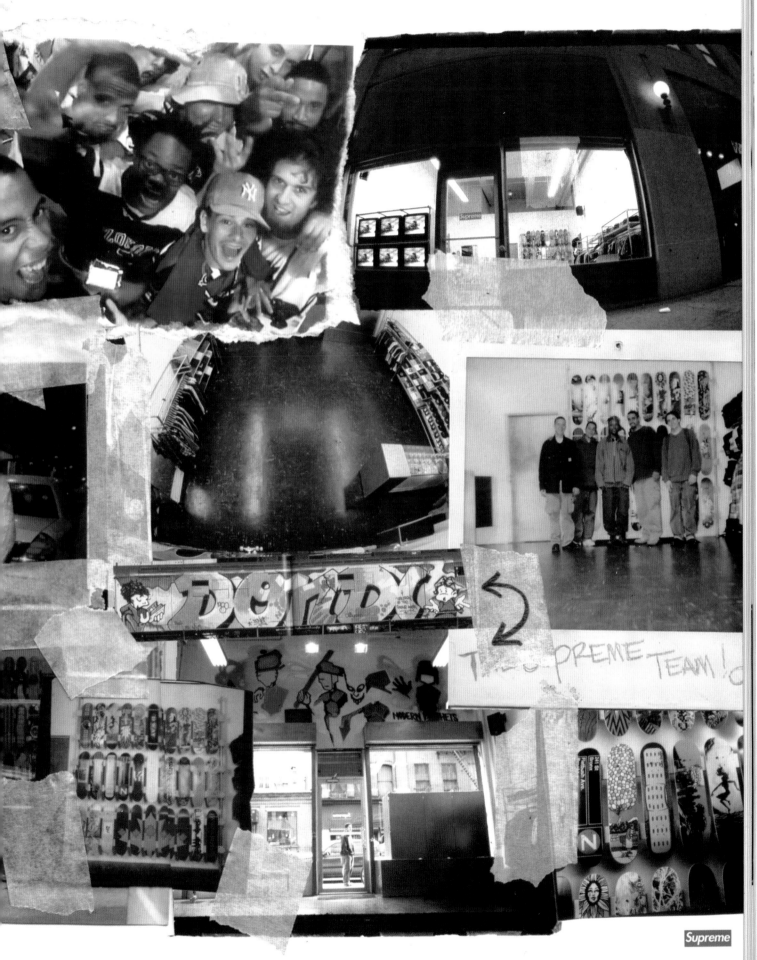

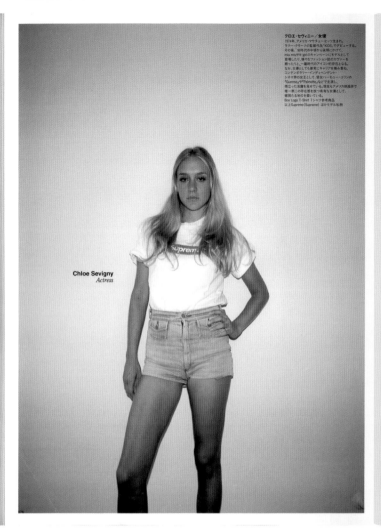

クロエ・セヴィニー／女優
1974年、アメリカ・マサチューセッツ州生まれ。
ラリー・クラーク監督作品「KIDS」でデビュード。
その後、90年代の中頃から後半にかけて、
miu miuやX-girlのキャンペーンにもゲストとして
登場したり、様々なファッション誌のカヴァーを
飾ったりと、後のファッションアイコンの存在となる。なお、女優としても着実にキャリアを積み重ね。
インディング・ラリー・インディペンデントの
シネマ界の女王として、彼女ハーキュリー・コリンの
「Gummo」や「Palmetto」などで主演。
限定の誕生を見せながら、現在もアメリカ映画界で
唯一のこの存在感を放つ今一番なる彼女を支援して、
根限りなき存在している。
Box Logo T-Shirt Tシャツ参考商品
以上Supreme（Supreme）ほかモデル私物

Chloe Sevigny
Actress

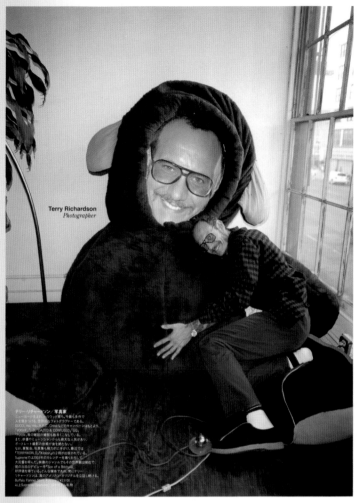

Terry Richardson
Photographer

テリー・リチャードソン／写真家
ニューヨークをベースに、ウッドストック育ちの
それを受ける30代、世界的なフォトグラファーである。
GUCCI、miu miu、YSL、Chloeなどのキャンペーンをより、
VOGUE、GQ、「DAZED & CONFUSED」「GQ」、
「Purple」等の雑誌の撮影も続々こなしている。
また、奔放ミュージシャンからも絶大な人気があり、
ポートレート撮影の精鋭にも定評がある。
なお、展覧会、写真集も精力的に取り組んでおり、最近では
「TERRYWORLD」やKozoなど2冊の出版されている。
SupremeではTERRYWORLD 2年のカレンダーも制作。今の
大反響を呼んだ、映画俳優のジャンルでもその世界観は確固に
彼の3冊のデビュー作「Son of Bob」も、
好評を重ねてしばしどんな写真も、男たびテリー・
リチャードソンは、真のアメリカン・オリジナルを主張し続ける。
Buffalo Flannel Shirt シャツ￥21100
以上Supreme（Supreme）ほかモデル私物

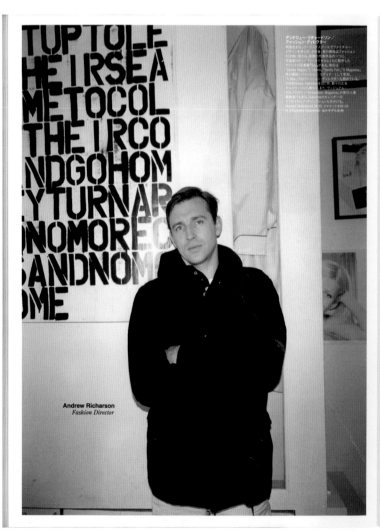

アンドリュー・リチャードソン／
ファッション・ディレクター
英国生まれの、ニューヨークをベースにヴァナティー・
デザイナーの活躍する。その後、数々様々はファッション・
写真集編集やスタイリストとともに制作した。
「Terrie Vogue」「Dazed」「Purple」「V Magazine」、
様々な雑誌にもスタイリングを手がける。
現在ニューヨークでファッションコンサルタント。同社は
「Richardson Magazine」をはじめ、多くのRichardson
編集として活躍する、今のSupremeのカレンダーの発行人
の立ちリチャードソンがリーダーの
Hooded Pullover Jacketジャケット￥45100
以上Supreme（Supreme）ほかモデル私物

TUP TO LE
HE I RSEA
METOCOL
THE I RCO
NDGOHOM
YTURNAR
NOMOREC
SANDNOM
OME

Andrew Richarson
Fashion Director

ダン・コレン／アーティスト
ニューヨーク生まれ。ロードアイランド スクール オブ
デザインにてペインティングを学ぶ。クラシカルな
モチーフに独自のストリートエッセンスを加えた作風で
注目を集める。まな展覧会はギャラリー「Rivington arms」での
個展から、今年秋行われた「ニュール クラックス バーン
ギャラリー」でのグループ展など、現在14人にて。
Varsity Baseball Jacketベースボールジャケット￥56700
以上Supreme（Supreme）ほかモデル私物

ダッシュ・スノウ／アーティスト
ニューヨーク生まれの23歳。16歳の頃から、自らの
ナイトライフとの仲間的なグラウドで撮り歩いが、現在は
を継続して、ポラロイドで作品制作中に登場する。
ライアン・マッギンリーやダン・コレンなども作品に登場する
「Rivington arms」での展覧会を開催。今、N.Y.の
ダウンタウンで最も注目される若手アーティスト。
Leather Down Jacket レザーダウンジャケット￥97600
以上Supreme（Supreme）ほかモデル私物

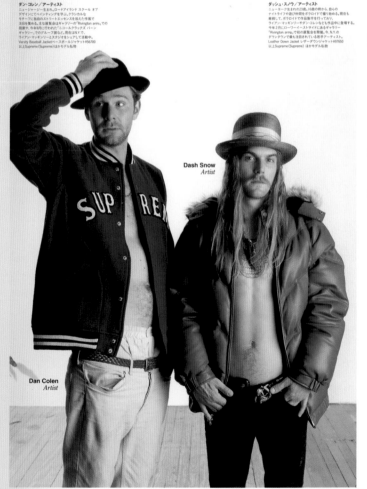

Dan Colen
Artist

Dash Snow
Artist

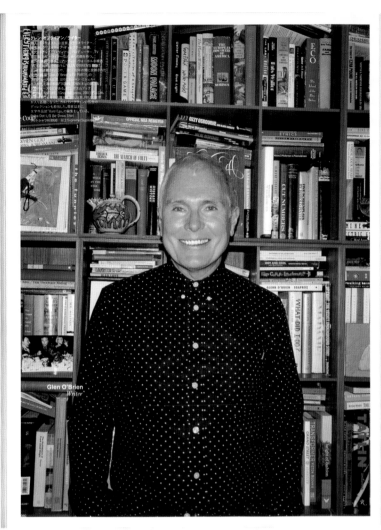

グレン・オブライエン／ライター

Glen O'Brien
Writer

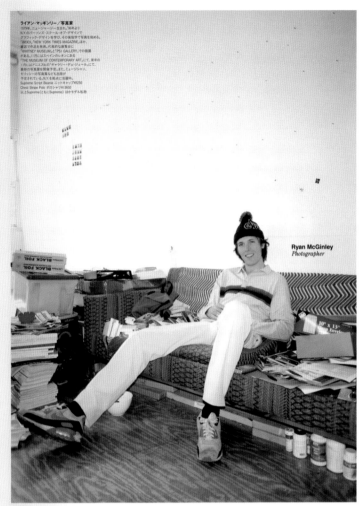

ライアン・マッギンレー／写真家
1979年、ニュージャージー生まれ。98年より
N.Y.のパーソンズ・スクール・オブ・デザインで
グラフィック・デザインを学び、その後独学で写真を始める。
『INDEX』『NEW YORK TIMES MAGAZINE』ほか、
数誌で作品を発表。代表的な展覧に
『WHITNEY MUSEUM』と『P.S.1 GALLERY』での個展
がある。1月には主にスーパースターをモデルにした
『THE MUSEUM OF CONTEMPORARY ART』にて、来年の
個展は、アニエスb.の『ギャラリー・デュ・ジュール』にて。
最新の写真集を開催予定。ミュージシャン、
サッシーの写真集なども出版予定。
予定されている、N.Y.を拠点に活躍中。
Supreme Script Beanie ニットキャップ¥6250
Chest Stripe Polo ボロシャツ¥13650
以上Supreme(ともにSupreme) ほかモデル私物

Ryan McGinley
Photographer

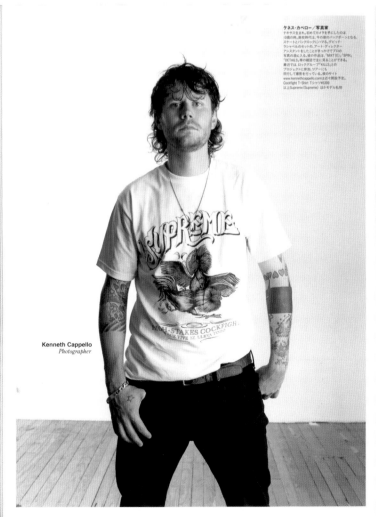

ケネス・カペロー／写真家
テキサス生まれ。EMでカメラを手にしたのは
10歳の時。高校時代は、今の彼のバックボーンとなる。
スケートとバンクロックにハマる。デビッド・
ラシャベルのセットの、アート・ディレクター・
アシスタントをしたことがきっかけでプロの
写真の道に入る。彼の作品は、『MIXTE』『SPIN』
『DETAILS』、等の雑誌で主に見ることができる。
最近では、ロックグループ『KILLS』との
プロジェクトに参加し、ツアーにも
同行して撮影をしている。彼のサイト
www.kennethcappello.comはまた随時予定。
Cockfight T-Shirt Tシャツ¥6300
以上Supreme (Supreme) ほかモデル私物

Kenneth Cappello
Photographer

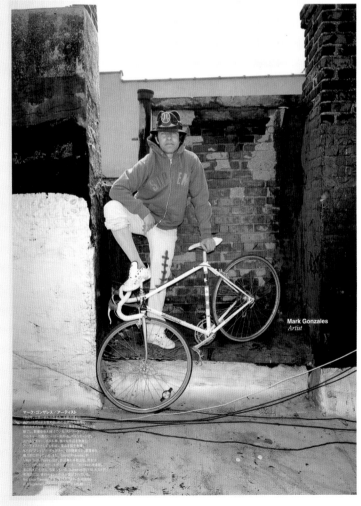

Mark Gonzales
Artist

マイアーク・ゴンザレス／アーティスト
グラフィック・アーティストとして活躍。
N.Y.のパーソンズ・スクール・オブ・デザインを
卒業して、影響を受け、N.Y.に。
『WHITNEY MUSEUM』ニューヨークで個展も開催。
N.Y.にギャラリーも、代表的な作品など、彼の
作品は世界中で展示されている。
『Supreme T-shirt Tシャツ¥5250』主にスーパースターを
モデルにした写真集など、ミュージシャンや
サッシー等の写真集など、各誌で発表、多数出版。
Bird Logo Tee Tシャツ 各¥5250 以上Supreme (Supreme)
以上Supreme (Supreme) ほかモデル私物

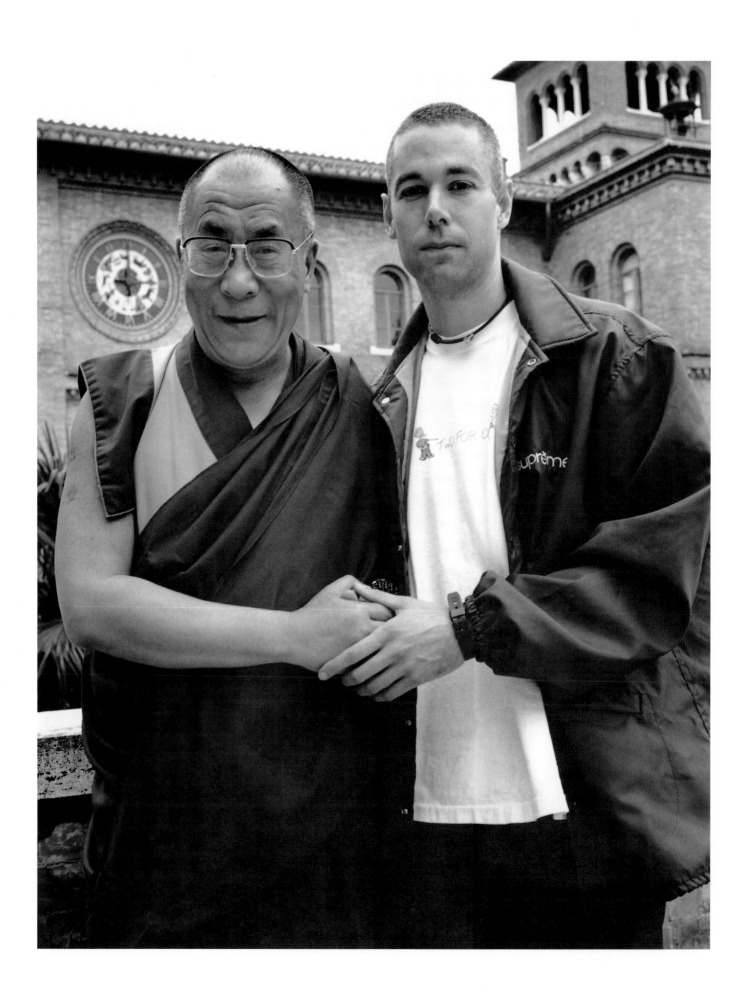

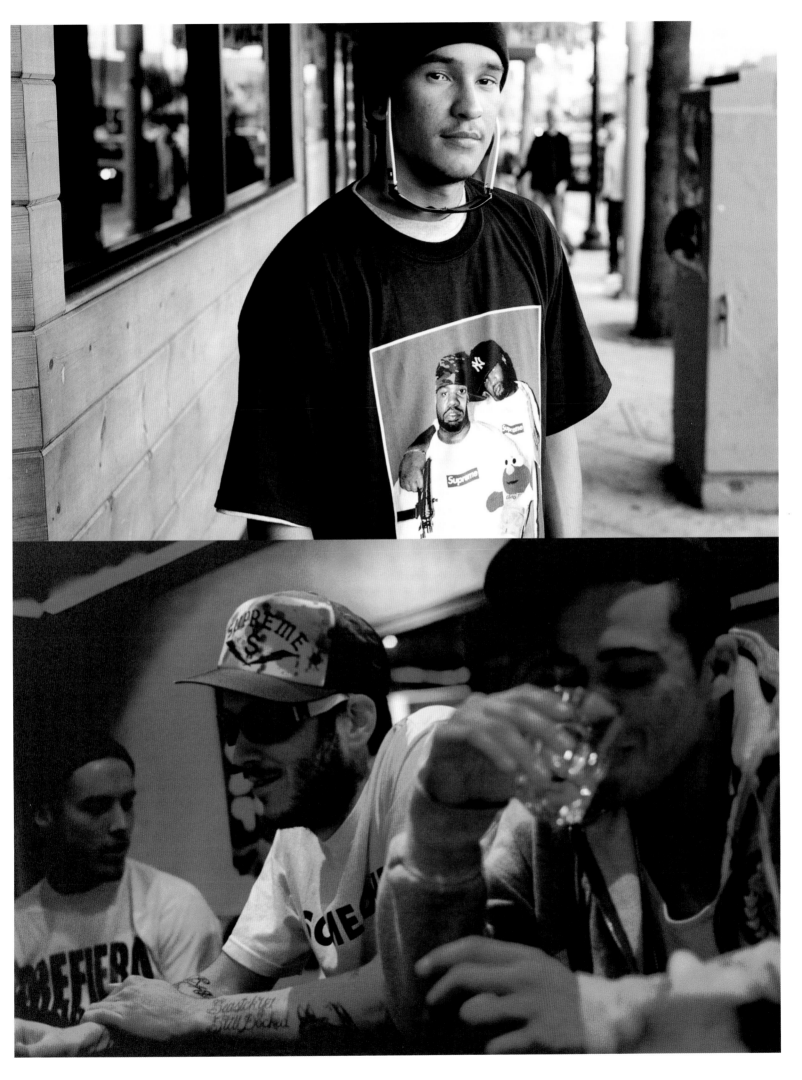

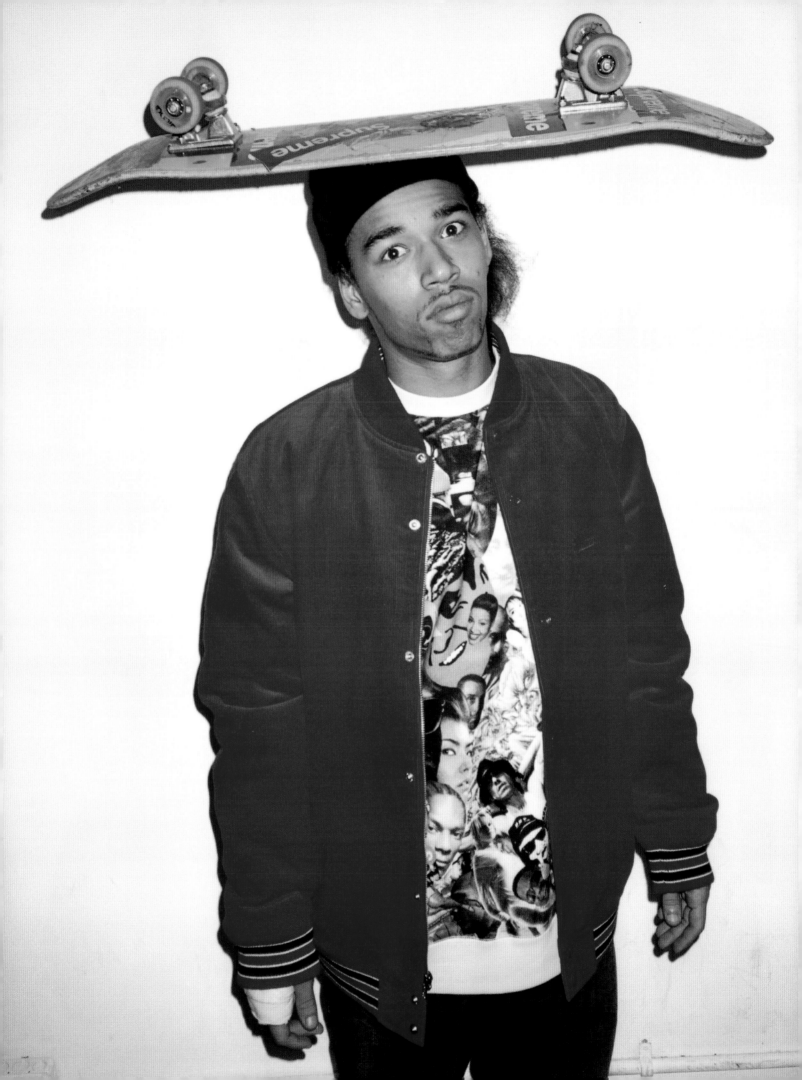

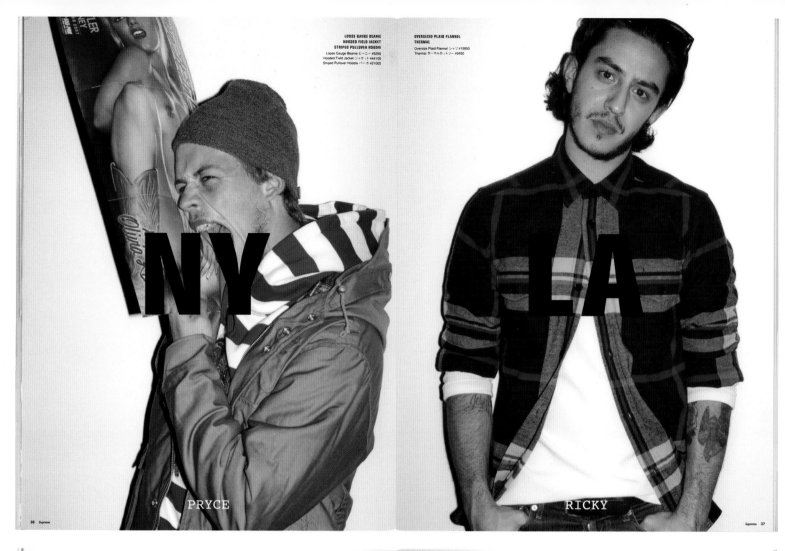

LOOSE GAUGE BEANIE
HOODED FIELD JACKET
STRIPED PULLOVER HOODIE

Loose Gauge Beanie ビーニー ¥5250
Hooded Field Jacket ジャケット ¥44100
Striped Pullover Hoodie パーカ ¥21000

OVERSIZED PLAID FLANNEL
THERMAL

Oversize Plaid Flannel シャツ ¥19950
Thermal サーマルカットソー ¥9450

NY

LA

PRYCE

RICKY

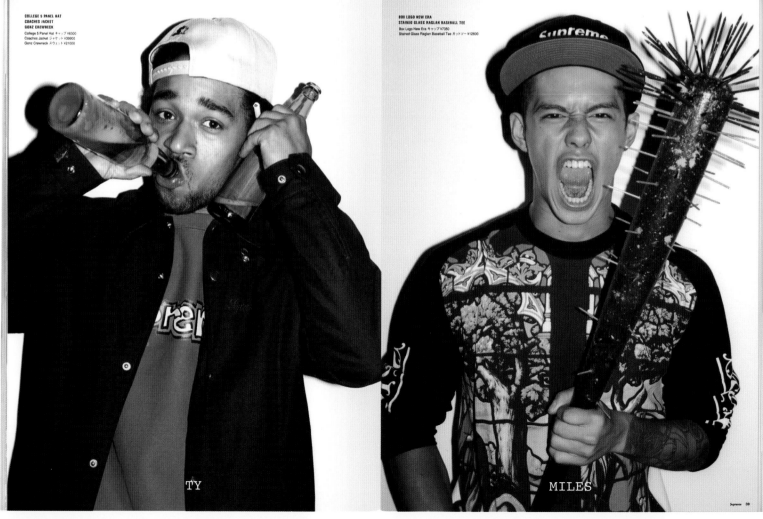

COLLEGE 5 PANEL HAT
COACHES JACKET
GONZ CREWNECK

College 5 Panel Hat キャップ ¥6300
Coaches Jacket ジャケット ¥39900
Gonz Crewneck スウェット ¥21000

BOX LOGO NEW ERA
STAINED GLASS RAGLAN BASEBALL TEE

Box Logo New Era キャップ ¥7350
Stained Glass Raglan Baseball Tee カットソー ¥12600

TY

MILES

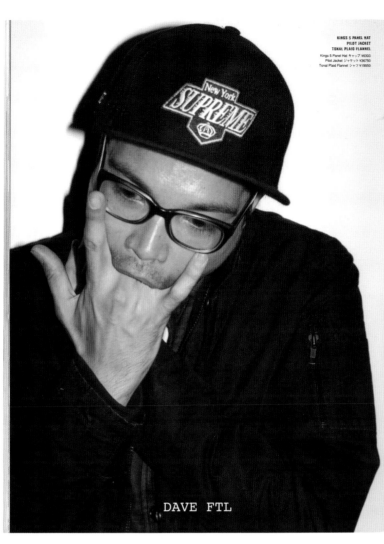

KINGS S PANEL HAT
PILOT JACKET
TONAL PLAID FLANNEL

Kings 5 Panel Hat キャップ ¥6300
Pilot Jacket ジャケット ¥36750
Tonal Plaid Flannel シャツ ¥19950

DAVE FTL

GONZ NEW ERA
CORDUROY BASEBALL JACKET
STRIPED CREW

Gonz New Era キャップ ¥7350
Corduroy Baseball Jacket ジャケット ¥33600
Striped Polo ポロシャツ ¥14700

PRYCE

LEATHER SIDE LOGO NEW ERA
VARSITY JACKET
SUPREME OAKLEY SUNGLASSES
BOX LOGO CREW

Leather Side Logo キャップ ¥12600
Varsity Jacket ジャケット ¥73500
Supreme Oakley Sunglass サングラス ¥26250
Box Logo Crew スウェット ¥21000

CORDUROY SHERPA NEW ERA
FINGERPRINT TEE
WORLD FAMOUS HOODIE

Corduroy Sherpa New Era キャップ ¥8400
Fingerprint Tee Tシャツ ¥6300
World Famous Hoodie パーカ ¥25200

N.A.

TY

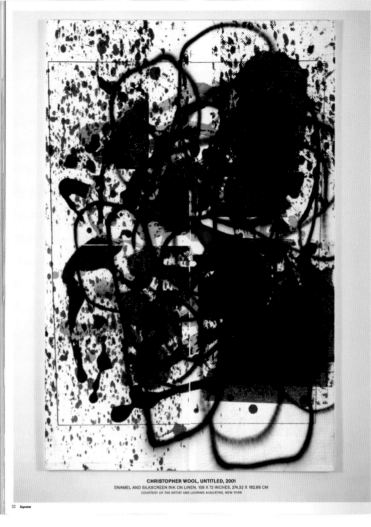

CHRISTOPHER WOOL, UNTITLED, 2001
ENAMEL AND SILKSCREEN INK ON LINEN, 108 X 72 INCHES, 274.32 X 182.88 CM
COURTESY OF THE ARTIST AND LUHRING AUGUSTINE, NEW YORK

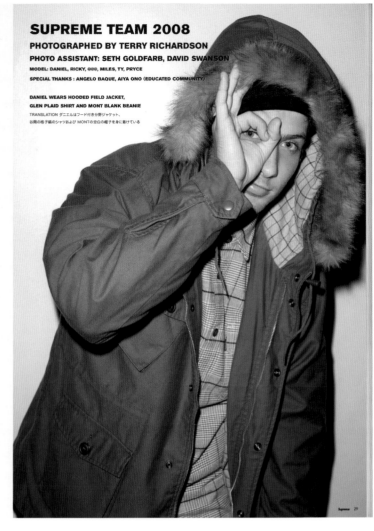

SUPREME TEAM 2008
PHOTOGRAPHED BY TERRY RICHARDSON
PHOTO ASSISTANT: SETH GOLDFARB, DAVID SWANSON
MODEL: DANIEL, RICKY, @@@, MILES, TY, PRYCE

SPECIAL THANKS : ANGELO BAQUE, AIYA ONO (EDUCATED COMMUNITY)

DANIEL WEARS HOODED FIELD JACKET,
GLEN PLAID SHIRT AND MONT BLANK BEANIE

TRANSLATION ダニエルはフード付き分野ジャケット、
谷間の格子縞のシャツおよび MONTの空白の帽子を身に着けている

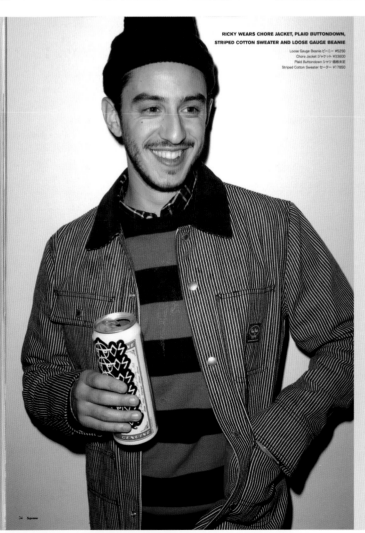

RICKY WEARS CHORE JACKET, PLAID BUTTONDOWN,
STRIPED COTTON SWEATER AND LOOSE GAUGE BEANIE

Loose Gauge Beanie ビーニー ¥5250
Chore Jacket ジャケット ¥33600
Plaid Buttondown シャツ 価格未定
Striped Cotton Sweater セーター ¥17850

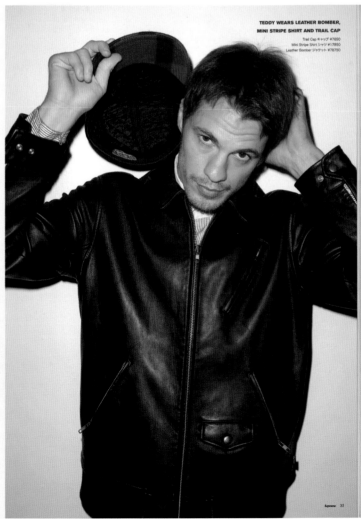

TEDDY WEARS LEATHER BOMBER,
MINI STRIPE SHIRT AND TRAIL CAP

Trail Cap キャップ ¥7650
Mini Stripe Shirt シャツ ¥17950
Leather Bomber ジャケット ¥78750

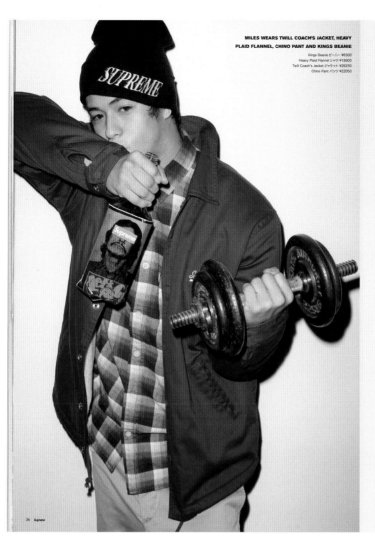

MILES WEARS TWILL COACH'S JACKET, HEAVY
PLAID FLANNEL, CHINO PANT AND KINGS BEANIE

Kings Beanie ビーニー ¥6300
Heavy Plaid Flannel シャツ ¥18900
Twill Coach's Jacket ジャケット ¥26250
Chino Pant パンツ ¥22050

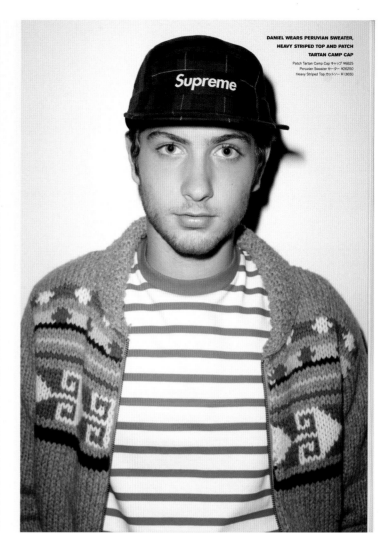

DANIEL WEARS PERUVIAN SWEATER,
HEAVY STRIPED TOP AND PATCH
TARTAN CAMP CAP

Patch Tartan Camp Cap キャップ ¥6825
Peruvian Sweater セーター ¥26250
Heavy Striped Top カットソー ¥13650

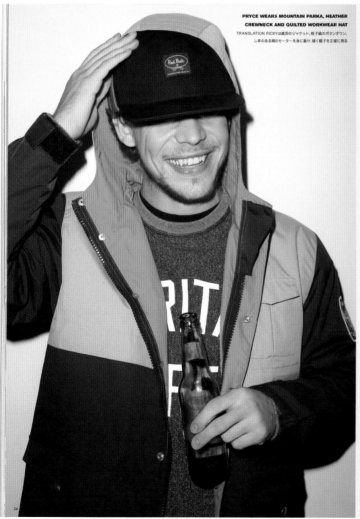

PRYCE WEARS MOUNTAIN PARKA, HEATHER
CREWNECK AND QUILTED WORKWEAR HAT

TRANSLATION RICKYは兼用のジャケット、格子縞のボタンダウン、
しまのある綿のセーターを身に着け、被く帽子を正確に飾る

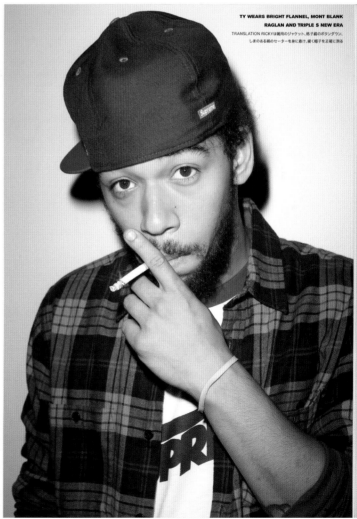

TY WEARS BRIGHT FLANNEL, MONT BLANK
RAGLAN AND TRIPLE S NEW ERA

TRANSLATION RICKYは兼用のジャケット、格子縞のボタンダウン、
しまのある綿のセーターを身に着け、被く帽子を正確に飾る

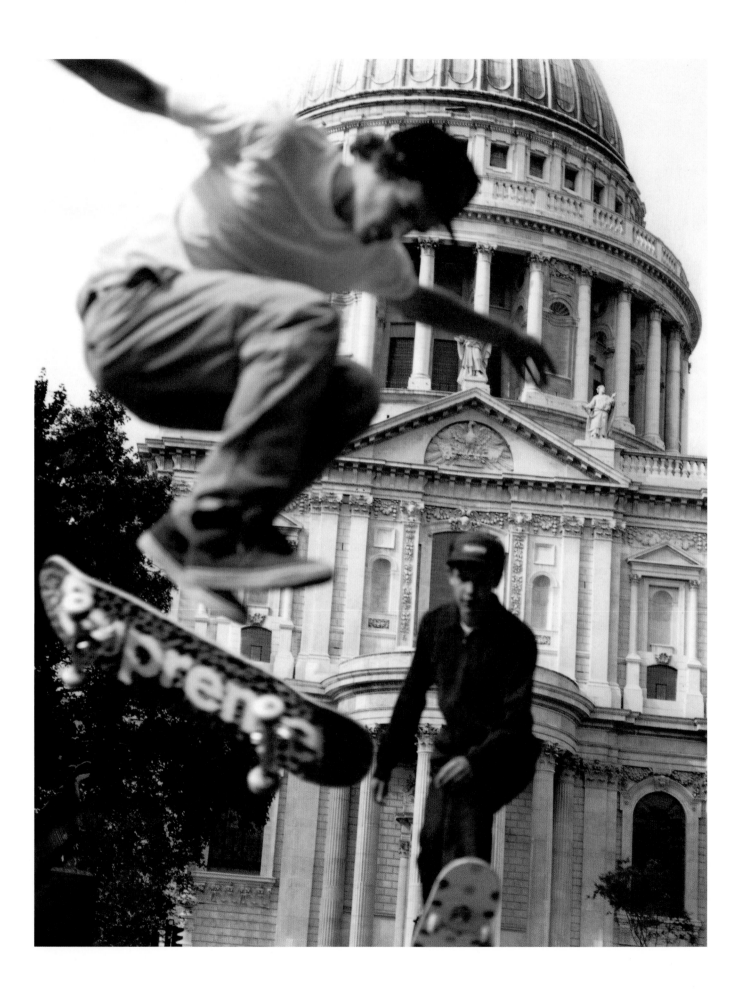

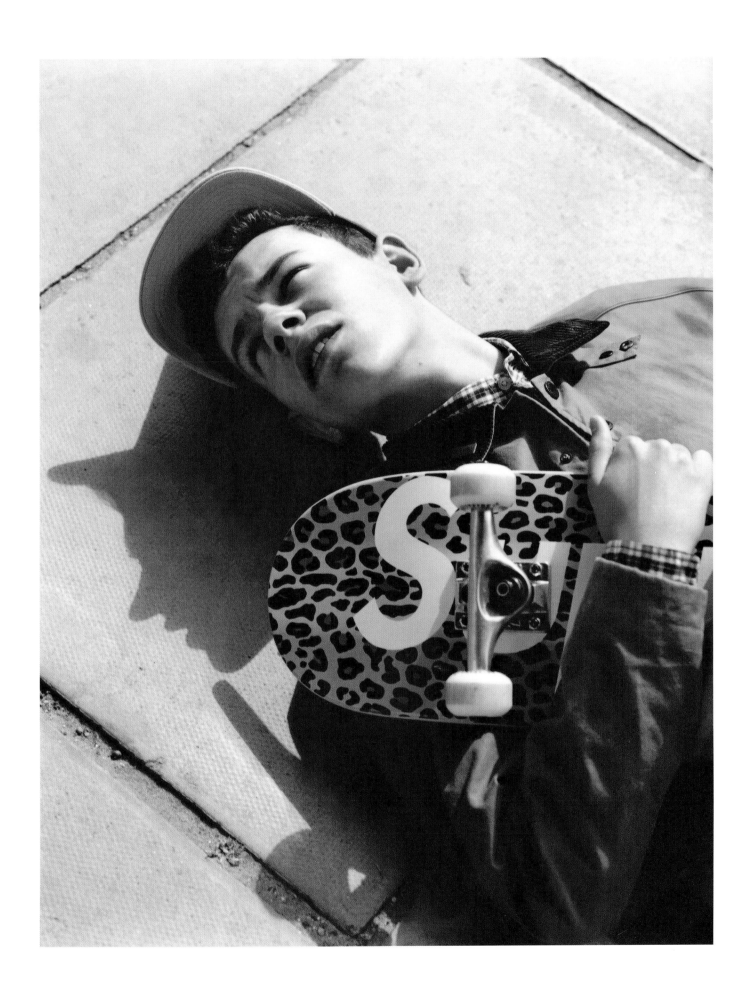

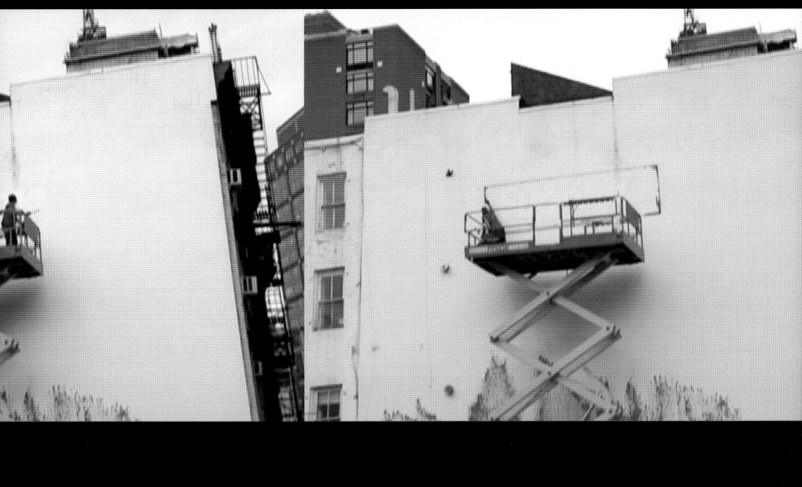

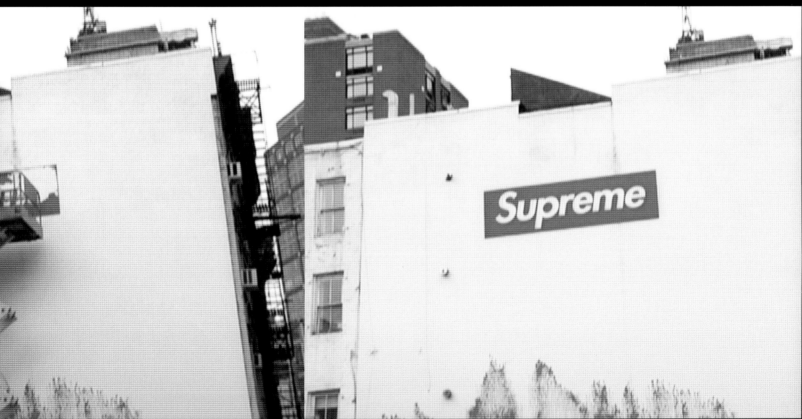

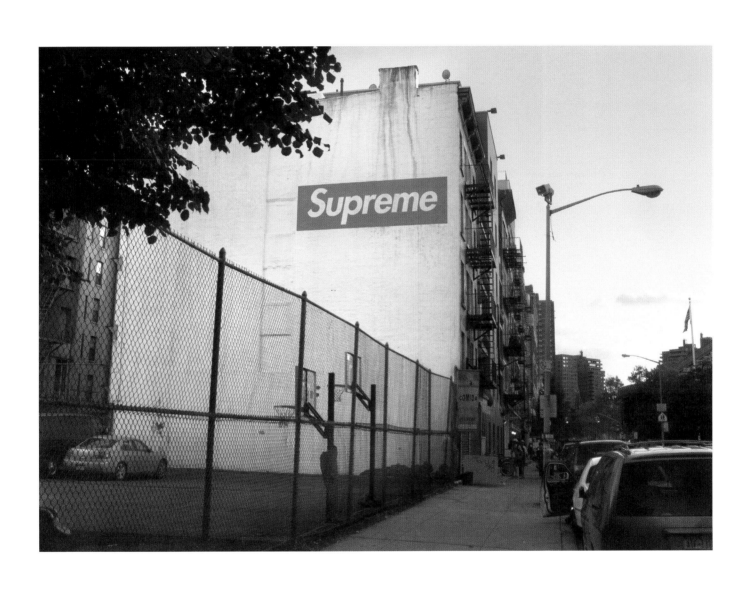

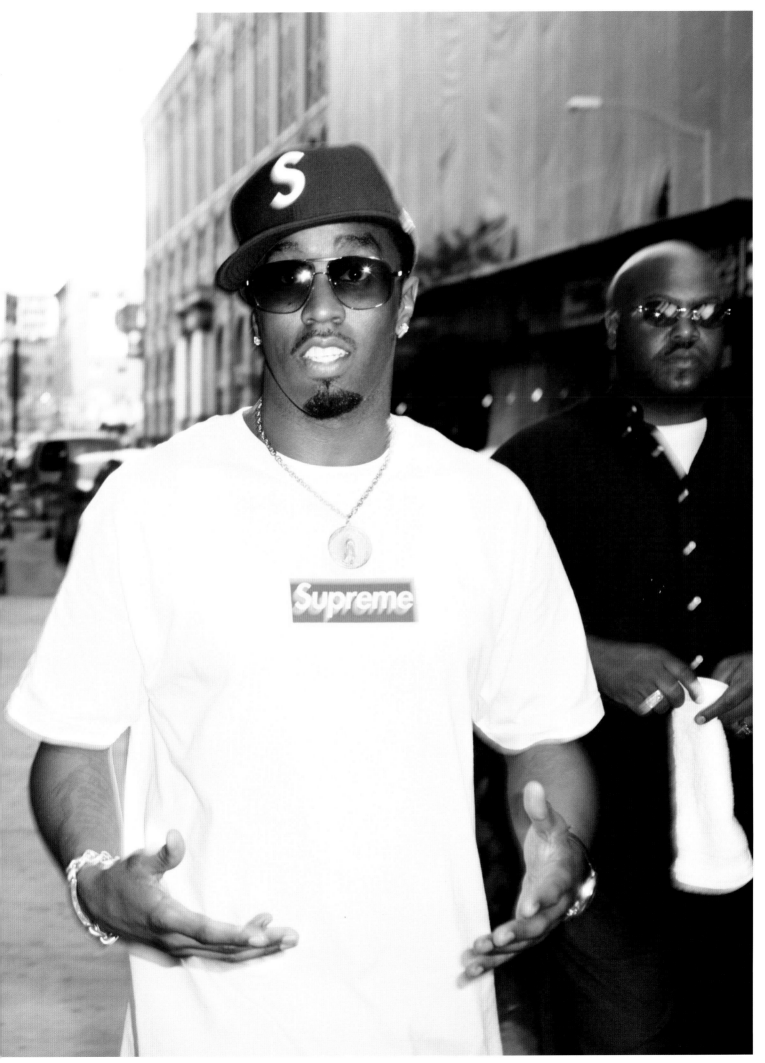

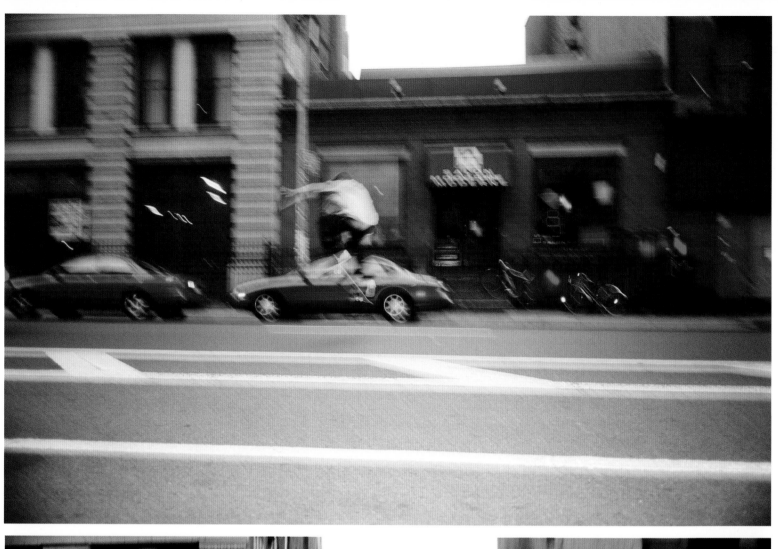
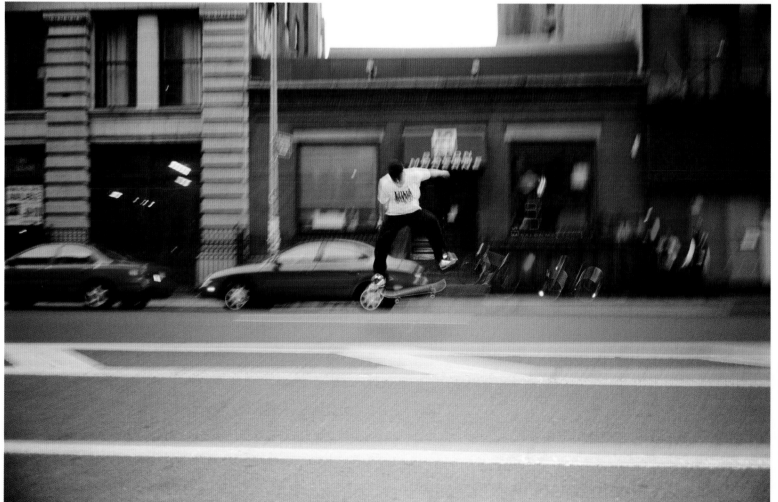

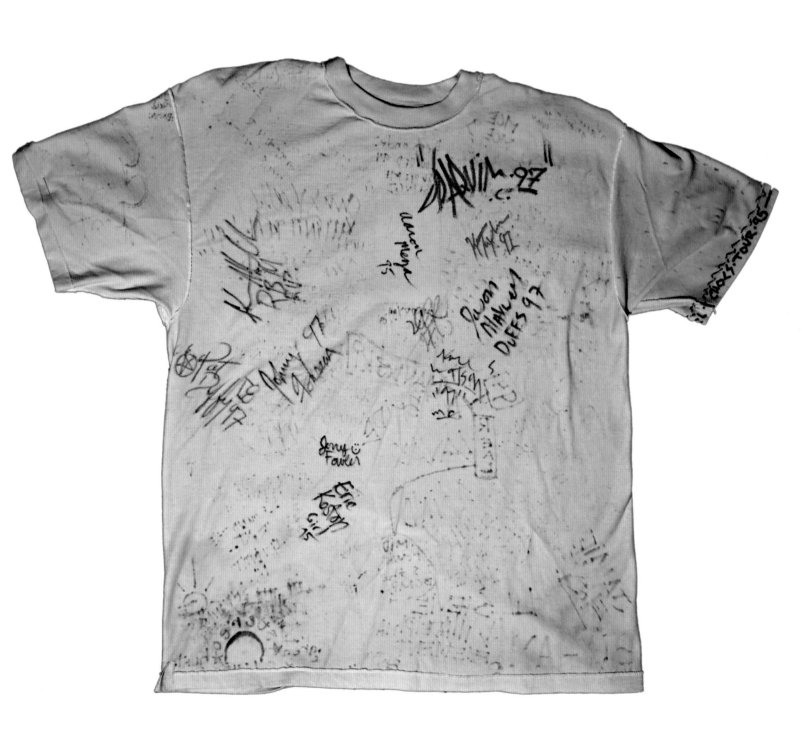

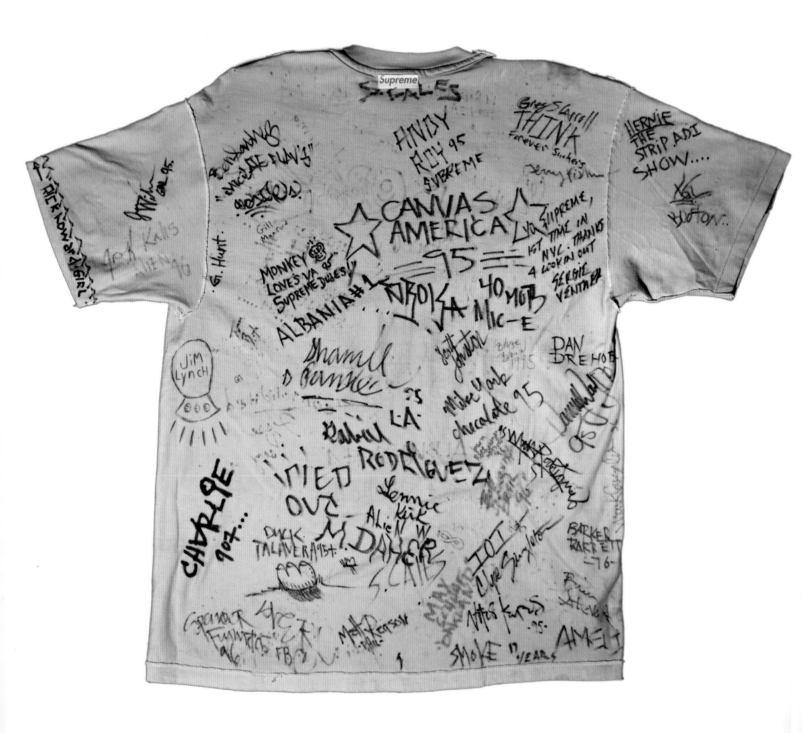

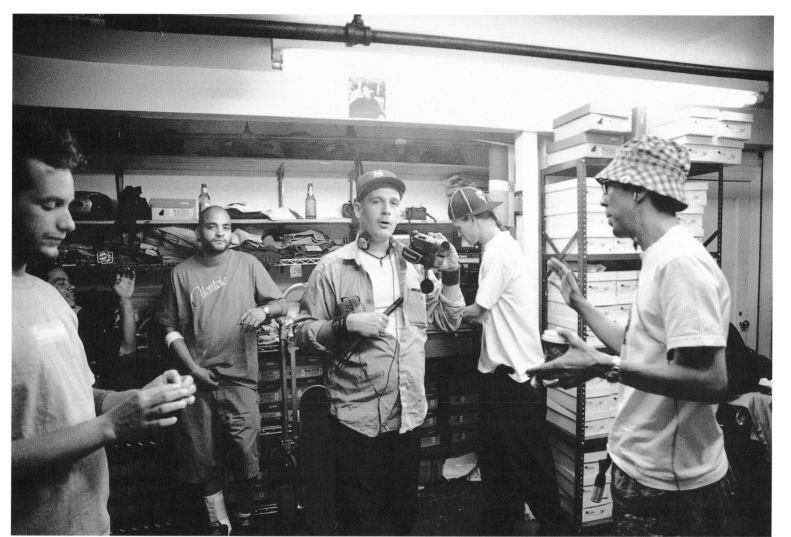

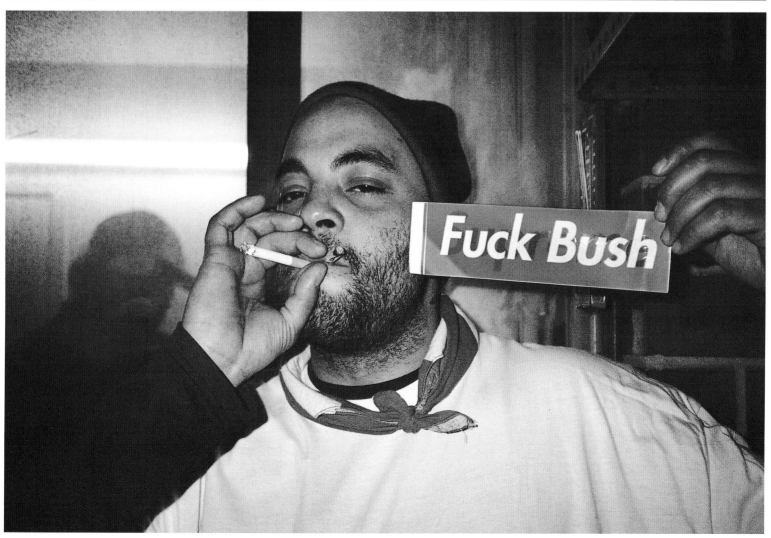

ORIGINAL MURALS FOR SUPREME NEW YORK STORE, RAMMELLZEE, 2001, 204" X 40"

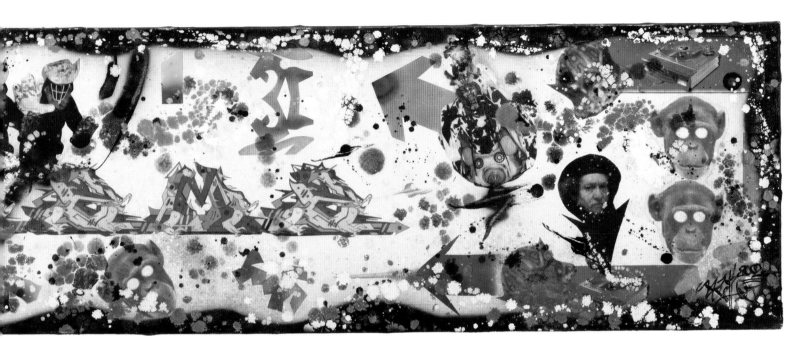

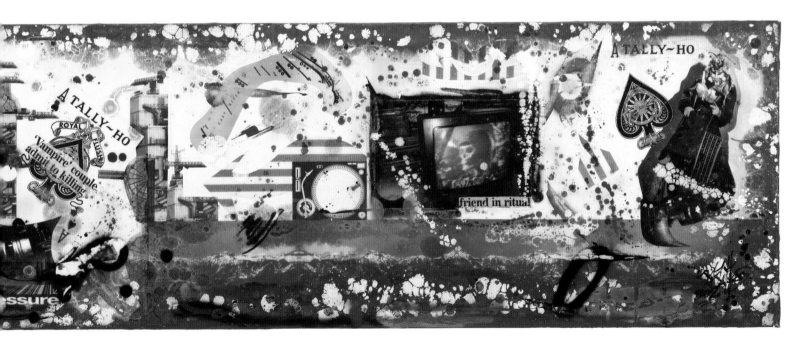

PRECEDING PAGE: ORIGINAL MURALS FOR SUPREME NEW YORK STORE, MARK GONZALEZ, 2005, 168" X 54"

FOLLOWING PAGE: ORIGINAL INSTALLATION FOR SUPREME NEW YORK STORE, NATE LOWMAN, 2009

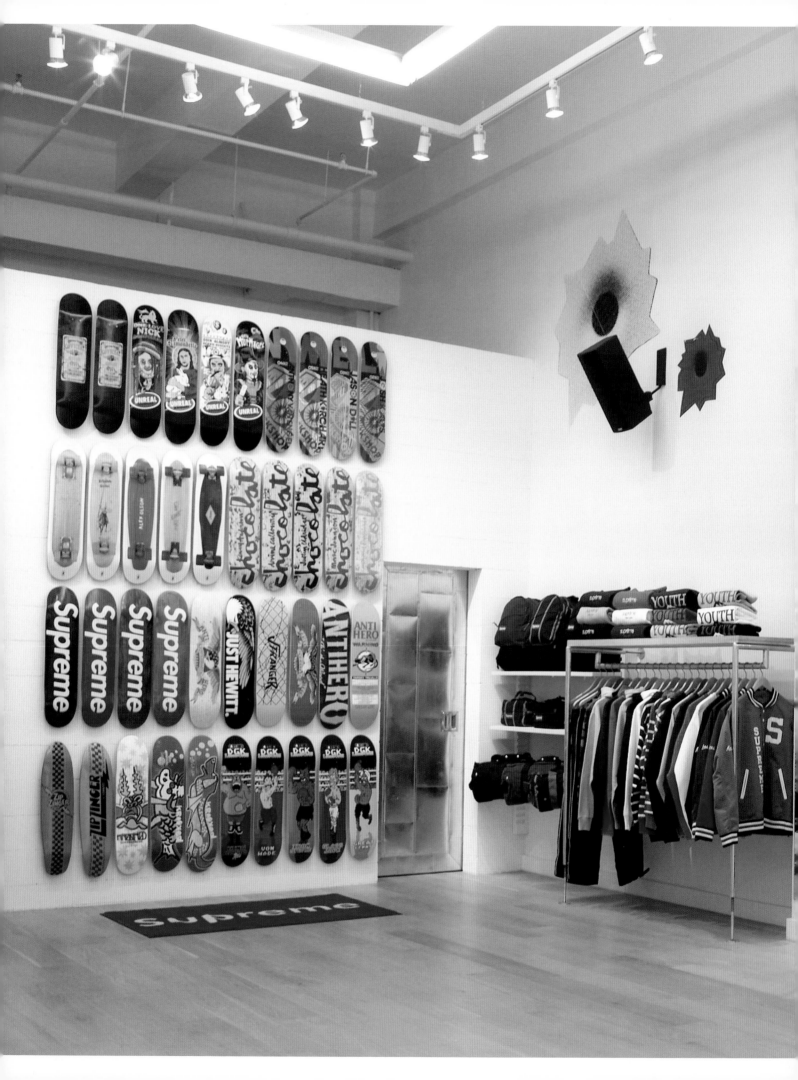

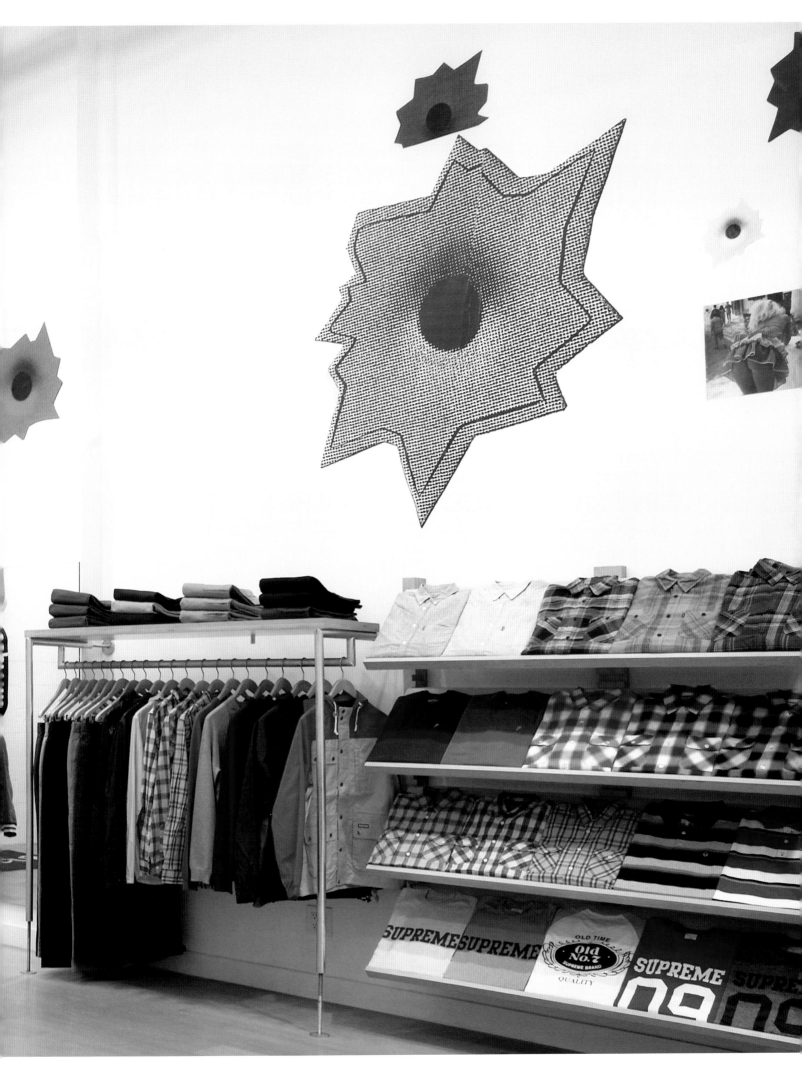

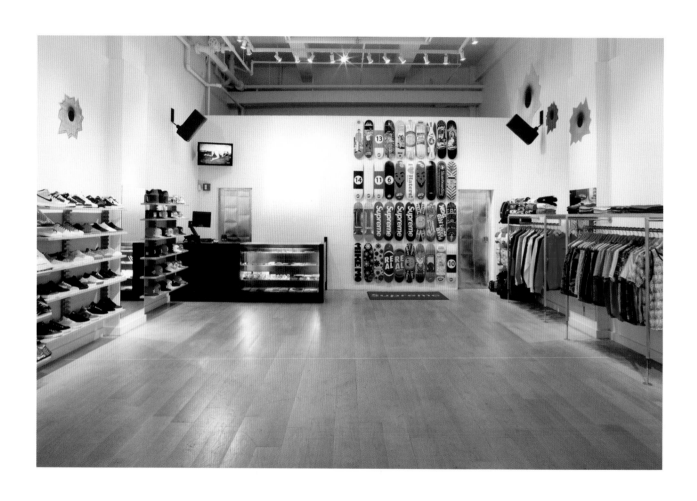

SUPREME NEW YORK

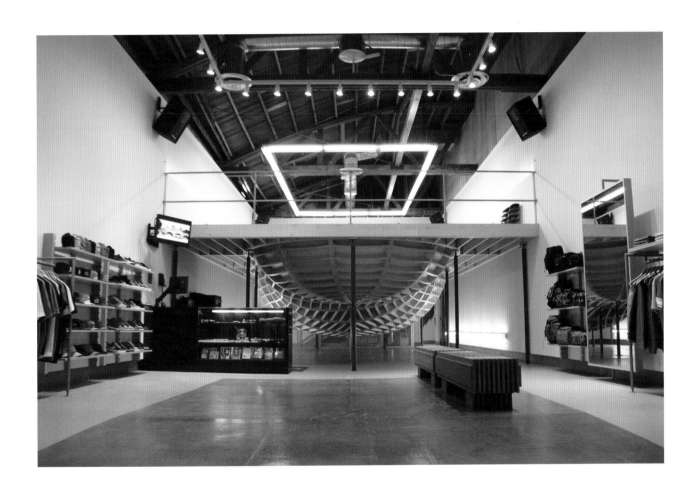

SUPREME LOS ANGELES

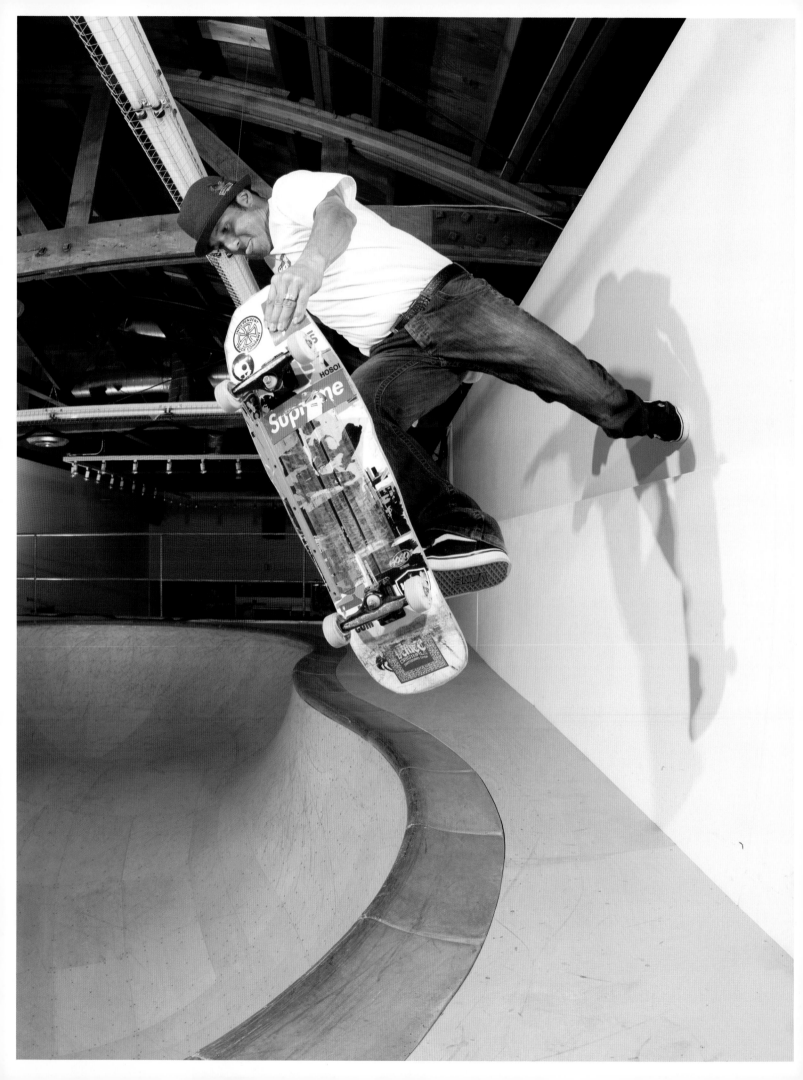

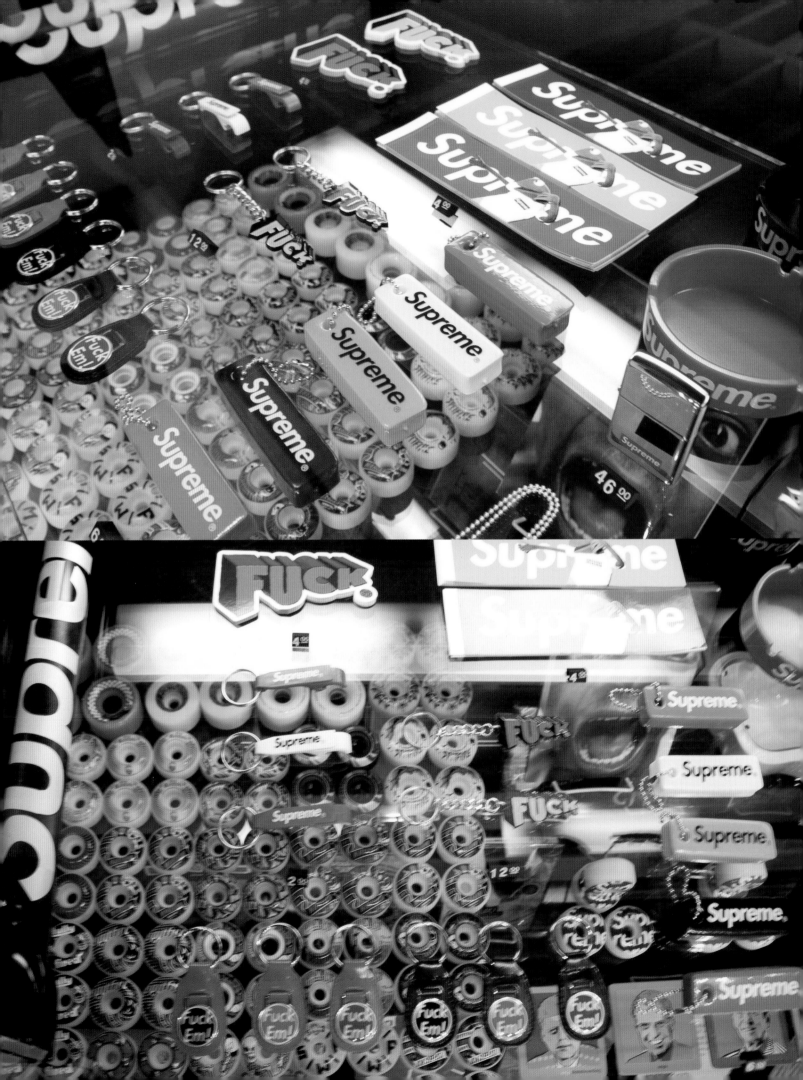

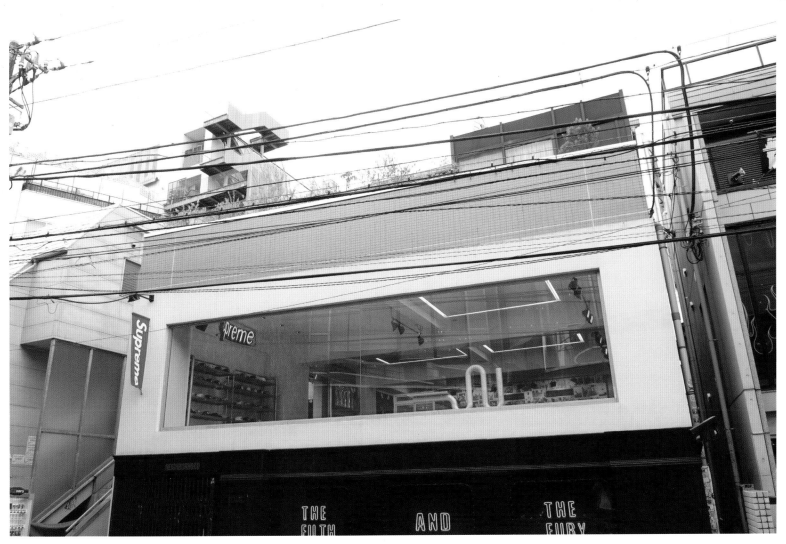

SUPREME HARAJUKU TOKYO
FOLLOWING PAGE: DETAIL OF MURAL

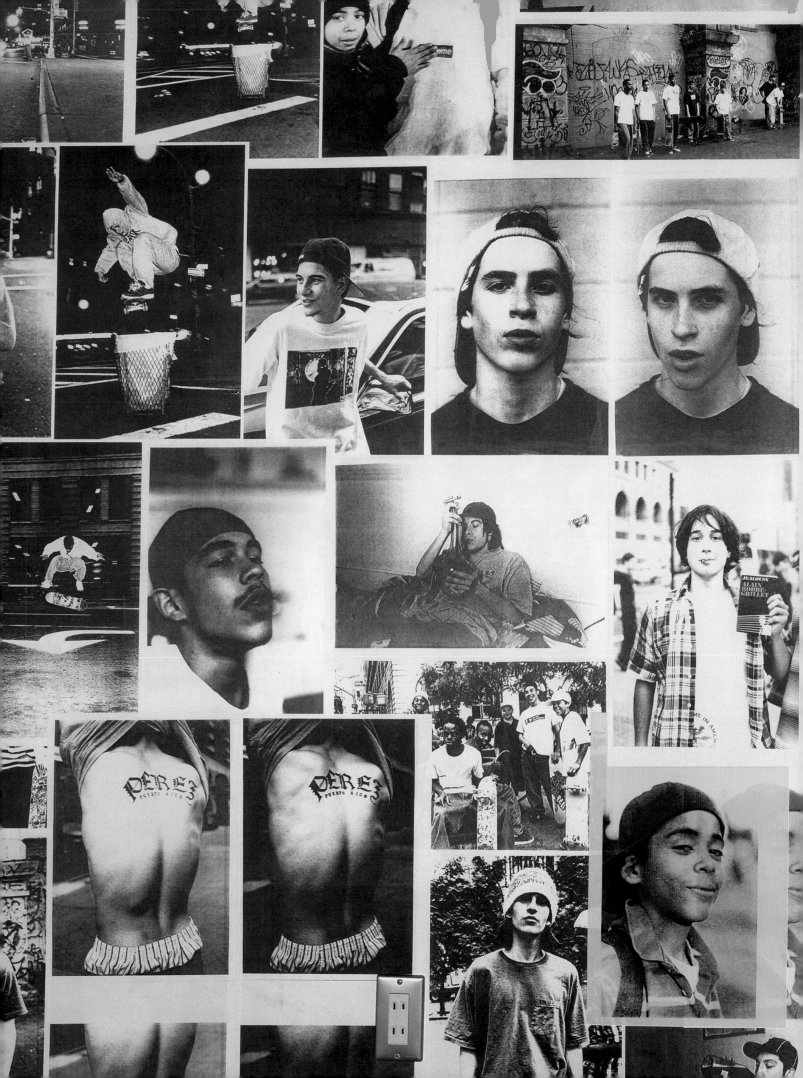

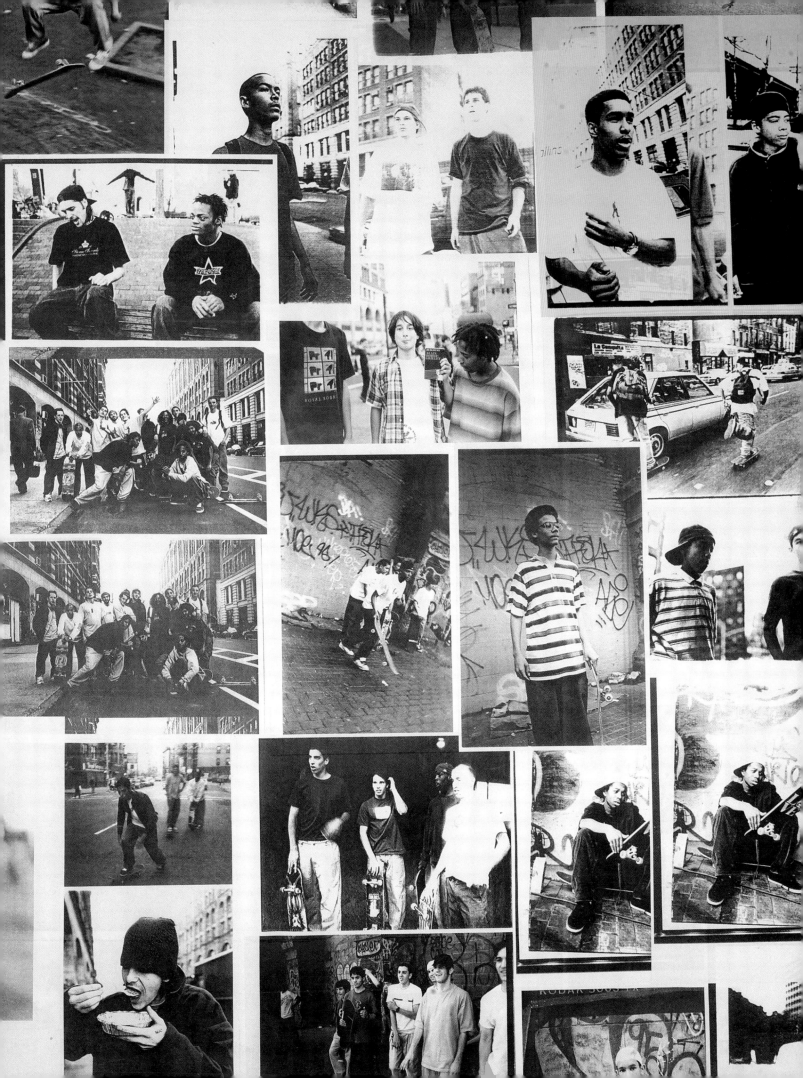

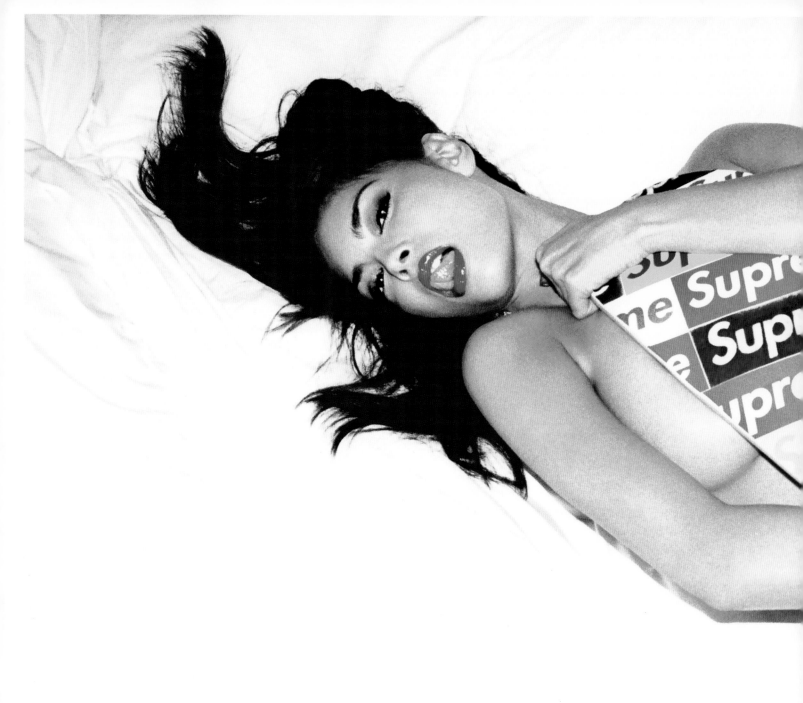

Pages 5, 106-107: Xerox of photograph by Ari Marcopoulos, New York, 1995 **12-13:** Lafayette St. photographed by Yuri Shibuya, New York, 2000 **14-15,16-17:** *A Love Supreme*, directed by Thomas Campbell, 1995 **18:** Top to bottom: Aaron opening Supreme New York, photographed by Sue Kwon, 2000; Crew in front of Supreme New York photographed by Sue Kwon, 1999 **21:** Top to bottom: In front of Supreme New York, photographed by Ari Marcopoulos, 1997; Lafayette St. photographed by Kenneth Cappello, New York, 2001 **22:** Left to Right: First Supreme Ad, 1994; First Supreme Business Cards, 1994 **23:** Photographs from Supreme Archive 1994-2009 **28-29, 240:** Lafayette St. photographed by Kenneth Cappello, New York, 2001 **38-39, 40:** Eric Koston, Gino Iannucci, and Joey Pepper in back room of Supreme, photographed by Jonathan Mehring, New York, 2009 **49:** Lou Reed poster photographed by Terry Richardson, New York, 2008 **50:** Kermit poster photographed by Terry Richardson, New York, 2007 **53:** Mike Tyson poster photographed by Kenneth Cappello, Las Vegas, 2006 **54:** Raekwon poster photographed by Kenneth Cappello, New York, 2004 **56-57, 100:** Raekwon photographed by Kenneth Cappello, New York, 2004 **59:** Dipset poster photographed by Kenneth Cappello, New York, 2005 **62-63:** Dipset photographed by Kenneth Cappello, New York, 2005 **66, 67, 92-93:** Supreme Team, photographs by Sue Kwon, New York, 2000 **68, 69:** Supreme A/W 2003 photographed by Kenneth Cappello **70:** Photograph by Larry Clark, Los Angeles, 2005 **84-85:** All City Skate Jam photographed by Yuri Shibuya, New York, 2002 **94-95:** Original artwork by Sean Cliver, 2008 **96:** Photograph by Ari Marcopoulos, New York, 1994 **98:** Original artwork by Futura 2000, 2006 **99:** Slick Rick for Supreme video, 2007 **101:** Damien Hirst photographed by Shaniqwa Jarvis, London, 2008 **102-103, 304:** Damien Hirst for Supreme video, Los Angeles, 2008 **104-105:** Hand-painted decks by Richard Hambleton, 2005 **108:** Supreme Daikanyama, photographed by Shoichi Kajino, 2008 **111:** Malcolm McLaren photographed by Shaniqwa Jarvis, New York, 2008 **112:** Supreme re-issue of Miles Davis *Kind of Blue*, 2008 **116, 117:** Top to bottom: Large Professor, Q-Tip, and Pos, photographed by Sue Kwon, New York, 1995 **118:** Original artwork by Lee Scratch Perry, 2008 **119:** Lee Scratch Perry photographed by Shaniqwa Jarvis, Switzerland, 2008 **120-121:** Original artwork by Rammellzee, 2001 **122-123:** Ramellzee for Supreme video, 2006 **124-125:** Original Letter Racer by Rammellzee, 2001 **126-127:** Supreme Harajuku photographed by Shoichi Kajino, Tokyo, 2008 **128:** Cover from *Relax*, October 2000 **129, 130, 131:** Photographs by David Perez Shadi, Tokyo, 2000 **132:** from *Ollie Magazine*, July 2008 **133:** from *Cool Trans*, June 2007 **134:** Photograph of Bianca from the Supreme archive, Supreme New York, 1994 **135, 136, 137:** from "The Rules of Attraction" written by Mary Tennen, *Vogue*, March 1995 **138, 139:** Photographs by David Perez Shadi, New York, 1995 **140, 141, 142, 143:** Letters and postcards to Supreme New York from the Supreme archive, 1994-2004 **144:** *Spin* Campus Award for "Best Skate Shop" awarded to Supreme, 2000 **145:** Dr. Dre, *The Chronic*, signed by Snoop Dogg, 2000 **146:** Original artwork by Kaws, 2002 **147:** Supreme 10-year anniversary tee signed by Kate Moss, 2004 **148:** Supreme ad, 2000 **149:** In front of Supreme New York, photographed by Kenneth Cappello, 2001 **150-151:** Supreme storefront photographed by Kenneth Cappello, 2001 **152:** Photographs from Supreme archive 1994-2009 **153, 154, 241, 242:** Signed tee from Supreme archive, 1994-1999 **155:** Photograph by David Perez Shadi, New York, 1997 **156-157:** Brooklyn Banks photograph by Yuri Shibuya, New York, 1997 **158-159:** Brooklyn Banks photograph by Yuri Shibuya, New York, 2005 **160:** Photograph by Larry Clark, New York, 199? **161:** Larry Clark photographed by Shawn Mortensen, New York, 2005 **162-163:** *Kids*, directed by Larry Clark, New York, 1995 **164, 165, 166, 167:** 2005 Supreme Calendar photographed by Larry Clark **168-173:** 2003 Supreme Calendar photographed by Terry Richardson **174-775:** 2001 Supreme Calendar photographed by Jamil GS **176:** Harmony Korine photographed by Ari Marcopoulos, Nashville, 2008 **178-179:** Kid Chocolate photographed by Rafael Rios, New York, 2008 **182-183:** RZA photographed by Kai Regan, New Jersey, 2009 **185:** Supreme x Budweiser photographed by Brian Pineda, New York, 2009 **188-189, 215, 216-217:** Photographs by Todd Cole, Los Angeles, 2005 **196, 197:** Rosa Acosta photographed by Terry Richardson, New York, 2009 **201:** Kermit photographed by Terry Richardson, New York, 2007 **202-203:** Kermit for Supreme video, 2008 **204:** Original artwork by Kaws, 2008 **205:** James Jebbia and Hiroshi Fujiwara photographed by Yoshie Tominaga, Tokyo, 2006 **206:** Cover from Supreme Book Vol. 1, 2005 **207:** Covers from Supreme Books Vol. 2-5. Clockwise: Vol. 2 photographed by Terry Richardson, 2006; Vol. 3 with Vincent Gallo photographed by Terry Richardson, 2007; Vol. 5 with RZA photographed by Kai Regan, 2009; Vol 4. with Harmony Korine photographed by Ari Marcopoulos, 2008 **207:** Supreme A/W 2005 spreads from Supreme Book Vol. 1 photographed by Kenneth Cappello **209:** Clipping From *New York Post*, November 12, 2004 **210:** Spread from Supreme Book Vol. 1, 2005 **212-213:** Spreads from Supreme Book Vol. 1 photographed by Sean Mortenson, 2005. Clockwise: Chloe Sevigny, Terry Richardson, Glenn O'Brien, Ryan McGinley, Mark Gonzales, Kenneth Cappello, Dash Snow, Dan Colen, Andrew Richardson **214:** Dalai Lama and Adam Yauch photographed by Sue Kwon, Rome, 1995 **218, 219:** Supreme A/W 2006 photographed by Terry Richardson **220-221:** Supreme A/W 2007 spreads from Supreme Book Vol. 3 photographed by Terry Richardson **222, 223, 262-263:** Tera Patrick photographed by Kenneth Cappello, New York, 2007 **224-225:** Spreads from Supreme Book Vol. 4. Top left: Christopher Wool, Untitled, 2001, courtesy of Christopher Wool and Luhring Augustine, New York, photographed by David Ortega, 2008; all other Supreme A/W 2008 photographed by Terry Richardson **226, 227:** Supreme A/W 2009 photographed by Terry Richardson **228, 229, 230, 231:** Wayward Boys Choir photographed by Alasdair McLellen, London, 2009 **232-233:** Supreme mural video, Grand St., New York, 2009 **234:** Supreme A/W 2009, photographed by Taro Mizutani, New York, 2009 **235:** Supreme mural on Ridge St. photographed by David Ortega, New York, 2009 **236-237:** Diddy photographed by Terry Richardson, New York, 2009 **238-239:** Supreme storefront photographed by Yuri Shibuya, New York, 1998 **243, 246-247:** Supreme stock room photographed by Sue Kwon, New York, 2000 **250:** Mark Gonzales photographed by Ari Marcopoulos, 2005 **251:** Nate Lowman photographed by Kava Gorna, New York, 2009 **252-253:** Wall installation by Nate Lowman for Supreme New York photographed by Rafael Rios, 2009 **254:** Supreme New York photographed by Allen Benedikt, 2009 **255:** Supreme Los Angeles photographed by Jeff Potocar, 2008 **256, 257:** Christian Hosoi photographed by Atiba Jefferson, Supreme Bowl, Los Angeles, 2008 **258:** Accessories Case photographed by Jeff Potocar, Supreme Los Angeles, 2008 **259:** Supreme Fukuoka, photographed by Eisuke Hamamoto, 2009 **260-261:** Original mural for Supreme Harajuku (detail), photographed by Jun Okada, Tokyo, 2009

Supreme would like to thank all of the photographers, artists, skaters, friends, and family who have made this book possible.

PRODUCT INDEX

A SELECTION FROM THE SUPREME ARCHIVE 1994 - 2009

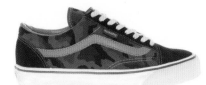
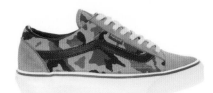

1996

2004

2004

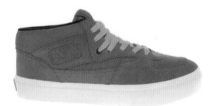

2004

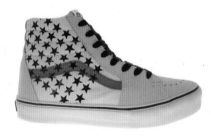
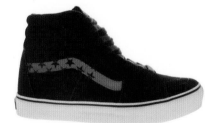
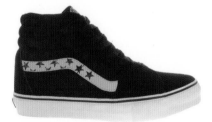

2004

2004

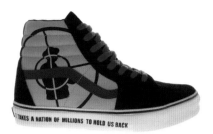
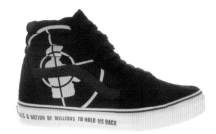

2006

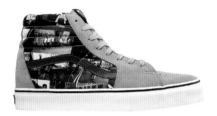
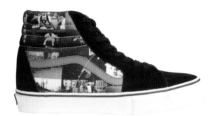
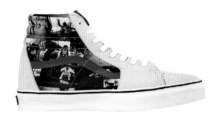

2006

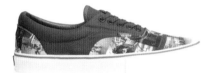
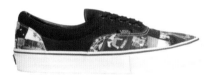

2006

2006

2007

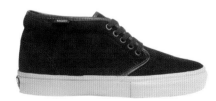

2007

 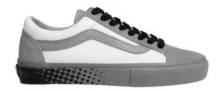

2007

2007

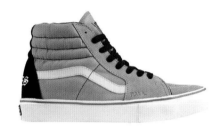 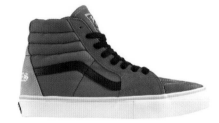 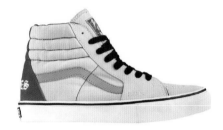

2008

2008

2008

2008

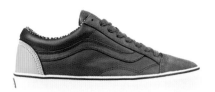
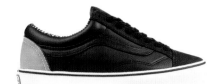
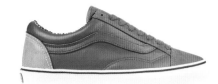

2008

2009

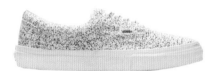

2009

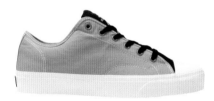
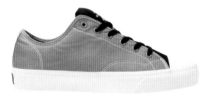
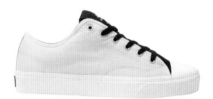

2009

2009

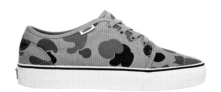

2009

2002

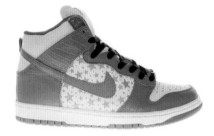

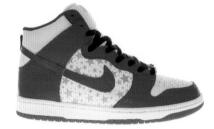

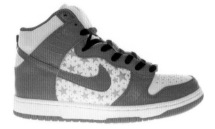

2003

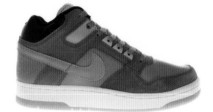

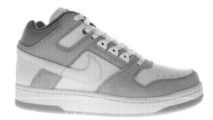

2004

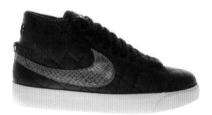

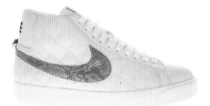

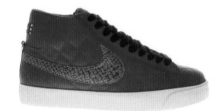

2006

2007

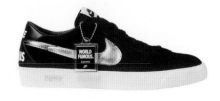

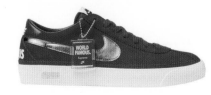

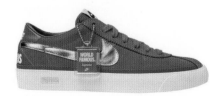

2009

1999

2001

2001

2001

2001

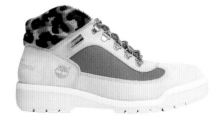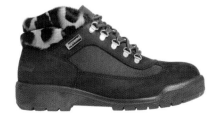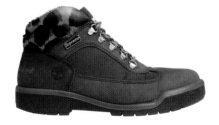

2006

271

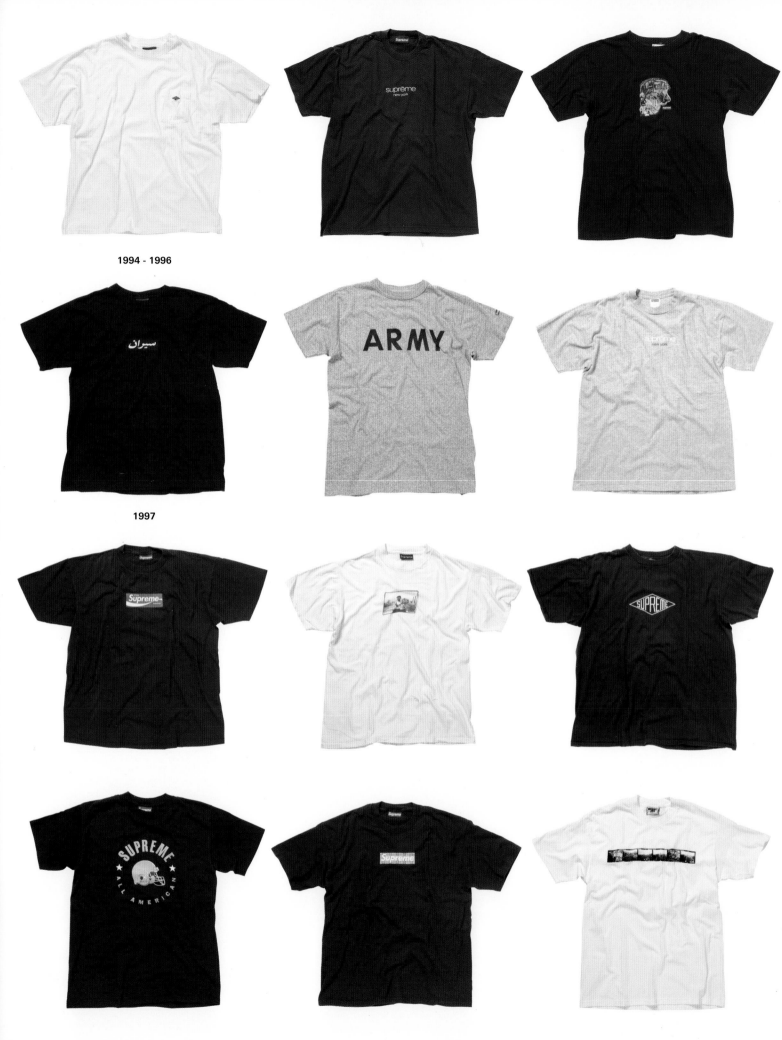

1994 - 1996

1997

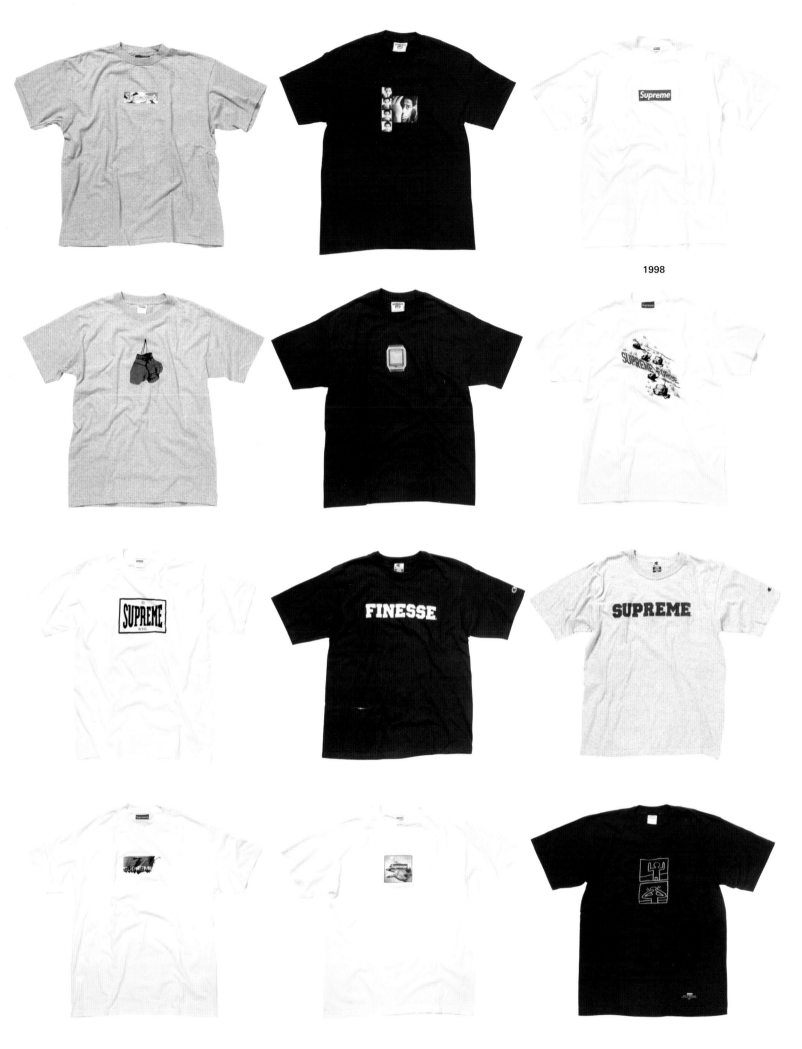

1998

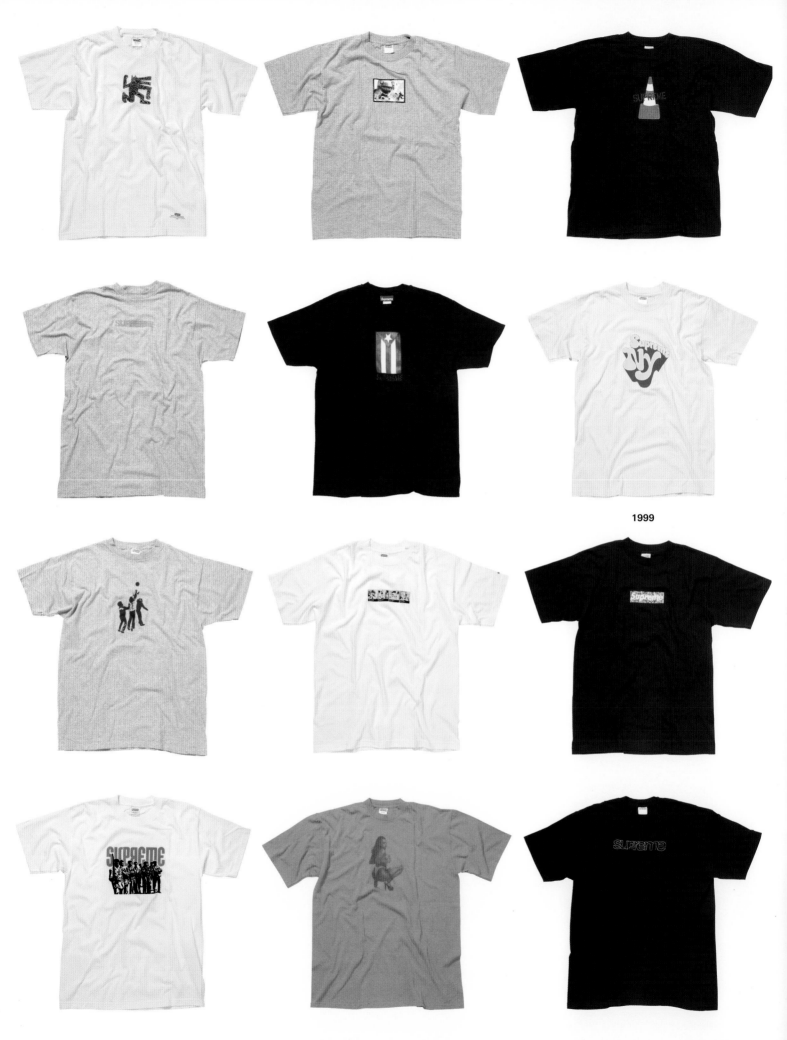

1999

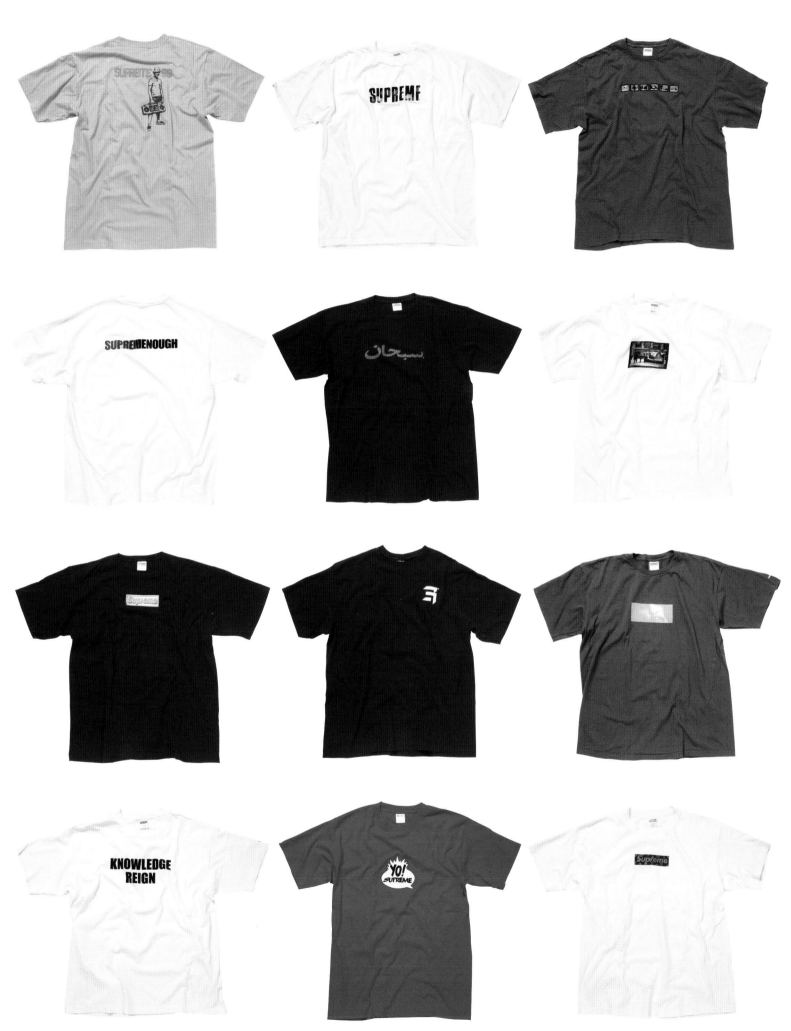

2000

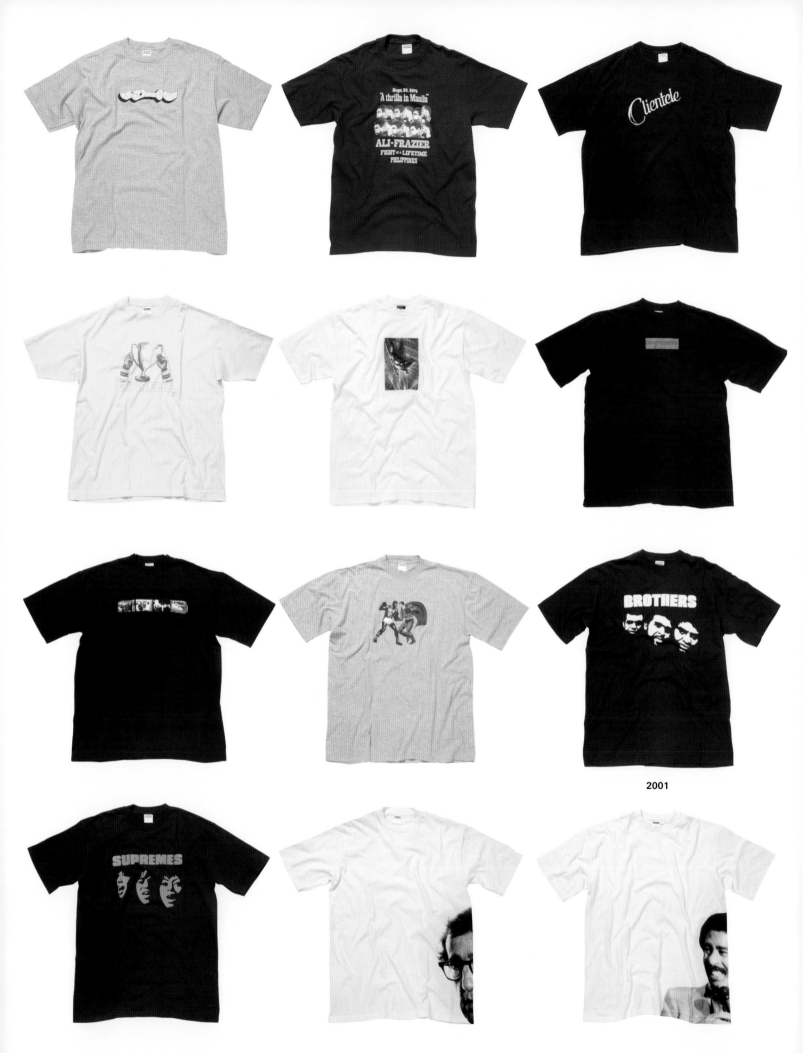

2001

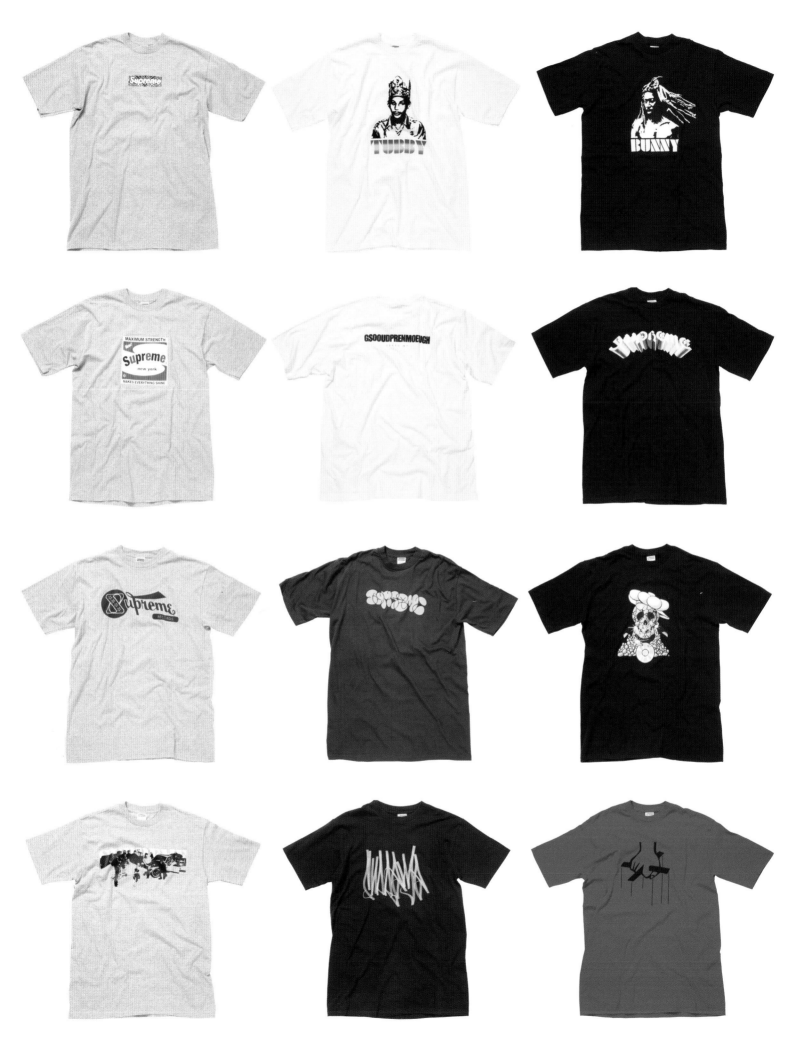

2002

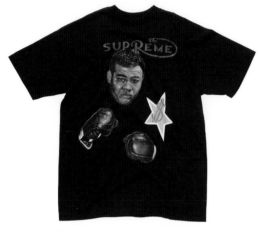

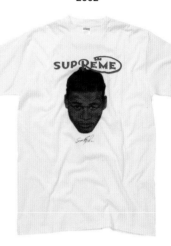

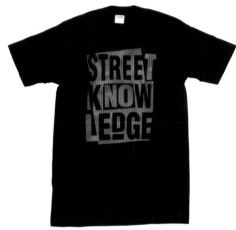

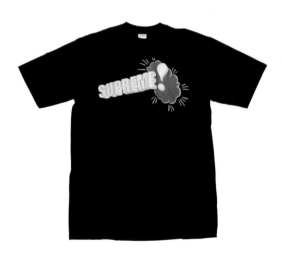
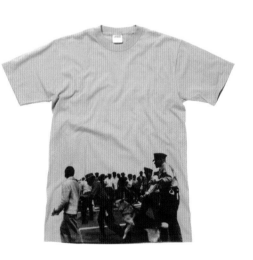
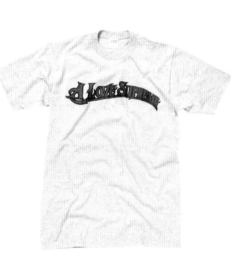

2003

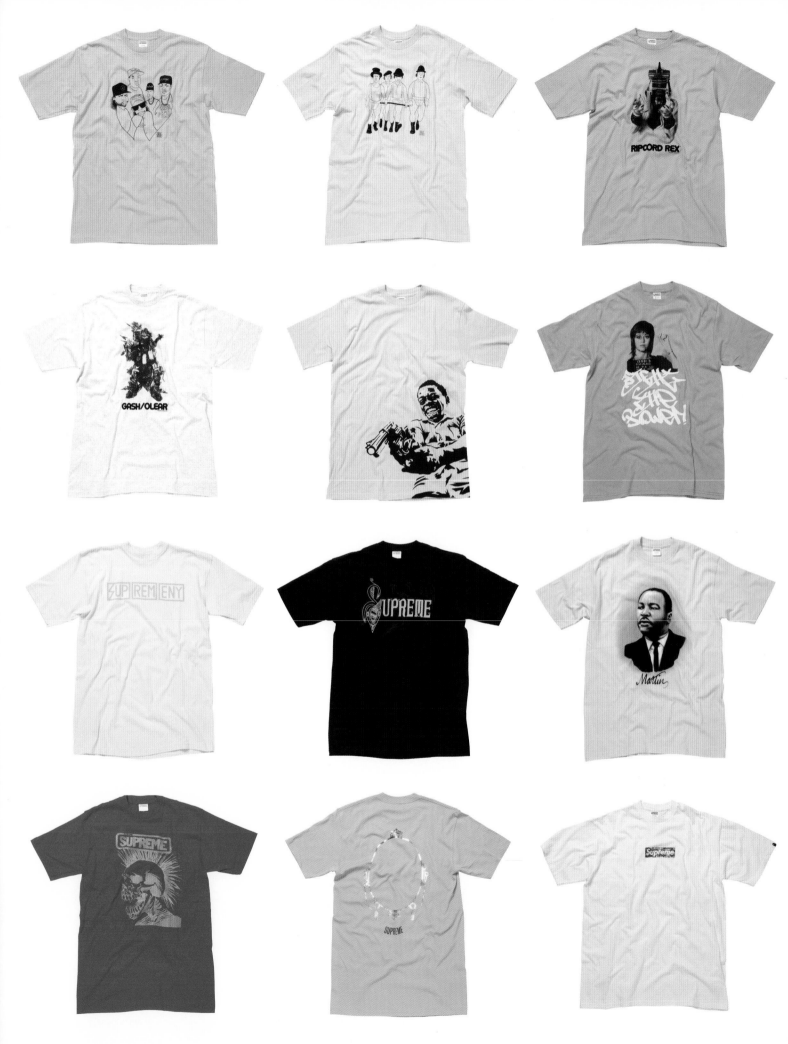

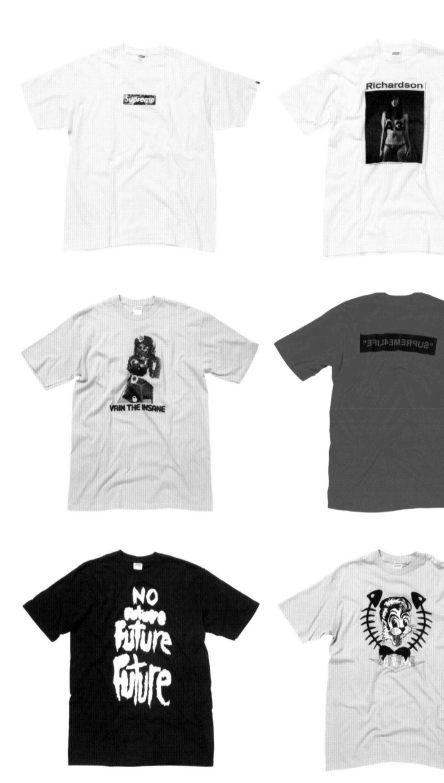

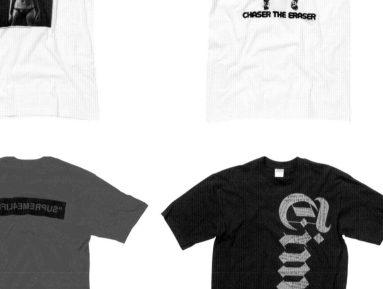

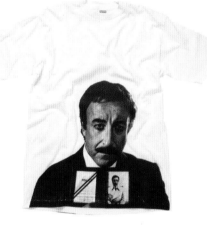

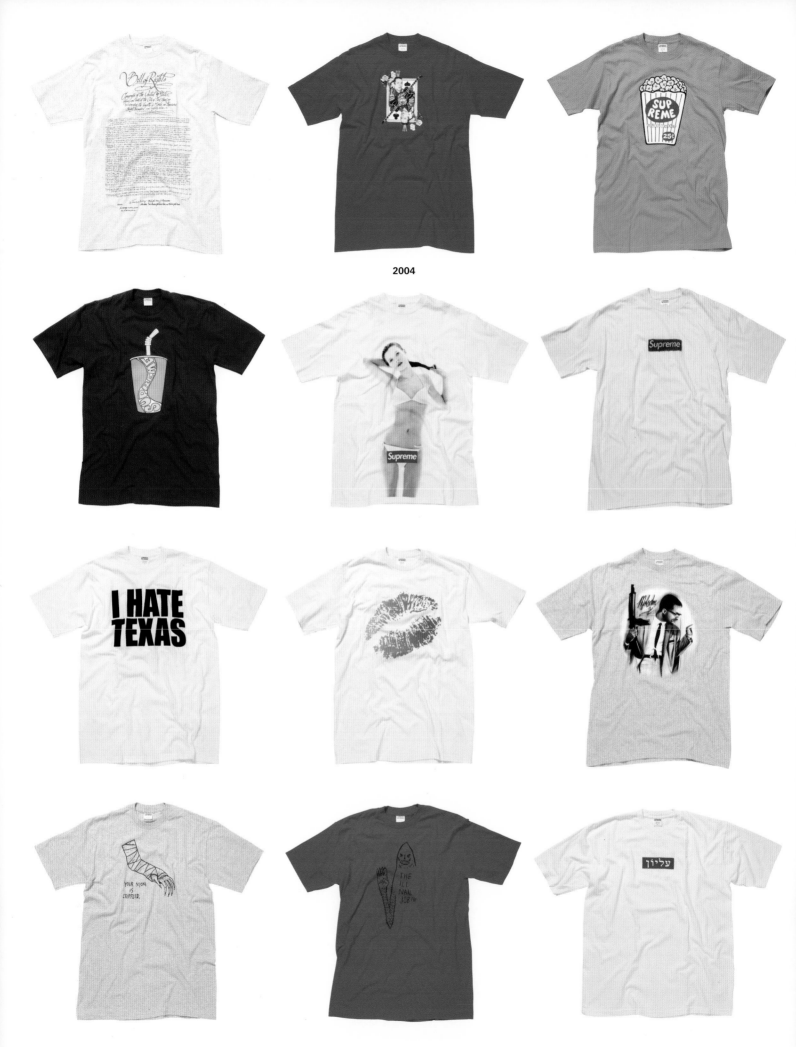

2004

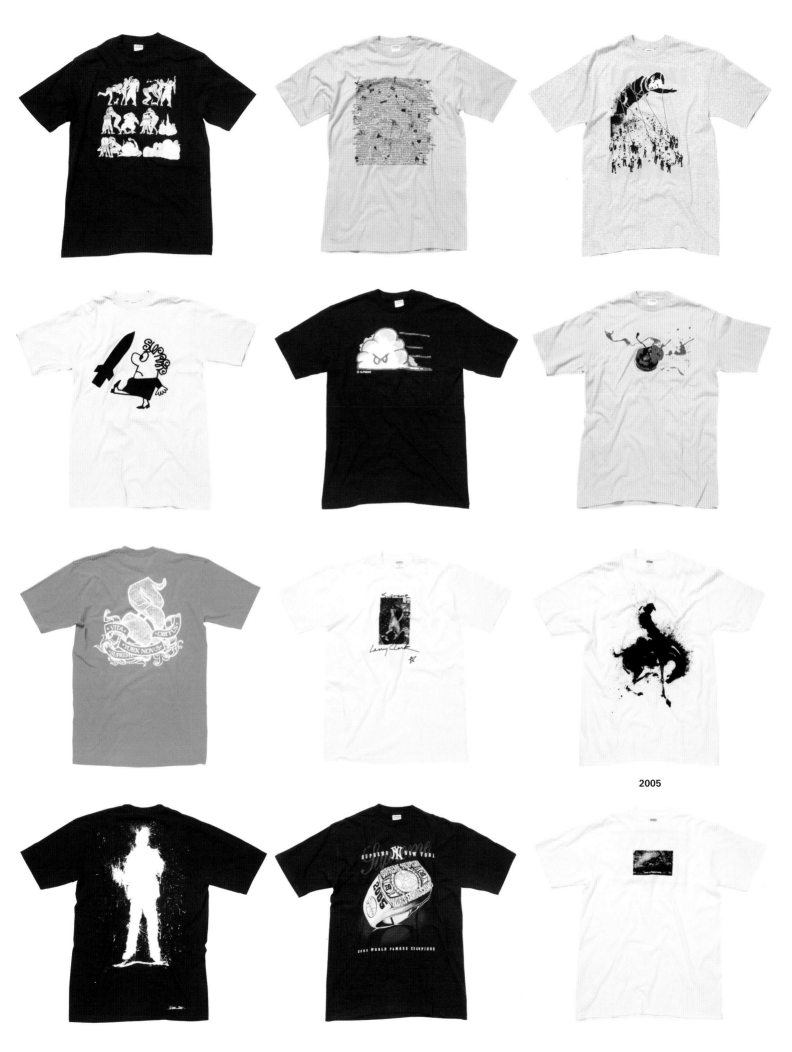

2005

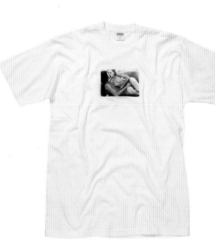

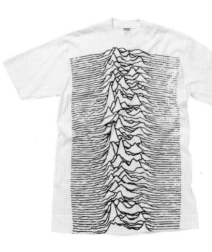

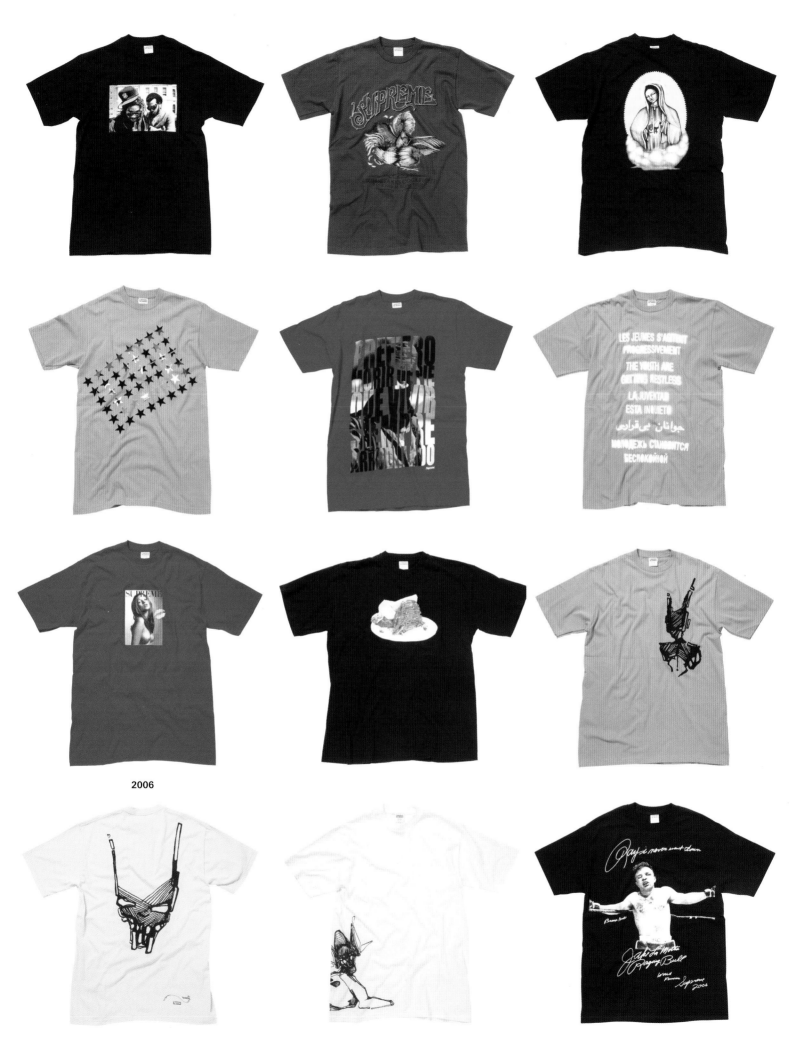

2006

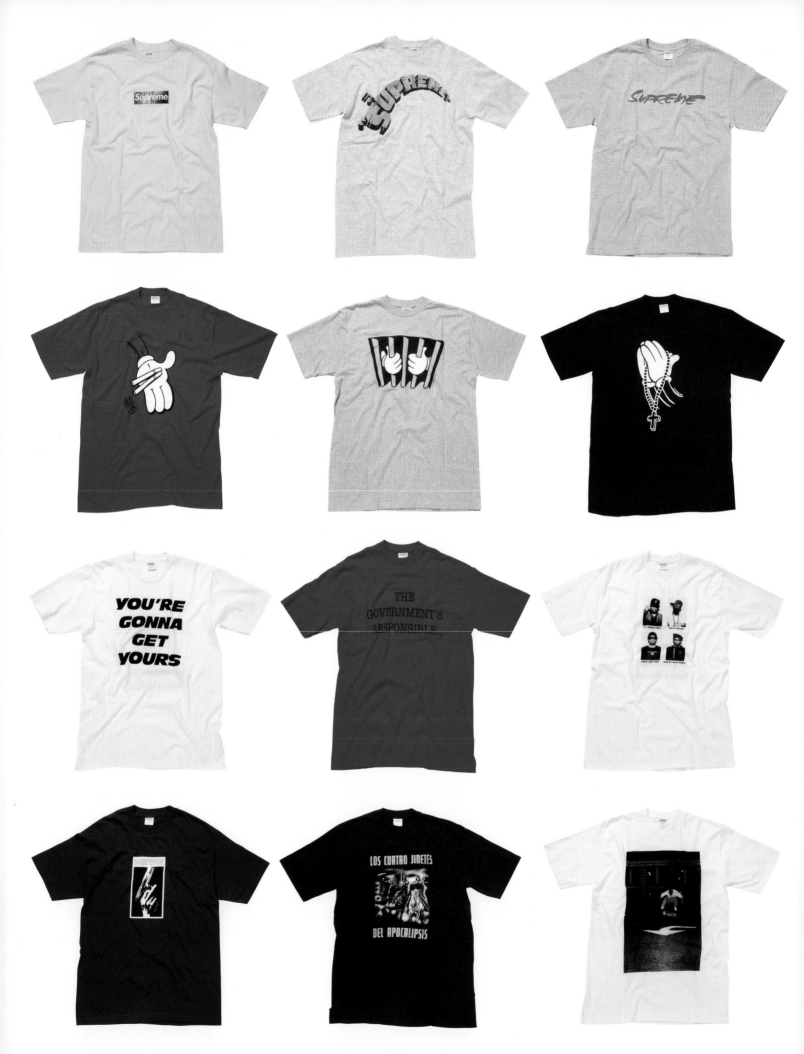

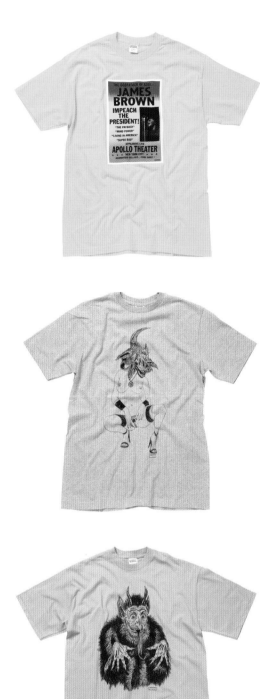

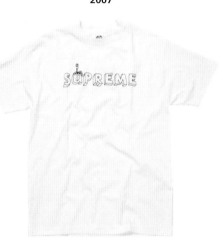

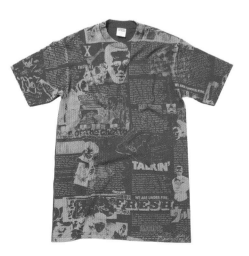

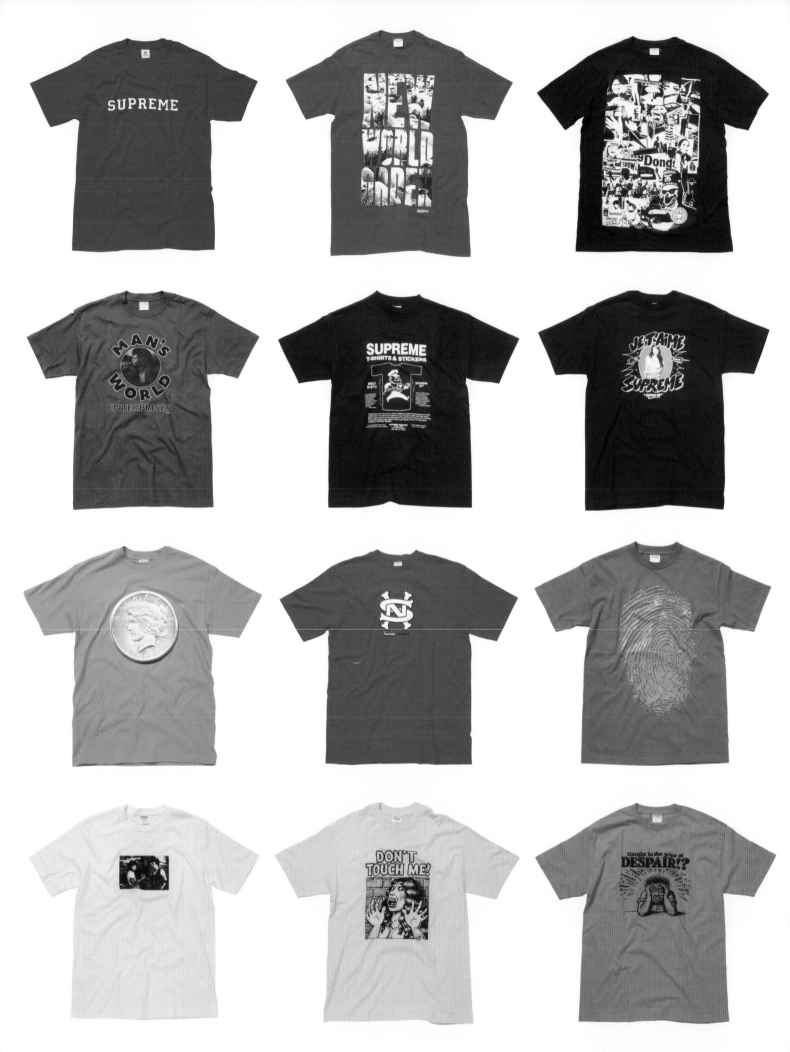

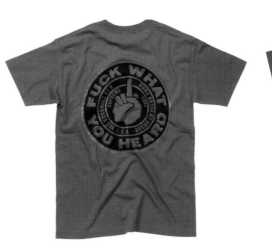

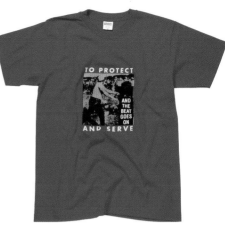

2008

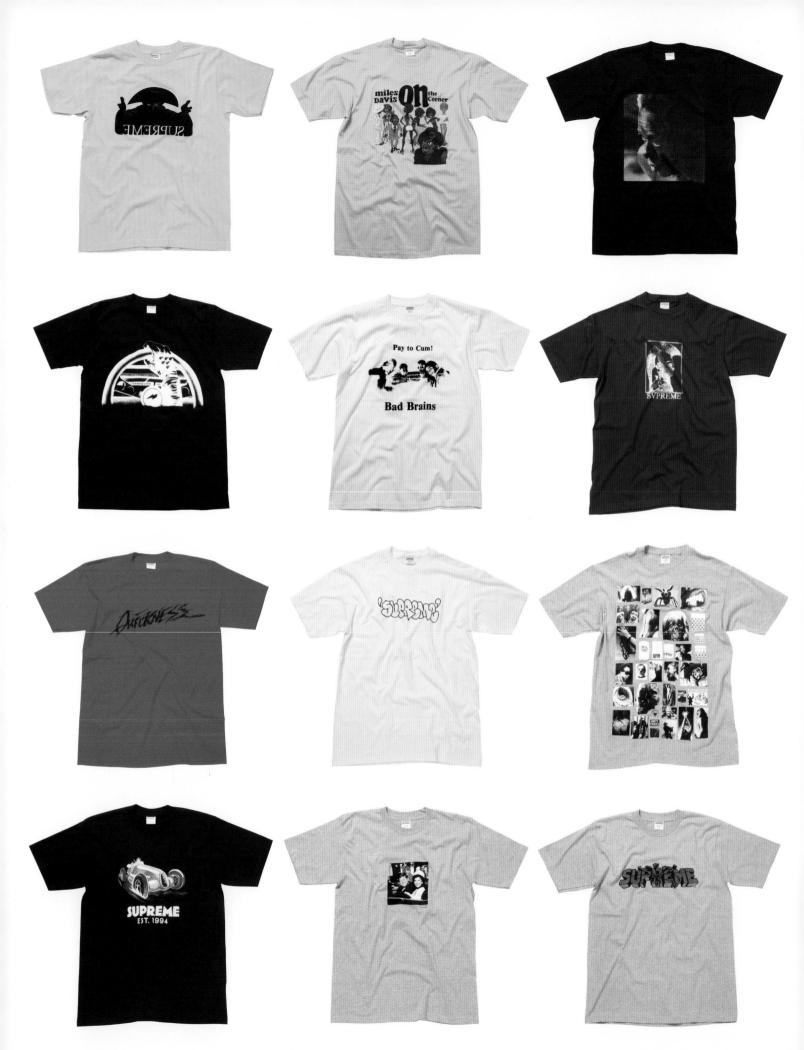

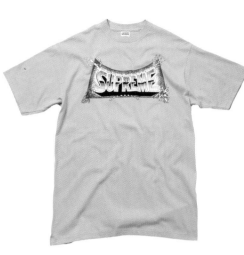

2009

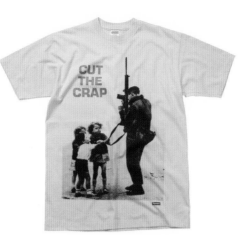

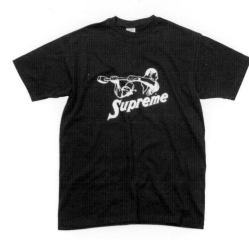

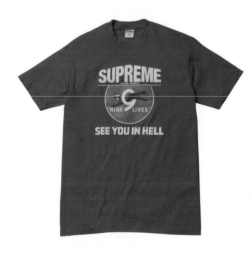

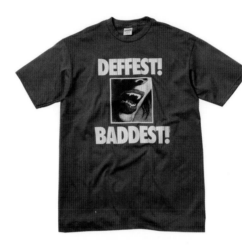

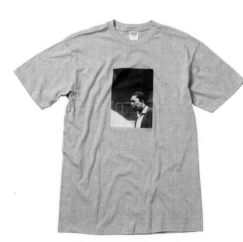

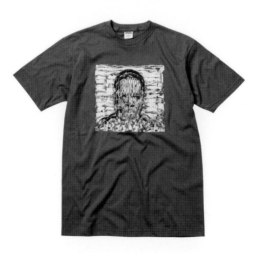

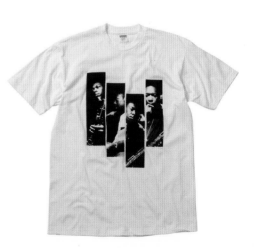

1997

1998

 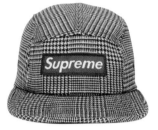

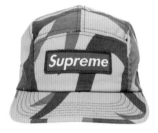 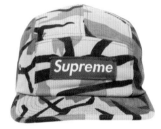 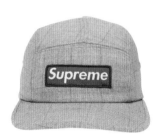

1999

 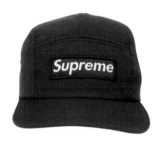 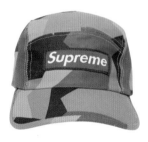

2000

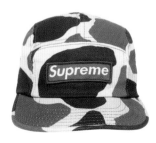

2001

2002

2003

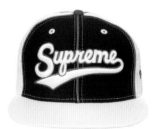

2004

2005

2006

 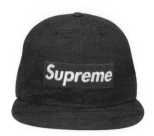

2007

2008

299

 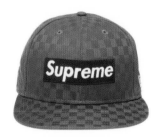

 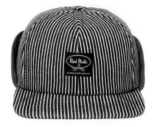

 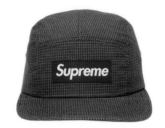

2009

 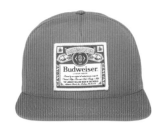

 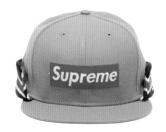

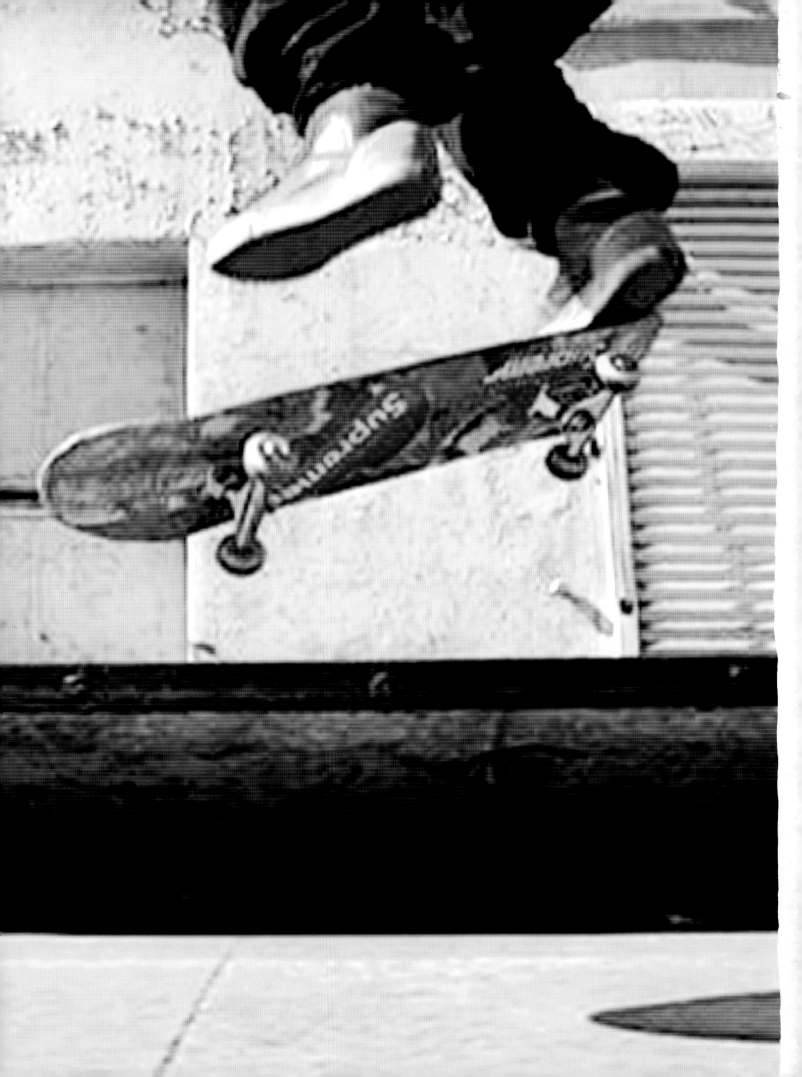